Themes in Contemporary Art

Edited by **Gill Perry** and **Paul Wood**

Yale University Press, New Haven and London
in association with The Open University

501240002

This publication forms part of an Open University course: AA318 *Art of the Twentieth Century*. The complete list of texts which make up this course can be found in the Preface. Details of this and other Open University courses can be obtained from the Course Information and Advice Centre, PO Box 724, The Open University, Milton Keynes MK7 6ZS, United Kingdom: tel. +44 (0)1908 653231, e-mail general-enquiries@open.ac.uk

Alternatively, you may visit the Open University website at http://www.open.ac.uk where you can learn more about the wide range of courses and packs offered at all levels by the Open University.

To purchase a selection of Open University course materials, visit the webshop at www.ouw.co.uk or contact Open University Worldwide, Michael Young Building, Walton Hall, Milton Keynes MK7 6AA, United Kingdom for a brochure. tel. +44 (0)1908 858785; fax +44 (0)1908 858787; e-mail ouwenq@open.ac.uk

Yale University Press
47 Bedford Square
London
WC1B 3DP

The Open University
Walton Hall
Milton Keynes
MK7 6AA

First published 2004 by Yale University Press in association with The Open University.

Library of Congress Control Number: 2004105258.

ISBN 0–300–10143–0 (cloth)
ISBN 0–300–10297–6 (paper)

Edited, designed and typeset by The Open University.
Printed and bound by CS Graphics, Singapore.

1.1

Contents

Preface

This is the final book of four in the series *Art of the Twentieth Century*. Although the books can be read independently and are accessible to the general reader, as a series they form the main texts of an Open University third-level course of the same name.

Themes in Contemporary Art discusses the art of the final third of the twentieth century, since the late 1960s: the period of postmodernism. The book opens with a chapter surveying developments in the period as a whole. This is followed by six chapters each discussing a particular aspect of postmodernist art in more detail. The first three look at the consequences of Conceptual Art: for the notion of the aesthetic, which had been central to modernist art; for painting; and for photography. The fourth chapter surveys the development of installation and performance-based art, as well as the emergence of video. The fifth chapter looks at various practices by women artists, and the final chapter considers the increasing globalisation of art at the end of the twentieth century and the beginning of the twenty-first.

All the books in the series include teaching elements. To encourage the reader to reflect on the material presented, most chapters contain short exercises in the form of questions printed in bold type. These are followed by discursive sections, the end of which is marked by a small black square. In addition, cross-references to topics covered in the other books in the series are provided throughout.

The four books in the series are:

> *Frameworks for Modern Art*, edited by Jason Gaiger
>
> *Art of the Avant-Gardes*, edited by Steve Edwards and Paul Wood
>
> *Varieties of Modernism*, edited by Paul Wood
>
> *Themes in Contemporary Art*, edited by Gill Perry and Paul Wood

There is also a companion reader:

> *Art of the Twentieth Century: A Reader*, edited by Jason Gaiger and Paul Wood

Open University courses are the result of a genuinely collaborative process and the book editors would like to thank the following people for their invaluable contributions: Julie Bennett, Kate Clements, Andrew Coleman and Alan Finch, course editors; Pam Bracewell, tutor assessor; Glen Darby and Liz Yeomans, graphic designers; Nicola Durbridge, learning and teaching advisor; Janet Fennell, course assistant; Heather Kelly, course manager; Liam Baldwin and Jo Walton, picture researchers. Special thanks are due to Professor Alex Potts, Department of the History of Art, University of Michigan, who as external assessor for the course read and commented on all the materials throughout the production process.

Introduction

Paul Wood

This book is the final volume in a series of four dealing with the art of the twentieth century as a whole, but it also provides an independent treatment of the 'postmodernist' art that has emerged since the late 1960s. The first book, entitled *Frameworks for Modern Art*, offers a thematic introduction to twentieth-century art, with studies of a 'readymade' by Marcel Duchamp, a modernist abstract painting by Barnett Newman, a series of works from the 'expanded field' of postmodernism by Ana Mendieta and a non-western installation by artists of the Aboriginal Australian community at Yuendumu. The other three books consist of chronologically based studies. *Art of the Avant-Gardes* discusses the Expressionist, Cubist and abstract art of the first third of the twentieth century. *Varieties of Modernism* examines the canonical modernism of the middle years of the twentieth century and the counter-currents of the neo-avant-garde, Pop Art and Minimal Art. This final book consists of seven chapters, the first a general introduction to postmodernist art, the rest discussing particular aspects of the art of the last third of the twentieth century.

Each chapter is a free-standing essay, but there are, of course, numerous points of intersection, and certain artists are discussed in more than one place. Chapter 1 is very wide ranging. Paul Wood offers a historical introduction to the period as a whole in order to provide a framework for the more specifically focused treatments that follow. He traces the break-up of the 'modernist' paradigm of art and the rapid emergence of a variety of non-medium-specific practices, including installations, land art, performance art and Conceptual Art in the 1960s and 1970s. There is an introduction to the concept of 'postmodernism' as it has figured in the visual arts, and a brief survey of the development of a fully fledged postmodernist practice of art, taking in the return to painting seen in the 1980s, and the array of installation and lens-based or time-based activities of the closing years of the twentieth century.

Chapters 2–4 take as their starting point the moment in the late 1960s when Conceptual Art seemed to redraw the map of possibilities for a critical art practice. In Chapter 2, Charles Harrison discusses the consequences of Conceptual Art for the aesthetic, that is to say, for the centring of art on its visual effects, and the closely related question of judgements of value, which had been so central to modernist art. Harrison's discussion looks at developments in Conceptual Art in the UK and the USA, before focusing closely on the work of the Art & Language group. In Chapter 3, Jason Gaiger considers the wider implications of Conceptual Art for the practice of painting. His essay is concerned with a variety of different attempts by artists to renew, or continue with, painting in the wake of the fundamental critique of the assumptions of modernism that had been effected by Conceptual Art. Gaiger's discussion is centred on aspects of the work of the German painter Gerhard Richter. In Chapter 4, Steve Edwards chooses not to focus on one particular artist, but to offer a broader survey of various practices of photographic-based art in the wake of conceptualism. He discusses the work of, among others, Dan Graham, Ed Ruscha, Robert Smithson, Martha Rosler, Jeff Wall and Allan Sekula.

The final three chapters analyse various aspects of the 'expanded field' of art activity in the late twentieth century. In Chapter 5, Kristine Stiles explores the many practices of installation, performance and video art. Stiles traces the emergence of these practices from the Fluxus activities and 'happenings' of the early 1960s, before addressing a gamut of postmodernist activity across the period from the 1970s to the 1990s. In Chapter 6, Gill Perry discusses a range of works on the theme of the home by a number of women artists active in the same period. These include Louise Bourgeois, Mona Hatoum and Rachel Whiteread. Perry looks at questions of gender, identity and meaning as they relate both to the making of art and to the spectator's encounter with it. In the final chapter, Niru Ratnam talks about the increasing globalisation of art practice towards the end of the twentieth century. He discusses the consequences for the canonical western conception of art of its opening up to various non-western practices, which is continuing to take place. He also looks at the connection between cultural globalisation and changing economic and political relationships around the world at the turn into the twenty-first century.

Taken together, the seven chapters offer both a comprehensive introduction to the field of contemporary art practice and an in-depth discussion of the critical themes and theories which play across that practice. At the beginning of the twenty-first century, many of art's conventional certainties are under challenge. What the work of art is, what it means to engage as a spectator with the work of art, what contemporary art's relationship is to traditional art, what art's relationship is to politics as well as to other cultural fields such as the mass media and the Internet – these are all questions that bear down insistently today upon the multifarious activities we term 'art'. *Themes in Contemporary Art*, read either alone or in conjunction with the other books in the series, aims to give the reader a historically informed purchase on what is happening in art now.

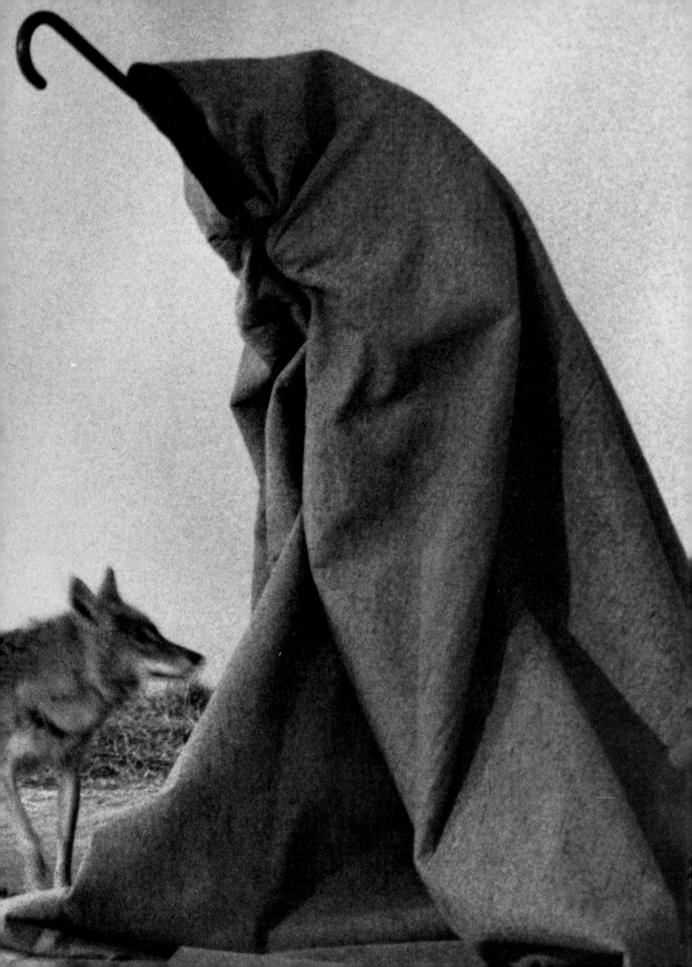

Inside the whale: an introduction to postmodernist art

Paul Wood

Introduction

'Postmodernism' is a convenient yet confusing term. The confusion arises because there is no universally accepted definition of 'postmodernism'. It does not refer to a specific style of art, and there is no agreement about the precise historical period to which it is relevant, nor whether it concerns the state of art alone or a wider socio-historical condition. Some dispute whether it is a legitimate notion at all, while others who do accept it cannot agree if it is a positive or a negative thing. But for all these problems, there is one countervailing benefit to its employment: it does point to the fact that something changed in art in the last third of the twentieth century, something perhaps as fundamental as the change that modernism itself represented.[1]

That was then and this is now

Modernist painting in the mid-1960s was exemplified by 'post-painterly abstraction'.[2] Its leading practitioners included Kenneth Noland and Jules Olitski.[3] Noland's painting was characterised by hard-edged bands of colour, initially in circles, then chevrons, and by the late 1960s, stretching horizontally across the width of the canvas. Olitski's work of the same time consisted of barely modulated fields of sprayed-on colour, marked along one or more edges by irregular lines or bands of colour, relatively roughly applied with a brush (Plate 1.2). Olitski himself wrote: 'I think of painting as possessed by a structure – i.e., shape and size, support and edge – but a structure born of the flow of color feeling … Color must be felt throughout.'[4] These paintings were controversial, and even at the time seem to have been perceived as test cases. For their defenders, such as the critics Clement Greenberg and Michael Fried, they communicated intense emotion, shorn of all literary or theatrical accoutrements, distilled through eyesight alone. Writing as early as 1960, Greenberg judged Noland's painting, along with that of Morris Louis, to be 'upsetting' and 'profound', of 'truly phenomenal originality'.[5] Fried regarded Noland's painting as possessed of 'passion, eloquence and fragile power' and saw the artist as a 'tense, critical, almost hurting presence in his work'.[6] He described Olitski's work as 'an impassioned attempt both to elicit and to record his most intuitive, evanescent coloristic impulses', concluding that his painting was nothing less than 'among the most beautiful, authoritative and moving creations of our time in any art'.[7]

PLATE 1.1 (facing page) Joseph Beuys, detail of *I Like America and America Likes Me* (Plate 1.6).

For more hostile critics, however, such paintings were bland symptoms of the way modernism had lost its critical edge and declined into a form of corporate decoration. The critic Lucy Lippard, for example, subsequently characterised moves away from modernism as 'escape attempts', from something constraining, imprisoning even. At the time, she singled out Olitski's painting as a form of 'visual *Muzak*'.[8] This was not just a witty way of saying it was boring, an irony on the classic modernist claim that abstract art was 'visual music'. The description hinted at something deeper. In so far as Muzak lulls us into passivity and consumption, there is an implication that modernist art is a cultural opiate, part of the ideological smokescreen concealing reality, rather than a genuine producer of increased self-consciousness. Care is required here. In the subsequent backlash against modernism, the 'autonomy' that was claimed for modernist art was frequently stereotyped to the point of misrepresentation, not least by politically committed social historians of art. As a counter to this, T.J. Clark has observed: 'Obviously, new movements need to take a distance from their forebears. Killing the father is a fact of artistic life. But killing a cardboard replica of the father … seems to me utterly futile, and a guarantee of bad, self-righteous, simplistic work.'[9] The point here is not to caricature either modernist criticism or the art it esteemed, but rather to underline the schism that had opened up in the avant-garde by the mid- to late 1960s.

At the other end of the period I am discussing, one of the largest sites in the world for the display of modern art opened in May 2000: Tate Modern in London. As well as the permanent collection, it included a temporary exhibition called 'Between Cinema and a Hard Place'. The title was taken from a multi-screen video work by the Canadian artist Gary Hill that formed part of the exhibition. Most of the works displayed were either videos or large-scale installations; there were no conventional paintings. Again, I will take examples by two artists. First, the Russian Ilya Kabakov exhibited a claustrophobic corridor, along which the viewer walked, in dim light, flanked

PLATE 1.2 Jules Olitski, *Instant Loveland*, 1968, acrylic on canvas, 295 × 646 cm. (© Tate, London 2003. © Jules Olitski/VAGA, New York/DACS, London 2004.)

by dingy municipal-style painted walls and framed 'plaques' consisting of faded wallpaper, old photographs and dog-eared, handwritten texts. After turning several corners, the viewer eventually reached the heart of the installation – a space littered with wood shavings, discarded masking tape and other rubbish, ending at a closed door, behind which played a tape of someone mournfully singing in Russian. The whole was a meticulously fabricated simulacrum of a run-down boarding-house or hotel, at an indeterminate point in the long decline of the USSR. The story recounted in the pictures and texts along the corridor purported to be (though it was actually a fictional construction of) the autobiography of the artist/author's mother. The end result was a kind of melancholic reflection on the stoicism required to cope with the purgatory of lived normality in a failed socialist society. The accompanying brochure referred to the work as a 'three-dimensional novel'.[10]

By contrast, an installation by the Canadian artist Stan Douglas involved the most sophisticated contemporary technology: a purpose-built viewing salon with theatre-like acoustics and dim lighting. The work of art consisted of two floor-to-ceiling video projections of two men having an argument, alternately sitting down, standing up and pacing around a room, and finally fighting (Plate 1.3). The room was a representation of an unbuilt modern housing project in postwar Vancouver. The six-minute loops of the argument played endlessly but, again according to the brochure, in computer-programmed sequences that would only ever repeat once in over two years.[11] The installation is seen as potentially opening up a series of reflections both upon the failed promises of western modernity at the social level, and upon the apparently inherent communication breakdowns of more intimate human relationships.

Whatever else one might say about these two kinds of art, the first from the 1960s and the second from the 1990s, it is quite clear that the criteria for judging, or even comprehending, them as art are quite different. To approach Kabakov's installation or Douglas's video with the criteria used by formalist critics in the 1960s to evaluate Noland's or Olitski's paintings would be to invite either incomprehension or rejection of them as significant works of visual art. To mention only the most obvious points: the medium-specificity of modernist painting is totally abrogated in the hybrid installations; both feature kinds of narrative and as such are to be experienced in time. There *are* antecedents for this kind of work, but they are to be found in the critical avant-gardes of the early twentieth century, and more particularly in the neo-avant-garde activities that gained ground from the mid-1950s onwards. However, until the mid-1960s, all these types of activity were, broadly speaking,

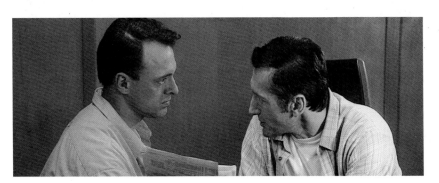

PLATE 1.3
Stan Douglas, *Win, Place or Show*, 1998, still from two-channel video projection, four-channel soundtrack – 204,023 variations with an average duration of 6 min each, dimensions variable. (Courtesy of David Zwirner, New York.)

subordinate to canonical modernism. Although modernism never went unchallenged, until the 1960s it had always weathered its crises. From that point on, the story took a different turn. It remains something of an open question whether what was going on amounts to a paradigm shift in the practice of art, or a compromise with forces in the wider culture that militate against hard-won standards of quality in the modern tradition. Seen from the point of view of modernist criticism, the postmodernist works would be either not really art at all, or, more simply, bad art (which is precisely how Greenberg put it in 1980: from the Procrustean bed of his judgement, 'the postmodern business' amounts to a 'retreat from the major to the minor: the hailing of the minor as major, or else the claim that the difference between the two isn't important'[12]). Yet, of course, in 2000 these works were specifically selected as exemplary of contemporary art, fit to mark the opening of one of the largest and most prestigious art museums in the world. However one may ultimately wish to characterise this change – from one phase of modern art (or modern*ism*) to another, or out of modernism into *post*modernism – there can be no doubt that a far-reaching shift in the premises underlying what may count as an interesting or valuable work of contemporary art has indeed taken place.

The watershed

The main outlines of this historical shift are widely acknowledged, even if its significance is not. In the rest of this chapter, I shall therefore sketch in a general background to provide a context for the more detailed studies in the chapters that follow. The watershed is located in the decade between *c.*1965 and *c.*1975. At the beginning of that period, although modernism was already challenged by Minimal Art and Pop Art, it was still possible to say that the modernist canon as theorised by Greenberg, Fried and others was represented by medium-specific painting, addressed to the production of autonomous aesthetic effects in its disinterested spectators. By the mid-1970s, such painting had been replaced at the forefront of the international art world by a hybrid, politicised practice, generically often referred to as 'conceptualism'. After an initial analytical phase, this had turned outwards to address the faultlines of contemporary society: principally class and gender division, though extending also to questions of race (or ethnicity) and the environment. That is, of course, to oversimplify, to isolate a dominant tendency; qualifications can always be entered and counter-currents found. Nonetheless, in broad outline that kind of change did happen.

This is a change of some magnitude, and it is worth rehearsing its main stages. By the mid-1960s, Minimal Art had become established in the New York avant-garde, although the name had not yet settled. Historically, minimalism occupies an unstable position. Looked at in one light, it can seem almost like the completion of the logic of modernist reductionism, the culmination of the long process of throwing out the inessential from the work of art in the pursuit of the most concentrated, most distilled, most unified effect. Yet looked at in another way, it may appear to be a violation of the cardinal principles of modernist art.

Minimalism was not just another style of autonomous abstraction, following on from Abstract Expressionism and post-painterly abstraction. Minimalism has a definite, albeit obliquely and allusively stated, relation to modernity, specifically contemporary American modernity. The painter Frank Stella was critical of the traditional process of painterly composing, balancing one part of the picture against another to produce a resolved composition: 'I had to do something about relational painting.'[13] The sculptor Donald Judd also wanted another way of proceeding, which he famously described not as an intuitive art of composing and balancing but as 'one thing after another': that is, something more in tune with industrial mass production.[14] In other words, he wanted something structurally and procedurally *of* contemporary reality (i.e. American reality), not of a previous, more artisanal (by extension, European) phase of modernity. Robert Morris spoke of contemporary industrial society, linking abstraction in art to the increasing abstraction of the production process at large. For him, industrial forming and machine-type production stimulated work that had 'the feel and look of openness, extendibility, accessibility, publicness' – the product of 'clear decision rather than groping craft'. Morris added the important rider that artwork made along such lines had social implications, standing opposed to 'exclusive specialness' and the sense of superiority attached to traditional art appreciation.[15] It is never stated overtly, but there is a sense of American pragmatism and democracy freeing art from the remnants of the elitism of the European tradition.

Both Judd and Morris clearly felt that a new form of art had to incorporate something of the ways and means of the new culture surrounding them: not images of that culture – that was the province of Pop Art – but something of its structuring principles and processes. A further point concerns the question of the relationship of the viewer to the work of art. The modernist work characteristically hung in a world of its own making – an autonomous sphere. The ideal modernist spectator was a disembodied eye, lifted out of the flux of life in time and history, apprehending the resolved ('significant') aesthetic form in a moment of instantaneity. Morris, in particular, overtly challenged the scarcely veiled idealist assumptions of high modernism, and instituted a 'phenomenological' turn.[16] Looking, indeed perception in general, was understood by Morris as thoroughly embodied, and as taking place in real time. At the other end of the operation, the object that was being looked at was also now emphatically conceived as a material thing, among other material things in the world. Carl Andre was the most explicit about this, regarding the revelation of the properties of material – of wood and of different metals – as at the heart of what he was about (Plate 1.4). As he plainly asserted, his art was 'atheistic and materialistic'.[17]

The upshot is that although the Minimal object may appear to be closely related to the unitary modernist work, it is actually distinct in three fundamental ways: it has a different ontological status, as a physical object rather than a pictorial 'form'; it is the product of a significantly different process of production; and it is the object of a different kind of apprehension or consumption. Minimal Art does indeed emerge out of modernism, particularly modernist painting: Judd cites his antecedents in the unified painting of Barnett Newman and Kenneth Noland. But Minimal Art takes modernism somewhere else.

From a modernist point of view, that somewhere else was a no-go area – a place, as Fried put it, 'at war' with the modernist sensibility.[18] Yet for the majority of others working in avant-garde art in the mid- to late 1960s, that somewhere else was a place that seemed to liberate all kinds of possibilities for further exploration. The limits of the art object, and indeed of art activity as such, were probed in a range of ways that would very quickly leave the Minimal object as far behind as that object had left modernist painting and sculpture.

The 'post-Minimal' explosion

If the mid-1960s had minimalism at the forefront, the next two or three years saw a range of avant-garde practices emerge that led to a far-reaching questioning of the kind of practice art was, the kinds of thing that were produced and the kind of relationship art had to other types of activity in the world. It may be argued that such work finally took up in a fully fledged way the questioning of the modern movement initially broached by Dada and Constructivism in the second decade of the twentieth century (and underpinned by the wider revolutionary challenge to the international capitalist system at the moment of its major crisis). That questioning had been put on hold by the hegemonic modernism of the mid-century, coupled with the eventual securing and stabilisation of the liberal capitalism that undergirded it. This is a schematic way of encapsulating a complex and epochal development. The challenge of the moment of 1968 was of a different order from that of 1917, but in the field of art it was as if a paradigm was finally unravelling, its contradictions having mounted to the point where the entire system was ripe for redefinition.[19]

A range of so-called 'post-minimalist' practices rapidly appeared, along with a rash of terms to describe them. These included anti-form, the related Italian movement Arte Povera, process art, performance or body art, land or earth

art, and, perhaps above all, Conceptual Art. 'Conceptual Art' is a term that initially applied to the work of relatively few artists using language to analyse the problems thrown up by the collapse of modernism and the coincident burgeoning of a range of alternatives to it (see Plates 2.6 and 2.10). Subsequently, in the 1970s, Conceptual Art took a political turn and was characterised by an increased use of photography, frequently in conjunction with texts of various kinds (see Plate 4.9). The term has since, however, mutated into 'conceptualism' — which is now often used by journalists and non-specialist commentators as a catch-all label for the gamut of postmodernist activity: that is, not simply the 'new avant-garde' of the 1960s and 1970s, but the photographic, video, performance and installation art of the 1980s and 1990s. The danger attendant on this usage is the homogenisation that is implicitly enforced across quite distinct activities: namely, 'Conceptual Art', a once-oppositional current (now historical), and 'conceptualism', a pervasive field that amounts to something like the status quo of contemporary art. These activities are positioned differently in the culture at large, united only by their difference from medium-specific modernist painting and sculpture, and a correspondingly greater emphasis on the 'idea'.[20]

The point I want to bring out here is the way in which the pursuit of quite specialised technical issues had consequences that were to prove far-reaching in terms of the reorientation of art practice. To take an example: one of the consequences of the drive towards an ever-greater unity of effect for modernist painting had been the progressive effacement of conventional figure–ground relations. In terms of painting itself, this led to the emergence of the 'all-over' canvas, and by the time of post-painterly abstraction to an increasing preoccupation with the point or place where the work of art was delimited from everything else: that is to say, its shape or its framing edge. Taken in a different way, however, the problem of figure and ground seemed to point to the exhaustion of painting, and culminated in the move off the wall into physical space with the unified 'specific object' of Minimal Art. But once it began to be noticed that the Minimal object sat in a space, usually the space of the gallery, it was easy to believe that all that had happened was that figure–ground relations had been transplanted. The specific object appeared as 'figure' to the 'ground' of the room space in which it sat. In short order, the absoluteness of the unitary gestalt object — the cube, for example — itself became questioned. Inexorably, it seemed, the question of context was opening up as the key issue to be addressed by the work of art.

The result was a rapid reversal of polarity. In no time at all the unitary form was replaced by anti-form: gallery spaces were filled by undifferentiated industrial waste, rolls of felt, scattered chips or blocks of wood, rolls of wire, literally anything, to produce an effect of what Morris called 'de-differentiation' (Plate 1.5).[21] On the one hand, then, there is an internal dynamic at work, concerned with questions of artistic form and perception. Vito Acconci used the new medium of video to raise questions about the identity of the artist and the spectator, for example, talking directly to the camera/viewer in a hypnotic monotone, filmed in disturbingly extreme close-up. Bruce Nauman has described how the performances and photographs he made at the time, of mundane activities such as pacing around in the studio or spilling a cup of

coffee, arose directly out of the newly open situation. It was as if the demolition of modernism had sent art back to square one:

> I spent a lot of time at the studio kind of reassessing, or assessing, why, why are you an artist and what do you do … that question, why is anyone an artist and what do artists do. I paced around a lot, so I tried to figure out a way of making that function as the work.[22]

On the other hand, there is a different kind of interest working alongside this, in one sense more contingent, but also conferring a certain character upon these formal shifts. In the increasingly radical climate of the late 1960s, these moves chimed with a drive to get away from all forms of hierarchy, both in society and within the work of art itself. It is as if a certain quest for a democracy of form paralleled the emergence of radical democracy in the wider New Left of the time. The performances and teaching of the German artist Joseph Beuys were based on the premise that 'Every human being is an artist.' For Beuys, artistic freedom became inseparable from creating the conditions for a future free social order:

> Self-determination and participation in the cultural sphere (freedom); in the structuring of laws (democracy); and in the sphere of economics (socialism). Self-administration and decentralization (three-fold structure) occurs: FREE DEMOCRATIC SOCIALISM.
>
> THE FIFTH INTERNATIONAL is born.[23]

It was sentiments such as these that underlay Beuys's troubling performances, such as the one in a New York gallery where, in the persona of a kind of shepherd, he cohabited with a coyote, symbolic of native America, in a cage bare except for straw and copies of the *Wall Street Journal* (Plate 1.6).

Around the same time, other works, made of increasingly heterodox materials, began to be placed outside the conventional contexts of art, such as private galleries, and located directly in the landscape or in the spaces of the city (although, crucially, such work tended still to be represented in gallery spaces in the form of photographic documentation, and indeed to be funded by

PLATE 1.5
Robert Morris,
Untitled (Tangle),
1967–8,
254 pieces of felt,
13 mm thick, overall
dimensions variable.
(National Gallery of
Canada, Ottawa.
Purchased in 1968.
© ARS, New York/
DACS, London 2004.)

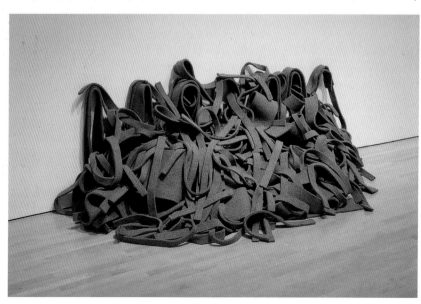

galleries and collectors too). Gordon Matta-Clark cut slits and holes through a variety of buildings, symbolic of opening up hitherto enclosed physical spaces while at the same time allegorising the opening of the closures wrought by ideology and politics in urban life. These included splitting an American suburban house in two (Plate 1.7), and burrowing conical holes through a seventeenth-century building in Les Halles, Paris, the better to dramatise the looming monolith of the soon-to-be-completed Pompidou Centre: the French government's cultural–architectural response to the events of May 1968.

One of the earliest and best-known examples of such work, undertaken in what Rosalind Krauss dubbed the 'expanded field' of art activity,[24] is Robert Smithson's *Spiral Jetty* of 1970: a 1,500 ft (457 m) long ramp of rocks protruding from Rozel Point into the Great Salt Lake in Utah, constructed with bulldozers, lorries and caterpillar digging machines in the summer of 1970 (Plate 1.8). Smithson had been a second-generation minimalist who, by the later 1960s, had begun to blur the boundaries of the artwork in the gallery and the world outside. Initially he imported traces of the world, in the form of rocks or other minerals, into the gallery, often displayed in minimalistic metal containers, along with documentation of the site they came from, in the form of photographs or maps. Smithson brought an eclectic approach to making art that was quite at variance with modernist specialisation – for example, mixing an interest in geology with science fiction, Surrealism with modern industry, language with mythology. The result was an increasingly hybrid practice dedicated to providing a less contained experience than that which seemed to be promised by the formally unified modernist – or even minimalist – work.

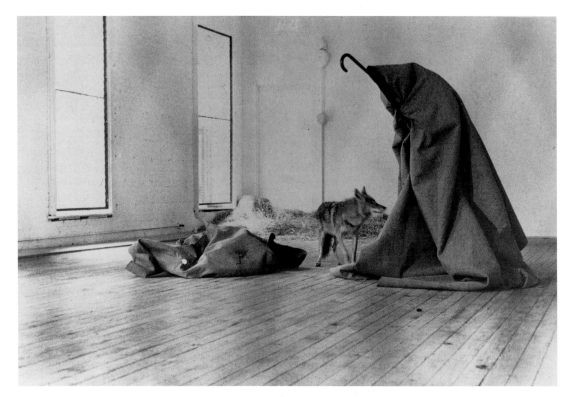

PLATE 1.6 Joseph Beuys, *I Like America and America Likes Me*, 1974, photograph of performance. (Courtesy Ronald Feldman Fine Arts, New York. Photo: © 2003 Caroline Tisdall. © DACS, London 2004.)

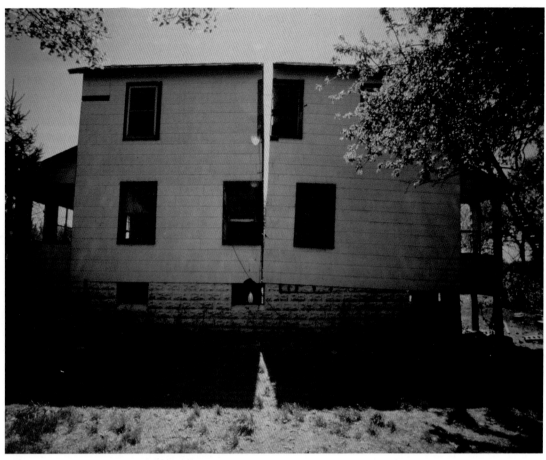

PLATE 1.7 Gordon Matta-Clark, *Splitting*, colour photograph, 68 x 99 cm. (Courtesy of the Estate of Gordon Matta-Clark and David Zwirner, New York. © ARS, New York/DACS, London 2004.)

In his essay 'A Sedimentation of the Mind', Smithson discussed an event that became a nodal point in the dispute between modernists and their post-Minimal opponents.[25] One night in the early 1950s, the sculptor and architect Tony Smith had driven his car along the then unfinished New Jersey turnpike. Later, in 1966, in an interview published in the influential journal *Artforum*, Smith had favourably compared the power of that experience with anything he had been able to feel when faced by a conventional work of art:

> It was a dark night and there were no lights or shoulder markers, lines, railings, or anything at all except the dark pavement moving through the landscape of the flats, rimmed by hills in the distance, but punctuated by stacks, towers, fumes, and colored lights. This drive was a revealing experience. The road and much of the landscape was artificial, and yet it couldn't be called a work of art. On the other hand, it did something for me that art had never done ... It seemed that there had been a reality there which had not had any expression in art.[26]

For Michael Fried, this was a paradigm of what he called 'theatricality', and as such stood opposed to the authentic experience of modernist art. Smithson explicitly rejected Fried's appeal to the 'innumerable conventions both of art and practical life', which Fried felt were crucial boundaries to be respected by the work, and the related experience, of art. Aligning himself with Allan Kaprow's rejection of the mentality that would 'put fences around their acts and thoughts', Smithson appealed to that sense of 'oceanic' 'de-differentiation', which for him characterised a suspension of boundaries between the self and the non-self. This rejection of boundaries and hierarchies accorded with Smithson's attachment to the notion of entropy, the eventual decay, settling and de-differentiation of all things: 'the artist experiences undifferentiated or unbounded methods of procedure that break with the focused limits of rational technique'.[27] It goes almost without saying that Smithson's embrace of entropy stands as an implicit critique of the contemporary fetishisation of technology in American society, ranging from the prosecution of the war in Vietnam to the space programme. It would be a mistake to regard Smithson as a proto-Green, but he did have a vision of the earth as something that exceeded modern western industrial society, and which art had to face up to if it was not to be reduced to being a contained symptom of that society. For Smithson, his own work and that of like-minded artists directly addressed an expansive experience of the world, relatively unconfined, as he saw it, compared with modernist painting and sculpture.

Faced with such developments, it was not long before attention to the physical aspects of the art object, and of the conditions under which it was viewed, began to mutate. A concern with, say, the characteristic verticality of the human spectator or the operation of gravity on matter – in short, the limiting conditions of our being in the world as humans in time and space – evolved into a concern with those factors considered in terms of institutions and history. Certain kinds of formal, structural innovation thus became inseparable from a wider revelation of what Smithson called 'cultural confinement'. In other words, in a process that would have been impossible to predict at the outset, but with the benefit of hindsight seems inexorable, the focus on specialised problems internal to the paradigm of modernist art quickly opened up to expose to artistic scrutiny first the spatio-temporal conditions of human existence, and then the social and political conditions too (see Plate 4.12).

Greenberg once observed how, at the inception of modernism, a curious process of inversion had taken place. By pursuing the condition of modernity ever more intensely, artists had been led to work upon the very basis of our perception of the world. The upshot was that the Impressionists, one of whose principal motivations had been the attempt truthfully to register in art the experience of the urban modern condition (the 'painting of modern life'), turned their painting into a dual engagement: with perception in general, and with the perception of paint on canvas and its inherent spatial illusionism in particular. The pursuit of realism transmuted into the engagement with autonomous art.[28] At the end of modernism, it is as if the reverse happened. Out of the pursuit of increasingly specialised technical problems of autonomous art and its delimitation from the world at large, there opened

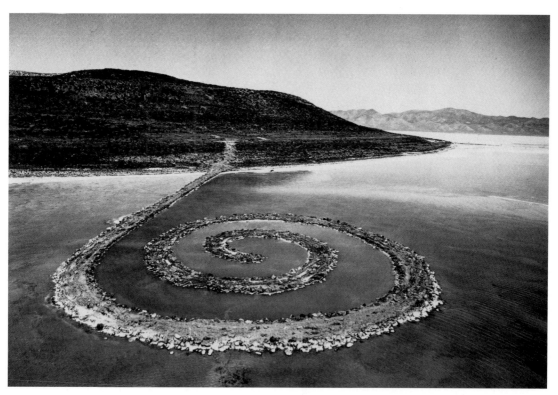

PLATE 1.8 Robert Smithson, *Spiral Jetty*, 1970, Great Salt Lake, Utah, black rock, salt crystals, earth, red water (algae), 1.06 × 4.57 × 457 m. (Courtesy James Cohan Gallery, New York. Collection: DIA Center for the Arts, New York. Photo: Gianfranco Gorgoni. © Estate of Robert Smithson/ VAGA, New York/DACS, London 2004.)

up spaces through which modernity poured back into art. By the early 1970s, avant-garde artists were addressing a gamut of institutional and political questions that redrew the map of art's relation to other signifying practices in the modern world, and indeed to the conventions of modern society itself. The modern world in all its contingency was back on the agenda of modern art, and this time, it seemed, not as a conservative retreat from the limits of modernism (as with the advocacy of social realism in the face of abstraction during the interwar period), but as a result of pushing through those limits, once they themselves had become conservative.

'Postmodernism' in inverted commas

Nobody is happy with 'postmodernism'. We use the word with a bad conscience, knowing it is not up to the job. As Charles Harrison has written, 'There can be no theory of the *postmodern* – no sensible identification of some art as postmodern art – which does not assume a certain means of identifying the modern.'[29] Even if we are slightly more particular with our

terms, and talk about 'postmodern*ist*' art, we still cannot avoid addressing that problem. Certainly, something different happened after the high water mark of Greenbergian 'Modernism' (capitalised by, among others, Greenberg himself). However, are we content to identify Greenberg's formalism with modernism in general? Nowadays few would be. But if there are other activities excluded from the formalist canon that we nonetheless still wish to think of as importantly modernist, what relation does 'postmodernist' practice have to them? If we were to identify modernism in art with a multifarious address to modernity, rather than with the pursuit of autonomous aesthetic value, in what sense could contemporary art possibly be 'postmodernist'? Only if we were to believe that society as a whole had somehow mutated into a condition that is beyond the modern. Again care is required. In a fundamental sense, we can never be beyond the modern. The modern is a moveable feast: oil paint was once modern, so too steam – and the wheel, come to that.

However, we can set some limits by accepting that the conceptualisation of a social and cultural condition as specifically 'modern' has a history. If we regard the world of our 'modernity' as having begun in the late eighteenth century, with the Industrial Revolution at the basis of society, with the French Revolution in politics and with Romanticism in culture, then we can agree that since then there have been different phases of modernity. We may accept, further, that presently we are on the cusp of another such phase, characterised by technological advance (particularly communications technology), political realignment (with the end of the Cold War and the confirmation of the USA as the only superpower) and globalisation of the production process. If we are on this cusp, it is quite likely that our art will reflect such profound change. But a too wholesale notion of postmodernism is deeply problematic, the more so if it is seen as a straightforward liberation from a negatively conceived modernism. It is only a modernism shorn of complexity that can be made to stand as the counterpart of 'postmodernism' in that way. Indeed, since canonical Greenbergian 'Modernism' has been displaced from the centre ground of critical writing, and the earlier avant-garde movements (in particular the work of Marcel Duchamp) have been enlisted as antecedents of late twentieth-century 'postmodernism', one can quickly arrive at the ridiculous situation where examples of 'proto-postmodernism' antedate the canonical formulations of modernism itself. At that point, the words swim away into a vortex of arbitrariness that renders them virtually meaningless. In short, while postmodernism has to be treated with caution as a name for contemporary art, we continue to employ it, bad conscience ever present, because sometimes it seems there is just no other way to start speaking at all.

Whatever the difficulties attendant on the term, however, it commands a vast literature. Perry Anderson has pointed out that the idea has a kind of prehistory reaching back as far as the 1930s. But it did not emerge in its prevalent contemporary usage until the 1970s.[30] At that time, a wave of critical thinking, which had been gathering momentum since the Second World War and which often involved a re-encounter with the radical political and cultural legacy of the early twentieth century, broke in the aftermath of 1968. The late 1960s marked a turning point in culture in every way, from

daily life, popular music and television, through to the fine arts. But politically the time marked a crisis for the Left. Since the Second World War, the official communist parties had atrophied and a New Left had taken on the role of the leading critical force against the status quo – on a spectrum of issues ranging from nuclear disarmament to civil rights to opposition to the war in Vietnam, as well as to the increasing alienation resulting from the commodification of all aspects of life in the metropolitan nations. If 1968 stood at the end of an approximately century-long chain of classic revolutionary socialist opposition, then its peculiar combination of cultural victory and political defeat generated a wide-ranging reconsideration of radical options. In the subsequent conjuncture, social class lost its pre-eminence in oppositional theory and practice, becoming only one element in a constellation of issues, including gender and sexuality, race and ethnicity, and the environment.

According to Anderson, the notion of a specifically postmodernist situation arose in the early to mid-1970s in the writings of Ibram Hassan and Charles Jencks: the former in cultural studies, the latter in architecture. Jencks set a new eclecticism against the rationalism of the post-Bauhaus International Style, typified by the 'glass box' office building. Hassan detected in figures such as John Cage, Robert Rauschenberg and Marshall McLuhan a new openness and indeterminacy that contrasted with the rigour and exclusivity characteristic of modernism. Hassan did suggest a social dimension to the concept when he wrote that:

> Postmodernism, as a mode of literary change, could be distinguished from the older avant-gardes (Cubism, Futurism, Dada, Surrealism etc) as well as from modernism. Neither Olympian and detached like the latter nor Bohemian and fractious like the former, postmodernism suggests a different kind of accommodation between art and society.[31]

But the fully developed sense of a postmodern historical situation, rather than a specifically postmodernist art, emerged in a debate between the philosophers Jean-François Lyotard and Jürgen Habermas at the beginning of the 1980s.

In *The Postmodern Condition: A Report on Knowledge*, first published in France in 1979, Lyotard argued that the social projects that had dominated western society since the eighteenth century had become exhausted. The aftermath of 1968 led Lyotard to question not just a specific historical event but the entirety of what he referred to as the 'grand narratives' of the Enlightenment – namely, the overarching visions of social emancipation and scientific progress that had underwritten virtually every project in the arts, the humanities and the natural sciences since those disciplines crystallised in their modern forms. In a backlash against his own leftism (in the 1968 period he had been involved in a group that claimed allegiance to the legacy of

Rosa Luxemburg), Lyotard rounded on the entire socialist tradition and identified the postmodern condition with what he called 'incredulity toward metanarratives'.[32] He concluded a postscript, added to the book in 1982, with the call: 'Let us wage a war on totality.'[33] In the wake of the Holocaust, the gulag, and the threat of nuclear annihilation, overarching goals were to be replaced by a reliance on the fragmentary, the pragmatic and the local. As attractive as this may sound in principle, it all stood in sharp contrast to the way things were actually going at the start of the 1980s. The election of conservative governments on both sides of the Atlantic pointed to an increasing concentration of power rather than its dispersal. Habermas, for one, eloquently defended the unfinished nature of the Enlightenment project, and the relative independence of the spheres of art, science and politics that has characterised modern western society, regarding the conception of postmodernism as indicative of the re-emergence of reactionary tendencies to which modernism was opposed.[34] Lyotard's negation indicates a tendentious aspect of postmodernist theory: the area where a supposedly dynamic *post* modernism shades into a potentially conservative *anti* modernism.

However, Lyotard's essentially negative response to 1968, and his consequent embrace of a conception of postmodernism, did not go unchallenged, even from within the ranks of those who were prepared to entertain the idea that a significant shift was taking place. It was possible to argue that something had changed, while not relinquishing the Left's traditional agenda of social progress and emancipation. The definitive statement of this postmodernist thesis came with the publication in 1984 of Fredric Jameson's long essay 'Post-Modernism: Or the Cultural Logic of Late Capitalism'.[35] What Jameson did was to anchor an observation of changes that had been and were still occurring across a range of cultural fields, including architecture, art, literature and cinema, in an analysis of contemporary capitalism itself. Jameson's fundamental point was that the definitive emergence of the consumer society marked a distinct phase in the evolution of capitalism, a phase wherein capitalism had become all-encompassing, with no outside. The cultural form of capitalism had become a kind of nature – the air we all breathe. In the words of Anderson's commentary, 'marked out by no stark political caesura', this shift nonetheless 'represents a momentous transformation in the underlying structures of contemporary bourgeois society'.[36]

For Jameson, the effect of this change upon art was registered in what he termed 'the waning of affect'. The 'supreme formal feature' of all the postmodernisms he reviewed was 'a new kind of flatness or depthlessness, a new kind of superficiality in the most literal sense'.[37] The contrast he chose to drive this point home was between a painting of shoes by van Gogh and a painting of shoes by Andy Warhol (Plates 1.9 and 1.10). While his reading of Warhol's work is highly selective, ignoring various critical dimensions that others have chosen to emphasise,[38] Jameson's point is nevertheless an important one. It goes beyond style to identity, with the argument that the

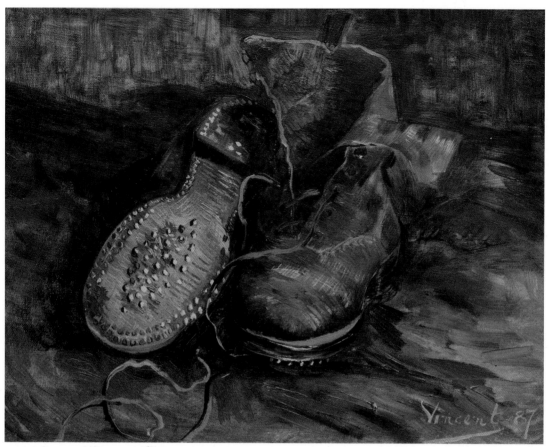

PLATE 1.9 Vincent van Gogh, *Peasant Shoes*, 1887, oil on canvas, 33 × 40 cm. (Museum of Art, Baltimore. Photo: AKG Images, London.)

formal features of *Diamond Dust Shoes* (Plate 1.10) point to the emergence of a specifically postmodern subjectivity: a condition quite at odds with the centred, expressive subjectivity at the heart of modernism. It is tantamount to a claim that we have become different sorts of people. As such, it skirts tendentious overstatement (generalising, for example, from a specific and narrow form of American experience), while yet trying to face the fact that things have changed and that this affects who we are and how we live. Jameson writes of the end of the autonomous bourgeois individual, dissolved in a world of bureaucracy and mass consumption, concluding starkly:

> As for expression and feelings or emotions, the liberation, in contemporary society, from the older *anomie* of the centred subject may also mean, not merely a liberation from anxiety, but a liberation from every other kind of feeling as well, since there is no longer a self present to do the feeling.[39]

There is an element of polemic in Jameson's formulation, but it does point to an increasing scepticism about the rhetoric of modernism: the autonomy of its subject, the disinterestedness of *his* taste, the presumed authenticity of subjective feeling and so on. For better or worse, much of the art of the period seems to bear out the pertinence of these ideas.

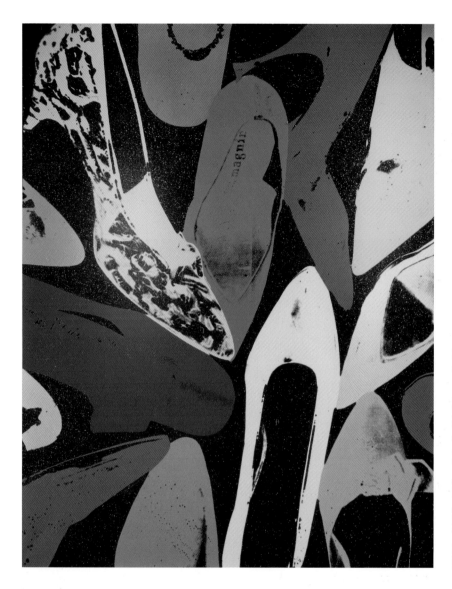

PLATE 1.10
Andy Warhol,
*Diamond Dust
Shoes*, 1980, polymer
paint, diamond dust
and silkscreen ink on
canvas, 229 × 178 cm.
(Photo: The Andy
Warhol Foundation/
Art Resource/Scala,
Florence. © The
Andy Warhol
Foundation for the
Visual Arts, Inc./ARS,
New York/DACS,
London 2004.)

Postmodernist art

In art, from the late 1970s into the 1980s, several distinct, even opposed, postmodernist tendencies appeared. One of the most important involved the evolution of the conceptual neo-avant-garde into a variety of hybrid practices, mixing photographs and texts, performances and installations, and making increasing use of the new technology of video, either to document performances or as a medium in its own right. Such art questioned the object of art, as well as its presumed end in aesthetic contemplation, largely out of a sense that, in its fixation on a purified aesthetic, art had failed to come to terms with the wider modern condition in which it was practised. As the English artist Victor Burgin put it: 'the consequence of modern art's disavowal of modern history remains its almost total failure to be about anything of consequence'.[40] Indeed, the modernist sense of aesthetic judgement was effectively suspended as artists worked to suppress the contemplative spectator of art in favour of a more active co-participant in the questioning of received meanings.

As politics in the leading western nations moved sharply to the right with the election of the Thatcher and Reagan administrations, there was much for radical artists to work on. Art moved quickly from a critique of the conventions of art itself to a politicised critique of the signifying practices of modernity at large – as enshrined in media such as film, television and advertising. It was this kind of activity the critic Hal Foster had in mind when he spoke of the postmodernist artist as 'a manipulator of signs more than a producer of art objects'.[41] One prominent preoccupation was the critique of institutions, perhaps best exemplified in the work of Hans Haacke, who set out to expose the workings of both the art institution and the wider institutions of power in society: most characteristically by turning the techniques of advertising back on itself (Plate 1.11).

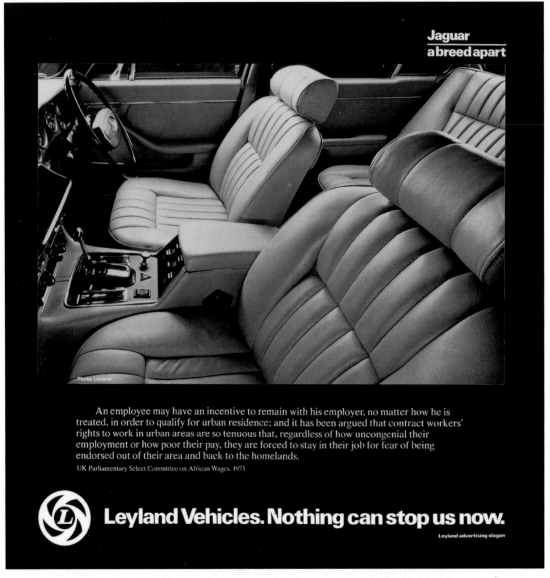

PLATE 1.11 Hans Haacke, *A Breed Apart*, 1978, one of seven panels, photographs on paper laid on board, each panel 91 x 91 cm. (© Tate, London 2003. © DACS, London 2004.)

However, in line with the emerging crisis of the Left in the years after 1968, and with gathering pace from the mid-1970s, the governing themes of much critical art began to shift away from more traditional anti-bourgeois class politics to the rapidly evolving sphere of gender politics. In particular, feminist work in various forms occupied a central position. In New York, the erstwhile conceptualist Adrian Piper embarked on a series of performative activities addressing issues raised by her gender and race, while Mierle Laderman Ukeles elaborated the idea of 'Maintenance Art', in which disregarded activities such as cleaning and washing were advanced as being on equal terms with art activity (Plate 1.12).[42] Yet however dominant such work was within the international artistic avant-garde, it remained a *bête noire* for much of the public at large, and in particular for the popular press. In England, the greatest controversy surrounded Mary Kelly's *Post-partum Document* (Plate 1.13). This was a multimedia documentation of the development of her son from birth to being able to write his own name. That is to say, using concepts from the psychoanalysis of Jacques Lacan (whose theories underlay Kelly's work and much feminist art and theory more generally), she traced the boy's passage through the Imaginary into the Symbolic (i.e. into *language*), with all that this implies from a Lacanian point of view for the structuring of identity in terms of gender difference.[43]

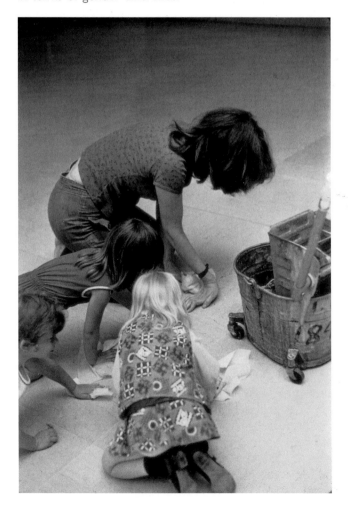

PLATE 1.12
Mierle Laderman Ukeles, *Washing Tracks/Maintenance: Inside*, 1973, photograph of performance at Wadsworth Atheneum, Hartford Connecticut. (Courtesy Ronald Feldman Fine Arts, New York.)

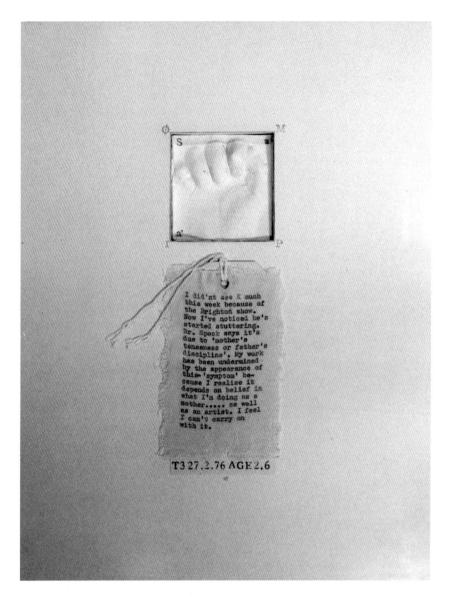

PLATE 1.13
Mary Kelly, *Post-partum Document* (*Documentation 4*): *Transitional Objects, Diary and Diagrams*, 1976, one of eight units, mixed media, 36 × 28 cm. (Collection Zürich Museum. Courtesy of Mary Kelly.)

It was such hybrid postconceptual practices that underwrote the most rigorous attempt to theorise what it was that distinguished postmodernist art from modernism. One of the most pervasive ideologies of the art of the 1970s and 1980s, following on as a reversal of what was perceived as the unified exclusivity of Greenbergian 'Modernism', was that art had become 'pluralistic'. Rosalind Krauss, whose views had evolved from a commitment to Greenberg's formalism towards an explicit postmodernism heavily dependent on French theory, would have none of this. For her, the celebrants of pluralism were simply looking in the wrong place. Krauss sardonically noted how 'We are asked to contemplate a great plethora of possibilities in the list that must now be used to draw a line around the art of the present', and went on to enumerate many of the types we have already noted here – video, performance, body art, Conceptual Art, earthworks and so on – concluding: 'If they have any unity it is not along the axis of a traditional notion of "style".'

But rather than accept this eclecticism at face value, Krauss raised the question: 'is the absence of a collective style the token of a real difference? Or is there not something else for which all these terms are possible manifestations? Are not all these separate "individuals" in fact moving in lockstep, only to a rather different drummer from the one called style?'[44]

Krauss's penchant for structure, which amounted to a move from one somewhat primitive formalism to another more sophisticated one, rather than the rejection of formal criticism altogether, led her to ascribe a fundamental unity to postmodernist art. This unifying factor was to be located not in art's appearance but in its underlying mode of signification – the way it produced its meanings. In some ways this can be regarded as another stage in the evolution of the quest for an ever greater directness of effect that has marked art since the late nineteenth century. For Krauss, what unified the apparent disparity of postmodernist art – all those performances and earthworks and photographs – was their reliance on the 'index'.[45]

In one branch of semiotic theory it is postulated that there are three kinds of sign (called 'symbol', 'icon' and 'index') – three broad ways in which the world becomes meaningful for its human denizens. First, there is the linguistic sign, the word or concept, which in semiotic theory is called the 'symbol'. According to accepted theory, linguistic signs are arbitrary. Linguistic concepts do not have any necessary relation to the world they describe; words operate in a system of differences from each other. Indeed, language is such a system of differences. But verbal language is not all we have; we have other aspects to our sensory apparatus – including our eyes. The second major type of sign is visual: pictures. These are generically referred to as 'icons'. And here there *is* a necessary relation between the sign and the thing in the world it refers to. The portrait has to resemble its sitter if it is to convey accurate information. The third kind of sign, the 'index', is again predominantly visual. The index is not, however, made by an act of copying some object or person in the world, by drawing or painting. It is a direct trace of the passage of something, such as a footprint, a shadow or a cast. One of the key features of the indexical sign, for Krauss, is that it includes the photograph: a kind of picture that is made, literally, by the passage of light. So, for Krauss, the apparent diversity of postmodernist art – all the various kinds of performance, all the digging of earthworks, and the pervasive use of photography – served only to conceal a common signifying origin. Her point was that the centre of gravity had shifted. The criteria that made the new art meaningful were different from the criteria in terms of which modernism made sense. Postmodernist art, to use a risky metaphor, spoke a different language.[46]

There was, however, another postmodernism in the 1980s. The 'postconceptual' variant of postmodernism had been born in a radical climate. But most of the utopian hopes attendant upon its emergence had proved fleeting. The transformation of the wide range of conceptual, performance and installation art into a quasi-official new avant-garde was signalled by the 'Documenta 5' exhibition in Kassel in 1972. In her book *Six Years: The Dematerialization of the Art Object*, documenting the rise and consolidation of the new art between 1967 and 1973, Lucy Lippard had written that: 'Hopes that "conceptual art" would be able to avoid the general commercialization ...

of modernism were for the most part unfounded.' Against expectations, by the early 1970s, 'the major conceptualists are selling work for substantial sums … they are represented by (and still more unexpected – showing in) the world's most prestigious galleries'.[47] Its apparent absorption by the market notwithstanding, this text- and photo-based work oriented upon a range of critical themes, from gender politics to the activities of multinational corporations, formed something like the centre ground of the avant-garde internationally during the 1970s.

The backlash came in the 1980s, with the market-stimulated emergence of 'a new spirit in painting', to quote the title of an exhibition at London's Royal Academy in 1981. Commercial imperatives joined hands with a trumpeted return to 'humanist values' in the production and distribution of a new figurative art. As the catalogue to 'A New Spirit in Painting' put it, 'the representation of human experiences, in other words people and their emotions, landscapes and still lives' had to return to the centre of art practice.[48] In an explicit contrast with the 'postconceptualist' strand of postmodernism, artists on both sides of the Atlantic were rapidly conscripted into a school of 'postmodernist' painting. In Italy, Sandro Chia and Francesco Clemente produced pictures

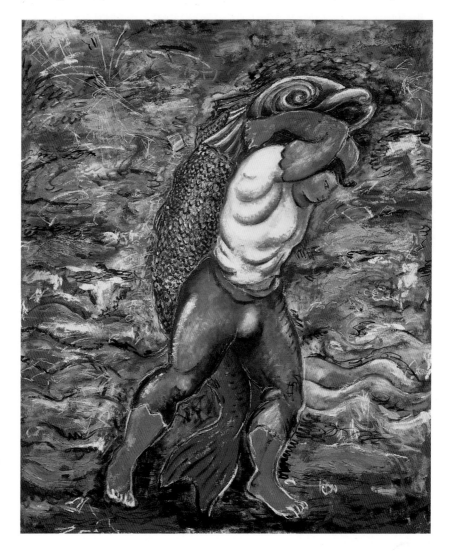

PLATE 1.14
Sandro Chia, *Water Bearer*, 1981, oil and pastel on canvas, 206 × 170 cm. (© Tate, London 2003. © Sandro Chia/VAGA, New York/DACS, London 2004.)

whose figurative references ranged from the Orientalist to the classical (Plate 1.14), but the dominant strain was a brand of reborn Expressionism, exemplified in the USA by Julian Schnabel and in Germany by Georg Baselitz. Each had a sort of gimmick or trademark that served to differentiate his work from traditional painterly Expressionism: Schnabel's roughly worked and hence 'expressive' surfaces were often made out of broken plates, while Baselitz's anguished figures were painted upside-down (Plate 1.15). However, relative to the institutional and gender critique of radical postmodernism, it all had the air of turning the clock back, not merely beyond Conceptual Art, but beyond even modernist abstraction. Schnabel's painting was extolled in the 'New Spirit' catalogue for its 'romance' and 'optimism', in contrast to conceptualism's 'narrow, puritan approach devoid of all joy in the senses'.[49] In mitigation, it should be acknowledged that Schnabel and Baselitz, to some extent, and Anselm Kiefer, to a greater extent, were all embarked on more complex practices than their conservative or journalistic apologists would have it. Kiefer, for example, used the turn to figuration to address the contentious issue of the Nazi period's relation to German culture in general, in an attempt at a new history painting (Plate 1.16). He briefly enjoyed enormous success with this work in the USA and Israel, but radical critics were less convinced: Benjamin Buchloh, for example, dubbed it 'polit-kitsch'.[50] Whatever the nuances of the new figuration, the art business and traditional art lovers showed a palpable desire to have it all made good again after Conceptual Art had come along and ruined everything.

In effect, then, by the mid-1980s, there were two postmodernisms, in critical theory no less than in art. One was conservative in nature and the other 'oppositional'. Conservative postmodernism can be seen as a reaction to the belief that modernism was, as described by the economist Daniel Bell, 'the agency for the dissolution of the bourgeois world view', and 'responsible for

PLATE 1.15
Georg Baselitz, *Adieu*, 1982, oil on canvas, 250 × 300 cm. (© Tate, London 2003. © Georg Baselitz.)

the loss of coherence in culture'.[51] From a critical point of view it is easy to interpret this as a confusion of symptom with cause – of modernist art with a breakdown of normative bourgeois capitalism. It is a re-run of the call to order of the First World War, which blamed modernist culture for what was really an imperialist conflict. What was needed, so it was claimed in both cases, was the restoration of order. In conservative postmodernist art this took the form of a return to figurative painting and the buttressing of the expressive, centred author. In such art, as in architecture, classicism provided a source book for an engagement with a renewed sense of wholeness over fragmentation, of universal human nature over assertions of difference.

The critic Hal Foster drew a sharp distinction between this and what he identified as an 'oppositional' postmodernism. Writing in the Preface to *Postmodern Culture*, the influential collection of essays he edited in 1983, Foster argued: 'In cultural politics today, a basic opposition exists between a postmodernism which seeks to deconstruct modernism and resist the status quo, and a postmodernism which repudiates the former to celebrate the latter: a postmodernism of resistance and a postmodernism of reaction.' Thus, for Foster, a properly critical postmodernism stood opposed to both official modernism and reactionary postmodernism. Such a 'resistant postmodernism' is 'concerned with a critical deconstruction of tradition, not an instrumental pastiche of pop- or pseudo-historical forms, with a critique of origins, not a return to them. In short, it seeks to question rather than exploit cultural codes, to explore rather than conceal social and political affiliations.'[52]

PLATE 1.16 Anselm Kiefer, *Parsifal III*, 1973, oil and blood on paper on canvas, 300 × 434 cm. (© Tate, London 2003. Courtesy of the artist.)

Inside the whale

There is no generally accepted authoritative account of the development of postmodernist art from the 1980s through to the end of the century. Even the concept of 'development' seems inappropriate, more fitted to the progressivist flowchart that Alfred Barr drew up for modernist abstraction in the 1930s.[53] Postmodernist art seems not to rely on any continuously evolving dynamic of formal innovation. Of course, the art does change, but the changes have tended to be thematic rather than technical. Postmodernist art is *about* something – some cultural condition, psychic malaise or social issue – much more overtly than modernism ever was.

It is possible to pick out several themes that animated art in the 1980s. It should come as no surprise to find that one was the interrogation of cardinal principles of modernism, such as authenticity and originality. Thus, Sherrie Levine took photographs of earlier canonical photographs, or in another case made a bronze cast of Duchamp's urinal (Plate 1.17). This type of sceptical probing of modernist conceptions of originality and expression can be traced back to the work of Jasper Johns and Robert Rauschenberg in the 1950s, in the wake of what they saw as the routinisation or stereotyping of originality in second-generation Abstract Expressionism. But it became a pronounced

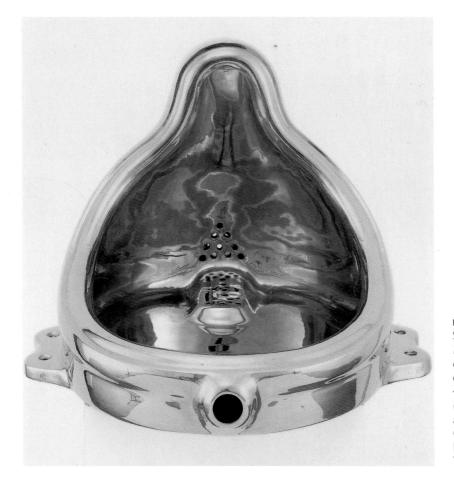

PLATE 1.17
Sherrie Levine,
Fountain: 5, 1996,
cast bronze,
edition 5 of 6,
43 x 41 x 31 cm.
(Courtesy of the
artist and Paula
Cooper Gallery,
New York. Photo:
Tom Powel.)

strand of postmodernism, both in art and criticism, as witness the title of Krauss's influential book of 1985: *The Originality of the Avant-Garde and Other Modernist Myths.*

Shading into the debate on originality was a growing interest in the consequences of art's commodification. Commodification has been fundamental to capitalism from its inception, but in capitalism's postmodern phase, it seems that nothing escapes.[54] Everything is affected, from the aura conferred on consumer durables through increasingly sophisticated advertising techniques, to human identity and sexuality. Jeff Koons installed vacuum cleaners in neon-lit glass showcases. He made – or, rather, had fabricated – detailed replicas of executive toys, and grotesquely enlarged ceramic sculptures of cultural icons, ranging from St John the Baptist to Michael Jackson and the Pink Panther (Plate 1.18). Similarly, Haim Steinbach purchased banal items such as drinking vessels, from plastic beakers to ancient earthenware, and displayed them on purpose-built shelves parodying the conventional base of a sculpture. In a different twist relating to the commodification of art itself, Louise Lawler took photographs of art as it was displayed in private collections: encompassing in a single image part of the bottom edge of a 'modernist masterpiece', the top of a sideboard and some dishes (Plate 1.19). A key refrain of postmodernist critics, including writers as different as Fredric Jameson and Jean Baudrillard, was the way in which reality seemed to be disappearing behind a welter of mass-media images. Baudrillard's influential conception of 'the hyperreality of simulation' implied that 'reality' had virtually

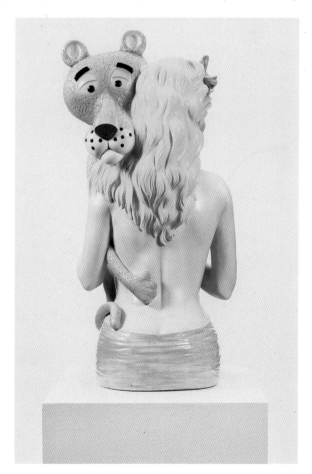

PLATE 1.18
Jeff Koons, *Pink Panther*, 1988, porcelain,
104 × 52 × 48 cm. (Photo: Christies Images
Ltd 2004. © Jeff Koons.)

disappeared as a register against which it was possible to check the truth or usefulness of what the media was saying.[55] Several artists, including painters, tried to capture this sense of living in, and indeed being *lived by*, an unending waterfall of images and projected identities, in which film stars, commodities, Old Master art and the various devices of modern art itself were indiscriminately mixed together (Plate 1.20).

For some artists these questions of identity maintained an explicit political edge. As conceptualist figures like Burgin and Haacke had done earlier, Barbara Kruger turned advertising techniques around, drawing on her own experience with Condé Nast magazines, to address issues of gender politics. Through a trademark repetition of black and white photographs and brightly coloured text she established a critical device that was equally at home in books, on gallery walls, on T-shirts, blown up to mural scale on the sides of buildings, or transformed into environments in which the spectator was completely encompassed by the work (Plate 1.21). In a way paralleling that in which Levine and Koons differentially replayed Duchamp, Kruger drew upon the legacy of the Constructivist poster in her polemically engaged feminist art. The main difference, it could be argued, consists in the fact that all this art was carried on within the structures of the developed international art world. In the 1920s, Varvara Stepanova worked on the journal *LEF* ('Left Front of the Arts') and in the state textile factory as part of a revolutionary project to abolish art and intercede in the production of a new life. Sixty years later, Kruger migrated

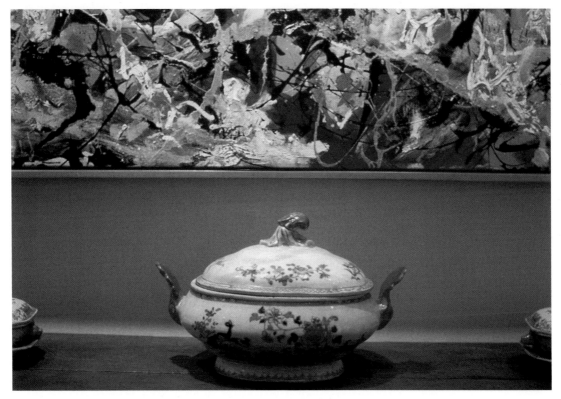

PLATE 1.19 Louise Lawler, *Pollock and Tureen*, 1984, arranged by Mr and Mrs Burton Tremaine, Connecticut, silver dye bleach print, 71 x 99 cm. (Metropolitan Museum of Art, New York. Purchase, The Horace W. Goldsmith Foundation and Jennifer and Joseph Duke Gifts, 2000 (2000.434). Photo: © 2001 The Metropolitan Museum of Art. Jackson Pollock, © ARS, New York/DACS, London 2004.)

from design work in the Condé Nast empire to become the leading light of the Mary Boone Gallery in New York, and a major player on the international exhibiting circuit: the prestige she thus accrued as a leading postmodernist artist bolstering the impact of her radical feminist art. Even if one suspends historical value judgement, one cannot but remark how things have changed and reflect on the consequences of such a situation for the very idea of a critical practice in art.

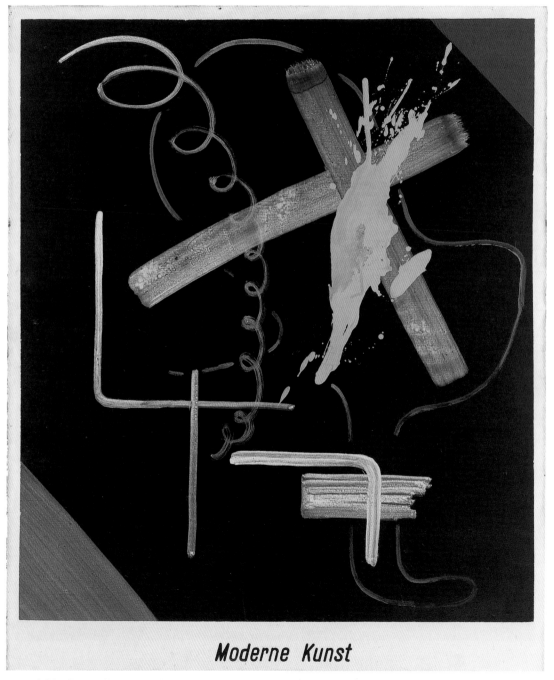

PLATE 1.20 Sigmar Polke, *Moderne Kunst*, 1968, artificial resin and oil on canvas, 150 x 125 cm. (On loan to Hamburg Kunsthalle. Photo: Bridgeman Art Library, London. © Sigmar Polke.)

This state of affairs remained broadly the same through the 1990s, with an increasing turn towards the use of video technology and large-scale installations of the kind discussed at the start of this chapter. A notable preoccupation that developed in relation to identity was the question of abjection, developed from the feminist writing of Julia Kristeva[56] but opening out beyond feminism to address the construction of different kinds of identity and the gulf between lived experience and the kinds of image presented as desirable by the mass media. Mike Kelley, for example, worked with discarded toys and trashy comics, probing the underside of assumptions about childhood and adolescent identities. In an interview from the early 1990s, Kelley remarked 'I'm of the generation of artists for whom there was an extreme reaction against the handmade and clichéd ideas of self-expression, including the notion that the handmade art object revealed a personal, expressive psychology.' Arguing that his grubby, pathetic stuffed toy animals and dolls represented a reaction against 'the modernist cult of the child, in which the child was seen as this innocent figure of pure, unsocialized creativity', Kelley went on: 'With my doll works, the viewer isn't led to reflect on the psychology of the artist but on the psychology of the culture' (Plate 1.22).[57]

PLATE 1.21 Barbara Kruger, *Untitled* (*We Will No Longer Be Seen and Not Heard*), 1985, lithograph on paper, 52 x 52 cm. (© Tate, London 2003. Courtesy of the artist and Mary Boone Gallery, New York.)

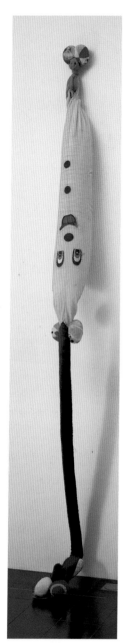

The postmodernist art of the last years of the twentieth century thus presents a picture of considerable diversity – not that there are many 'pictures' as such to be seen. Painting's obituary has often been written, but it never quite lies down and dies. It continues to be taught in schools and colleges and to be exhibited in galleries. For all its capacity for survival, however, there is little or nothing that is not determinedly conservative that could be said to constitute a traditional picture inviting a traditional aesthetic response. To carry on a practice of painting has not been easy, and various oblique devices, distancing effects and double-codings have come into play to keep it alive (see Plates 2.23 and 3.13).

What is not in doubt is that painting has been displaced from the centre ground of postmodernist activity to an extent that is without precedent in the mainstream practice of art since the Renaissance. Precedents for the relative marginality of painting can, of course, be found in the oppositional avant-gardes of the early twentieth century, principally Dada, Constructivism and, to a lesser extent, Surrealism. That fact alone points to something important about the art of the late twentieth century. It lays claim to the inheritance of the critical avant-gardes, and by extension, of course, to their opposition to canonical modernism with its exclusive dedication to the aesthetic effect. It makes that claim with regard both to the avant-gardes of the distant past and to the Conceptual Art of the late 1960s and early 1970s. Both phases of avant-gardism, the conceptual neo-avant-garde no less than the classic avant-gardes, maintained a wide-ranging ideological opposition to an entrenched modernist system, even as both remained enmeshed within its economic circuits of distribution and exchange.

There is a considerable distance between that and the current situation. For the system has not only remained intact, but become even more powerful and entrenched: a worldwide system for the production, distribution and consumption of art on a spectacular scale. Yet the art it shows, sells and talks about is non-medium-specific 'conceptualist' postmodernism. The shift can be dramatised with one example. When artists first began using video in the late 1960s, it was widely regarded as a more democratic medium than supposedly elitist modernist painting. Now, a work such as Gary Hill's multi-screen *Between Cinema and a Hard Place*, shown in Tate Modern's inaugural exhibition in 2000, requires for its maintenance not only a large stock of spares (which have to be purchased in advance, because of the built-in obsolescence of television hardware) but specially trained curator-technicians who have to travel with the work to install it anywhere it is shown. Whatever the critical merit of its content, the work of art is, in short, entirely dependent on the institution of the museum for its continued existence. The same can be said of the entire installation genre. The art historian Thomas Crow has observed the paradox that:

> The making of non-commodity art involved intense curatorial activity, and artists became more like commercial curators, middlemen for themselves. Though couched as a protest against a division of labour in which the producer was subordinated to the demands of a commercial apparatus, the cost was a more complete identification of the producer with that apparatus.[58]

It is worth pondering the consequences of this shift from margin to centre. Is this a situation where the margins have taken over the centre and everything is that much more liberated and free? Or has something more Orwellian taken place, where the successful animals now eat from the same table as the human farmers — have, in fact, become indistinguishable from them?[59] Is the sphere of postmodernism the scene of a successful revolution, a kind of cultural launch pad for further strikes against the self-regarding capitalism that has taken over the world? Or is it a symptom of that very capitalism, drained of genuinely oppositional force — a parody of avant-gardism mutated into fashion and spectacle?

The answer, weak as it may seem, is probably a mixture of 'a bit of both' and 'it depends where you look'. To take the former point first, in the interview cited above, Mike Kelley, who is explicitly concerned to criticise various fictions of identity in contemporary culture, talked about the paradox involved when a doll that cost him 50 cents became 'worth' $40,000 because it had turned into a work of art:

> It shows the strange position that art plays within the culture and how worth is determined. You can say that's terrible, but that's the way everything operates. Worth in this culture is dependent upon money, and people won't talk about the issues involved in the work unless the thing that gives it value in the culture is applied to it.[60]

In other words, only by being *in* the culture and valued by it, however paradoxically, can the critical artwork make its point about the solecisms and illusions *of* the parent culture. Moreover, the range of possibilities appears limitless. Younger British artists like Paul Harrison and John Wood explore the physical aspects of embodied being-in-the-world in a range of pared-down tableaux. Others, including Matt Calderwood, allegorise ever-present aspects of the human condition, such as risk or purposelessness, in tightly structured self-referential performances. While yet others, such as the Irish artist Alanna O'Kelly, use video to address major historical issues like the Irish famine and its attendant elegies of loss and mourning. It would clearly be absurd to claim that all artists exhibiting in Tate Modern, the Pompidou Centre, Documenta or the Venice Biennale are united in their criticism of the dominant culture. Postmodernist art does amount to a new academy, on a global scale, and these artists, despite their heterodox methods and media, are the new academicians. Nonetheless, many artists combine the need to work within the expanded system of art with a critical edge. To disallow the possibility of that would be to concede that the avant-garde has become academic without exception. The evidence seems to be that a certain critical space continues to be won back from the overpowering spectacle of contemporary art.

Turning now to the second point, 'it depends where you look': an equally double-edged feature of the contemporary art system is that it has increasingly absorbed artists from places outside the traditional European and American heartlands of the avant-garde/modernist tradition. These include hybrid forms of painting such as the contemporary art based on traditional sources produced by South African Bushmen, Pacific north-west coast Native Americans

and Indigenous Australians (Plate 1.23). Contemporary Chinese artists have also produced interesting hybrids of traditional lacquer techniques, Socialist Realism and multinational consumer iconography (Plate 1.24). Other symptoms of globalisation include more characteristically postmodernist installation- or photographic-based art. Thus, Doris Salcedo has addressed questions of war and violence related to the ongoing civil war in Colombia (see Plate 6.28). In 2002, the former-Yugoslavian artist Breda Beban curated an exhibition concerned with the problematic and provisional nature of 'Balkan' identity, which included Igor Grubic's photograph of himself and his girlfriend, *Igor and Sandra*, their heads covered in beach towels (Plate 1.25). As the catalogue states, a relaxed holiday image becomes a comment on the complex historical question of Orientalism and the Ottoman heritage: something that is 'permanently being re-conceptualised as long as societies of the Balkans perceive historic identity as something of crucial importance'.[61] One critical view here has been that such work is simply engulfed by the art

PLATE 1.23 Rover Thomas, *Cyclone Tracy*, 1991, earth pigments and natural binder on canvas, 168 × 183 cm. (National Gallery of Australia, Canberra. Courtesy of the Warmun Art Centre.)

system, so that serious socio-political problems are aestheticised – for example, by being viewed by middle-class westerners in the security of multi-million pound art museums – and that traditional life forms are prostituted, as well as individuals being grossly exploited, by a market that, whatever its ideological fiction, is driven by a hunger for novelty. To the converse, it may be argued that, for example, Indigenous Australian communities have been economically and politically empowered by the international market success of 'Aboriginal Art'. Comparably, in the Colombian case, Salcedo has argued that:

> The silent contemplation of each viewer permits the life seen in the work to reappear … It is because of this that the work of art preserves life, offering the possibility that an intimacy develops in a human being when he or she receives something of the experience of another. Art sustains the possibility of an encounter between people who come from quite distinct realities.[62]

These are questions that do not admit of any black and white resolution, although a note of caution is justified amid a widespread tendency to over-celebrate contemporary cultural openness. Idealisations about the benefits institutions like Tate Modern or the Guggenheim Bilbao can bring to the areas in which they are located need to be set against the sheer directness with which art is nowadays used by corporations in establishing their trading identities. The almost universal acceptance of so-called enterprise culture in the last twenty-five years is one of the defining markers of the postmodern condition. Avant-garde art has always been conceived either as explicitly opposed to the ethical and political values of the dominant culture, or as implicitly asserting aesthetic values that are somehow more permanent than or otherwise superior to them. It is of no small significance, therefore, when the dominant culture starts to view avant-garde art as helping to advance its own business values. In a powerful and exhaustively documented study

PLATE 1.24 The Luo Brothers, *Welcome the World Famous Brand Name*, collage and lacquer on wood, 246 x 126 x 3 cm. (Courtesy QCA Gallery, Brisbane and Ray Hughes Gallery, Sydney.)

PLATE 1.25
Igor Grubic,
Sandra and Igor,
2001, colour print,
150 × 100 cm.
(Courtesy of the
artist and Site Gallery,
Sheffield.)

published in 2002, Chin-tao Wu argued that: 'never before has the corporate world in America and Britain exercised such sway over high culture'. It is surely not an inconsiderable matter that multinational corporations have

> successfully transformed art museums and galleries into their own public relations vehicles, by taking over the function, and by exploiting the social status, that cultural institutions enjoy in our society … In short, business influence is by now well advanced in every phase of contemporary art – in its production, its dissemination and its reception.[63]

It is not easy to decide what this adds up to and to formulate an adequately considered response. In the current economic climate in the UK, neither the Tate nor many individual works of art would exist without business sponsorship. To take only one example, Rachel Whiteread's *House*, surely one of the most significant works of its time, would never have been realised without the sponsorship of Beck's beer and the construction company Tarmac. In Jameson's world of total capitalisation, there are no lagoons of unsullied probity from which to launch one's critical forays. To ignore this framework within which the meanings of contemporary art are produced would be to ignore an important, albeit implicit, aspect of those meanings, although at the same time it would be equally false to deny such meanings any measure of autonomy from their enabling institutions. Personally, I would rather have *House* and the Tate than not. It is not, after all, as if business sponsorship of the arts has usurped some prior golden age of public funding. Visual art in the UK today occupies a more prominent place in the culture as a whole than ever before. What is at issue is the extent to which radical art has become incorporated into the fabric of that culture at the expense of being able to maintain critical distance, or whether the very fact of its prominence contributes to making the culture as a whole more open. Arguments can be advanced from both sides. It would be no more than inverted snobbery for anyone involved in art to denigrate the success of a generation of British artists, or to bemoan the recent proliferation of galleries and museums.

Nonetheless, to regard the values of capitalist corporations as synonymous with the values of the entire community, or as serving any kind of generalised emancipation, let alone enduring freedom, would be to have swallowed a large piece of ideological bait whole. To borrow another idea from George Orwell: contemporary postmodernist art is well and truly 'inside the whale'.[64] Only time will tell if it has the desire or the capacity to cause indigestion.

Notes

1 Chapter 1 of *Frameworks for Modern Art* contains a discussion of some of the key themes and issues associated with the postmodern turn, set in an overarching introduction to the art of the twentieth century; see pp.30–50, esp. pp.36–7.

2 'Post-painterly abstraction' is a term coined by the American critic Clement Greenberg to describe the 'hard-edged' abstraction that superseded second-generation Abstract Expressionism at the forefront of modernist painting. See Chapter 6 of *Varieties of Modernism*.

3 The work of Frank Stella – considered by some the most significant painter of his generation – presents a more complex case. Undeniably a form of 'post-painterly abstraction', it was admired by some modernists (e.g. Michael Fried), but rejected by others (e.g. Greenberg). It was also valued, for different reasons, by Minimal artists including Donald Judd and Carl Andre. For a discussion of Stella's work, as well as that of Noland and Olitski, see Chapter 6 of *Varieties of Modernism*.

4 Olitski, 'Painting in Color' (1966/67), in Harrison and Wood, *Art in Theory 1900–2000*, VIB11, p.795.

5 Greenberg, 'Louis and Noland', pp.28–9.

6 Fried, *Three American Painters*, pp.32–3. The opening section of this essay is reprinted in Harrison and Wood, *Art in Theory 1900–2000*, VIB9, pp.787–93.

7 Fried, 'Jules Olitski's New Paintings', pp.38, 40.

8 Lippard, 'Escape Attempts'. The phrase 'visual *Muzak*' is quoted in Kosuth, 'Art after Philosophy' (1969), in Harrison and Wood, *Art in Theory 1900–2000*, VIIA11, p.855.

9 Clark, 'Modernism, Postmodernism and Steam', p.160.

10 Blazwick, untitled note to Ilya Kabakov, *Labyrinth*.

11 Barson, untitled note to Stan Douglas, *Win, Place or Show*.

12 Greenberg, 'The Notion of "Postmodern"' (1980), in Hoesterer, *Zeitgeist in Babel*, pp.48–9.

13 Stella, Pratt Institute Lecture (1960), in Harrison and Wood, *Art in Theory 1900–1990*, VIIA3, p.821. Elsewhere Stella stated: 'the European geometric painters really strive for what I call relational painting. The basis of their whole idea is balance. You do something in one corner and you balance it with something in the other corner. Now the "new painting"' is being characterised as symmetrical … It's nonrelational', quoted in Glaser, 'Questions to Stella and Judd' (1966), in Battcock, *Minimal Art*, p.149.

14 Judd, 'Specific Objects', in Harrison and Wood, *Art in Theory 1900–2000*, VIIA5, p.827.

15 Morris, 'Notes on Sculpture 1–3' (1966–7), in *ibid.*, VIIA6, pp.834–5.

16 Phenomenology is associated with the philosophy of Maurice Merleau-Ponty. It rejects the mind/body distinction and regards human perception and cognition as rooted in the embodied nature of our life in the world. Although, in his writings of the mid-1960s, Fried made much of the notion of 'opticality'

and of paintings' appeal to eyesight alone, he too subsequently came to stress the role of the body in perception. This did nothing to lessen his conflict with the minimalists. For Morris's phenomenological stance, see Morris, 'Notes on Sculpture 4: Beyond Objects' (1969), in Harrison and Wood, *Art in Theory 1900–2000*, VIIB4, pp.881–5, and Morris, 'Some Notes on the Phenomenology of Making', pp.62–6. In the latter publication, Morris writes of 'the final secularization that is going on in art now' (p.63).

17 Quoted in Bourdon, 'The Razed Sites of Carl Andre' (1966), in Battcock, *Minimal Art*, p.107. He also added that it was 'communistic'. Since this was being asserted at the height of the Vietnam War, Andre was thereby aligning his 'abstract' sculpture with the struggle against imperialism in a way that arcs back from the moment of 1968 to the aftermath of 1917, and the Soviet Constructivists' search for an appropriately 'communist' form. By the late 1960s, Andre and others – including Morris but not Judd – were active in the militant Art Workers' Coalition. The quotation in full is: 'My work is atheistic, materialistic, and communistic. It's atheistic because it's without transcendent form, without spiritual or intellectual quality. Materialistic because it's made out of its own materials without pretension to other materials. And communistic because the form is equally accessible to all men.' For more on the Art Workers' Coalition, see Graham, Presentation to an Open Hearing of the Art Workers' Coalition (1969), in Harrison and Wood, *Art in Theory 1900–2000*, VIIC2, pp.915–17, and Art Workers' Coalition: Statement of Demands (1969–70), in *ibid.*, VIIC6, pp.926–7.

18 Fried, 'Art and Objecthood', in Harrison and Wood, *Art in Theory 1900–2000*, VIIA7, p.843.

19 For further discussion of the relation of the historical avant-gardes to the neo-avant-gardes of the late 1950s and 1960s, see Wood, *Conceptual Art*, esp. pp.10–17.

20 The distinction between 'Conceptual Art' in a historical sense and a more inclusive notion of 'conceptualism' is advanced in Wood, *Conceptual Art*, see esp. pp.7–9, 74–6. See also Harrison, 'Conceptual Art'.

21 Morris derived the term from the psychology of perception of Anton Ehrenzweig, as described in *The Hidden Order of Art*. Ehrenzweig wrote of 'the dualism of form and content' as 'the bugbear of aesthetics', and advocated that attention be paid to unconscious scanning rather than the analytic discrimination of detail. He argued that: 'Art teaching, instead of concentrating on abstract analysis of form, could train this precious syncretistic faculty and clear the way for the emergence of a new realism' (p.32). Morris related the shift away from the specific object of minimalism to this perceptual liberation. He wrote that: 'What was relevant to the '60s was the necessity of reconstituting the object as art. Objects were an obvious first step away from illusionism, allusion and metaphor.' The problem was that the minimalist cube or rectangle had inadvertently smuggled into its new anti-illusionism 'the essentially idealistic imagery of the geometric'. By going beyond objects, artists were able to go beyond 'pre-thought images' and open up the field of 'chance, contingency, indeterminacy – in short, the entire area of process'. The new post-object work meant that 'Ends and means are brought together in a way that never existed before in art.' See Morris, 'Notes on Sculpture 4: Beyond Objects' (1969), in Harrison and Wood, *Art in Theory 1900–2000*, VIIB4, pp.881–5; quotes pp.883–4.

22 Nauman, Interview with Michele De Angelus (1980), in Harrison and Wood, *Art in Theory 1900–2000*, VIIB14, pp.910–11.

23 Beuys, 'I Am Searching for Field Character' (1973), in *ibid.*, VIIC8, pp.929–30. For a discussion of Beuys's work, see Chapter 9 of *Varieties of Modernism*.

24 Krauss, 'Sculpture in the Expanded Field' (1979), in *The Originality of the Avant-Garde and Other Modernist Myths*, pp.276–91.

25 Smithson, 'A Sedimentation of the Mind: Earth Projects' (1968), in Harrison and Wood, *Art in Theory 1900–2000*, VIIB3, pp.877–8.

26 Smith, from an Interview with Samuel Wagstaff Jr (1966), in *ibid.*, VIA22, p.760.

27 Smithson, 'A Sedimentation of the Mind: Earth Projects' (1968), in *ibid.*, VIIB3, pp.877–8.

28 Greenberg, 'Abstract Art' (1944), in O'Brian, *Clement Greenberg*, vol.1, pp.199–204, esp. pp.201–2.

29 Harrison, from Introduction to Part VIII 'Ideas of the Postmodern', in Harrison and Wood, *Art in Theory 1900–2000*, VIII, p.1014.

30 Anderson, *The Origins of Postmodernity*, chapters 1 and 2.

31 Hassan, 'The Question of Postmodernism' (1980), quoted in *ibid.*, pp.18–19.

32 Lyotard, Introduction to *The Postmodern Condition* (1979), in Harrison and Wood, *Art in Theory 1900–2000*, VIIIC2, pp.1122.

33 Lyotard, 'What Is Postmodernism?' (1982), in *ibid.*, VIIIC4, p.1137.

34 Habermas, 'Modernity – An Incomplete Project' (1980/81), in *ibid.*, VIIIC3, pp.1123–31.

35 See Jameson, 'The Deconstruction of Expression' (1984), in *ibid.*, VIIIA10, pp.1046–51.

36 Anderson, *The Origins of Postmodernity*, pp.55–6.

37 Jameson, 'The Deconstruction of Expression' (1984), in Harrison and Wood, *Art in Theory 1900–2000*, VIIIA10, p.1048.

38 See *Varieties of Modernism*, Chapter 11.

39 Jameson, 'The Deconstruction of Expression' (1984), in Harrison and Wood, *Art in Theory 1900–2000*, VIIIA10, p.1051.

40 Burgin, from 'The Absence of Presence' (1984), in *ibid.*, VIIIB5, p.1072.

41 Foster, from 'Subversive Signs' (1982), in *ibid.*, VIIIA5, p.1038.

42 Ukeles, 'Maintenance Art Manifesto' (1969), in *ibid.*, VIIC3, pp.917–19.

43 Kelly, *Post-partum Document.*

44 Krauss, 'Notes on the Index, Part 1' (1976), in Harrison and Wood, *Art in Theory 1900–2000*, VIID12, pp.994–9; quotes pp.994–5. (For the full text see Krauss, 'Notes on the Index, Parts 1 and 2' (1976/77), in *The Originality of the Avant-Garde and Other Modernist Myths*, pp.196–219.) Krauss had left *Artforum* with Annette Michelson in 1974 to found *October*. If *Artforum* was the leading art world journal during the Minimal/Conceptual period of the late 1960s to the early 1970s, *October* has enjoyed a similar status as the pre-eminent site of postmodernist debate. The most notable difference is that whereas *Artforum* was a lavishly illustrated commercial journal whose heyday was comparatively brief, *October* is an austere academic quarterly that has maintained its influence in scholarly circles for over twenty-five years.

45 Krauss, 'Notes on the Index, Part 1' (1976), in Harrison and Wood, *Art in Theory 1900–2000*, VIID12, pp.994–9.

46 The account of semiotics given here tries to follow Krauss's argument. It has been claimed, however, that Krauss tends to conflate two distinct approaches: those of Charles Sanders Pearce and Ferdinand de Saussure. The former employs the symbol/icon/index distinction; the latter views language as a system of differences. According to Steve Edwards, Pearce does not use the concept of 'difference', and Saussure restricts his analysis to verbal and written language. (For Edwards's discussion of Pearce's semiotics, see Chapter 13 of *Art of the Avant-Gardes*.) The point of the present discussion is less to provide an account of semiotics as such than to demonstrate how Krauss tried to postulate a *structural* difference between modernist and postmodernist art. Hers was not the only such attempt: Craig Owens employed the distinction made in German philosophy between 'symbolic' and 'allegorical' modes of signification, arguing that modernist art was characterised by the former, postmodernism by the latter. See Owens, 'The Allegorical Impulse: Towards a Theory of Postmodernism' (1980), in Harrison and Wood, *Art in Theory 1900–2000*, VIIIA3, pp.1025–32.

47 Lippard, 'Interview with Ursula Meyer' and 'Postface' to *Six Years* (1973), in Harrison and Wood, *Art in Theory 1900–2000*, VIIC4, pp.920–1.

48 Joachimides, Rosenthal and Serota, *A New Spirit in Painting*, pp.11–12. See also Harrison and Wood, 'Modernity and Modernism Reconsidered'; for painting in the 1970s and 1980s, see esp. pp.226–36.

49 Joachimides, Rosenthal and Serota, *A New Spirit in Painting*, pp.11–12.

50 See Buchloh, 'A Note on Gerhard Richter's *18 Oktober 1977*'; 'polit-kitsch' is a pun on the term *politische kunst* – political art.

51 Bell, from 'Modernism and Capitalism' (1978), in Harrison and Wood, *Art in Theory 1900–2000*, VIIIC1, pp.1117, 1118.

52 Foster, 'Postmodernism: A Preface', pp.xi–xii.

53 Barr's flowchart is discussed in Chapter 1 of *Frameworks for Modern Art*.

54 See Wood, 'Commodity'.

55 Baudrillard, 'The Hyper-realism of Simulation' (1976), in Harrison and Wood, *Art in Theory 1900–2000*, VIIIA1, pp.1018–20.

56 See Kristeva, 'Powers of Horror' (1980), in *ibid.*, VIIIC5, pp.1137–9.

57 Kelley, 'Dirty Toys: Mike Kelley Interviewed' (1991/2), in *ibid.*, VIIIB14, p.1100.

58 Crow, 'The Return of Hank Herron', p.82.

59 Orwell, *Animal Farm*.

60 Kelley, 'Dirty Toys: Mike Kelley Interviewed' (1991/2), in Harrison and Wood, *Art in Theory 1900–2000*, VIIIB14, p.1101.

61 Beban, *Imaginary Balkans*, p.16.

62 Salcedo, Interview with Charles Merewether (1999), in Harrison and Wood, *Art in Theory 1900–2000*, VIIIC15, pp.1181–2.

63 Wu, *Privatising Culture*, p.2.

64 Orwell, *'Inside the Whale' and Other Essays*.

References

Anderson, P., *The Origins of Postmodernity*, London: Verso, 1998.

Barson, T., untitled note to Stan Douglas, *Win, Place or Show*, in *Between Cinema and a Hard Place*, not paginated.

Battcock, G. (ed.), *Minimal Art: A Critical Anthology*, New York: Dutton, 1968.

Beban, B., *Imaginary Balkans*, exhibition catalogue, Site Gallery, Sheffield, 2002.

Between Cinema and a Hard Place, exhibition catalogue, Tate Modern, London, 2000.

Blazwick, I., untitled note to Ilya Kabakov, *Labyrinth: My Mother's Album*, in *Between Cinema and a Hard Place*, not paginated.

Buchloh, B., 'A Note on Gerhard Richter's *18 Oktober 1977*', in *Gerhard Richter 18 Oktober 1977*, exhibition catalogue, Institute of Contemporary Art, London, 1989, p.50.

Clark, T.J., 'Modernism, Postmodernism and Steam', *October*, no.100, spring 2002, pp.154–74.

Crow, T., 'The Return of Hank Herron: Simulated Abstraction and the Service Economy of Art', in *Modern Art in the Common Culture*, New Haven and London: Yale University Press, 1996, pp.69–84.

Edwards, S. and Wood, P. (eds), *Art of the Avant-Gardes*, New Haven and London: Yale University Press in association with The Open University, 2004.

Ehrenzweig, A., *The Hidden Order of Art*, London: Weidenfeld & Nicolson, 1967.

Foster, H., 'Postmodernism: A Preface', in Foster (ed.), *Postmodern Culture*, London: Pluto Press, 1985, pp.ix–xvi.

Fried, M., 'Jules Olitski's New Paintings', *Artforum*, vol.4, no.3, November 1966, pp.36–40.

Fried, M., *Three American Painters: Kenneth Noland, Jules Olitski, Frank Stella*, exhibition catalogue, Fogg Art Museum, Harvard, 1965.

Gaiger, J. (ed.), *Frameworks for Modern Art*, New Haven and London: Yale University Press in association with The Open University, 2003.

Greenberg, C., 'Louis and Noland', *Art International*, vol.4, no.5, May 1960, pp.26–9.

Harrison, C., 'Conceptual Art', in P. Smith and C. Wilde (eds), *A Companion to Art Theory*, Malden, MA and Oxford: Blackwell, 2002, pp.317–26.

Harrison, C. and Wood, P. (eds), *Art in Theory 1900–2000: An Anthology of Changing Ideas*, Malden, MA and Oxford: Blackwell, 2003.

Harrison, C. and Wood, P., 'Modernity and Modernism Reconsidered', in P. Wood, F. Frascina, J. Harris and C. Harrison (eds), *Modernism in Dispute*, London: Yale University Press, 1993, pp.170–260.

Hoesterer, I. (ed.), *Zeitgeist in Babel: The Postmodernist Controversy*, Bloomington: Indiana University Press, 1991.

Joachimides, C.M., Rosenthal, N. and Serota, N., *A New Spirit in Painting*, exhibition catalogue, Royal Academy of Arts, London, 1981.

Kelly, M., *Post-partum Document*, London and New York: Routledge, 1985.

Krauss, R., *The Originality of the Avant-Garde and Other Modernist Myths*, Cambridge, MA: MIT Press, 1985.

Lippard, L., 'Escape Attempts', in A. Goldstein and A. Rorimer (eds), *Reconsidering the Object of Art: 1965–1975*, exhibition catalogue, Museum of Contemporary Art, Los Angeles, 1995, pp.16–38.

Lippard, L., *Six Years: The Dematerialisation of the Art Object*, Berkeley: University of California Press, 1997.

Lyotard, J.-F., *The Postmodern Condition: A Report on Knowledge*, Minneapolis: UMI Press, 1984.

Morris, R., 'Some Notes on the Phenomenology of Making', *Artforum*, vol.8, April 1970, pp.62–6.

O'Brian, J. (ed.), *Clement Greenberg: The Collected Essays and Criticism*, vol.1: *Perceptions and Judgments, 1939–1944*, Chicago: University of Chicago Press, 1986.

Orwell, G., *Animal Farm*, Harmondsworth: Penguin, 1951.

Orwell, G., *'Inside the Whale' and Other Essays*, Harmondsworth: Penguin, 1962.

Wood, P., 'Commodity', in R.S. Nelson and R. Shiff (eds), *Critical Terms for Art History*, Chicago: University of Chicago Press, 1996, pp.257–80.

Wood, P., *Conceptual Art*, London: Tate Publications, 2002.

Wood, P. (ed.), *Varieties of Modernism*, New Haven and London: Yale University Press in association with The Open University, 2004.

Wu, C., *Privatising Culture: Corporate Art Intervention since the 1980s*, London: Verso, 2002.

N(i) 3 L(i) 1 2 M(i) b 9
2*

B(iii) b 1 N(i) 1 Z(i) 8*

P(ii) B C D O(ii) P(ii)

Z(ii) 1 F(iii) 5 8 I(iii) A(i
 X(ii) 2 N(i) 3 L(i) 1 2 M
X(i) 1 2*

B(iii) b 1 A 2 N(i) 1 Z(i)

P(i) Q(ii) P(ii) S(ii) 1-5
Z(ii) 1 F(iii) 5 8 I(iii) A(i
 N(i) 3 L(i) 1 2 M(i) b 9

CHAPTER 2

Conceptual Art, the aesthetic and the end(s) of art

Charles Harrison

Introduction

The aims of this chapter are to consider the breakdown in the authority of modernist aesthetics and critical discourse that occurred in the 1960s, to discuss the ensuing development of forms of Conceptual Art in the late 1960s and early 1970s, and to review some consequent changes in the priorities of criticism. Modernist criticism was typically concerned with the relative 'quality of effect' in painting and sculpture conveyed through visible arrangements of shapes and colours. But viewers of Conceptual Art were confronted with works that were largely devoid of colour and that in many cases had no single definable shape: see, for example, Plates 2.2–2.7. Anyone mindful of the history of avant-gardism in the twentieth century would be likely to pause before simply denying such things the status of art. The first question to be faced, therefore, was just *how* these entities might be conceived of as works of art – and not as mere statements, proposals, documents, works of criticism or theoretical essays. The second was *why* so much should apparently be dispensed with that had previously contributed to art's sensuous appeal.

The study of Conceptual Art is complicated by difficulty in restricting the field of reference of the term. Since the 1970s, 'conceptual' has been widely used as a catch-all label for a range of artistic products that resist inclusion in more specific technical categories such as painting and sculpture. Something similar happened to the term 'abstract' during the third to fifth decades of the twentieth century, when those who were not professionally implicated applied it to more or less any work that was hard to understand. The normal barrier to understanding abstract art was that it did not picture things in the world in immediately recoverable ways, this being the formerly indispensable function by which paintings and sculptures had been recognised as such. That one might conceive of something as a painting *without* its having to be a picture of anything was certainly an idea by which the first practitioners of abstract art had been fascinated during the first two decades of the twentieth century. The subsequent prevalence of 'abstract' as a description for the new and stylistically unfamiliar provides confirmation that the prising apart of art from picturing was indeed a process that had wide implications. The more the currency of the term spread, however, the more remote its meaning inevitably became from that strange and barely thinkable possibility that had first possessed the imaginations of Wassily Kandinsky, Kasimir Malevich, Piet Mondrian and others.

PLATE **2.1** (facing page) Art & Language, detail of *Index 01* (Plate 2.12), showing section of wall display.

It has been customary to regard 'exhibitions' as those situations where various objects are in discrete occupation of a room or site, etc: perceptors appear, to peruse. In the case of so-called 'environmental' exhibitions, it is easily shown that aspects of the discrete arrangement remain. Instead of inflected, dominating surfaces, etc., there are inflected, dominating sites, etc. Objections to this view which call up questions of degree (in respect of fineness of supported detail) are irrelevant here since they are integral to the discrete situation, only serving to distinguish one mode from another there.

It is absurd to suggest that spatial considerations are at all bound to the relations of things at a certain level above that of minimum visibility.

Our proposals so far concern an interior situation: to declare open a volume of (free) air would be to acquire 'administrative' problems which inform a further decomplexity. (A distinction, as appropriate to these proposals, between, say, designator and designandum is beyond the scope of this writing.) Administrative problems are anyway only partially distinguished in a formal sense from others concerning requirements of specificity, etc. Inside, dimensional aspects remain physically explicit; 'air-conditioning' itself acquires a contextual decorum.

It is traditional to expect so-called ordinary things to be identifiable: there is nothing in the instrumental situation which demands identifiability. It may be true that the situation will remain only partially interpreted along many axes: there is a lack of a system of rules like those of correspondence.

A complete interpretation in terms of operations with sensitive instruments, etc., would amount to showing a veneer over the extended possibilities which the work supports. It is easy to define what is meant by saying that a magnitude which is only 'computable' with the help of, say, instruments and one which one can take a ruler to are nonetheless values of the same physical magnitude. It means that the visible or stated relations of the functor to other physical functor are the same. Obviously, anyway, one is still with experience.

Ornamental detail in the rooms may be objected to on the grounds that it offers a 'strong' experiential competitiveness which would never be supported by the air medium (the competition would never be met). Here, the all black, all grey all white, etc., environmental situations inform ornamental values. Extremes of air-temperature (either very hot or very cold) are cut-out for several reasons: one is that to allow the air to become self-importantly hot or cold indicates an insistence upon just one of its properties; another, which is secondary here, is that extremes of high or low temperature make us dwell on tactile experience. Any sound coming from the equipment is not ornamental so long as it is consistent with the functioning of the equipment. Terry Atkinson has written : 'Sounds from outside should be eliminated, although sounds from outside kept at a very low level might well be consistent with the super-usual quality'.

The demand made of the equipment would be that it keep the temperature constant: this is another reason for going inside. Prescriptions which go much further in specifying the dress of the room are mostly useless; it has to be looked at *mutatis mutandis.*

Terms like 'neutral' are irrelevant in this context except perhaps with one application - a 'social' one. There the term might indicate an absence of the feeling that what was occurring was technologically miraculous (such feelings are engendered by air-conditioning, in, say, London, whereas people are used to it in New York).

Rubrics like 'Non Exhibition', etc., are not inaccurate, they are just nonsensical. Obviously, there are cases where, for instance, sense is not exhibited, but the usage of the term itself is not similar to the present one.

It can't be said that we are relying on old-fashioned logical postulates (The Bellman's map in *The Hunting of the Snark*), or that the experiences offered are in any sense cut-down; rather they rely less on the vagaries of a detailed situation.

PLATE **2.2** Michael Baldwin, *Remarks on Air-Conditioning,* 1967, photostat, dimensions variable. (Courtesy of the Lisson Gallery and the artist.)

PLATE **2.3** Mel Ramsden, *Guaranteed Painting*, 1967–8, liquitex on canvas with photostat, two sections, each 92 × 92 cm. (Collection Bischofberger, Zurich.)

PLATE **2.4** Robert Barry, *Something Which is Very Near in Place and Time, but Not Yet Known to Me*, 2 August 1969, installation from the exhibition 'When Attitudes become Form', Institute of Contemporary Arts, London, September 1969. (Photo: Charles Harrison. Courtesy of Klemens Gasser & Tanja Grunert, Inc. and the artist.)

PLATE **2.5**
Douglas Huebler,
Location Piece No. 1,
1969, map 41 x 70 cm;
typed statement on
paper 41 x 34 cm;
thirteen photographs
each 31 x 36 cm
(not shown). (Photo: Gian
Sinigaglia/Archivio Panza/
Giorgio Colombo, Milan.
© ARS, New York and
DACS, London 2004.)

Location Piece #1

New York – Los Angeles

In February, 1969 the airspace over each of the thirteen states
between New York and Los Angeles was documented by a photograph
made as the camera was pointed more or less straight out the airplane
window (with no "interesting" view intended).

The photographs join together the east and west coast of the
United States as each serves to "mark" one of the thirteen states
flown over during that particular flight.

The photographs are not, however, "keyed" to the state over
which they were made, but only exist as documents that join with an
American Airlines System Map and this statement to constitute the
form of this piece.

February, 1969

PLATE 2.6
Joseph Kosuth, *Titled (Art as Idea as Idea)*, definition of the word 'meaning', *c.*1967, photostat on paper mounted on wood, 119 x 119 cm. (The Menil Collection, Houston. Photo: Hickey-Robertson, Houston. © ARS, New York and DACS, London 2004.)

It is much the same, I believe, with the idea of the 'conceptual', which replaced 'abstract' as a mark of the controversial at a time when it seemed that the potential for development in abstract art was exhausted. On the one hand, the increasing currency of the term testifies to the significance of the change it refers to: in this case a change in the grounds on which artistic objects are recognised, defined and judged as such. On the other hand, that very currency serves to obscure the specific conditions that certain artists faced in the later 1960s, when they contemplated those new modes of practice to which the term was first attached. In both cases, what is at issue is the character of a transformational moment in the history of art. In the study of each of these moments, what is required is a sympathetic imagination of the *practical* conditions – the framework of problems and possibilities – by which the pursuit of art seemed at the time to be defined for a number of those who were engaged in it.

PLATE 2.7
Lawrence Weiner, *One Aerosol Can of Enamel Sprayed to Conclusion Directly upon the Floor*, 1968. (© ARS, New York and DACS, London 2004.)

One aerosol can of enamel sprayed to conclusion directly upon the floor

Uncertain objects

In 1963, Henry Flynt published an essay on 'Concept Art' in an anthology edited by the avant-garde composer La Monte Young.[1] Flynt was associated with the Fluxus group and took part in several of its concerts and other manifestations. Written in 1961, his idiosyncratic essay was more clearly addressed to music and to mathematics than to art. The term 'Conceptual Art' first gained currency in 1967 following publication of Sol LeWitt's 'Paragraphs on Conceptual Art' in a special issue published by the American magazine *Artforum*.[2] LeWitt was involved in the minimalist tendency in New York in the mid-1960s and by 1969 was producing various specifications for wall drawings intended to be executed by others (Plate 2.8). 'When an artist uses a conceptual form of art,' he wrote, 'it means that all of the planning and decisions are made beforehand and the execution is a perfunctory affair ... Conceptual art is only good when the idea is good.'[3]

In the broadest sense of the term, 'Conceptual Art' might be said to shade at one extreme into an art of performance, and at the other to be concerned with ideas that issue in the form of texts, plans, diagrams or photographs. The distinction between an art of performance and an art of ideas is certainly not one that could be rigidly applied to all the avant-garde work of the later 1960s and early 1970s, but it may be used to mark out a number of different types of enterprise within the wider Conceptual Art movement. This chapter will not be much concerned with those kinds of avant-garde activity that edge into performance or poetry. Rather, I mean to concentrate on a type of work that was specifically addressed to the recent and current condition of fine art, diverse as it had become, which engaged with modernist theory as the dominant account of that condition and which aspired to be mainstream in that sense at least. The nature of this engagement served to distinguish the Conceptual Art avant-garde from such earlier and more recent avant-garde movements as Dada and Fluxus, whose oppositional character had been established at an intentional distance from the conclaves of the dominant culture, and whose claims to critical virtue were necessarily issued from the margins.

PLATE **2.8** Sol LeWitt, plan for drawing on north wall, Dwan Gallery, October 1969, 88 × 49 cm. (Photo: Giorgio Colombo, Milan. © ARS, New York and DACS, London 2004.)

The Conceptual Art I have in mind was generally characterised by the lack of physically robust material – no expressive brushwork on the walls, no accumulations of three-dimensional stuff on the floor – and by the recourse to linguistic specification and description that followed from that absence, words being the most effective means to draw the spectator's attention to objects that were imperceptible or imaginary or merely theoretical.

The works illustrated in Plates 2.2–2.7 were all produced between 1967 and 1969, during what I would regard as the first and definitive phase of the Conceptual Art movement. Michael Baldwin (b.1945) is an English artist who joined with Terry Atkinson (b.1939), David Bainbridge (b.1941) and Harold Hurrell (b.1940) in 1968 to adopt 'Art & Language' as a name for the collaborative practice they had variously developed over the previous two years. In the spring of the following year, they published the first issue of the journal *Art-Language* in Coventry (Plate 2.9; the subtitle, 'The Journal of conceptual art', was removed after the first issue). Mel Ramsden (b.1944) is also an English artist who was working in New York in the late 1960s. In 1970, he and the Australian artist Ian Burn (1939–93) merged their separate collaboration with Art & Language.

The four American artists Robert Barry (b.1936), Douglas Huebler (1924–97), Joseph Kosuth (b.1945) and Lawrence Weiner (b.1940) showed together in New York in January 1969. The exhibition, 'January 5–31 1969', was organised in a vacant office building by the avant-garde dealer–entrepreneur Seth Siegelaub. It was announced with the formula '0 Objects, 0 Painters, 0 Sculptors, 4 Artists … 32 Works'.

In the summer of 1969, Kosuth was invited to act as American editor of *Art-Language*. Although pursuing an independent career, he retained his links with Art & Language until 1976, when they were severed by local action taken in concert with Art & Language. By that time some twenty-five artists were variously associated with the group name, more or less equally divided between England and New York, where an Art & Language Foundation published three issues of a journal called *The Fox* in 1975–6. Since 1977, however, the artistic work of Art & Language has been in the hands of Baldwin and Ramsden alone.

The works I shall principally be concerned with in this chapter will be by the artists listed above, although it should be borne in mind that contributions to the Conceptual Art movement as broadly defined were made by artists working in many other locations across the world. The exhibition 'Global Conceptualism: Points of Origin 1950s–1980s', mounted in 1999 at Queens Museum of Art in New York, included works by over 135 individuals from Asia, western and eastern Europe, Latin America, North America, the former USSR, Africa, Australia and New Zealand.[4]

VOLUME I NUMBER I MAY 1969

Art-Language

The Journal of conceptual art

Edited by Terry Atkinson, David Bainbridge,
Michael Baldwin, Harold Hurrell

Contents

Art-Language *is published three times a year*

Price 75p UK, $2.50 USA All rights reserved
Printed in Great Britain

PLATE **2.9**
Art-Language, vol.1, no.1, May 1969, cover.

I mean to give some emphasis to the work of Art & Language as exemplary of an 'analytical' tendency within the larger Conceptual Art movement. Plates 2.10–2.12 show a specific installation of *Index 01*, one the most substantial works associated with this tendency. It was produced by Art & Language for exhibition at 'Documenta 5' in Kassel, West Germany in 1972. Mounted on four plinths are eight filing cabinets filled with 87 texts published in the journal *Art-Language* or otherwise authored by members of the expanded practice and circulated among them. A typed and photographically enlarged index is pasted onto the surrounding walls or onto the wall behind the cabinets (depending on the physical conditions of the display). To make the index, each text was read in relation to each of the others, and the relation between each pair was then specified as one of compatibility (+), of incompatibility (–) or of incommensurability (T; meaning that the contents of the texts in question were too different to be compared without a radical transformation of the grounds on which comparison was made). In its printed form the wall-mounted index gives a listing for each text, with each of the others listed alongside it under one of the three specified relations.

At the time of its first exhibition, ten names were listed in connection with the production of *Index 01*, although levels of responsibility for that production

PLATE 2.10 Art & Language, *Index 01*, 1972, eight metal filing cabinets with texts and photostat wall display, dimensions variable, installation at Musée d'art moderne de Lille Métropole, Villeneuve d'Ascq, France, 2001. (Collection Alesco AG, Zurich. Photo: Matthieu Langrand.)

varied greatly. The work may be thought of as an attempt to make a kind of map of a particular conversational world – one in which what was thought about, talked about and written about was the condition of art, the problems of defining it, of making it, of criticising it and of teaching it. A spectator/ reader of the *Index* could use it to sample the nature and concerns of this conversation and to trace its patterns of consensus and disagreement,

PLATE **2.11** Art & Language, detail of *Index 01*, showing open file-drawer with text.

E 1 (+) N(ii) Z(ii) 1 F(iii) 5 8 I(iii) A(ii) F G H L Q(ii) S(ii) 6 T(ii) 2
 X(ii) 2 N(i) 3 L(i) 1 2 M(i) b 9 U(i) a 1 2 Z(i) 8* K(i)* I(i)* M(ii)*
 X(i) 1 2*

 (−) V(i) 1 B(iii) b 1 N(i) 1 Z(i) 8* K(i)* I(i)* M(ii)* X(i) 1 2*

 (T) L(ii) P(ii) B C D O(ii) P(ii) S(ii) 1–5 Y(ii) 1 3 S(i) P(i)

 2 (+) N(ii) Z(ii) 1 F(iii) 5 8 I(iii) A(ii) f A 3–5 F G H L Q(ii) S(ii) 6
 T(ii) 2 X(ii) 2 N(i) 3 L(i) 1 2 M(i) b 9 U(i) a 1 2 Z(i) 8* K(i)* I(i)*
 M(ii)* X(i) 1 2*

 (−) V(i) 1 B(iii) b 1 A 2 N(i) 1 Z(i) 8* K(i)* I(i)* M(ii)* X(i) 1 2*

 (T) L(ii) P(i) Q(ii) P(ii) S(ii) 1–5 Y(ii) 1 3 S(i)

 3 (+) N(ii) Z(ii) 1 F(iii) 5 8 I(iii) A(ii) f A 3 F G H Q(ii) S(ii) 6 T(ii) 2
 X(ii) 2 N(i) 3 L(i) 1 2 M(i) b 9 U(i) a 1 2 Z(i) 8* Y(ii) 1 3 K(i)* I(i)*
 M(ii)* X(i) 1 2*

 (−) V(i) 1 B(iii) b 1 A 4–6 K L Z(i) 8* K(i)* I(i)* M(i)* N(i) 1 X(i) 1 2*

 (T) L(ii) P(ii) O(ii) S(ii) 1–5 S(i) P(i)

PLATE **2.12** Art & Language, detail of *Index 01*, showing section of wall display.

of orthodoxy and eccentricity. The work might also be thought of – as it subsequently has been within Art & Language itself – as a kind of updating of the genre of the Artist's Studio: that is to say, as a staged representation of the conceptual artist's place of work.

At this point I should acknowledge an interest. I have acted as editor of *Art-Language* since 1971, am among those associated with the exhibition of the *Index* at 'Documenta' and with some subsequent works in the name of Art & Language, and have continued to collaborate with Baldwin and Ramsden on literary and theoretical projects. Given this long association, my view of Art & Language work in particular and of the Conceptual Art movement in general is bound to be partisan in certain respects. In compensation I can offer the advantages of direct acquaintance with some relevant work.

Look carefully at Plates 2.2–2.7, paying particular attention to the details of size and medium given in the captions. Within the limits of the information provided, assume for the moment that each of these is *in some sense* intended as a work of art. What characteristics or properties would you say that these works have in common?

Many of the most common features are kinds of negative. None employs colour and none exhibits any significant personal touch. None makes any obvious pretence to value in terms of quality of materials or skill of technical execution. None fits securely into the category of either painting or sculpture. Kosuth's *Titled (Art as Idea as Idea)* resembles certain paintings of the time in size and format but is simply a tonally reversed photographic enlargement of a dictionary definition. (Kosuth's designation of the work as *Titled* takes its point from the practice of the minimalist Donald Judd, who labelled each of his works *Untitled* so as to prevent anyone from attaching a further and irrelevant title to it. By the same token a series of works from 1967 by Atkinson and Baldwin is labelled *Title Equals Text Nos. 1, 2, 3* etc., so as to identify each with the extensive text that is printed on its face.) Ramsden's *Guaranteed Painting* uses paint on canvas, but in such a manner as to efface the signs of manual application, and like the other five works it employs some form of printing. It is not so much a painting in itself as a two-part work that makes a kind of ironic *use* of painting. (The device of the guarantee was suggested by the practice of American artists like Dan Flavin, whose works were made of standard commercially available units – in Flavin's case fluorescent light tubes – and who were therefore obliged to issue them with certificates of authorship and authenticity.) All six works are in principle entirely repeatable in their form of presentation, although *Remarks on Air-Conditioning* is the only one of the six that was actually first *published* in the form of an essay rather than a wall-mounted object. (It represents the opening section of a longer text. This concerns the idea, proposed and discussed by Atkinson and Baldwin, that a volume of air-conditioned air should be considered as an art object.[5])

Of the common features that might be expressed in positive terms, perhaps the most obvious is that each of the works incorporates – in some cases perhaps *is* – a text of some kind, although the text in question varies considerably in length. Less easily formulated but equally significant is the observation that each of the works presents some problem to the spectator who approaches it as a work *of art*. That is to say, there is a problem in identifying just what it is that is supposed to be the object of critical attention:

is it the text itself, or the object, concept or state of affairs the text refers to – the 'Something' in Barry's work, the line traced across the USA in Huebler's, the volume of air-conditioned air in Baldwin's, the puddle of sprayed paint in Weiner's – or some combination of the two? ∎

That art might be made out of the problems of definition of art was not a new idea in the later 1960s. The point had been made by Marcel Duchamp with the first of his readymades as early as 1914, while much of the work of the Dada and Surrealist avant-gardes had been designed deliberately to strain the limits of what could be taken for art. In the later 1950s and early 1960s, the critical establishment of a modernist mainstream was accompanied by renewed interest in Dada and Surrealism – and by a revival of just those avant-garde strategies that modernist criticism had tended increasingly to disparage. Notable among the artists involved were Piero Manzoni in Italy, Yves Klein in France, and Jasper Johns, Robert Rauschenberg and Robert Morris in the USA. The emergence of the international Fluxus movement in the early 1960s provided further evidence of this revival. Specific works that might be seen as antecedents for the Conceptual Art movement include Rauschenberg's *Portrait of Iris Clert* and Morris's *Metered Bulb* (Plate 2.13). (Both were included in the first major retrospective survey of the Conceptual Art movement, held at the Musée d'art moderne de la ville de Paris in the winter of 1989–90.) The first of these is a telegram sent by Rauschenberg to the Iris Clert Gallery in Paris in 1961, following a request for a contribution to an exhibition of portraits of the owner. It reads 'THIS IS A PORTRAIT OF IRIS CLERT IF I SAY SO'. It can be seen as a kind of avant-garde parody on the idea that the meaning of a work is decided by the intention of the artist, and also, perhaps, as a kind of flagrant aside on the relationship between representation and resemblance.

Morris's *Metered Bulb* dates from 1962–3, a time when he had contacts with artists of the Fluxus movement. It is composed of an electric light bulb with socket and chain switch fixed above an electric meter. When the switch is pulled to illumine the bulb the meter records the consumption of units of electricity. It is one of a series of works Morris made at the time that seem both to raise questions about the conditions of an object's being regarded as art, and to short-circuit interpretation through some self-documenting aspect. In this case we might be led to ask just what it would mean to talk of the *Metered Bulb* as a 'work of art': for instance, is it (a) a kind of composition, the form of which involves its having both an 'on' and an 'off' state; or is it (b) an object that is only 'art' when the bulb is lit and the recording system in operation; or is it (c) 'art' by virtue of its capacity to produce in the spectator an unresolvable state of uncertainty as to whether (a) or (b) – or (c) – is correct?

What distinguishes the works illustrated in Plates 2.2–2.7 from these enterprises of the early 1960s is principally a slight change in the circumstances to which they are respectively addressed. At a time when the dominant model of art was still the large-scale painting of the American Abstract Expressionists, both Rauschenberg and Morris could claim a kind of exceptional character for their work by looking back to an earlier phase of avant-gardism. By the later 1960s, however, the identification of modernism with painting and of painting with abstraction no longer seemed secure. In a larger view, it could be said that the twentieth century saw a gradual decline in the work of art conceived as a unique object to be regarded by a solitary spectator. What was now at issue

PLATE **2.13**
Robert Morris,
Metered Bulb,
1962–3, mixed media,
43 × 20 × 21 cm.
(Collection Jasper
Johns. © ARS, New
York and DACS,
London 2004.)

was whether 'art' required any 'objects' at all. A work by Atkinson and Baldwin from 1967 takes the form of a photographically enlarged text mounted on board (Plate 2.14). The text opens, 'We need objects?'[6] In an interview recorded in October 1969, Weiner asserted, 'I do not mind objects, but I do not care to make them. The object – by virtue of being a unique commodity – becomes something that might make it impossible for people to see the art for the forest.'[7] In a statement for the catalogue of Siegelaub's January 1969 exhibition, Huebler wrote, 'The world is full of objects, more or less interesting; I do not wish to add any more. I prefer, simply, to state the existence of things in terms of time and/or place.'[8]

We need objects?

One may argue that an extensional object is merely designated, i.e. it is directly referred to in a Fregean context, it is distinct from 'idea' and the set of properties which make it up. The 'mode of presentation' of that object may be said to subsist somewhere between the concept, if you like, or idea (of it) and its simple designation – its simple picking out, distinguishing from others. It is that which is designated. The mode of presentation, or object constituted in terms of mode of present- ation is not the object itself in this extensional sense, nor is it anything entirely 'subjective' or, if you like, accountable only in a private experiential or ideational domain. In the Fregean system one can effectively compare the 'object', the 'mode of presentation'. I associate object and the ideational one with the table, the cube – the cube as a relational entity presented sensorily in a certain way, and the retinal image of each individual spectator.

Intention as 'the object in a certain mode of presentation'. For reasons of antipsychologism, Frege wanted to make sure that the object, in the extensional sense should neither be confused with its mode of presentation nor the idea of it.

PLATE 2.14 Terry Atkinson and Michael Baldwin, Art & Language, *38 Paintings* (*Painting No. 11*), 1967, photostat, dimensions variable. (Courtesy of the Lisson Gallery and the artists.)

In fact, just how straightforward a matter 'stating the existence of things' could actually be was the subject of considerable disagreement among those concerned in the Conceptual Art movement. The most extensive deliberations on the problems involved were those published in the journal *Art-Language*, and they have always been widely regarded as difficult reading. Referring back much later to this period, Baldwin has written, 'An artistic practice consisting exclusively in the production of texts seemed to place a world of hitherto unimaginably complex entities within the grasp of the artist.'[9] But on the other hand, 'We were also aware that an art composed of ideas, or concepts, held intentionally would need to appear in *some* extended form, even if this was to be textual; and this text would have to have *some* coherence.'[10]

In due course I will return to the works shown in Plates 2.2–2.7, and will give particular consideration to the relationship between two issues skated over in the discussion above: those of definition and of value. First, though, I want to sketch in some general background to the emergence of works such as these at the end of the 1960s, and to offer some reasons for the incursion of language into the domain of the visual arts.

A crisis of modernism

In the history of art it is sometimes possible to connect substantial changes of direction and priority to relatively specific moments in time. The period of the late 1960s was one such moment; to be more specific, I would say the period from the summer of 1967, when *Artforum* published its special issue, until the spring of 1969, when the exhibition 'When Attitudes become Form: Works – Concepts – Processes – Situations – Information' opened at the Kunsthalle in Berne, Switzerland. (A revised version of this exhibition was installed at the Institute of Contemporary Arts in London in September 1969. Plates 2.15 and 2.16 show views of this latter installation.) A similar moment had occurred in the 1860s with the emergence of artistic modernism in France, at a time when responses to the exhibition of Édouard Manet's *Olympia* served among other factors to mark a new kind of division between modern 'Realists' and traditionalists. From that moment on, long-term critical success was to become increasingly associated with an apparently rapid turnover of styles, while all possibility of practical development seemed denied to those artists who adhered to institutionally validated concepts of tradition, taste and competence. A century later, however, it was the adherents to a now established modernist tradition who seemed denied the possibility of further significant development, and the prevailing critical account of that tradition that seemed suddenly to be lacking authority and plausibility. Matters were not helped by the fact that a powerful curatorial and distributive apparatus was now in place, which paid lip-service to the relevant modernist protocols while sharing none of the deeper critical and ethical commitments

PLATE **2.15** 'When Attitudes become Form', exhibition installation at the Institute of Contemporary Arts, London, September 1969. (Photo: Charles Harrison.)

that they were supposed to serve. (At a symposium held in May 1966, the critic Michael Fried spoke publicly of his depression at the growth of an *uncritical* admiration for the modernist artists he esteemed, and at the 'valueless and appetiteless voraciousness of contemporary culture'.[11])

I should make clear the sense in which I am here using the concept of modernism. I mean it to stand for a kind of *value*, but one associated both with a specific historical period and with a body of theory (of which the prevailing art-critical exemplar is the writing of Clement Greenberg). Modernism is the singular value that an influential body of theory and criticism represents as common to various works of art since Manet that it regards as most deserving of attention on aesthetic grounds. The works seen as possessing this value are those that compose the modernist canon. As is common in aesthetic theories, there is a clear tendency to circularity. For the critic of a modernist persuasion, a work of art might be both technically accomplished and politically correct in its tendency, but it could not be significantly *good* unless it was also modern, and would not be significantly modern unless it was good – good, it should be said, in the eyes of those who deemed themselves qualified to make the right kinds of comparative judgement. For Fried, 'The issue of *value* or *quality* or *level* is explicitly, nakedly, and excruciatingly central: the desire of contemporary painters and sculptors to match or approach in quality the great works of the past is what gives modernist painting and sculpture their history.'[12] How, then, was this elusive modernist 'quality' to be assessed? Certainly not by gauging the work's address to the topical concerns of the culture; still less by counting such up-to-date features of the physical environment – typically, machinery in one

PLATE **2.16** 'When Attitudes become Form', exhibition installation at the Institute of Contemporary Arts, London, September 1969. (Photo: Charles Harrison.)

form or another – as it might serve to illustrate. After all, much of the art canonised in modernist criticism is abstract. In Fried's memorable formulation, 'Roughly speaking, the history of painting from Manet through Synthetic Cubism and Matisse may be characterized in terms of the gradual withdrawal of painting from the task of representing reality – or of reality from the power of painting to represent it.'[13] Rather, what was looked for was a kind of critical difference and development with respect to other recent and approved 'major' work in the same medium – which tended to mean painting or sculpture. The typical measure of this development was that it involved the shedding of any aspects or functions of the medium that proved to be inessential – inessential, that is to say, to the stimulation of aesthetic response in those spectators who were adequately equipped with sensibility. This is the process referred to by Greenberg as 'the self-critical tendency of Modernist painting'.[14] In his theory of art, it is the identification of modernism with the self-critical development of specific media that assures the maintenance of 'past standards of excellence'.[15]

In so far as the value of modernism as I have described it may be associated with a particular historical period, the inauguration of that period in the 1860s is marked by advances in painting that occurred principally in Paris. In the 1960s, on the other hand, the very continuance of a tradition of painting was among the points at issue, and while modern art now had a new centre of development in New York, signs of significant change could be observed extensively on both sides of the Atlantic. The exhibition 'When Attitudes become Form' was intended to survey a new international avant-garde, and it included some 120 works by 70 artists drawn from nine countries. Even under the most liberal of descriptions, no more than two or three of these works could conceivably have been considered as paintings. And as to that preoccupation with the 'great works of the past' that the modernist critics saw as indispensable to achievement in the present, Kosuth's views may be taken as representative of many of his fellow exhibitors in 'When Attitudes become Form':

> We have our own time and our own reality and it need not be justified by being hooked into European art history. Nothing being done could be done without the accumulated knowledge we have at our disposal, obviously. One can never completely escape the past, but to look in that direction intentionally and blatantly is creative timidity. The academic and conservative mind always craves historical justification.[16]

The changes at issue were not sudden in themselves – indeed, if we can give credence to the idea of a 'Global Conceptualism' originating in the 1950s, we would have to allow that the signs had been building up worldwide for at least a decade – nor were they marked by any particularly momentous events. However, their eventual fruition in the later 1960s coincided both with the final years of a phase of relative economic prosperity and social liberalism in the West, and with a not-unconnected period of widespread political protest. In New York many of those artists who were involved in the Conceptual Art movement were also members of the Art Workers' Coalition, which co-ordinated artworld opposition to the war in Vietnam and campaigned against the effects of racial and sexual prejudice in the policies of American museums. In the words of Siegelaub:

there was an attitude of general distrust towards the object, seen as a necessary finalization of the art work, and consequently towards its physical existence and its market value. There was also the underlying desire and attempt to avoid this commercialization of artistic production, a resistance nourished, for the most part, by the historic context: the Vietnam war and subsequent questioning of the American way of life. This was certainly the most seriously sustained attempt to date to avoid the fatality of the art object as commodity.[17]

For whatever reasons, it must have seemed to many quite separate individuals and groups during the late 1960s as though there had been a noticeable widening of distance where divisions tended ordinarily to occur, whether between generations, between teachers and students, or simply between people of different inclinations and commitments. The modernist account of the development of art had never gone unopposed, but by the early 1960s it had become dominant, even hegemonic, empowered in part by the international success of American Abstract Expressionism, to which it provided a telling intellectual complement. For all the resolute political individualism of the Abstract Expressionists themselves, that dominance was now inescapably associated with the exercise of American military and economic power. At the same time, it was as though certain fault lines in the modernist account had become impossible to ignore, while overt fissures showed here and there on the surfaces of its subscribing institutions – on the walls of galleries and museums, in the pages of magazines, and in the studios of art colleges. Talking of the business of learning how to be an artist in the mid-1960s, Baldwin has described modernism as 'like a surface that wouldn't bear your weight; you'd try to put your foot down somewhere and that bit would just seem to break off and float away'.[18]

Among the clearest signs of a breach in the authority of modernist criticism were separate essays published by Fried and Greenberg in 1967. Each had clearly been prompted to mount a defence of the nature of his preferences and of the grounds of his judgements. Fried's 'Art and Objecthood' was published in the *Artforum* special issue referred to earlier. It was written to defend the abstract painting and sculpture he admired against the 'literalism' of Judd, Morris and others of the minimalist tendency.[19] He regarded their work as reliant on an essentially theatrical encounter between spectator and art object. What he meant was that the specific *circumstances* of that encounter must always bear upon the received sense of the work. He thus saw this effect as compromising the experience of perpetual 'presentness'[20] that he associated with painting such as Kenneth Noland's and sculpture such as Anthony Caro's. His essay offered an impassioned argument to the effect that aesthetic value was contained within the individual arts – and he clearly had painting and sculpture specifically in mind – while a sensibility 'corrupted or perverted by theatre'[21] reigned in the ground in-between. This, of course, was just the territory that had already been colonised by 'happenings', performances, installations, environments and the like.

Greenberg's 'Complaints of an Art Critic' was written to support two principal theses. The first is that aesthetic judgements upon works of art coincide with involuntary and thus *disinterested* responses to their non-literary properties and effects, and that these judgements are not modified by subsequent reflection or thought. 'Because esthetic judgements are immediate, intuitive,

undeliberate, and involuntary, they leave no room for the conscious application of standards, criteria, rules, or precepts.'[22] Other things being equal, a painting by Henri Matisse is for Greenberg always better than a painting by Edvard Munch, and no amount of research into the troubled psychology – or 'literature' – of Munch's pictures can make it otherwise. Greenberg's second thesis is that the history of art is decided by 'sheer quality' – by the observable succession of the 'best' works – as distinct, for instance, from its being established in a series of iconographies or contested through differing accounts of social practices.

In these two remarkable texts the hegemonic voice of modernism can still be heard, for better or worse – or for better *and* worse – speaking in American accents for a mainstream tendency in artistic culture. It speaks defensively, however, as though already responsive to those intellectual instruments that were soon to be widely deployed, in the name of a postmodernist plurality, to sharpen the critique of hegemonic powers and to oppose the convergence of cultural values. It also speaks in the face of an emerging art to which it is explicitly hostile. The summer 1967 special issue of *Artforum* in which Fried's 'Art and Objecthood' was published also included the third of Morris's 'Notes on Sculpture', an essay by Robert Smithson on 'The Development of an Air Terminal Site' and LeWitt's 'Paragraphs on Conceptual Art', which effectively both offered a name to a movement and sketched out some of the priorities according to which contributions to that movement might be judged. Proposed in the same journal a few months later, Greenberg's definition of aesthetic judgement appeared already to be simply *inapplicable* to a steadily growing number of enterprises. How, after all, was judgement based on an immediate and involuntary response to visual effects to be exercised on works such as those illustrated in Plates 2.2–2.7 and Plates 2.10–2.12, where such visual properties as might be in evidence tended to be inessential, or variable or accidental, and where there might be reflective work to do or choices to make before the spectator/reader was in a position to identify the art in the first place?

One of the axioms of LeWitt's 'Paragraphs on Conceptual Art' was 'What the work of art looks like isn't too important'.[23] If valid, this would imply the potential redundancy of an entire tradition of criticism and interpretation based on the analysis of visual properties – the tradition upon which modernist criticism depends and to which it makes a definitive contribution. I have suggested – following Greenberg – that the contained easel picture was associated with particular modes of attention, and by implication with particular kinds of social circumstance.[24] While the specific work of art was physically marked off from other objects, art as a whole was clearly distinguished from other kinds of social practice. The resulting procedures did indeed serve to provide some appropriate kinds of focus, *so long* as the highest critical achievements of art could be associated with the traditions of painting and sculpture, and with works in which those traditions were plausibly distinguished and continued. But what if those distinctions had effectively lost their practical necessity? For instance, what would it say about the continuing substance of the traditions in question if it transpired that the only substantial difference remaining between a painting and a sculpture was that one went on the wall and the other on the floor – and that it did not much matter which was which (Plate 2.17)? For all Greenberg's and Fried's considerable success in theorising a modernist tendency

PLATE **2.17** Terry Atkinson and Michael Baldwin, Art & Language, *Painting-Sculpture*, 1966–7, alkyd paint on masonite, two parts each 81 × 51 cm. (Private collection. Courtesy of the Lisson Gallery and the artists.)

in the fine arts, by the mid-1960s it had become practically and theoretically difficult to maintain either the macroscopic distinction (between art and other modes of social practice) or the microscopic focus (on the bounded surface within the frame) without disqualifying large areas of significant cultural activity, and without increasingly conservative investment in media that seemed simply to be running out of steam.

Of the time when he was working on the Art & Language *Index*, Baldwin has written, 'One of the things I recall being interested in was the way it might have killed off the "edges" of artworks.'[25] A conventional painting is contained within its framing edges. Indeed, the function of the frame is in part to manage the relations between the painting and the surrounding world of not-the-painting in such a manner as to emphasise the self-sufficiency of the former. But an index to a body of discursive text may do just the opposite. It will tend to raise awareness of the partial character of its contents – the possibility that relevant additions to any of its categories might be made from outside the particular sample offered to view. Later forms of *Index* exhibited by Art & Language in 1973 and 1974 were designed to take explicit account of those interests on the part of spectators/readers that must affect their responses to the material presented to view, and of the potentially limitless body of unindexed material that extends from the margins of any given text (Plate 2.18).

ART AND LANGUAGE

01 (c)

Select a topic of interest from the 'topic list' (02) and find a place in the text (on microfilm) that's indexed by that topic number. The index set of each concatenatory unit (expression) is potentially the topic set whose several members **are** designated '1' – '16'. Each line of the (microfilmed) index can be read as listing possible relations of 'going-on' (e.g., A to B, B to C, etc.) in discourse. The numerals '1'...'16' refer to the items in the topic list. 'x' is a bound variable substitutable for a term designating any relevant pair of items of the text which instantiate the relation A to B...etc.

No textual items are named in the index... it merely lists the kinds of item (relational individuals) that can be considered together in relation to one another.

Select a concatenation expression that seems promising (as a relation). You can continue to uncover figure-ground circumstances with respect to the grammar (logic) of concatenation by trying to map the continuance of a concatenation relation with respect to your interest (hence selection) of either a topic or an item of text. You are considering the sets which are the life conditions of your interest(s).

Topic List (02 (c)
1) Idiolect
2) Ideology
3) Ideology revision
4) Interest
5) Technology/Bureaucracy
6) Modalities
7) Pragmatics
8) Situations...Guessing who...
9) Socialization
10) Indexicality
11) Going on grammar
12) AL Teleology
13) Community presuppositions
14) Good faith, bad faith
15) Darwinian descent
16) History/Methodology

PLATE 2.18 Art & Language, *Index 05*, 1973, instructions for reading the index, photostat, dimensions variable. (Collection Philippe and Carine Meaille, France.)

The moment of 'postmodernism'?

The concept of *post*modernism was not to gain currency in the art world until the later 1970s, but once the term took hold it would be widely applied to aspects of the art of the later 1960s with which modernist theory and criticism found itself uneasy, or to which it was downright hostile. Now, when that period is reviewed in the light of hindsight, various otherwise disparate incidents and manifestations tend to be grouped together as signs of the decline of modernism and the establishment of the postmodern. In fact, I think we should be cautious about assuming too rigid a distinction between modernism and the postmodern. It is now common in English-language art history and criticism to conceive of modernism as both a phase and a tendency in western art, lasting approximately a hundred years from the 1860s to the 1960s. However, we should bear in mind that the concept of a mainstream 'modernist art' – from Manet's markedly artificial works to the post-painterly abstraction of Morris Louis and Kenneth Noland – was not widely theorised until the very end of the period in question. The most forthright exposition of that concept, Greenberg's essay 'Modernist Painting,' was not published until 1960, and was little discussed until after its reprinting in the European journal *Art and Literature* in 1965. It was not included in *Art and Culture*, the volume of Greenberg's collected essays first published in 1961, which appeared in paperback in 1965 and which publicised his views outside the relatively restricted magazine audience to which those essays had originally been addressed.[26]

What I mean to suggest is that, where art was concerned, the advancement of a self-conscious art-historical understanding of modernism was in itself an enabling condition and perhaps even an early manifestation of *post*modernist theory and practice – that is to say, of those very tendencies and values by which modernism was to be opposed. It was a sign, in other words, that in regarding the critical development of art one might stand apart from those modernist tendencies that Greenberg had represented as 'spontaneous and subliminal' and as 'altogether a question of practice, immanent to practice and never a topic of theory',[27] and treat them as just that – a topic of theory. This, I think, is what the Conceptual Art movement stood for, in its English-language manifestations at least – this grasping at alternative theory in the face of a newly established modernist account of modern art, and of its values and its development. The perception driving this movement was that the account in question had become unsustainable even as it achieved dominance. To a sceptical eye, what the modernist critics represented as inescapable and *involuntary* conditions of aesthetic practice appeared increasingly like the habits of mind of a failing power – one that in restricting its own focus became the more easily resisted.

We should be quite clear about what was involved. Modernist theory proposed that a 'spontaneous and subliminal' self-critical process lay at the heart of the practice of art – a process that was thus somehow prior to language, or out of reach of language. It was just this process that led to art being *good*. But once that very process had itself been theorised, the one thing it could no longer be was spontaneous and subliminal. Nor was it any

longer out of reach of language. It was as though the painter standing in front of the canvas, brush in hand, found that what was on the end of that brush was no longer a medium of wordless expression; it was art history, art criticism, art theory, concepts … *words*. 'I'm believing painting to be a language, or wishing language to be any sort of recognition', Johns wrote in a sketchbook some time before 1964.[28] Commencing in 1959, he had painted a number of works in which colours seem to compete with, or to be replaced on the surface of the canvas by, their verbal labels (Plate 2.19). Meanwhile, a highly literate kind of modernist criticism continued to expatiate on the 'purely visual' virtues of ever-more refined kinds of abstract painting and sculpture. It was coming to seem increasingly as though the art in question was *made* of the very theoretical concepts that represented it as spontaneous and 'prior to theory'. In 1965, in his long and forceful essay 'Three American Painters', Fried could claim with some justice that 'criticism that shares the basic premises

PLATE **2.19**
Jasper Johns, *Jubilee*, 1959, oil and collage on canvas, 153 × 112 cm. (© Jasper Johns/ VAGA, New York/ DACS, London 2004.)

of modernist painting finds itself compelled to play a role in its development closely akin to, and potentially only somewhat less important than, that of new paintings themselves'.[29] But such claims were open to a different interpretation than the one Fried had had in mind. As Ramsden has said, referring back to the moment of the late 1960s, 'It had become necessary, finally, that the "talk" went up on the wall.'[30]

Under these circumstances, putting a text where business-as-normal might expect a painting was a kind of aggressive avant-garde act: an open assertion, perhaps, of a suppressed truth about the relations that now obtained between artistic practice and criticism. There were also class connotations – more evident in the UK than in the USA – in the movement of artists onto the ground of writing, thereby reclaiming the initiative from their supposedly better-educated interpreters. There are connections to be made here with the development over the same period of certain intellectual critiques of modernist art history. It had become increasingly clear that the establishment of a modernist canon entailed a degree of strategic amnesia regarding those untidy avant-garde enterprises from earlier periods – and particularly from the moment of the Russian Revolution – in which the barriers between art and language had been broken down in the interests of cultural and political provocation. In other narratives than those of modernist art history, such enterprises might be reinstated so as to furnish significant practical precedents.

The strategy of putting the talk up on the wall could also claim some substantial theoretical support. In 1964, the philosopher Arthur Danto visited an exhibition of Andy Warhol's *Brillo Box* (Plate 2.20) at the Stable Gallery in New York. His conclusion was that Warhol had demonstrated a fundamental point about the essence of art. In Danto's view there was nothing intended to distinguish Warhol's Brillo boxes from the ones on the supermarket shelf, *except* for the all-important fact that the former were art and the latter were not. What this appeared to him to demonstrate was that art could not be defined in terms either of the intrinsic or of the manifest properties of specific works; it could not be determined by what the viewer feels or sees in front of it. Rather, it must depend on some factor 'outside' the work: in other words, in Danto's view, on its being the object of a theory of art developed by some relevant community – in this case the artworld. 'To see something as art requires something the eye cannot descry – an atmosphere of artistic theory, a knowledge of the history of art: an artworld.'[31] To put the matter crudely, what makes the difference between one object and another is the *discourse* that it provokes. The Brillo box in the gallery 'speaks' of art and the world and of the relations between them as the one on the shelf does not. Danto's conclusion was that artworks are not to be defined as things made through the application of artistic techniques; rather, they are brought into existence *in theory*.

Against such a thesis it might be argued that it drives an unreasonably broad wedge between sensual experience and theory, and between artistic techniques and theory. It might be granted that Danto's philosophical argument is entirely relevant to such actually readymade objects as Duchamp's snow shovel – and to the paradox that there may be two perceptually indistinguishable objects only one of which is a work of art – but that it is necessarily inattentive to the thoroughly perceptible differences between

PLATE **2.20** Andy Warhol, *Brillo Box*, 1964, synthetic polymer paint and silkscreen on wood, 43 × 43 × 37 cm. (Museum of Modern Art, New York. Purchase. DIGITAL IMAGE © 2003 The Museum of Modern Art, New York/Photo: Scala, Florence. 358.1997. © The Andy Warhol Foundation for the Visual Arts, Inc./ARS, New York and DACS, London 2004.)

Warhol's original Brillo boxes, which were made of wood with roughly silkscreened decoration, and the commercially produced cardboard boxes on which they were modelled. For our present purposes, however, what is significant about Danto's argument is not so much its validity as its timeliness. It seemed to answer to that combination of restless testing of the nature of art and copious theorising that had increasingly characterised the various avant-garde movements of the twentieth century. And more enticingly still, it allowed a significant part in the establishment of new art to just those 'external' factors that modernist criticism was concerned to eliminate from its considerations – among them the effect of its own stipulations. In fact, it was clear to some people in the mid-1960s that work such as Judd's was 'installational' in the sense that it functioned as art with regard not only to the state of modernist theory, but also to the art gallery as a condition of the New York artworld. Danto's work may not have been responsible for the tendency to identify modernism as an institution in its own right, but in initiating what was to become a dominant 'institutional theory' of aesthetics, he certainly provided that tendency with some supporting argument.[32] As he himself observed in a much later publication, Greenberg's modernist narrative was progressive, just like the earlier Renaissance narrative that saw art 'getting better and better over time at the "conquest of appearance"':

> That narrative ended for painting when moving pictures proved far better able to depict reality than painting could. Modernism began by asking what painting should do in the light of that. And it began to probe its own identity. Greenberg defined a new narrative in terms of an ascent to the identifying conditions of the art. And he found this in the material conditions of the medium. Greenberg's narrative … comes to an end with Pop … It came to an end when art came to an end, when art, as it were, recognized there was no special way a work of art had to be.[33]

'When art came to an end' 1

The circumstance Danto describes might well appear liberating: not literally the end of art, but the end of art regulated by the application of specific criteria and by the expectation of historical development. Writing in the catalogue to the 'When Attitudes become Form' exhibition in 1969, the French critic Grégoire Müller claimed that 'With this new movement, art is liberated from all its fetters.'[34] Yet where there are no limits there can be no significance. In the absence of any appropriate technical category or genre, just how was any given work of art to be distinguished from the rest of the signifying stuff that decides our experience of the world? If the protocols of modernist criticism were to be abandoned or overthrown, what – if anything – was to be put in their place? The question that hangs over the Conceptual Art movement is this: if it is no longer useful or relevant to distinguish between works of art through analyses of their shapes and colours, if, indeed, there are no intrinsic properties by means of which an object can be recognised as an *art* object, how is criticism – and more importantly *self*-criticism – to proceed, and on what basis? If it is the case that certain works are 'talked'

into importance by the inhabitants of the artworld, is this all that criticism really amounts to? Are there other grounds on which to distinguish the exceptional from the indifferent – or from the mildly interesting, the passable, the good-in-its-way and so on – or are such distinctions bound in the end to lose all substance once accuracy of resemblance ceases to be a relevant criterion? It is certainly the case that since the early 1970s the concept of 'quality' has become virtually unusable in art criticism, and has had to be abandoned to its compromising association with the snobbery of connoisseurship and the auction house, and to its disastrous co-option to the jargon of educational administrators and management consultants. Does this tell us something about the failure of a specific cultural regime – one that can no longer plausibly defend the autonomy of its values – or is it indicative of a significant change in the very meaning of art, which until recently had tended to be virtually synonymous with its perceived aesthetic merit?

In normal discussions of previous avant-garde movements – Cubism, say, or Constructivism – the objects that came into critical consideration had for the most part had discernible features in common, and could be compared on the basis of these. Even in the case of abstract painting and sculpture, candidates for attention were united by their adherence to one medium or the other and by their recognisable *avoidance* of descriptive representation. With Conceptual Art, however, we are dealing with a range of enterprises in which problems of identification and description are often the very stuff that the viewer is invited to address. Is an endless playing with the definition of art all that art now has to offer? Should we be comparing the relevant works on the basis of their ingenuity in posing the problems in question, so that the less probable it is that the object proposed should be accepted as a work of art, the 'better' it is *as art*?

It is time, finally, to return to the works referred to at the outset of this chapter. I want particularly to consider the different ways in which language is used in some of those illustrated in Plates 2.2–2.7. While it is significant that the use of language is a common feature, we should be careful about drawing conclusions from this, unless and until it is clear just what it is in each case that is 'the work' under consideration. Kosuth, for instance, claimed in 1969, 'I didn't consider the photostat a work of art; only the idea was art. The words in the definition supplied the *art information* ... the shift from the perceptual to the conceptual is a shift from the physical to the mental.'[35] In his view, the work of art is not the photostat mounted on the wall, but the idea of the *idea* of theory as art. Its interest, for Kosuth, lies in the critical effect that this idea has on our thought about art. The definition of 'meaning' (Plate 2.6) is one of a long series of such definitions issued by the artist in 1967–8. Others include 'art', 'painting', 'time', 'square', 'colour', 'theory' and 'definition' itself. Faced with any two of these it would not, I think, make a great deal of sense to ask which is the more successful work of art. It would be more to the point to give critical consideration to the character of the series as a whole. We might ask, for instance, whether there is some common aspect to the words included, and whether there are others that would definitely not fit. By such means we work for an understanding of the nature of the system in question, and of the kinds of critical observations that may be relevant. The process is not so very different from that by which we learn how to make critical distinctions between different kinds of painting. To

respond to the character of Mondrian's painting is to perceive the principle that a drip of paint on its surface would read as an accident and would spoil it. But to apply the same principle to a painting by Pollock would be to miss the point of his work. We make such judgements intuitively, I think, even before we have any real theoretical understanding of the works in question – and as part of the process of acquiring it. It is on the basis of such intuitions that theory and criticism are most soundly developed. In the case of Kosuth's work, addition of the definition of, say, 'Sin' or 'Turnip' to his series would seem like a kind of offence to its intentional style: the equivalent of a drip on the surface of a Mondrian. The one would import dramatic and irrelevant considerations of morality and of religion, the other would connect too immediately to the material and natural world. To sense this is to begin to recognise a kind of intellectual decorum by which the series of definitions is itself defined: a decorum that aligns itself with the priorities of modernist criticism and theory.

Writing in 1969, Kosuth claimed that 'Being an artist now means to question the nature of art. If one is questioning the nature of painting, one cannot be questioning the nature of art.'[36] For all his vaunted anti-modernism, Kosuth's assumption that the modern artist is necessarily concerned with problems 'intrinsic to art' is one that he shared with the Fried of 'Three American Painters'. However, in place of specific traditions of painting and sculpture he proposed a tradition of inquiry into the function of art that he saw as initiated by the readymades of Duchamp:

> The 'value' of particular artists after Duchamp can be weighed according to how much they questioned the nature of art …
> Artists question the nature of art by presenting new propositions as to art's nature. And to do this one cannot concern oneself with the handed-down 'language' of traditional art.[37]

This is very close to suggesting that the value of any given work of art lies in its sheer improbability.

Weiner's texts, on the other hand, sketch out particular situations and processes or list the properties of a hypothetical object or physical state of affairs (Plate 2.7). Asked in 1969, 'What is the subject matter of your work?' he replied, 'Materials'.[38] For the reader/spectator or 'receiver' of the text, what follows from it is a possible realisation of the physical circumstance that it describes. As descriptions the texts are typically highly general and imprecise – allowing, perhaps, for some resonance to develop between description and realisation. In any given case the realisation may be either actual or imaginary, according to whether either Weiner or the receiver (curator or purchaser) has 'built' the piece in question, or whether it remains 'unbuilt'. In Weiner's words, each of these possibilities is 'equal and consistent with the intent of the artist', so that 'the decision as to condition rests with the receiver upon the occasion of receivership'.[39] If you bought a work by Weiner in 1969 (which at the time would have cost you exactly $1,000) you would receive a piece of paper with the specification of the work, signed by the artist, and would then be able to decide whether to have the artist realise it, to realise it yourself in whatever form seemed appropriate, or to leave it unrealised. If you were a curator installing a work for exhibition you would similarly make the decision whether to have it realised or not.

Plate 2.21 shows Weiner's *A River Spanned* as represented in the exhibition 'When Attitudes become Form' at the Institute of Contemporary Arts in London in September 1969. As the curator at that time responsible for the installation, I made the labour-saving decision not to have the work in question physically realised. It was therefore represented in the gallery simply by a card giving the catalogue number and title. But had I, for instance, arranged for a line to be fired across the Thames attached to an arrow, that would have constituted an appropriate realisation for the purposes of the exhibition.

In the case of Barry, no such equivalence is intended between the object and its linguistic description. In the installation shown in Plate 2.4, it is the 'object' described that is conceived as the artwork. In the course of the previous three years, Barry had moved from relatively conventional abstract paintings, to paintings composed only of four square corners, to wires strung between different walls, to radio carrier waves 'occupying' the space of a room, to quantities of gas released into the atmosphere.[40] Like Kosuth's work, although to different conclusions, such enterprises seem to combine the implications of two specific strands in the art and theory of the twentieth century. On the one hand, there is the Duchampian idea of the readymade: the object that 'becomes' art by virtue of an act of selection or nomination – and through the absorption of that by the artworld. On the other hand, there is the progressivist tendency within modernist theory: the tendency to associate development in art with an increasing reduction of means. As expounded by Greenberg, the reduction in question operates within specific media. His

PLATE **2.21** Lawrence Weiner, *A River Spanned*, 1969, installation from the exhibition 'When Attitudes become Form', Institute of Contemporary Arts, London, September 1969. (Photo: Charles Harrison. © ARS, New York and DACS, London 2004.)

principal concern is with painting's gradual elimination of pictorial depth. During the 1960s, however, and in the wake of American minimalism, the reductive tendency in modernist theory was itself subject to a kind of avant-garde reduction, such that development became associated with the pursuit of ever-more refined 'least objects'. (The tendency in question was given a degree of credibility – and a label – in an article on 'The Dematerialization of Art' by Lucy Lippard and John Chandler, published in February 1968.[41]) In Barry's case, these two twentieth-century strands are combined such that the 'object' nominated as art is so lacking in substantial presence that it exists only as a kind of possibility in the mind.

It might seem that Baldwin's *Remarks on Air-Conditioning* (Plate 2.2) has much in common with Barry's work, in so far as it proposes something lacking in substantial presence – a volume of air-conditioned air – as its starting point. In fact, the common ground serves only to highlight the differences. The objective of *Remarks on Air-Conditioning* is not to claim a still more exotic object as a work of art; it is to explore the problems that such an object would pose for the habits and assumptions that attend upon such concepts as 'exhibition', 'perception' and 'criticism'. Baldwin has written:

> The question was, 'Is it necessary actually to install air-conditioning as described in the text, or will the text do just as well?' (Is the text to be identified as the art – the meaning – we make and is any concrete 'realisation' of it merely a conservative-contemplative distraction?) Here begins the distinction between Conceptual Art thought of as some sort of Minimalism or Duchampian selection occasionally outside the realm of middle-sized dry goods and Conceptual Art thought of as a fundamentally textual cultural practice.[42]

The implication is that such 'objects' as Weiner's or Barry's might well be 'outside the realm of middle-sized dry goods', but that they still rely – conservatively – upon an audience capable of being fascinated by avant-garde exotica. In fact, a Conceptual Art conceived as a 'fundamentally textual cultural practice' was always likely to confront two considerable obstacles. The first was to persuade those who came to art expecting to exercise the competences of spectators that what they needed to be was assiduous readers – and readers who might have to deal with texts that are strange kinds of hybrid: neither literature nor philosophy but *art* taking the form of writing. The second was to establish some appropriate medium of distribution, display and transfer of ownership. To put the matter bluntly, in the history and criticism of Conceptual Art there was – and still is – great potential for confusion as to the status of pieces of paper with writing on them.[43]

The question that is typically at issue is where the value of the work is to be located, and just what kind of value it is. Traditionally, the value of works of fine art has been associated with their autographic character: that is to say, with their being handmade, and with the hand in question being both individually distinguishable and esteemed for its technical ability. That a work is actually signed may enhance its monetary value, but only – in theory – because the signature serves to enable or to confirm a correct identification of the artist's individual style. The autographic work is typically unique. The philosopher Nelson Goodman offers a useful distinction between the 'autographic' and 'allographic' arts (an allograph is a writing or signature made

on behalf of another): 'Let us speak of a work of art as *autographic* if and only if the distinction between original and forgery of it is significant; or better, if and only if even the most exact duplication of it does not thereby count as genuine.'[44] For any 'original' product of a given hand there is, at least in theory, some correlation between its aesthetic and its monetary value. All other things being equal, a work that is recognisably from the hand of van Gogh will be worth very much more than a work from the hand of Joe Bloggs. The reason for this, in principle, is that the work of van Gogh is that much 'better' than the work of Joe Bloggs.

Works of music or literature, on the other hand, are non-autographic, or 'allographic'. Someone might pay a great deal of money for the original manuscript of *Pride and Prejudice*, and might be influenced in doing so by the critical esteem accorded to Jane Austen's work. But no one in their right mind would claim either that the collector in question had become the owner of *Pride and Prejudice* the novel or that the price paid reflected the beauty of Jane Austen's handwriting. We do not think of the novel as co-extensive with any one copy of it or even all the copies of it. Similar considerations would apply to the relationship between an autographic musical score and the piece of music for which it serves — allographically — as notation. In any purposeful enterprise of criticism we clearly need to take account of the manner by which we become aware of the specific work at issue, since it will tell us a great deal about the *kind* of work it is.

There is an important caution to be observed, however. The difference between the autographic and the allographic work is not a simple matter of the uniqueness of the one and the repeatability of the other. As Goodman notes:

> The etcher … makes a plate from which impressions are then taken on paper. These prints are the end-products; and although they may differ appreciably from one another, all are instances of the original work. But even the most exact copy produced otherwise than by printing from that plate counts not as an original but as an imitation or forgery.[45]

According to this distinction, however small the printed edition in which it circulates, the novel is an allographic art, while however large the edition, the artist's print is autographic. The difference is reflected in differences of monetary value. A first edition of *Pride and Prejudice* would no doubt fetch a great deal of money in a sale of rare books, but a cheap paperback edition would do just as well for someone who wanted to read the novel. An etching from an original plate by Rembrandt, on the other hand, will be valued hugely more than an exact facsimile of the same image.

With the preceding discussion in mind, how easy do you think it would be to classify the works illustrated in Plates 2.2–2.7?

I would expect you to find it far from easy. On the one hand, as we have already observed, none of the works appears positively to rely for its effect on the uniqueness of the artist's touch. As described earlier, the canvas in Ramsden's work is hand-painted and in that sense clearly autographic. The same could hardly be said for its accompanying guarantee, however, and we might ask how essential it is to the integrity of the work as a whole that the

painting the guarantee refers to should actually be an authentic product from the artist's hand.

In the case of Huebler's work, the American Airlines map is marked with what we may assume to be the artist's own handwriting, but it is far from clear that the form of the work would be substantially damaged were we to substitute an identical map on which the same text had been printed or written in another hand.

As regards the works by Barry, Kosuth and Weiner, the printed texts that are their means of presentation are repeatable without loss and could hardly be seen as 'artists' editions' in the manner of etchings or lithographs. Yet each of these artists would be likely to claim that the means of presentation is not to be confused with the 'art' content of the work, which is not itself simply repeatable.

As an essay published in a magazine, *Remarks on Air-Conditioning* can be seen as just that. But in the form in which it is reproduced here – a photostat in the collection of a French art gallery – a single copy of the same text seems to have been eventually accorded a status closer to that of the artist's print.

Of one thing we can, I think, be sure. None of these works was intended as a work of literature. Each needs to be seen as addressed to a tradition of art, and as located somewhere within that extensive problem field that the concept 'work of art' serves to define. ■

In an interview quoted earlier, Siegelaub referred to an 'underlying desire and attempt to avoid [the] commercialization of artistic production' that he associated with the 'dematerialization' of art.[46] His testament carries the authority of the entrepreneur most ingeniously involved in the early exhibition, distribution and sale of works of Conceptual Art. But the fact remains that the art market not only survived the late 1960s more or less untransformed, but has massively expanded in the period since. The products of the Conceptual Art movement were and are among the items traded on that market as commodities for collectors who like avant-garde art. Artists have had either to conspire in the means by which some actual or token commodity-status is achieved for their output or to abandon any prospect of professional standing – with consequent loss of public presence for their work. However thoroughly the discriminatory apparatus of modernist critics may have been disparaged, effective discriminations continue to be practised by the market, by collectors and sponsors, and by the curatorial apparatus of modern art museums.

Kosuth's strategy may be seen as representative of the procedures adopted by many artists of the period to signal their dissent from the aesthetic values attached to the unique and 'original' artwork, while satisfying the association between autograph and transferable property on which the art market normally depends. All that is received by the purchaser of any one of his 'definitions' is a kind of certificate: the printed definition itself, cut from a dictionary and pasted onto a small card signed and dated by the artist. It is these certificates that constitute title to the property in question and that are now traded on the art market. There is nothing to prevent anyone from making their own version of the enlarged and tonally reversed photostat. But without an accompanying certificate it would have no commercial value and would not be accepted for public exhibition as 'a Kosuth'.

'When art came to an end' 2

Danto's 'end of art' was a deliberate echo of a previous use of the same concept in the work of the early nineteenth-century German philosopher G.W.F. Hegel. For Hegel, the 'end of art' came with the transition from the classical to the Romantic epoch. He saw the change as one from a state in which aesthetic awareness – crudely, the sense of excellence – provided the highest possible form of self-expression for the human spirit, to one in which religion and philosophy furnish more adequate vehicles for our increased levels of self-awareness, and in which artistic media must always be limited in their capacity to express that self-awareness, since they give it only *sensuous* expression: 'Thought and reflection have taken their flight above fine art.'[47]

In 1969, Atkinson and Baldwin were involved in the design and implementation of a course in Art Theory at Coventry College of Art, in England. The first of its kind to be established in the country, this course owed its origins to the shared conversational practice that the name of Art & Language served to identify. A central component of the course was labelled 'Romanticism'. It was intended neither as an art-historical survey of the Romantic movement, nor as a means of instructing students in how to romanticise their production or themselves. Rather, the reference was to Hegel's notion of the end of art and to the 'objective humour' that he saw as the defining feature of the late Romantic art of his own time. We might think of this as something like ironic reflection.

I offer a picturesque example to explain how the idea of objective humour might be applied in the context of more recent artistic culture. Tate Modern in London houses a notable series of paintings by Mark Rothko: the so-called 'Seagram Murals'.[48] These were painted at the end of the 1950s, and might be thought of as representing the zenith of American modernist abstraction. They were acquired by the Tate Gallery in the year that the Coventry Art Theory course officially began. They are famous for their ability to imbue spectators with a sense of gravitas – or at least of pathos. On entering the gallery in which they are displayed it is not unusual to see at least one visitor apparently on the verge of tears. The paintings have been widely seen as touching on some common human sensibilities and as expressing a universal sense of the tragic. To conceive of them like this is perhaps to make certain elevated assumptions about the solemn conditions of their production and about the noble character of the artist. But the Seagram Murals were actually planned as decorations for a scandalously expensive restaurant in New York. Confiding to a fellow-passenger on a transatlantic sea voyage, Rothko said, 'I accepted this assignment as a challenge, with strictly malicious intentions. I hope to paint something that will ruin the appetite of every son of a bitch who ever eats in that room.'[49] Whatever else may be said about these paintings, it seems clear that they have their roots in the specific contradictions of high culture under the conditions of advanced capitalism, and in the modes of bravado and bathos that these tend to produce. Now it may be that this evidence of the work's sheer contingency seems incommensurable with the deep and sensitive character of the feelings of those who are moved in the paintings' presence. We may therefore try to deny it or to ignore it or to

dismiss it as irrelevant. Yet if we can face the apparent loss of a cherished pathos, once the contingency of Rothko's work is admitted and located, what is revealed is a deeper order: in this case, we might say, the complex pattern of relations between two large and co-existing value systems, one corporate and commercial, the other individualistic and aesthetic. If I understand it correctly, what Hegel called 'objective humour' works in this manner to indicate the contingency at the heart of the apparently profound, and thus to speak to a more fully self-conscious view of culture and history.

This, as I take it, was the reason why the members of Art & Language adopted 'Romanticism' as the title for a strand of teaching that was to be offered at the close of the 1960s. The point was that if the culture of art were to be kept critically alive, it would be 'objective humour' – and not the transcendent virtues of modernist colour and form – that would need to be taught and learned. The Art Theory course was not actually predicated upon the end of art, but to some of those who were still committed to the ethos of studio practice it certainly appeared as a kind of anti-art enterprise. In applying a type of 'objective humour' to modern art as a whole – in approaching it as a system of beliefs and practices that might be examined and explained – the teaching of Art Theory put that system into question. Among the crucial matters at stake was the issue of just what kind of work counted as *artwork*. As already suggested, so long as what one was aiming to do was produce an object that could be labelled a painting or a sculpture, the modernist tradition had presented a range of precedents to which new work could be critically related, for better or worse. But if what one was aiming to make was simply 'an artwork', there was no practical guidance about what such a thing should look like. Indeed, as LeWitt had suggested, what it looked like might no longer be an issue. That being the case, perhaps the real *work* of art was no longer to be done through the manipulation of materials in the studio, but rather as a matter of theoretical inquiry, to be pursued by reading and by writing, and even, perhaps, by conversational exchange. In so far as this work had a representable outcome, Art & Language would call it Conceptual Art.

The Art Theory course lasted formally for a bare two years. Although assiduously followed by a number of students, it was opposed by several of the staff and was regarded with deep suspicion by the administration. It was dismantled by the arbitrary exercise of power from above. An officer of the National Council for Diplomas in Art and Design was called on to issue a ruling that only 'tangible, visual art objects' could be accepted for assessment as student work. Baldwin and others were removed from the teaching staff. Those who for two years had been working on extensive texts separately or together were informed, in effect, that in the field of fine art evidence of thought would not be counted as evidence of work.[50]

In the course of the crisis at Coventry, a familiar argument was trotted out. Reading and writing were all very well, but they were the proper occupations of Art History and Complementary Studies rather than the studio, and should thus take up no more than the 15 per cent of the timetable allocated to such diversions. A student who aspired to score well in Fine Art was expected to show evidence of individual *artistic* talent and application, and for that what was required was clearly autographic 'visual' production, which, by a kind of

reductio ad absurdum, was defined as more or less anything that could neither be written nor read. Yet the real and substantial interest of the Art Theory course was that it was conceived by those involved, whether as teachers or as students, *both* as a means to learn in common *and* as a way to make art – and as such as a means of resistance to the stereotypes of artistic individualism and personality that were normally invested in the autographic. The combination was crucial and under the circumstances was seen as disruptive.

Art & Language's *Index 01* might be thought of as a kind of outcome of the Art Theory course: a consequence of the work that had enabled that course and that was enabled by it, but also a consequence of the course's suppression, since the effect of that suppression was to direct the work towards a different public forum.[51] The exhibition of the *Index* was a kind of communal enterprise, although not in the sense that the work involved had been equally distributed among the ten individuals whose names were attached to it. Some of these took no actual part in either the design or the implementation of the indexing system, but may merely have been responsible for written material included in the files. What the *Index* represented was a discursive activity held in common, for which those named shared responsibility in principle, and to which the spectator/reader was offered access.

As an installation, *Index 01* was designed to be as bland as possible, the aim being that attention should be drawn to the contents of the files and to the indexing system rather than to the material components of the display. To quote an analogy often used within the conversational world of Art & Language, 'Setting up displays is beginning to get like pointing your finger for a dog – the dog looks at your finger.'[52] The normal expectation of art exhibitions at the time was that they would provide their visitors with impressive spectacle. But the development of Conceptual Art was in part impelled by a perception that the increasing co-option of art to a modernist culture of spectacle had been achieved at the expense of its critical and subversive content. (Some such viewpoint seemed to lie behind Weiner's concern, quoted earlier, that the 'object … might make it impossible for people to see the art for the forest'.) What was required therefore was a strategy to prevent co-option, such as confronting the visitor with the sheer absurdity of playing the sensitive spectator in the face of something that was there to be *read*. On the other hand, if what was offered up could simply be incorporated in another category without leaving any awkward remainder – if it could be *adequately* described as a 'book' or an 'essay' – then the power of anomaly would be lost, and with it the possibility of effective critical connection to a tradition of art.

Why should this connection have mattered? On this point opinions are likely to be divided. According to one view, Conceptual Art stands for a kind of epochal change: it is the art of the 'end of art'. It requires the contrasting context of traditional modes so that its own radicalism will stand out the more clearly. According to a second view, the Conceptual Art movement was both a partial cause and a symptom of a crisis of modernism. It was a necessarily *transitional* episode, during which certain artists called attention to the loss of art's capacity to draw in intellectual and political content – a loss that seemed commensurate with its conscription to a culture of

spectacle. From this point of view, Conceptual Art's justification lay in the prospect that that loss could be resisted, and that art could be both understood and continued as a practice productive of complexity and depth – features that happened traditionally to have been associated with pictures. To quote a text by Art & Language from a much later phase in its activity, 'if Conceptual Art did have a true destiny, it was not Conceptual Art'.[53]

The Artist's Studio

In fact, since the later 1970s, the majority of Art & Language's artistic production has been in the medium of painting – although the results have not always been surfaces that could be hung on the wall in a conventional manner. Ten years after the exhibition of *Index 01* at 'Documenta 5', Art & Language was invited back to Kassel for 'Documenta 7', with a comparably large space to fill. Baldwin and Ramsden compiled another kind of index, this time, however, in pictorial form. Two large paintings were planned on the theme of the Artist's Studio. A pictorial composition was worked out on a detailed maquette (Plate 2.22). It shows seven figures variously disposed in a cluttered studio. Four of these are apparently at work with brushes in their mouths on a picture laid out on the floor. At the left and right are, respectively, a seated guitarist and a standing man at work among the publications on a table. Kneeling against the back wall at the left is a long-haired figure in a bowed pose suggestive of despair. Around the walls, stacked in cupboards, lying on the floor and piled on tables are paintings, drawings, prints, items of Conceptual Art, posters, musical recordings, journals, books and pamphlets, the majority of them taken from different phases of Art & Language's production. The picture is in that sense readable as an index of Art & Language's work – as compositions in the traditional genre of the Artist's Studio may sometimes be.

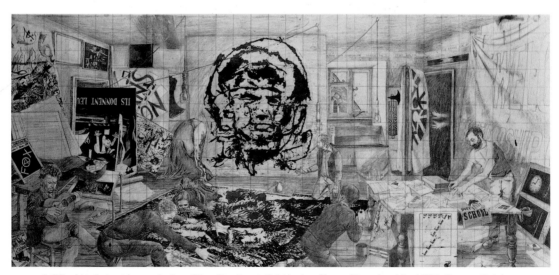

PLATE **2.22** Art & Language, *Index: The Studio at 3 Wesley Place; Drawing (1)*, 1981–2, pencil, ink, watercolour and collage on paper, 76 × 162 cm. (Tate, London.)

Particularly prominent are *Portrait of V.I. Lenin in Disguise in the Style of Jackson Pollock*,[54] on the facing wall in the centre, and *Attacked by an Unknown Man in a City Park: A Dying Woman; Drawn and Painted by Mouth* (Plate 2.23) – the work on which several of the figures are shown as engaged. That these and other details can be confirmed against the existence of things in the world is of course no guarantee that the painting tells a consistent documentary truth. It is particularly untrustworthy in the matter of its dramatis personae, one of whom (the despairing figure) is taken from William Blake's etching of *Satan Smiting Job with Plague Boils*, while another (the woman sprawled over the painting on the floor) is based on Victorine Meurend, the model for Manet's *Olympia* in 1863.

Once this maquette was completed, it was squared up and copied same-size with a pencil held in the mouth. The resulting line drawing was then precisely enlarged to the size of the *Painter's Studio* by Gustave Courbet – one of the most notable examples of the genre. It was then coloured-in with crayons, and finally painted over in black ink with brushes held in the mouth (Plate 2.24). The effect of the 'by mouth' expedient is automatistically to produce the appearance of expressionistic distortion and expressionistic surface, and perhaps to insinuate into the consciousness of the spectator a certain insecurity about the authenticity of authorship. A second painting based on the same composition was made by mouth in black ink alone using the same

PLATE **2.23** Art & Language, *Attacked by an Unknown Man in a City Park: A Dying Woman; Drawn and Painted by Mouth*, 1981, ink and crayon on paper mounted on wood, 176 × 258 cm. (Private collection, Paris. Photo: Konstantinos Ignatiadis, Paris. Courtesy of the Lisson Gallery, London.)

composition but without squaring up, so that distortion occurred over a larger scale as Baldwin and Ramsden navigated across the floor – as it were by dead-reckoning – with their faces only a brush-length away from the paper (Plate 2.25). The titles of the works are *Index: The Studio at 3 Wesley Place Painted by Mouth* (*I*) and (*II*).

To inquire further into the apparently bizarre 'by mouth' procedure and the distortion that it produces is both to recall the conditions to which the Conceptual Art movement responded – in its analytical mode at least – and to acknowledge its bearing on subsequent ambitious work in the sphere of

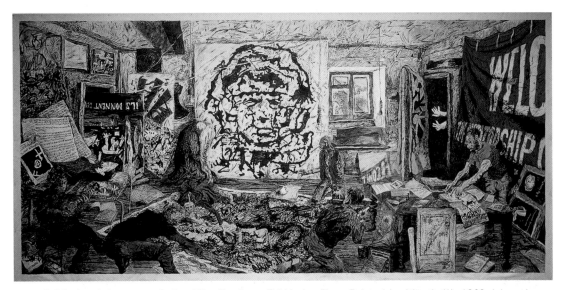

PLATE **2.24** Art & Language, *Index: The Studio at 3 Wesley Place Painted by Mouth* (*I*), 1982, ink and crayon on paper mounted on canvas, 343 × 727 cm. (Collection Annick and Anton Herbert, Ghent.)

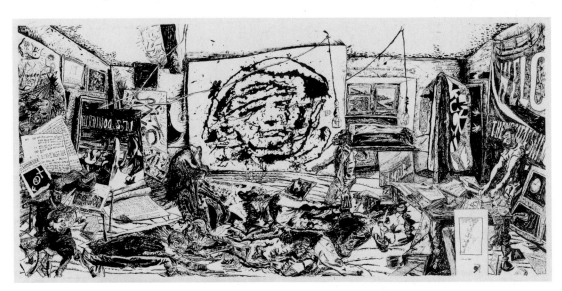

PLATE **2.25** Art & Language, *Index: The Studio at 3 Wesley Place Painted by Mouth* (*II*), 1982, ink on paper mounted on canvas, 343 × 727 cm. (Private collection, Paris.)

art. By the 1960s, modernist abstract art was coming to seem somewhat fragile and over-protected. The culture of its appreciation left little room for scepticism. In the late 1940s and 1950s, the works of Mark Rothko and Barnett Newman had come accompanied by claims – both from the artists themselves and from some of their more excited supporters – that were inflated to the very margins of self-parody. No younger artist could have got away with such portentousness without seeming anachronistic and self-deluded. The precocious Frank Stella had responded by taking a devastatingly laconic approach to the development of modernist abstraction – as though there were a book of rules and all he had to do was follow them. The development of the Conceptual Art movement was symptomatic of a similar need for deflation – an equivalent for Hegel's 'objective humour' that would be adequate to the time. With the benefit of hindsight, we might say that the problem was how to recover a kind of complexity and depth in art that could somehow live alongside the shallowness, artificiality and travesty of which artistic culture is *also* composed – as any realistic view must confirm.

The two Art & Language 'studio' paintings were made at a time when there was widespread interest in the idea of a 'new spirit' in art (see Chapter 3), a new figure-based painting, a new Expressionism: a time when those who had always been uncomfortable with the Conceptual Art movement were looking forward to a restoration of business-as-normal. They are large and ambitious paintings, but they are also intentionally deflating of certain ideas about artistic authorship: in particular, of the idea that what the artist authentically possesses is a means of autographic self-expression. Whatever we are to make our art out of, they seem to say, it can no longer be ideas such as these. It is certainly true that these works refer to, and to a large extent depend upon, a tradition of painting. Courbet's studio painting provided an indispensable point of reference, and a studio painting by Georges Braque is also quoted in the top left of the composition. There are further references to works by Jacques-Louis David, by Édouard Manet, by Pablo Picasso and by Jackson Pollock. But, in one crucial sense at least, Art & Language's paintings may be seen as outcomes of the Conceptual Art movement of the late 1960s and early 1970s: on the one hand, they are clearly positioned in relation to the 'high art' mainstream as conceived in modernist critical theory; on the other, they seem designed to unsettle those on the lookout for something to appreciate, who may have some difficulty reconciling their expectations of 'high art' with the deflating claim that these pictures were painted by mouth.

Notes

1 Flynt, 'Concept Art' (1961), in Young, *An Anthology*, unpaginated.

2 LeWitt, 'Paragraphs on Conceptual Art', first published in *Artforum*, vol.5, no.10, summer 1967, pp.79–84; reprinted in Harrison and Wood, *Art in Theory 1900–2000*, VIIA8, pp.846–9. LeWitt's subsequent 'Sentences on Conceptual Art' was first published in *Art-Language*, vol.1, no.1, May 1969, pp.11–13 and is reprinted in Harrison and Wood, *Art in Theory 1900–2000*, VIIA9, pp.849–51.

3 LeWitt, 'Paragraphs on Conceptual Art' (1967), in Harrison and Wood, *Art in Theory 1900–2000*, VIIA8, pp.846, 849.

4 See the exhibition catalogue *Global Conceptualism: Points of Origin 1950s–1980s.*

5 Baldwin sent the full text to the American artist Robert Smithson in the course of a correspondence. Smithson published it in the magazine *Arts.*

6 'Here is [an] example of what were called "Paintings", all texts of various kinds, from paragraphs of our own notes to favourite quotations from the work of others. The text is seen both as the "equivalent" of a painted surface and, of course, as something which entirely suppresses its literal presence. The "object" was something much discussed in connection with Minimal Art. A Fregean object was something that much more exotic than anything treated by 1960s art criticism. It was an object that lived in logic and language', Michael Baldwin in Baldwin, Harrison and Ramsden, *Art & Language in Practice*, p.221. Gottlob Frege was a German mathematician and logician, working during the late nineteenth and early twentieth centuries.

7 Quoted in Meyer, *Conceptual Art*, pp.217–18; reprinted in Harrison and Wood, *Art in Theory 1900–2000*, VIIB7, p.893.

8 Quoted in *L'Art conceptuel, une perspective*, p.168.

9 Baldwin, Harrison and Ramsden, *Art & Language in Practice*, p.69.

10 Note to the author, 2001, quoted in Harrison, 'Conceptual Art', p.324.

11 Fried, in *Art Criticism in the Sixties*, unpaginated.

12 *Ibid.*

13 Fried, from *Three American Painters* (1965), in Harrison and Wood, *Art in Theory 1900–2000*, VIB9, p.788.

14 Greenberg, 'Modernist Painting' (1960), in *ibid.*, VIB5, p.778.

15 *Ibid.*, p.779.

16 Kosuth, in 'Four Interviews; with Barry, Huebler, Kosuth, Weiner', first published in *Arts Magazine*, vol.43, no.4, February 1969, pp.22–3; reprinted in *L'Art conceptuel, une perspective*, pp.82–3; quote p.83.

17 Siegelaub, 'Some Remarks on so-called "Conceptual Art": Extracts from Unpublished Interviews with Robert Horvitz (1987) and Claude Ginz (1989)', in *L'Art conceptuel, une perspective*, p.92.

18 In conversation with the author, 2003.

19 'Art and Objecthood' was first published in *Artforum*, vol.5, no.10, summer 1967, pp.12–23; there is an edited version in Harrison and Wood, *Art in Theory 1900–2000*, VIIA7, pp.835–46.

20 Harrison and Wood, *Art in Theory 1900–2000*, VIIA7, p.845.

21 *Ibid.*

22 'Complaints of an Art Critic' was first published in *Artforum*, vol.61, no.2, October 1967, pp.38–9; reprinted in Harrison and Orton, *Modernism, Criticism, Realism*, pp.3–8; quote p.4.

23 Harrison and Wood, *Art in Theory 1900–2000*, VIIA8, p.847.

24 In *Varieties of Modernism*, Chapter 4.

25 Note to the author, 1989, quoted in Harrison, *Essays on Art & Language*, p.71.

26 Greenberg, *Art and Culture.*

27 Greenberg, 'Modernist Painting' (1960), in Harrison and Wood, *Art in Theory 1900–2000*, VIB5, p.778.

28 Quoted by John Cage in 'Jasper Johns', cited in Harrison and Orton, 'Jasper Johns', p.100 n.20.

29 Fried, from *Three American Painters* (1965), in Harrison and Wood, *Art in*

Theory 1900–2000, VIB9, p.791.

30 Note to the author, November 1981, quoted in Harrison, *Essays on Art & Language*, pp.20–1; Ramsden was referring to his own 'Guaranteed' and 'Secret' paintings.

31 Danto, 'The Artworld', *Journal of Philosophy*, vol.61, no.19, 15 October 1964, pp.571–84; quoted in Kelly, *Encyclopedia of Aesthetics*, vol.2, p.508.

32 Danto himself became increasingly resistant to the development of an 'institutional' theory of art. Its principal exponent was George Dickie, whose *Art and the Aesthetic: An Institutional Analysis* was based on an article, 'Defining Art', published in 1969 in the *American Philosophical Quarterly*, vol.6, no.3, pp.253–56.

33 Danto, *After the End of Art*, p.125.

34 Quoted in Harrison, 'Art Object and Art Work' (1969), in *L'Art conceptuel, une perspective*, pp.55, 61.

35 Kosuth, in 'Four Interviews; with Barry, Huebler, Kosuth, Weiner', first published in *Arts Magazine*, vol.43, no.4, February 1969, pp.22–3; reprinted in *L'Art conceptuel, une perspective*, pp.82–3; quote p.83.

36 *Ibid.*

37 Kosuth, 'Art after Philosophy', first published in *Studio International*, vol.178, no.915, October 1969, pp.134–7; reprinted in Harrison and Wood, *Art in Theory 1900–2000*, VIIA11, pp.852–61; quote p.856.

38 Weiner, in 'Four Interviews; with Barry, Huebler, Kosuth, Weiner', first published in *Arts Magazine*, vol.43, no.4, February 1969, pp.22–3; reprinted in *L'Art conceptuel, une perspective*, pp.82–3; quote p.83.

39 See Weiner's statement for the catalogue of Siegelaub's 'January 5–31 1969' exhibition, reprinted in Harrison and Wood, *Art in Theory 1900–2000*, VIIB7, p.894.

40 Barry, in 'Four Interviews; with Barry, Huebler, Kosuth, Weiner', first published in *Arts Magazine*, vol.43, no.4, February 1969, pp.22–3; reprinted as Interview with Arthur R. Rose in Harrison and Wood, *Art in Theory 1900–2000*, VIIA10, pp.851–2.

41 Lippard and Chandler, 'The Dematerialization of Art'.

42 Baldwin, Harrison and Ramsden, *Art & Language in Practice*, p.214.

43 This potential for confusion was directly addressed in the editorial introduction to *Art-Language*, vol.1, no.1, pp.1, 3: 'Suppose the following hypothesis is advanced: that this editorial, in itself an attempt to evince some outlines as to what "conceptual art" is, is held out as a "conceptual art" work ... Suppose an artist exhibits an essay in an art exhibition (the way a print might be exhibited). The pages are simply laid out flat in reading order behind glass within a frame ... It goes as follows; "On why this is an essay"'; reprinted in Harrison and Wood, *Art in Theory 1900–2000*, VIIB5, pp.885, 887.

44 Goodman, *Languages of Art*, p.113.

45 *Ibid.*, p.114.

46 Siegelaub, 'Some Remarks on so-called "Conceptual Art": Extracts from Unpublished Interviews with Robert Horvitz (1987) and Claude Ginz (1989)', in *L'Art conceptuel, une perspective*, p.92.

47 Hegel, from *Lectures on Aesthetics* (1886), in Harrison, Wood and Gaiger, *Art in Theory 1815–1900*, IA10, p.61.

48 See Chapter 3 of *Frameworks for Modern Art*.

49 As reported by John Fischer in 'Mark Rothko', p.22.

50 For some contemporary discussion of these events, see Pilkington *et al.*,

'Some Concerns in Fine Art Education' and Morris, Jacks and Harrison, 'Some Concerns in Fine Art Education II'. The ramifications of the edict on 'tangible, visual art objects' continued to affect students pursuing similar concerns elsewhere. For further discussion, see Everitt, 'Four Midland Polytechnic Fine-Art Departments' and Berry, Wood and Wright, 'Remarks on Art Education'.

51 Among the names associated with Art & Language at 'Documenta 5' were those of Philip Pilkington and David Rushton, who had both been students on the Art Theory course and whose work with Baldwin on the *Index* served both to represent and to continue.

52 Corris and Ramsden, 'Frameworks and Phantoms', p.49.

53 Art & Language, 'On Conceptual Art and Painting and Speaking and Seeing', p.43.

54 Art & Language's first major series of paintings, made in 1979–80, was *Portrait of V.I. Lenin in the Style of Jackson Pollock*. These offer strange collisions between the iconic content of Stalinist Socialist Realism and the modernist avant-gardism of Pollock's drip-and-spatter style. The radical unsuitability of the latter for the making of precise portrait-like images is apparently contradicted in Art & Language's works, as a recognisable image of Lenin emerges in each.

References

Art & Language, 'On Conceptual Art and Painting and Speaking and Seeing: Three Corrected Transcripts', *Art-Language*, New Series no.1, June 1994, pp.30–69.

Art Criticism in the Sixties: A Symposium of the Poses Institute of Fine Arts, Brandeis University, Waltham, Mass., New York: October House, 1967.

Baldwin, M., Harrison, C. and Ramsden, M., *Art & Language in Practice*, vol.1, Barcelona: Fundació Antoni Tàpies, 1999.

Berry, P., Wood, P. and Wright, K., 'Remarks on Art Education', *Studio International*, vol.184, no.949, November 1972, pp.179–81.

Cage, J., 'Jasper Johns: Stories and Ideas', catalogue introduction, *Jasper Johns*, exhibition catalogue, Jewish Museum, New York, 1964.

Corris, M. and Ramsden, M., 'Frameworks and Phantoms', *Art-Language*, vol.2, no.3, September 1973, pp.38–52.

Danto, A.C., *After the End of Art: Contemporary Art and the Pale of History*, Princeton, NJ: Princeton University Press, 1997.

Dickie, G., *Art and the Aesthetic: An Institutional Analysis*, Ithaca: Cornell University Press, 1974.

Everitt, A., 'Four Midland Polytechnic Fine-Art Departments', *Studio International*, vol.184, no.949, November 1972, pp.176–8.

Fischer, J., 'Mark Rothko: Portrait of the Artist as an Angry Man', *Harper's Magazine*, no.241, July 1970, pp.16–23.

Fried, M., 'Three American Painters', catalogue introduction, *Three American Painters*, exhibition catalogue, Fogg Art Museum, Cambridge, MA, 1965.

Gaiger, J. (ed.), *Frameworks for Modern Art*, New Haven and London: Yale University Press in association with The Open University, 2003.

Global Conceptualism: Points of Origin 1950s–1980s, exhibition catalogue, Queens Museum of Art, New York, 1999.

Goodman, N., *Languages of Art*, Indianapolis: Hackett, 1976.

Greenberg, C., *Art and Culture*, Boston: Beacon Press, 1961.

Harrison, C., 'Conceptual Art', in P. Smith and C. Wilde (eds), *A Companion to Art Theory*, Oxford: Blackwell, 2002, pp.317–26.

Harrison, C., *Essays on Art & Language*, Cambridge, MA and London: MIT Press, 2001.

Harrison, C. and Orton, F., 'Jasper Johns: "Meaning what you see"', *Art History*, vol.7, no.1, March 1984, pp.78–101.

Harrison, C. and Orton, F., *Modernism, Criticism, Realism*, New York: Harper & Row, 1984.

Harrison, C. and Wood, P. (eds), *Art in Theory 1900–2000: An Anthology of Changing Ideas*, Malden, MA and Oxford: Blackwell, 2003.

Harrison, C., Wood, P. and Gaiger, J. (eds), *Art in Theory 1815–1900: An Anthology of Changing Ideas*, Oxford: Blackwell, 1998.

Kelly, M. (ed.), *Encyclopedia of Aesthetics*, vol.2, Oxford: Oxford University Press, 1998.

L'Art conceptuel, une perspective, exhibition catalogue, Musée d'art moderne de la ville de Paris, 1989.

Lippard, L. and Chandler, J., 'The Dematerialization of Art', *Art International*, vol.13, no.2, February 1968, pp.31–6.

Meyer, U. (ed.), *Conceptual Art*, New York: Dutton, 1972.

Morris, L., Jacks, D. and Harrison, C., 'Some Concerns in Fine Art Education II', *Studio International*, vol.183, no.938, November 1971, pp.168–70.

Pilkington, P., Lole, K., Rushton, D. and Harrison, C., 'Some Concerns in Fine Art Education', *Studio International*, vol.183, no.937, October 1971, pp.120–2.

Wood, P. (ed.), *Varieties of Modernism*, New Haven and London: Yale University Press in association with The Open University, 2004.

Young, L.M. (ed.), *An Anthology*, New York: L. Young and J. MacLow, 1963.

Post-conceptual painting: Gerhard Richter's extended leave-taking

Jason Gaiger

Introduction

This chapter is concerned with the continuation of the practice of painting in Europe and the USA in the last third of the twentieth century and with the attempt to sustain its critical and progressive impetus in the face of widespread acknowledgement that by the mid- to late 1960s it had lost its position at the forefront of ambitious art. It is thus, by extension, also concerned with the temporal character of art and with its ineliminable historical and social dimension. To confront the possibility that a form of art as historically significant as painting might forfeit its claim to serious critical attention is to recognise that the concept and practice of art is part of a changing constellation of elements that has no fixed or final form. Since the meaning of art is tied to the conditions of its production and reception, the form and substance of artworks can, and must, change over time: artworks are historical through and through. (The case of music offers a good example: although sonatas, string quartets and symphonies continue to be written, the period in which these forms served as the principal vehicle for musical expression in the West lasted for little more than 200 years.) By the final decades of the twentieth century, it seemed to many artists and critics that painting was 'a shape of life grown old', condemned to an increasingly conservative rehearsal of strategies and gestures that had lost their original significance.[1]

There had, of course, been challenges to the supremacy of painting before. As early as the second decade of the twentieth century, Marcel Duchamp announced his 'abandonment of painting', and the attempt by the historical avant-garde to break down the barriers between art and life led to the exploration of a wide variety of alternative artistic practices. From a broader historical perspective, it might appear as if the 'crisis' of painting in the 1960s was simply a repetition and deepening of a periodic process of reaction against its assumed superiority. However, it seems that something different did take place. By the last third of the twentieth century, not only did painting cease to command the same sort of attention that it had for so long claimed as its unquestioned right, it ceased to act even as a negative reference point against which other forms of art were measured. The fact that the contemporary artworld acknowledges painting as simply *one* form of art among many represents a decisive change in its status. What brought this situation about? And what possibilities remained open to artists who did not wish simply to rehearse the achievements of the past but to establish painting's ongoing claim to truth and validity?

PLATE **3.1** (facing page) detail of Gerhard Richter, *January* (Plate 3.31).

If we are to identify a genuine transformation in art's critical potential, then we must consider the grounds on which the claims for this potential are made. In the case of painting, critical interest has frequently resided in the productive tension between the content or subject matter of the depiction and the depictive elements of the painting itself. To look at a painting as a work of art is a highly complex process because it requires us to attend both to what is depicted and to the structure and organisation of the particular depiction. To use convenient shorthand, we are asked to consider not only the subject of the painting and its painted surface, but also the dynamic interplay between the two. Throughout the evolving history of art, 'the distinctive interest in what is visually rather than verbally articulated'[2] has been richly accommodated by the myriad complexities of this relation, which demands a projective and imaginative engagement on the part of the viewer as well as the artist. Since the space of the viewer and the space of the depiction do not coincide, the viewer must constantly relate his or her perception of the painting as a physical object to his or her perception of the painting as a work of artifice or illusion. The materiality of the medium and the fictionality of the representation stand in a relation of reciprocal tension and enhancement. The attentive viewer is made aware of the physical presence of pigment on canvas (or some other opaque ground) even while participating in the illusion that these marks sustain: the one is seen in and through the other.

A painting is bound both by the physical limits of the medium and by the contrast between the world it creates and the world out of which it is created. For many artists, the means to prevent a work of art from becoming 'merely' decorative or entertaining is to be found in its internal construction and the resistance it offers to immediate assimilation. In the second half of the nineteenth century, avant-garde artists such as Édouard Manet rejected the smooth finish and deep illusionistic space of salon painting for a technique that deliberately emphasised the procedures out of which their paintings were made. At the same time, they incorporated a new range of subject matter, drawing on their experience of a rapidly changing urban and rural world. It is out of this productive tension between the exigency of truth to materials and the exigency of truth to reality that modernism in the visual arts began. It has frequently been pointed out that the birth of modernism was virtually contemporaneous with the invention of photography. It seems plausible that the reproductive possibilities afforded by photography encouraged artists to break with a conception of painting that was still primarily based on imitation, allowing the work of art to be grasped as an independent entity that contains its own productive possibilities. This idea is given succinct expression in Paul Klee's dictum that 'Art does not reproduce the visible, it makes visible.'[3] On this view, a painting is to be regarded not as an imitation of reality, but as the creation of a new reality that possesses its own intrinsic significance. At the same time, however, it is frequently assumed that the reality of a work of art stands in a relation of contrast to the reality of the empirical world and, at least implicitly, asks to be measured against it. This is the case not only for figurative painting, but also for abstract art, in which the artist's freedom to construct and arrange the elements of the composition has been opposed to the absence of such freedom in the external world.

The question with which we are confronted here is whether, and to what extent, this complex set of relations between painting and empirical reality

has lost its capacity to engage us as viewers, or whether the tensions we have identified still remain sufficiently productive to allow artists to address issues of substantive critical interest through the medium of paint. In the last third of the twentieth century, the practice of painting was confronted with two significant challenges that have, if anything, advanced rather than receded in the present day. These are, first, the sheer ubiquity of the photographic image and, second, the breakdown of modernism as a sustaining paradigm for the making and appreciation of art. Let us consider each of these challenges in turn. As we have seen, the invention of photography originally acted as a catalyst for a process of critical reflection on the limits and possibilities of painting. However, the sheer proliferation of photographic and digital images in an increasingly mediatised world has decisively changed our relation to earlier forms of reproduction. In societies that are saturated with images, painting no longer occupies a privileged place as a provider of visual information. Moreover, the availability of reproductive technologies has undermined the dimension of craft or skill that still remains painting's indispensable precondition. Painting's very handmade quality, its slowness of execution and the artist's laborious reliance on brushes, oils and primers, make it seem a relic from an earlier era. The veneration once accorded to holy images, and the sense of awe that accompanied painting's capacity to create the illusion of an absent reality, have been replaced by an unassimilable surfeit of images whose purpose and origin often remain obscure to us.

It is a central tenet of modernism that the ceding of painting's imitative and narrative functions enabled artists to discover compensating virtues in the specific formal properties of the medium itself. The challenge of photography was to be met by focusing on the resources and limitations that were proper to painting. However, by the mid- to late 1960s, Clement Greenberg's account of a progressive struggle in which each of the arts sought to establish its 'unique and proper area of competence' no longer seemed plausible.[4] Not only was there a loss of confidence in abstraction as a universal language for the communication of ideas and feelings, but the very idea of aesthetic purity came to be seen as limited and exclusionary. The emergence of new forms of art that could not be assimilated within the modernist paradigm was accompanied by the recovery of earlier avant-garde movements, such as Dada and Constructivism, that had been neglected or consciously excluded from the developmental narrative of modernism. The historical and aesthetic rationale that modernism had provided began to give way, and painting was obliged to relinquish its position at the vanguard of ambitious art to a variety of new artistic media.

The challenge to painting came not only from new reproductive technologies such as film and video, but from a series of artistic movements, including performance art, land art and Conceptual Art, that questioned both the conventions of modernism and its sustaining institutions. Thus, for example, performance artists challenged the idea of the 'work' as a self-subsistent entity and focused attention on the relation between the artist and the viewer. Performance artists and land artists left the confines of the gallery, producing work that could not be exhibited or displayed in any conventional sense, and conceptual artists questioned the role of the artwork as a perceptual object, with its attendant connotations of visual sensitivity, connoisseurship and aesthetic appreciation. In different ways, each of these movements drew

attention to the processes through which artworks were constructed and their legitimacy maintained. Although even the most radical art movements of the 1960s ultimately proved assimilable to both the market and the museum, the intention at least was to disrupt the commodification of art and to prevent its neutralisation as a merely aesthetic object. In this context, a continued concern with the practice of painting began to look decidedly conservative, if not reactionary, and there was no shortage of artists and critics who were prepared to announce the 'end of painting' as a significant form of art.

Painting defended against its devotees

As the 1970s turned into the 1980s, however, a powerful counter-reaction was in train that heralded the return of painting as a major force on the international art scene. For many of those artists and critics who had participated in the critical and emancipatory struggles of the previous two decades, this was interpreted as 'a sign of a general regression' and as 'the product of a consciousness that fails to perceive the historical determination of its own condition'.[5] Nonetheless, a younger generation of artists started to produce oil paintings once again on a monumental scale, reinstating putatively redundant modes of figuration through highly gestural and expressive brushwork. In Germany, artists such as Georg Baselitz (Plate 3.2), Jörg Immendorf, Anselm Kiefer and Markus Lüpertz, many of whom had continued to paint throughout the 1960s and 1970s and were then 'rediscovered' by critics, were grouped together as 'Neo-expressionists', while in Italy painters such as Sandro Chia (see Plate 1.14) and Francesco Clemente were celebrated as pioneers of a new 'Trans-avantgarde'. In the USA, too, artists such as Julian Schnabel achieved significant commercial success through a series of grandiloquent works that were self-consciously invested with a rhetoric of artistic genius. As if in response to the difficulties presented by the radical art movements of the 1960s and 1970s, the art market reacted enthusiastically to these developments. Against the background of Thatcherite and Reaganite economics, a new generation of collectors started to invest in art, enabling painters to command large sums of money for their work. The fact that interventionist collectors such as Charles Saatchi were able to establish the reputation of artists and to increase the market value of their work by buying it in bulk further served to fuel suspicions that the international success of large-scale figurative painting was motivated as much by cynicism and opportunism as by a genuine rediscovery of painterly values.

For many critics and curators, however, the re-emergence of painting as a presence in contemporary art signified the triumphant consolidation of a threatened artistic tradition and a decisive rejection of the oppositional spirit that had dominated the previous two decades. At stake in these debates was not simply a preference for one type of art over another, or the right of new developments in art to critical acceptance, but two incompatible and conflicting understandings of the relation of art to its wider social and historical context. We can clarify these issues by considering the 'manifesto' that accompanied

PLATE **3.2** Georg Baselitz, *Triangle between Arm and Torso*, 1973, oil and charcoal on canvas, 250 × 180 cm.
(Photo: Frank Oleski, Cologne. © Georg Baselitz.)

a large exhibition entitled 'A New Spirit in Painting' that was held at London's Royal Academy in 1981.[6] The exhibition encompassed thirty-eight painters and three generations of artists. The organisers elected to show the work of contemporary 'Neo-expressionist' and 'Trans-avantgarde' artists such as Baselitz, Chia, Kiefer, Lüpertz and Schnabel alongside the work of older artists such as Francis Bacon, Balthus and Picasso. They also included work by artists such as Frank Auerbach, Lucian Freud (Plate 3.3) and David Hockney, who had continued to produce figurative painting in a relatively traditional idiom throughout their careers but for whom commercial success had not resulted in comparable critical attention.

In language that is redolent of G.W.F. Hegel's famous assertion in his lectures on aesthetics (1818–31) that 'art is, and remains for us, on the side of its highest destiny, a thing of the past',[7] the curators began their catalogue essay with the admission that 'We are in a period when it seems to many people that painting has lost its relevance as one of the highest and most eloquent forms of artistic expression.' Hegel believed that changes in the relation between art and society, and, above all, the loss of art's earlier religious and spiritual functions, had led to an irreversible transformation in the very meaning and status of art. In contrast, the curators expressed the conviction that painting could succeed in reoccupying the position it had previously held, if, indeed, it had ever lost it. In their view, despite losing ground to 'newer' means, such as photography, video, performance and environments, 'the art of painting … is in fact flourishing. Great painting is being produced today and we have every reason to think that this will continue.'[8]

Here I want to focus on the *reasons* that the curators of the exhibition adduced for painting's continued flourishing. Hegel's observations on the 'end of art' were not motivated by his own personal likes and dislikes but by his belief that, in the highly reflective culture of modern civil society, understanding had replaced feeling as the primary mode of access to works of art, thereby breaking the relation of immediacy that had previously sustained our relation to art. Similarly, the curators' faith in the continuing vitality and seriousness of painting was founded not simply in admiration for the work of certain living artists, but in a commitment to a deeper set of beliefs and values. The nature of this commitment comes most clearly to the fore in their assertion that:

> it is surely unthinkable that the representation of human experiences, in other words people and their emotions, landscapes and still-lives could forever be excluded from painting. They must in the long run again return to the centre of the argument of painting.[9]

The unspoken corollary here is that the representation of human experiences must also return to the centre of the argument of art and that painting is uniquely equipped for this purpose. For the need to represent human emotions and the reality of the world around us is identified as a permanent and enduring concern that remains above the shifting and merely topical interests of the artworld.

There is, then, a residual humanism at the basis of the 'new spirit' in painting that manifests itself in a renewed emphasis on the subjectivity of the artist. Whereas there may be strong grounds for identifying a limited number of 'anthropological constants' – that is to say, certain features of human lived

PLATE **3.3** Lucian Freud, *The Big Man*, 1976–7, oil on canvas, 92 × 92 cm. (Private collection. Photo: Bridgeman Art Library, London.)

experience that are common to all human beings simply *as* human beings – there is nothing binding about the form in which these species characteristics are articulated in the highly artificial and conventionalised media of art. The attempt to establish painting as an art of universal as opposed to topical significance begs the question in so far as it treats the conventions of painting as something natural and timeless rather than as the product of specific historical and cultural circumstances. Regardless of whether or not we are able to identify unchanging features of human experience – a question that must, surely, remain open – the attempt to *articulate* this experience in the language of art is a highly particularised practice that is subject to change over time. By appealing to timeless values in order to establish the ongoing validity of painting, the curators of 'A New Spirit in Painting' contradicted one of the most fundamental insights of the modern period, an insight that is closely identified with the philosophy of Hegel. This is

the recognition that artworks, like actions and events, gain their specific value and meaning only within particular cultural and historical contexts. The supposedly 'universal' categories always turn out to serve the specific cultural and curatorial enterprise of those who put them forward.

As we have seen, for many theorists and critics who refused to relinquish what they saw as the advances of the 1960s, the subsequent return to painting represented a deliberate suppression of art's own history. The revival of 'expressionist' modes of representation in Italy and Germany was seen as especially problematic. In an article published in 1981, the same year as the 'New Spirit in Painting' exhibition, the critic and theorist Benjamin Buchloh criticised artists who 'operate under the naïve assumption that gestural delineation, high-contrast colour, and heavy impasto are immediate (unmediated, noncoded) representations of the artist's desire', reminding his readers that the rhetoric of expressionist art was a highly formalised language like any other.[10] Similar claims were put forward by Hal Foster, who maintained that Neo-expressionism 'presents expressionism not as a historically specific movement but as a natural, essential category – a style with a specific purchase on the human condition and a natural (i.e. mythical) relation to German culture'.[11] Both critics argued that the history of painting could not be regarded simply as a repository of styles that remained unproblematically available for use by contemporary artists. Once wrested from their original historical context, the innovative formal developments of Expressionist painting ceased to be authentic, and functioned rather as 'quotations' or 'references' of authenticity within a new pictorial framework. Irrespective of the sincerity of the individual artist, the employment of such procedures could result only in a pastiche of previous forms of painting.[12]

As a number of contemporary artists and theorists were quick to realise, however, this very criticism could be turned round and used in defence of painting. In a cultural climate that was increasingly suspicious both of grand historical narratives and of claims to authenticity, contemporary painting was celebrated for its self-conscious eclecticism and for its appropriation of past styles. This more 'knowing', second-order defence of painting conceived the end of modernism as initiating a new period of artistic freedom in which artists could draw on a plurality of methods and techniques without any correspondent claim to unmediated self-expression. Representative here is the work of the American artist David Salle, who explicitly refused to develop a 'signature style' – except in so far as this itself became his signature style – by employing a variety of different techniques and painterly 'vocabularies' within the compass of a single painting (Plate 3.4). Salle combined images taken from comic books, art history and commercial pornography with seeming indifference, overlaying or abutting different images and styles. Although his work has been interpreted as a challenge to the sustaining myth of the artist as genius and as a postmodern celebration of the unassailable equality of styles and approaches, it has also been criticised for its breezy cynicism and calculated effects. By the 1990s, the art market boom that had projected such work to the centre of critical attention had gone bust, leading critics to wonder just what all the fuss had been about. A retrospective of Salle's work held at the Stedelijk Museum in Amsterdam in 1999 provided an opportunity for critics to reflect upon the meteoric rise and fall of figurative painting, which, just a decade later, had once again entered into rapid decline.[13]

PLATE **3.4** David Salle, *We'll Shake the Bag*, 1980, acrylic on canvas, 122 × 183 cm. (Courtesy Gagosian Gallery. © David Salle/VAGA, New York/DACS, London 2004.)

In an influential essay entitled 'The End of Painting', first published in the journal *October* in 1981, Douglas Crimp argued that:

> The rhetoric that accompanies [the] resurrection of painting is almost entirely reactionary: it reacts specifically against all those art practices of the 1960s and 1970s that abandoned painting and worked to reveal the ideological supports of painting, as well as the ideology that painting, in turn, supports.[14]

For Crimp, the only way in which painting could legitimately be sustained as an artistic practice was by participating in and extending the institutional critique that had animated the radical art movements of the preceding decades. In his view, this was achieved in an exemplary way by the French artist Daniel Buren, whose activity as a painter was informed by the strategies of Conceptual Art. From the late 1960s onwards, Buren restricted his artistic output to works consisting of 8.7-cm wide alternating stripes of white and colour. This instantly recognisable, but unchanging, formal motif was employed not only in museum and gallery spaces, but also on the outside of buildings and in the streets on billboards, flagpoles and even on sandwich boards. By stripping away all remnants of aesthetic and visual interest, Buren sought to redirect the spectator's attention back to the conditions of exhibition and to the particular circumstances under which works of art are circulated and displayed. As Buren declared, 'The ambition of this work is quite different. It aims at nothing less than abolishing the code that has until now made art what it is, in its production and in its institutions.'[15]

It is arguable, however, that in the course of time the very invariability of Buren's output has led to a progressive dimunition of its critical potential. His trademark stripes are now a thoroughly domesticated and familiar presence in the contemporary artworld, equally at home in international art fairs as in the courtyard of the Palais Royale in Paris, where his commissioned 'intervention' fulfils an essentially spectacular function (Plate 3.5).[16] Buren's negation of the established 'code' of painting and the insouciant eclecticism of 'postmodern' painters such as Salle and Schnabel can both be seen as variants on an endgame in which the exhaustion of painting is taken through its final steps. On the one hand, painting is reduced to the mere repetition of empty conventions; on the other, its history is treated as effectively over, creating a situation in which anything is possible but nothing really matters. Despite the seeming inevitability of these two very different but closely related responses, we should be wary of chiliastic pronouncements that promise to usher in, if not actually to bring about, the 'end of painting' as a historical enterprise. There remains a third possibility, one that is, perhaps, less insistent in its claims for contemporaneity, but which may well offer a more promising means of addressing the specific historical circumstances of painting in the closing decades of the twentieth century. This possibility consists in continuing to work with the limited means of painting in full cognisance of the challenges with which it is confronted, while yet maintaining a dogged belief in its critical and emancipatory potential.

PLATE **3.5** Daniel Buren, *The Two Plateaux*, Palais Royale, Paris, 1986. (Photo: Robert Holmes/Corbis. © ADAGP, Paris and DACS, London, 2004.)

In what follows, I shall consider this third approach by looking at the work of the German artist Gerhard Richter, who has persisted with the 'daily practice of painting' for more than forty years. Richter has made the problem of how to continue painting central to his work as an artist, producing a body of work that incorporates a critical and reflexive understanding of the history of painting alongside a close engagement with the forms and structures of the modern, mediatised world. Throughout his career, he has commented on and analysed his work in a series of notes and interviews. As with all artists' statements, these need to be approached with due caution: they contain much that is contradictory, misleading and polemical alongside genuine insights into his ideas and working practices. However, Richter's interpretation of the role and significance of painting has undoubtedly contributed to the large critical discourse that has grown up around his work and the one needs to be approached in and through the other.

I do not want to present Richter as a unique or isolated case. Other artists have sought to confront similar challenges and have arrived at different and equally interesting solutions. Examples include Richter's friend and colleague Sigmar Polke and the English group Art & Language, whose work is discussed in detail in Chapter 2. What makes Richter's work of particular interest to us here is that his way out of the decline of modernism and the apparent impasse of painting in the 1960s was to turn to photography and to confront directly the efficacy of the photographic image as a means of representing the external world. It thus allows us to reconsider in a different context the two central challenges to painting that I discussed in the first part of this chapter: the ubiquity of the photographic image and the breakdown of modernism as a sustaining paradigm.

Gerhard Richter and the daily practice of painting

One has to believe in what one is doing, one has to commit oneself inwardly, in order to do painting. Once obsessed, one ultimately carries it to the point of believing that one might change human beings through painting. But if one lacks this passionate commitment, there is nothing left to do. Then it is best to leave it alone. For basically painting is total idiocy.[17]

This much-quoted remark was recorded by Richter in his notebook in 1973. Although assertoric in form, it expresses something akin to a hope – the hope that the limited and insufficient means of painting may yet suffice to make a difference in the world. Richter allows himself this optimism of the will only by holding fast to its stoic corollary – pessimism of the mind. Painting is at once 'intrinsically capable of giving form to our best, most human, most humane qualities' and 'total idiocy'.[18] The conjunction of these two contradictory claims marks the space that Richter has sought to occupy throughout his career. Without abandoning the critical and utopian aspirations of the historical avant-garde, he is nonetheless much more sanguine about

the possibility – and even the desirability – of their effective realisation. His project is as much about resisting false affirmation and illusory promises as it is an attempt to sustain the potential that still resides in the practice of painting. His solution has been to maintain a critical approach to his own work, recognising its inadequacy as a vehicle for social change, while holding on to the recognition that painting, as a picturing of the world that never simply mirrors the world, continues to hold out the possibility that things might be different.

Much has been made of the unusual circumstances of Richter's upbringing and his exposure to two different traditions of art in divided Germany. He was born in Dresden in 1932, spending his childhood under the Third Reich and then Soviet Occupation. He remained in the East after the partition of Germany and in 1949 he became a citizen of the newly founded German Democratic Republic (GDR). His earliest art-related job was for a state-owned concern making political banners. In 1952, he was admitted to the Dresden Art Academy where he received a thorough formal training but only selective access to artistic developments in the West. In the final year of his studies he received a commission to paint a mural in the German Hygiene Museum in Dresden – surviving photographs show it to have been firmly in the tradition of Socialist Realism – and he began to work as a public artist. According to Richter's own testimony, it was the opportunity to view the work of the postwar avant-garde at the second 'Documenta' exhibition in Kassel in 1959 that led to his flight to the Federal Republic of Germany (FRG) in 1961, just months before the erection of the Berlin Wall. After his arrival in the West, Richter remained highly critical of the 'criminal' regime in the GDR, rejecting the intrusion of state ideology into art. At the same time, however, his experiences in the GDR allowed him to maintain a critical distance from the situation in the FRG with its corresponding ideology of artistic 'freedom' and the complacent assumption that the mere fact of opposition to official culture could act as a guarantee of aesthetic quality and market success.

As a comparatively mature student, Richter took up his studies once again in 1961 at the Art Academy in Düsseldorf, one of the principal centres of experimental art in the FRG. Here he was confronted by two contrasting and seemingly irreconcilable tendencies. His teacher, Karl Otto Götz, was a leading exponent of *art informel*, a European variant of gestural abstraction that had been given prominent coverage at the recent 'Documenta' exhibition. Advocates of *art informel* sought to sustain the high value placed on abstract painting while promoting an integrated vision of the continued progress of art, which they saw as disrupted but not broken by Fascism and the Second World War. At the same time, Richter was also exposed to the emergent neo-Dada and Fluxus movements, which sought to undermine the very idea of the autonomous artwork through performances and 'happenings'. In February 1963, Fluxus was brought inside the gates of the Düsseldorf Academy by Joseph Beuys, who, together with George Maciunas, organised an anarchic two-day 'Festum Fluxorum Fluxus' at which Maciunas delivered the group's 'manifesto'.[19] It was through the activities of this 'neo-avant-garde' that Richter was first made aware of the practices of the historical avant-garde, including Duchamp and German Dada.

Although Richter found the iconoclasm of Fluxus liberating, it ultimately prompted him to look for new ways of painting rather than to abandon painting altogether. The task that confronted him was to find a way of working that could avoid both the subjectivism of *art informel* and the anti-art activism of Fluxus. In part, this involved looking beyond the current situation in Germany and the assimilation of new developments in the USA, where artists such as Robert Rauschenberg, Roy Lichtenstein and Andy Warhol had begun to incorporate the imagery and resources of the mass media into the construction of their work. In October 1963, Richter organised an exhibition together with his fellow student Konrad Lueg in a furniture store in Düsseldorf. The exhibition, which involved the two artists posing as living sculptures on furniture that was raised off the ground on plinths, was entitled 'Living with Pop – A Demonstration for Capitalist Realism' (Plate 3.6). The idea of 'Capitalist Realism' offered a witty inversion of 'Socialist Realism', while also suggesting an equally distanced and critical approach to the consumerism of western culture and the triumphal celebration of West Germany's postwar 'economic miracle'.

Among the exhibits included in 'Living with Pop' was a painting entitled *Stag* (Plate 3.7), one of the first pieces in which Richter painted not directly from nature but from a photograph. Enveloped in a schematic network of trunks and branches, the stag is isolated from the surrounding forest through being rendered in the black-and-white tones of a photographic image. Richter heightens this photograph-like quality by imitating the effect of imprecision or 'blurring' that is created by insufficient depth of field.[20] As a consequence, the spectator can no longer securely locate the object in relation to the picture plane and instead of being given a stable image we are required to exert ourselves to fix what we see. The result is a sudden but fleeting emergence of the real within the strained and artificial conventions of late twentieth-century painting. In the early 1960s, one would have thought that it was impossible for an ambitious artist to paint such a popular and indisputably 'German' subject as a stag in a forest. Yet the detour through photography lifts the subject free from the realm of kitsch and gives a startling immediacy.

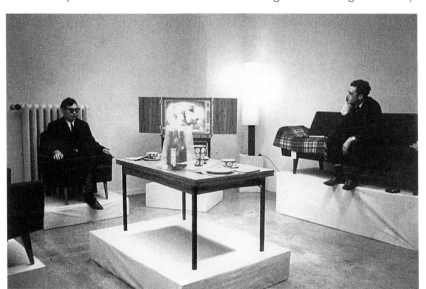

PLATE **3.6**
Konrad Lueg and Gerhard Richter, *Living with Pop – A Demonstration for Capitalist Realism*, Berges furniture store, Düsseldorf, 1963, photograph. (Photo: Reiner Ruthenbeck. © DACS, London 2004.)

PLATE **3.7** Gerhard Richter, *Stag*, 1963, oil on canvas, 150 × 200 cm. (Private collection.)

It is as if the resource of photography, which is always at one step removed from reality, allowed Richter to approach reality once again. In an interview given in 1972, he described the sense of liberation that accompanied his decision to employ photographic images as the source for his work:

> I was surprised by photography, which we all use so massively every day. Suddenly, I saw it in a new way, as a picture that offered me a new view, free of all the conventional criteria I had always associated with art. It had no style, no composition, no judgement. It freed me from personal experience. That's why I wanted to have it, to show it – not to use it as a means to painting but to use painting as a means to photography.[21]

Richter's attempt to 'use painting as a means to photography' enabled him to engage with a wide diversity of subject matter, ranging from images that reflected the current obsessions of magazines and newspapers (Plate 3.8) to images of the utterly banal and everyday (Plate 3.9). It also enabled him to depict subjects drawn directly from recent German history, such as the continued presence of American military forces (Plate 3.10), or his own Uncle Rudi, proudly posing before the camera in his Nazi uniform (Plate 3.11).

PLATE **3.8** Gerhard Richter, *Woman Descending the Staircase*, 1965, oil on canvas, 201 × 130 cm. (The Art Institute of Chicago. Roy J. and Frances R. Friedman Endowment; gift of Lannan Foundation, 1997.176, reproduction.)

PLATE **3.9** Gerhard Richter, *Toilet Paper*, 1965, oil on canvas, 70 x 65 cm. (Private collection. Courtesy Massimo Martino Fine Arts and Projects, Medrisio, Switzerland.)

At the time, Richter was insistent that his choice of subjects was arbitrary. Part of the freedom of using found photographs was that he did not have to invent his subject matter any more or compose the painting in any ordinary sense. He saw himself as freed from many of the traditional demands that had been placed upon painters: problems of perspectival organisation, the achievement of coherent pictorial space and the grouping or arrangement of the subject were already resolved by the photographic source. Ironically,

PLATE **3.10** Gerhard Richter, *Phantom Interceptors*, 1964, oil on canvas, 140 × 190 cm. (Froehlich Collection, Stuttgart.)

this enabled Richter to focus on such purely 'painterly' concerns as the handling of the paint, the distribution of tonal values and the format and size of the canvas. Photo-painting not only allowed him to reintroduce figuration into his work and to depict in a 'high art' context a range of subject matter that had slipped beyond the reach of ambitious painting. It also enabled him to continue the investigation of the physical elements of painting that was central to *art informel* without descending into rhetorical pathos or relying upon suspect notions of individual self-expression.[22] Photography not only provided the subject matter, but also placed constraints on the artist's tendency to impose his or her own subjective viewpoint. Richter claimed that he valued photography for the way in which it 'keeps you from stylising, from seeing "falsely", from giving an overly personal interpretation to the subject'.[23] It is for this reason, too, that he prefers to use press and amateur photographs (including his own) as a basis for this work rather than 'art' photography with its deployment of artistic conventions and compositional effects. We need to bear in mind, however, that Richter still had to decide which photographs to use and that this involved a process of selection.

PLATE **3.11** Gerhard Richter, *Uncle Rudi*, 1965, oil on canvas, 87 × 50 cm.
(The Czech Museum of Fine Arts, Prague. Lidice Collection, GR 85.)

PLATE **3.12** Gerhard Richter, *Administrative Building*, 1964, oil on canvas, 97 × 150 cm. (Private collection.)

Look carefully at the reproduction of Richter's painting entitled *Administrative Building* (Plate 3.12). What features of the painting allow you to recognise that it was made from a photograph and how does this affect the way in which you look at it as a work of art?

The most obvious visual clue is the way the paint has been dragged horizontally, creating the impression that the 'viewer' is moving past the building at speed, as if the image were a snapshot taken from a passing car – but the high viewpoint contradicts this suggestion. (Although there is a long-standing tradition of painting in which artists have used a *sfumato* technique (from the Italian word meaning 'softened, vaporous') to eradicate outlines and to soften transitions – the work of the Italian Renaissance painter Antonio Correggio offers a good example – the dragging of the paint seems to be the result not of the imposition of a particular painterly style but of an attempt to reproduce an effect that we know and recognise from photographic images.) Equally significant, of course, is the reduction of the palette to a range of greys and black. Again, there is an art-historical precedent for this in the technique of *grisaille*, a form of painting in grey monochrome. However, the intention here is clearly to capture the *look* of a black-and-white photograph. Once we have made the connection to photography, we can identify many of the characteristic features of a hastily taken snapshot. These include the arbitrary cropping of the parked cars, the out-of-focus tree that partially blocks the foreground, and the adoption of a viewpoint that cannot take in the subject in its entirety. While all of these features are visible from a reproduction, it is important to be aware that we are looking at a photographic illustration of a painting that is itself based on a photograph, thereby turning

the loop full circle. The reduction in size and the elimination of the actual texture and application of the paint diminishes the impact of the work, much of whose power derives from the contrast between its physical presence as a painting and our awareness of the smaller format and smooth surface of its photographic source. Whereas no illustration is ever adequate to the original, these differences serve as a reminder that even in the age of mechanical reproducibility a painting remains a singular entity whose salient properties cannot be captured exhaustively in photographic plates. For all his reliance on photography, Richter is still engaged in the task of painting. ■

The constitutive tension between the subject of the painting and the painted surface that I discussed in the opening section of this chapter is given a further level of complexity in a work such as this because the source of the painting is itself a depiction. When Richter makes a photo-painting, he not only paints a person, a house, a car, or whatever, but also the photograph or section of the newspaper from which the image is taken. *Administrative Building* is both a painting of a building and a painting of a photograph. By keeping this double-register open, Richter gives heightened prominence to the artefactual or illusory character of painting: the photo-paintings do not offer a window onto the world, but rather a strategic intervention in the mass-circulation of images. In his notes and interviews, Richter has repeatedly insisted on the superiority of photography over painting as a means of representing reality and its success in altering our ways of thinking and seeing. He maintains that the speed and reliability of photography – indeed, its very 'objectivity' as a conveyer of information – has progressively undermined the persuasiveness of painting: 'Photographs were regarded as true, paintings as artificial. The painted picture was no longer credible; its representation froze into immobility, because it was not authentic but invented.'[24] Richter's photo-paintings can be seen as a way of addressing head-on this crisis in painting. By making a painting of a photograph rather than inventing his subject, he sought to overcome the artificiality of painting and to get 'reality' back into his work. At the same time, however, the size and scale of a photo-painting, together with the viewer's awareness of the labour that must have gone into producing it in comparison to the snapshot on which it is based, invite the viewer to contemplate the image in a way that is rarely afforded to non-art photographs. The subjects that Richter chooses to paint are lifted out of the flood of images and accorded a different status. Rather than simply endorsing the triumph of photography over painting, Richter's photo-paintings open up a space for critical reflection that allows us to see photographs as themselves constructs or representations whose putative claim to truth can itself be subject to critical scrutiny.

Sigmar Polke's raster paintings

We can illuminate this feature of Richter's work by considering the so-called *Rasterbilder* or 'raster paintings' that were produced at roughly the same time by his fellow student at the Düsseldorf Art Academy, Sigmar Polke. Like Richter, Polke immigrated to the FRG from the eastern bloc – his family left Polish Silesia in 1953 when he was twelve years old – and he retained a

PLATE **3.13** Sigmar Polke, *Goethe's Works*, 1963, oil and lacquer on canvas, 31 × 51 cm. (Brandhorst Collection, Cologne. © Sigmar Polke.)

similarly distanced and ironic attitude to western consumerist culture. Together with Richter and Lueg, he was one of the co-founders of 'Capitalist Realism' in 1963. His work from this period subtly satirises the complacency and materialism of the German middle classes while simultaneously exploring the artificiality of painting and its relation to the pervasive presence of advertising and media images in postwar Germany. *Goethe's Works* (Plate 3.13) of 1963, for example, plays with the characteristic tension between surface and illusory depth in a painting, but also suggests the reduction of high culture to a mere 'veneer' or surface decoration. Polke was fascinated by the kitsch elements of German culture: his paintings of the 1960s are filled with palm trees, flamingos and strings of sausages. With his series of raster paintings (Plates 3.14 and 3.15), he turned his attention to modern mechanisms of reproduction and the techniques employed for the mass distribution of images. 'Raster' is a technical term used to describe the screen or grid that provides the basis for images on a television set or on a printing plate. However, its scope is wider in German than in English, extending to cover almost any representational framework. In commercial printing, the rastering process involves dividing the tones of the original photograph into individual 'benday' dots that reconverge into a coherent image when seen from an appropriate distance. Before the advent of digital technology, this was the only available means of autotype reproduction. The dots were most conspicuous in photographs in newspapers, which used a coarser grid size. Already in 1927, the German cultural theorist Siegfried Kracauer had noted the paradoxical and elusive quality of such reproductions:

PLATE **3.14** Sigmar Polke, *Girlfriends*, 1965, dispersion on canvas, 150 × 190 cm. (Froehlich Collection, Stuttgart. © Sigmar Polke.)

> This is what the film diva looks like. She is twenty-four years old, featured on the cover of an illustrated magazine, standing in front of the Excelsior Hotel on the Lido … If one were to look through a magnifying glass, one could make out the grain, the millions of little dots that constitute the diva, the waves, and the hotel. The picture, however, refers not to the dot matrix but to the living diva on the Lido.[25]

The closer we approach the image, the less we see, until finally the visible image breaks down into a series of dots on a grid. In his raster paintings, Polke massively accentuates this feature, allowing the dots to take on a life of their own independent of their representational function. The dots are made insistently present, as if looked at through a magnifying glass; we can no longer see the image without being aware of its constitutive elements. At the same time, the dots fulfil a decorative or ornamental role, forming abstract patterns or designs that tie Polke's paintings back to the concerns of *art informel*. Although the eroticised imagery invites us to approach the paintings more closely, the result is not any increase in detail, but the dissolution of the image into abstract patterns and shapes. The 'availability' of the depicted figures is revealed as an illusion, together with the purported gratification that such images offer: we are 'perpetually cheated' of what is 'perpetually

PLATE **3.15**
Sigmar Polke,
Bunnies, 1966,
acrylic on canvas,
150 × 100 cm.
(Hirshhorn Museum
and Sculpture Garden,
Smithsonian Institution,
Joseph H. Hirschhorn
Bequest and Purchase
Funds, 1992. Photo:
Lee Stalsworth.
© Sigmar Polke.)

promised'.[26] The viewer's attention continually oscillates between the legible subject and the intrusive presence of the means of representation.

One of the ways in which Polke draws our attention to the dots out of which raster images are made is by introducing irregularities and distortions that disrupt the smooth, technical perfection of the original. He also allows the colours to slip away from their moorings, creating random effects or strange dislocations such as the floating lips of the bunny girls. The image appears to dissolve before our eyes, but we are unable to make it fully cohere once again. The function of the original media image as a vehicle for social communication is effectively blocked, drawing our attention instead to

the very means or processes through which it has been constructed. Although Polke's raster paintings *refer* to techniques of mass reproduction, they are themselves individual paintings produced through the laborious application of acrylic or dispersion to canvas. This constitutes an important difference from the silk-screen prints that Warhol was producing in the USA at this time. The different working practices of Richter and Polke, on the one hand, and of Warhol, on the other, invite comparison. Whereas Warhol employed commercial reproduction techniques to investigate the iconography of celebrity and consumerism, Richter and Polke forsook the mechanical transfer of images to canvas in favour of a continued preoccupation with the physical practice of painting. To this extent, their work is closer to that of Lichtenstein, whose meticulously painted canvases imitate modern techniques of reproduction in order to question the distinction between 'high' and 'low' art. However, whereas Lichtenstein either parodies or rejects painting's traditional reliance on gesture and expression by effectively neutralising the significance of the individual brushstroke, Richter and Polke mobilise these resources in an ongoing dialogue with painting's own history. To look at their work is to be made aware of the *difference* between painting and photography even as the two are brought into dialogue with one another.

Photography as readymade

In an important essay, first published in 1977, Buchloh suggested that Richter's photo-paintings of the 1960s and 1970s could be interpreted as an extended engagement with Duchamp's conception of the 'readymade'. The snapshots and media images that Richter used as the basis of his work possess the status of something mass-produced and non-unique: in modern society such images circulate as a 'given' component of everyday reality. As paintings *of* photographs, Richter's photo-paintings bring about the same transition from utilitarian object to artwork that Duchamp achieved with found objects such as combs and urinals. Once a photograph has been painted, we can no longer look at it simply for its informational content but are obliged to approach it through the category of 'art' with all the complex assumptions that this entails. Support for Buchloh's argument can be found in works such as Richter's *Ema (Nude on a Staircase)* (Plate 3.16), with its reference back to Duchamp's last 'perceptual painting', *Nude Descending a Staircase* (1912), and in Richter's own acknowledgement that 'Everything since Duchamp has been a readymade, even when hand-painted.'[27] As Buchloh points out, however, Richter's employment of the concept of the readymade also involves a *critique* of its historical reception and the way in which it had degenerated into a 'reified idealist conception' in contemporary artistic practice. The appropriation of mass-produced objects by artists in the 1960s and 1970s could no longer sustain the same critical impetus that had animated Duchamp's work 50 years earlier. Although Richter's photo-paintings engage with the idea of the readymade, they do not simply *present* found photographs as works of art. Rather, each of the three components – the concept of the readymade, the iconography of photography, and the practice of painting – are drawn together in a complex whole whose internal relations remain in a state of productive tension that is never fully resolved.[28]

PLATE **3.16** Gerhard Richter, *Ema* (*Nude on a Staircase*), 1966, oil on canvas, 200 × 130 cm. (Museum Ludwig, Cologne. Photo: Rheinisches Bildarchiv, Cologne.)

Consider the following observation by Richter, made in one of his 'notes' from 1964–5. What light does it cast on his practice of painting from photographs at this time?

> A photograph is taken in order to inform. What matters to the photographer and to the viewer is the result, the legible information, the fact captured in an image. Alternatively, the photograph can be regarded as a picture, in which case the information conveyed changes radically. However, because it is very hard to turn a photograph into a picture simply by declaring it to be one, I have to make a painted copy.[29]

Richter suggests that there are two different ways in which we can look at a photograph. The first is to consider it primarily for the visual information that it provides. Given the sheer quantity of photographic images that we encounter on an everyday basis, this is by far and away the most common way of seeing photographs. However, he maintains that we can also look at a photograph 'as a picture', that is, we can consider it in terms of its formal composition and the way in which it *presents* the information it contains. Since Richter is mainly concerned with amateur and press photographs rather than with 'art' photography, these features need not necessarily be intentional. The Duchampian strategy of simply 'declaring' something to be a work of art is insufficient here: our over-familiarity with photographs prevents us from *seeing* them in the way Richter requires. His solution is to draw our attention to the presentational features of photographs by making a painted copy. The change in size, format and scale, together with our awareness of the changed means through which the image has been produced, makes certain features of the original photograph perspicuous. Our attention is directed away from the presentational content, the 'fact captured in an image', and toward the material presentation of the image itself. In contrast to Duchamp, who abandoned the merely 'retinal' preoccupations of painting in favour of the artistic strategy of the readymade, Richter relies on the distinctive presence of painting – inseparable here from its status as a singular and non-substitutable entity that has been laboriously made by hand – in order to make us look in a new way at his photographic source. Both strategies bring about a 'transfiguration of the commonplace',[30] but in Richter's case this is achieved through re-engaging rather than abandoning the possibilities of painting. ∎

In the essay I cited above, Buchloh argues that since photography

> is always presented as the most empirical of all the media, it is difficult to preserve a critical distance with regard to the camera ... Photography not only gives presence to what already exists, but, by its participation in the past, confers upon it an additional degree of authenticity. It thereby serves to justify and preserve the status quo.[31]

On Buchloh's view, it is just this capacity to 'justify and preserve the status quo' that is put into question by Richter's photo-paintings. Unlike a snapshot or press photograph, which, prior to the advent of digital photography, offered a photo-mechanical record of visual appearances at a particular moment in time, the production of a painting is a gradual and deliberative activity. To approach photography through painting is thus to see both painting and

photography in a different way. Richter's photo-paintings invite us to reflect upon the adequacy of both forms of representation in relation to the experience that they seek to capture, implicating the viewer in the very process of constructing meaning and coherence from the resulting image. As the philosopher Peter Osborne has put it:

> Photo-painting acts to add a moment of cognitive self-reflection, of historical and representational self-consciousness, to the experience of the photographic image. It creates a space and a time for reflection upon that image which is qualitatively different from that of the photograph itself, haunted as such experience is by the trace of the object.[32]

I shall return to these issues once again at the end of this chapter in relation to Richter's last major series of photo-paintings, entitled *October 18, 1977* (Plates 3.25–3.30). Painted in 1988, eleven years after the events they depict, these paintings document the events surrounding the deaths of members of Germany's Red Army Faction in Stammheim prison near Stuttgart. They are explicitly concerned with problems of historical memory and the representation of the past, and create a new interpretative context within which to view the photo-paintings of the 1960s and 1970s. First, however, I want to consider the subsequent development of Richter's work and the sheer diversity of types of painting that he has pursued, often alongside one another, ranging from large-scale abstraction to portraiture and landscape. As we shall see, the photo-paintings represent only one facet of his output, and, for certain periods at least, he was pursuing figurative work at the same time as producing abstract paintings.

A not inconsiderable list

In 1962, Richter began to keep a regularly updated 'worklist' in which he recorded his output in chronological order. By the early 1990s, the list already included over 700 items, encompassing photo-paintings, townscapes, landscapes, portraits, cloud paintings, still-lifes, monochromes, colour charts and abstract paintings. Despite occasional forays into other types of artwork, including three-dimensional objects and sculptural installations, the diversity of Richter's output is, on the whole, a diversity internal to painting. Even his early installation piece, *Four Panes of Glass* (Plate 3.17), of 1967, can be interpreted as a sort of 'negative' demonstration of the significance of painting. As Richter has observed, the original motivation for the piece arose from his ongoing dialogue with the legacy of Duchamp. His explicit point of reference is *The Large Glass* (1915–23), a work through which Duchamp sought to explore the consequences of his decision to 'abandon' painting. Richter maintains that the strict simplicity of *Four Panes of Glass* was intended as a critique of Duchamp's 'mystery mongering'.[33] However, his explanation that when we look through the glass we 'see everything but grasp nothing' goes further than this, suggesting that the refractive medium of painting is still needed to help us to understand and to interpret the world around us.[34]

Without ever giving up on his commitment to painting, Richter has consistently described his investigation of what can still be achieved through the medium of paint in terms that are characteristically hesitant and doubting. In contrast to the postmodern celebration of the 'availability' of different styles and forms of art – an availability that is justified through the adoption of a supposedly post-historical perspective on the art of the past – Richter has made an attitude of 'continual uncertainty' into his artistic credo.[35] It is symptomatic that when colour reappeared in his work after the monochrome austerity of the photo-paintings, it did so in the form of the *Colour Charts*, a series of paintings in which he placed unmodulated areas of colour alongside one another in rectangular blocks without any trace of facture. The earliest *Colour Charts* date from 1966, but Richter also worked on the series in 1971 and again in 1973–4. The painting reproduced here (Plate 3.18) is from 1966 and contains 192 colours arranged in random order on a rigid grid. It is possible to see this painting as a literal working through of Duchamp's observation that once artists began to work with industrially manufactured, 'readymade' tubes of paint, they were effectively producing 'works of assemblage', or

PLATE **3.18** Gerhard Richter, *192 Colours*, 1966, gloss paint on canvas, 200 × 150 cm. (Hamburg Kunsthalle. Photo: Bridgeman Art Library, London.)

'assisted readymades'.[36] Although sometimes painted on an imposing scale, these canvases resemble nothing so much as manufacturers' catalogues for industrially produced paint. By evacuating colour of any descriptive, symbolic or expressive function, Richter deflates the claim to spiritual significance that attended the use of colour in a modernist painting tradition that extends from the work of Wassily Kandinsky through to Mark Rothko.

With the first of the *Colour Charts* in 1966, Richter also began the process of working concurrently on different types of painting that has since become such a prominent feature of his practice. In 1968, he began a series of black and white townscapes, which form another distinct sub-category of his output. The painting shown here, *Cityscape F* (Plate 3.19), is one of three versions of the same subject. Although fully legible from a sufficient viewing distance (or in reproduction), close up the surface forms an array of discrete gestural

PLATE **3.19** Gerhard Richter, *Cityscape F*, 1968, oil on canvas, 200 × 200 cm. (Deutsche Bundesbank, Frankfurt.)

brushmarks. Unlike, for example, certain Impressionist paintings in which the image appears to dissolve or break up as one approaches the canvas, Richter's townscapes present us with two different and incompatible modalities: they are made to occupy an unstable space between representation and abstraction. That same year, Richter painted four small landscapes using photographs that he had taken himself in Corsica, followed by a further series of subjects from the landscape around Düsseldorf (Plate 3.20). Not only did these paintings contravene an effective taboo on the representation of natural beauty in ambitious art, they deliberately evoked the example of nineteenth-century German Romantic landscape painting, above all the work of Caspar David Friedrich (Plate 3.21). Richter has subsequently explored the full repertoire of Romantic motifs, including sea- and cloudscapes, rainbows, icebergs, mountain ranges and pastoral views. In part, this represents a refusal to accept the co-option of the heritage of German Romanticism by the ideology of National Socialism and an attempt to sustain a more complex relation to the unfulfilled promise contained in Romantic images of nature. Richter has described his landscapes and still lifes as a form of 'yearning', arguing that 'though these pictures are motivated by the dream of classical order and a pristine world – by nostalgia, in other words – the anachronism in them takes on a subversive and contemporary quality'.[37] Like so much of Richter's work, this 'subversive and contemporary quality' depends upon our knowledge of his working practice and the balance or contrast provided by his other types of painting. It also depends on the contrast between the facture of the paintings and the flat surface of his photographic source. Richter's photo-paintings are not painted as 'landscapes' are painted: they are painted versions of flat things that introject atmosphere.

Just one year after he began working on these paintings, Richter painted the first of what was to become an extensive series of grey monochromes. When seen in isolation, the so-called *Grey Paintings* initially appear rather unprepossessing. However, they play a central role in his development as a painter. In the catalogue to a large retrospective of Richter's work held at the Museum of Modern Art, New York in 2002, Robert Storr observed that Richter had to date painted over 100 grey monochromes, constituting approximately one-tenth of his entire production (Plate 3.22).[38] Although there is a rich history of monochrome painting stretching back to the work of Aleksandr Rodchenko and Kasimir Malevich, and plentiful examples from the latter half of the twentieth century, including works by Yves Klein, Piero Manzoni, Robert Ryman and Alan Charlton among others, it seems that Richter's motivations were essentially negative and that the first monochromes were painted out of a sense of closure and exhaustion. The decision to work in grey was informed by his belief that it 'makes no statement whatsoever; it evokes neither feelings nor associations; it is really neither visible or invisible'. At the time he 'did not know what to paint, or what there might be to paint' and believed that 'so wretched a start could lead to nothing meaningful'.[39] According to Richter's own testimony, it was through working on the grey paintings rather than through any theoretical advance that he found a way out of this dilemma. Once he actually began painting monochromes, he became aware of important differences in surface, texture and scale. These subtle differences gradually turned the paintings from sheerly negative

PLATE **3.20** Gerhard Richter, *Landscape near Hubbelrath*, 1969, oil on canvas, 100 × 140 cm. (Sammlung Ludwig, Ludwig Forum für Internationale Kunst, Aachen. Photo: Anne Gold.)

PLATE **3.21** Caspar David Friedrich, *The Large Enclosure, Dresden*, c.1832, oil on canvas, 74 × 103 cm. (Galerie Neue Meister, Staatliche Kunstsammlungen, Dresden.)

PLATE **3.22**
Gerhard Richter,
Grey, 1974,
oil on canvas,
250 × 195 cm.
(© Tate, London
2003. Lent from a
private collection,
1992.)

'non-statements' to constructive meditations, which he believed could achieve their own sense of rightness. No one of the monochromes is exactly like any of the others, and each possesses its own distinctive character. This is connected to the fact that they all remain illusion-bearing surfaces: that is to say, they do not just look flat.

A similar attitude of uncertainty seems to have accompanied the abstract paintings that Richter began producing in the mid-1970s (Plate 3.23). Many of these paintings began with a recognisable image, often taken from a photographic source, which Richter then covered over with subsequent layers of paint so that no part of the original image remained visible in the finished canvas. These works, which now constitute by far and away the largest part of his output, were initially subject to a great deal of criticism. The framework that theorists and critics had developed in order to interpret the photo-paintings of the 1960s and 1970s no longer seemed viable in relation to his abstract work, and he refused to countenance the claim that these uningratiating paintings were

intended merely as demonstrations of the impossibility of abstraction. In an exchange with Buchloh, Richter insisted on using the word 'insufficiency' in place of Buchloh's 'bankruptcy' to describe the fate of both abstraction and realism as models for contemporary art practice.[40] The difference is significant, for whereas bankruptcy suggests an irretrievable breakdown, the recognition of insufficiency leaves open the possibility of continuing with necessarily inadequate means in the hope that this may yet allow something to be achieved that is not merely cynical and retrospective.

Richter's protestations notwithstanding, the acidic colours and unsettling contrasts employed in his abstract paintings of the early 1980s (Plate 3.24)

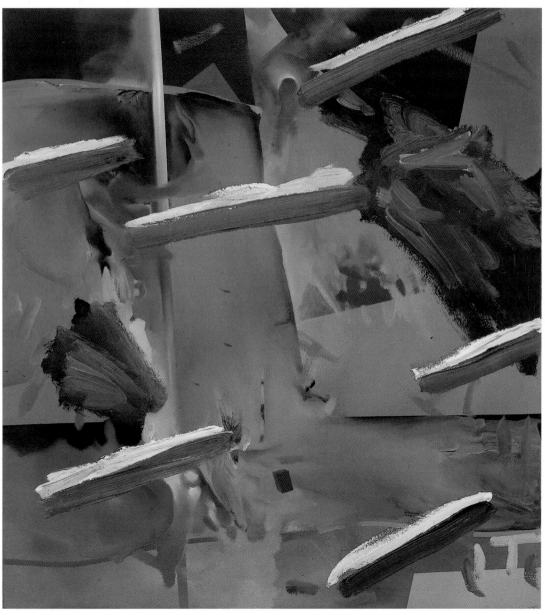

PLATE **3.23** Gerhard Richter, *Abstract Painting*, 1976, oil on canvas, 65 × 60 cm. (Barbara Mathes Gallery, New York.)

seem to carry little conviction, and it is easy to see why critics believed that he was simply rehearsing the repertoire of gestural abstraction without any belief in its capacity to communicate. The emergence of Neo-expressionism provided a convenient framework for interpreting his work, which was widely seen as a knowing play with expressive modes of representation. Both Richter and Polke were included in the 'New Spirit in Painting' exhibition, and few

PLATE **3.24** Gerhard Richter, *Abstract Picture*, 1984, oil on canvas, 200 × 160 cm. (Photo: Christies Images/Corbis.)

critics were able to distinguish the features of their work from that of their younger contemporaries.[41] Richter, however, has always insisted on the sincerity of his commitment to abstraction, and he has vigorously denied the claim that he is simply 'making the spectacle of painting visible in its rhetoric, without practising it'.[42] By the late 1980s, he began to employ many of the techniques with which he had experimented in the earlier abstracts, including the dragging of paint and the use of multiple layers that both obscure and reveal what is hidden below, in larger and more ambitious works. He developed a working method that involved obliterative overpainting and the deliberate cultivation of chance effects, characterising his work as a series of 'interventions', including both the addition and the removal of paint from the surface of the canvas.

Perception, memory and the representation of history

In 1988, after a hiatus of more than a decade, Richter returned once again to monochrome photo-painting with a series of fifteen paintings collectively titled *October 18, 1977*. The series title marks the date on which two members of the terrorist Red Army Faction, Andreas Baader and Gudrun Ensslin, were found dead in their cells at a purpose-built high security prison at Stammheim. A third member of the group, Jan-Carl Raspe, was badly wounded, and died soon afterwards in prison. Only the fourth, Irmgard Möller, who had suffered a stab wound, survived. Ensslin was found hanged; Baader and Raspe had been shot in the head. There is still uncertainty as to whether the prisoners decided on collective suicide or whether they were murdered by the German security forces. A year earlier, Ulrike Meinhof, another member of the group, had been found hanged in her cell, and in 1974 Holger Meins had died of starvation in a hunger strike held in protest at their conditions of imprisonment. Richter's series of paintings is based on contemporary photographs, press cuttings and television footage. In austere black and white, and with varying degrees of visibility, the paintings present a series of images relating to the terrorists' arrest, imprisonment and death.

The first painting in the series is a portrait of the young Meinhof based on a publicity photograph taken in 1970 (Plate 3.25). This is followed by two paintings of the arrest of Baader, Meins and Raspe in 1972, whose source is a German television news video in which Meins is shown being made to strip while an armoured car trains its gun on him (Plate 3.26). (Richter described the subject of these two paintings as 'the arrest of Meins, forced to surrender to the clenched power of the state'.[43]) Three paintings show Ensslin on her way to an identification parade shortly after her arrest; a fourth depicts her hanged body in its cell. One painting depicts Baader's cell, with its large bookcase (Plate 3.27), and another the record player in which he is said to have hidden the gun with which he was killed. There are two images of Baader after he was found shot (Plates 3.28 and 3.29), and three images of Meinhof on the floor of her cell after her body had been cut down. The

PLATE **3.25**
Gerhard Richter, *Youth Portrait*, 1988, oil on canvas, 73 x 62 cm. (The Museum of Modern Art, New York. 169.1995.a. DIGITAL IMAGE © 2003 The Museum of Modern Art, New York/Scala, Florence.)

PLATES 3.25–3.30 are all from the series *October 18, 1977*. (The Museum of Modern Art, New York. The Sidney and Harriet Janis Collection, gift of Philip Johnson, and acquired through the Lillie P. Bliss Bequest (all by exchange); Enid A. Haupt Fund; Nina and Gordon Bunshaft Bequest Fund; and gift of Emily Rauh Pulitzer.)

series concludes with a large painting of the funeral of Baader, Ensslin and Raspe (Plate 3.30), showing their coffins being carried through the middle of a large crowd. Just as the title of the series is informative only to the historically aware observer, so the title of each painting is determinedly neutral. The portrait of Meinhof, for example, is simply titled *Youth Portrait*, while the paintings of Baader's dead body are titled *Man Shot Down 1* and *Man Shot Down 2*.

As the German art historian Martin Henatsch has observed, it is probably not coincidental that these works were painted at the same time as the collapse of the socialist system in the GDR.[44] Richter himself has described the series as a 'leave-taking' on several different levels: first, directly, in so far

PLATE **3.26** Gerhard Richter, *Arrest I*, 1988, oil on canvas, 92 × 127 cm. (The Museum of Modern Art, New York. 169.1995.b. DIGITAL IMAGE © 2003 The Museum of Modern Art, New York/Scala, Florence.)

as death itself is a leave-taking; secondly, on an ideological level, it is a leave-taking from 'the illusion that unacceptable circumstances of life can be changed by this conventional expedient of violent struggle (this kind of revolutionary thought and action is futile and passé)'; and thirdly, on a personal level, it is a leave-taking from the work he began in the 1960s.[45] All of the paintings in the series are pervaded by a sense of melancholy and despair. However, these feelings should not be confused with Richter's own responses but should be seen as part of the materials with which the paintings work. The question remains as to why Richter chose to focus his attention on the extra-parliamentary opposition in Germany and its descent into violence and terror. At a time when other German artists were revisiting the catastrophe of National Socialism in a highly belated demonstration of 'coming to terms with the past' – the process of *Vergangenheitsbewältigung* having commenced in Germany some thirty years earlier[46] – Richter addressed the more recent, but also more controversial, subject of terrorist activity in the 1970s. In this context, it is important to recognise that the activities of the Baader–Meinhof group were themselves an attempt to 'come to terms with the past', and that one of their principal goals was to expose what they saw as the complicity between the newly founded FRG and the Third Reich.

PLATE **3.27** Gerhard Richter, *Cell*, 1988, oil on canvas, 201 x 140 cm. (The Museum of Modern Art, New York. DIGITAL IMAGE © 2003 The Museum of Modern Art, New York/Scala, Florence.)

PLATE **3.28** Gerhard Richter, *Man Shot Down 1*, 1988, oil on canvas, 101 × 141 cm.
(The Museum of Modern Art, New York. DIGITAL IMAGE © 2003 The
Museum of Modern Art, New York/Scala, Florence.)

PLATE **3.29** Gerhard Richter, *Man Shot Down 2*, 1988, oil on canvas, 101 × 141 cm.
(The Museum of Modern Art, New York. DIGITAL IMAGE © 2003 The
Museum of Modern Art, New York/Scala, Florence.)

PLATE **3.30** Gerhard Richter, *Funeral*, 1988, oil on canvas, 200 × 320 cm. (The Museum of Modern Art, New York. DIGITAL IMAGE © 2003 The Museum of Modern Art, New York/Scala, Florence.)

The origins of the Baader–Meinhof group are to be found in the student protest movements of the late 1960s and the development of an organised opposition to the government's arms policy and its support of the Vietnam War. Members of the group were committed to the view that despite the 'economic miracle' and the establishment of stable democratic institutions, postwar German society represented a perpetuation of the National Socialist regime, with its authoritarian power structures and its apparatus of repression. They sought to distance themselves from the 'crimes' of their parents' generation and pointed to the presence of high-ranking figures in government and industry who had been active members of the Nazi party.[47] In 1967, Ensslin insisted: 'We must organise opposition. Violence can only be answered with violence. This is the generation of Auschwitz – one cannot argue with such people.'[48] Through increasingly desperate acts of terrorism, including bomb attacks, hijacking, kidnap and murder, they sought to provoke the state to reveal its true, oppressive character. Although the group never succeeded in winning widespread public support, the massive media attention that surrounded their arrest and trial inevitably focused attention on the political and ethical motivations for their actions. Indirectly, then, for Richter to return to this highly troubled period of recent German history was also to return to its National Socialist past and to address issues of historical continuity and discontinuity.

Richter has described the paintings as 'dull, grey, mostly very blurred, diffuse. Their presence is the horror and the hard-to-bear refusal to answer, to explain, to give an opinion.'[49] Pictorially, this 'refusal to explain' is communicated through the tension between the information given in the paintings and the indistinctness of the image that prevents the viewer from ever fully bringing the subject into focus. Just as Richter's earlier photo-paintings had cast doubt on the veracity of photography and the naive assumption that the mere photo-mechanical record of visual appearances can capture the complexity of experience, so these paintings invite us to question the 'truth' of the photographic records and their circulation through the mass-media. It is as if the 'diffusion' of the image imposes the act of recalling, with all its hesitation and lack of certainty, between the viewer and the harsh clarity of the police photograph. Rather than being given putative access to past events, the viewer is asked to reflect upon the materials out of which representations of the past are constructed and to acknowledge the incompletion and inadequacy of all attempts at 're-presentation'.

To an even greater degree than in the earlier photo-paintings, the withdrawal of concrete information is compensated for by the animation of the painted surface, whose construction owes much to techniques that Richter had developed through working on the *Grey Paintings* and the later abstracts. Thus, for example, the vertical 'dragging' of paint in *Cell* (Plate 3.27) can be linked both to the characteristic 'blurring' of photographic images and to the long downward pull through which the paint is layered in some of his abstracts. Many of the non-representational elements of *October 18, 1977* are also to be found in a series of large abstract paintings from the following year, including *January* (Plate 3.31). The sombre colour scheme of these paintings and the dense overworking of areas of black and grey exude a comparable sense of bleak opacity. In the Baader–Meinhof paintings, however, with their insistent reference to historical reality, Richter has set himself the task of meeting the twin demands of *both* realism and abstraction. Differences in the treatment of the same image, such as the two views of Baader after he has been shot, draw attention to a simultaneous provision and withholding of information, and to the way in which the photographic sources have been reworked. The comparatively greater detail in *Man Shot Down 1* heightens its 'documentary' quality, whereas the extreme indistinctness of *Man Shot Down 2* lifts the image away from the particular, resulting in a more spectral and generalised image of death. By rendering explicit the choices out of which the paintings have been made, Richter insists upon the diversity of ways in which his chosen subject can be presented and implicates the viewer in the process of constructing meaning.

The strongly divided response that greeted the paintings when they were first exhibited in Germany in 1989 was further exacerbated in 1995 when it was announced that the entire cycle had been purchased by the Museum of Modern Art, New York. Whereas some German critics professed a concern that the paintings would be rendered 'ineffective' if viewed by a public insufficiently familiar with recent German history, Richter expressed the hope that their relocation to an 'art context' could help to prevent them from being viewed in exclusively political terms and might ultimately serve to

PLATE **3.31** Gerhard Richter, *January*, 1989, oil on canvas, diptych: left canvas 320 × 199 cm; right canvas 320 × 199 cm; overall dimensions 320 × 400 cm. (The Saint Louis Art Museum. Purchase: Funds given by Mr and Mrs James E. Schneithorst, Mrs Henry L. Freund and the Henry L. and Natalie Edison Freund Charitable Trust; Alice P. Francis, by exchange 28:1990.)

clarify their content.[50] Beyond their address to a 'historically specific public experience', the paintings offer a further challenge that can only be understood in the context of the history of modern art itself. Contrary to what has been claimed, the provocation of the series resides not in a forlorn attempt to resuscitate the genre of history painting – a claim that is belied by Richter's insistence on the non-repeatability of the series – but in his dogged refusal to accept the split between art's social function and its autonomy. As a 'leave-taking' from his own work of the 1960s and 1970s, *October 18, 1977* is, at the same time, a reaffirmation of the political and aesthetic relevance of painting. These paintings cannot, of course, offer answers to a question as complex as the role – and limits – of civil disobedience in a democratic society, but they do open up a space for critical reflection that includes our own role in interpreting the past. That Richter succeeded in doing so in and through the medium of paint suggests that a definitive leave-taking from the long and complex history of painting would be premature.

Notes

1 The phrase 'a shape of life grown old' is taken from the Preface to G.W.F. Hegel's *Philosophy of Right* (1821). The full quotation reads: 'When philosophy paints its grey in grey, then has a shape of life grown old. The owl of Minerva spreads its wings only with the falling of dusk' (Hegel, *Philosophy of Right*, p.13). Hegel's ideas in relation to art are discussed below. For a concise overview of Hegel's aesthetics, see Gaiger, 'The Aesthetics of Kant and Hegel'.

2 Michael Podro, *Depiction*, p.2.

3 'Kunst gibt nicht das Sichtbare wieder, sondern macht sichtbar', from Paul Klee, 'Schöpferische Konfession' ('Artistic Credo') of 1920, reprinted in Grohmann, *Paul Klee*, p.97.

4 Greenberg, 'Modernist Painting' (1960/5), in Harrison and Wood, *Art in Theory 1900–2000*, VIB5, pp.773–9; quote p.775.

5 See Buchloh, 'Readymade, Photography and Painting' (1977), reprinted in expanded form in *Neo-avantgarde and the Culture Industry*, pp.365–403; quote pp.389–90.

6 The curators of the Royal Academy exhibition were Christos M. Joachimides, Norman Rosenthal and Nicholas Serota. In the co-authored catalogue, they describe the exhibition as both a 'manifesto' and a 'reflection on the current state of painting'. All quotations are from the 'Preface' to the exhibition catalogue, *A New Spirit in Painting*, pp.11–13. Another large exhibition of contemporary painting was held a year later in Berlin under the title 'Zeitgeist' ('Spirit of the Age').

7 Hegel's lectures on aesthetics were delivered in Berlin between 1818 and his death in 1831. They were published posthumously in 1835–8. Excerpts from the Introduction, from which this quotation is taken, are reprinted in Harrison, Wood and Gaiger, *Art in Theory, 1815–1900*, IA10, pp.58–74; quote p.61.

8 Joachimides, Rosenthal and Serota, *A New Spirit in Painting*, p.11.

9 *Ibid.*, p.12.

10 Buchloh, 'Figures of Authority, Ciphers of Regression', p.58.

11 Foster, 'Between Modernism and the Media', p.44.

12 The philosopher Jonathan Gilmore draws an analogy between the 'life' of a style and the 'life' of a biological species. He points out that 'once a particular species dies out, even if an animal evolved that had precisely its physical properties, the new animal would belong to a new species'. In the same way, once a style has died out, even if later artists produce work that possesses the same properties as work in the original style, it cannot be said to belong to that style. Gilmore concludes that 'A style is a historical particular, a thing that exists over a certain period of time, but not a *type* of thing of which there can be instances.' See Gilmore, *The Life of a Style*, p.105.

13 See, for example, Cameron, 'Salle Days' and Hickey, 'Signs and the Times'.

14 Crimp, 'The End of Painting', p.74.

15 Buren, *Reboundings*, cited in Crimp, 'The End of Painting', p.85. For other writings by Buren, see Harrison and Wood, *Art in Theory: 1900–2000*, VIIA12–13, pp.861–7.

16 For an assessment of the extent to which Buren's work has been co-opted into the world of artistic spectacle, see Lütticken, 'Stripes, No Stars'.

17 Richter, 'Notes 1973', in *The Daily Practice of Painting*, p.78.

18 Richter, 'Interview with Wolfgang Pehnt, 1984', in *The Daily Practice of Painting*, p.118.

19 For Maciunas's earlier Fluxus text, 'Neo-Dada in Music, Theatre, Poetry, Art' (1962), see Harrison and Wood, *Art in Theory: 1900–2000*, VIA11, pp.727–9.

20 Strictly speaking, of course, a painting cannot be said to be 'blurred' at all. This is something that Richter himself observed in an interview in 1972: 'Pictures are something different [from camera shake]; for instance, they are never blurred. What we regard as blurring is imprecision, and that means that they are different from the object represented. But, since pictures are not made for purposes of comparison with reality, they cannot be blurred or imprecise, or different (different from what?). How can, say, paint on canvas be blurred?' (Richter, 'Interview with Rolf Schön, 1972', in *The Daily Practice of Painting*, p.74.)

21 *Ibid.*, pp.72–3.

22 Richter has insisted upon the continuity of his early photo-painting with the concerns of *art informel*. In one of his notes from 1964–5, he observed: 'My work is far closer to the Informel than to any kind of "realism". The photograph has an abstraction of its own, which it is not easy to see through' (Richter, 'Notes, 1964–5', in *The Daily Practice of Painting*, p.30).

23 Interview with Irmeline Lebeer, cited in Chevrier, 'Between the Fine Arts and the Media', p.35.

24 Richter, 'Notes, 1964–5', in *The Daily Practice of Painting*, p.31.

25 Kracauer, 'Photography', p.47.

26 This phrase comes from T.W. Adorno's and Max Horkheimer's analysis of the culture industry in their book *Dialectic of Enlightenment*: 'The culture industry perpetually cheats its consumers of what it perpetually promises. The promissory note which, with its plots and staging, it draws on pleasure is endlessly prolonged; the promise, which is actually all the spectacle consists of, is illusory: all it actually confirms is that the real point will never be reached, that the diner must be satisfied with the menu' (p.139).

27 Richter, 'Notes, 1982', in *The Daily Practice of Painting*, p.101. In an interview given in 1991, Richter explained that '*Nude Descending a Staircase* rather irritated me. I thought very highly of it, but I could never accept that it had put paid, once and for all, to a certain kind of painting. So I did the opposite and painted a "conventional nude".' See 'Interview with Jonas Storsve, 1991', in *The Daily Practice of Painting*, p.25.

28 See, Buchloh, 'Readymade, Photography and Painting', in *Neo-Avantgarde and the Culture Industry*, esp. pp.370–5.

29 Richter, 'Notes, 1964–5', in *The Daily Practice of Painting*, p.31.

30 This phrase is taken from the title of a book by the American philosopher and art critic Arthur Danto, *The Transfiguration of the Commonplace*.

31 Buchloh, 'Readymade, Photography and Painting', in *Neo-Avantgarde and the Culture Industry*, p.376.

32 Osborne, 'Painting Negation', p.107.

33 See Richter, 'Interview with Jonas Storsve, 1991', in *The Daily Practice of Painting*, p.225.

34 Cited in Storr, *Gerhard Richter: Forty Years of Painting*, p.49.

35 See, for example, Richter's claim that: 'I am inconsistent, non-committal, passive; I like the indefinite, the boundless; I like continual uncertainty. Other qualities may be conducive to achievement, publicity, success; but they are all outworn – as outworn as ideologies, opinions, concepts and names for things' (Richter, 'Notes, 1966', in *The Daily Practice of Painting*, p.58).

36 Duchamp, 'Apropos of Readymades' (1961), in Sanouillet and Peterson, *The Writings of Marcel Duchamp*, pp.141–2.

37 Richter 'Notes, 1981', in *The Daily Practice of Painting*, p.98.

38 Storr, *Gerhard Richter: Forty Years of Painting*, p.56.

39 Richter, 'From a letter to Edy de Wilde, 23 February 1975', in *The Daily Practice of Painting*, p.82.

40 Richter, 'Interview with Benjamin H.D. Buchloh, 1986', in *The Daily Practice of Painting*, p.132. Excerpts from this interview are reprinted in Harrison and Wood, *Art in Theory 1900–2000*, VIIIC8, pp.1147–57.

41 Richter was represented in the exhibition by a series of four paintings based on Titian's *Annunciation*. This experiment, which he has not repeated, involved treating Titian's painting in much the same way as a photographic readymade. Each of his paintings subjects the original to a progressively freer and more 'painterly' imitation, resulting by the fourth of the series in a virtually abstract painting.

42 The phrase is Buchloh's. See Richter, 'Interview with Benjamin H.D. Buchloh, 1986', in *The Daily Practice of Painting*, p.132, and Harrison and Wood, *Art in Theory 1900–2000*, VIIIC8, p.1045.

43 Richter, 'Notes for a press conference, November–December 1988', in *The Daily Practice of Painting*, p.175.

44 See Henatsch, *18 Oktober 1977*, p.6.

45 Richter, 'Notes, 1989', in *The Daily Practice of Painting*, p.178.

46 Cf., for example, Andreas Huyssen's discussion of Anselm Kiefer's large exhibition at the Nationalgalerie in Berlin in 1991: 'When American critics praise Kiefer as the lone artist-hero who struggles against the repression of the fascist past in his own country, they simply betray ignorance of the fact that *Vergangenheitsbewältigung*, a coming to terms with the past, has been the dominant ethos in German intellectual life for the past thirty years. To accuse a predominantly left-liberal German culture of the repression of fascism is ludicrous. For German critics the issue was rather how Kiefer went about dealing with the past.' (Huyssen, 'Kiefer in Berlin', pp.85–6.)

47 The most prominent example is Hanns-Martin Schleyer, president of the Federal Association of German Employers and a trustee of Daimler-Benz, who was kidnapped by members of the Red Army Faction in 1977 in the hope of negotiating the release of the prisoners held at Stammheim and subsequently murdered. In his detailed study of *October 18,1977*, Robert Storr informs us that Schleyer 'had been head of the Nazi movement in Innsbruck' and 'was the senior SS officer in Prague responsible for subordinating Czechoslovakian industry to the German war effort'. He was also suspected of commanding an SS unit in the massacre of Czech men, women and children. See Storr, *Gerhard Richter: October 18, 1977*, p.44.

48 Cited in Henatsch, *18 Oktober 1977*, p.26.

49 Richter, 'Notes for a press conference, November–December 1988', in *The Daily Practice of Painting*, p.175.

50 See Storr, *Gerhard Richter: October 18, 1977*, pp.35–6, 39 n.

References

Adorno, T. and Horkheimer, M., *Dialectic of Enlightenment*, trans. J. Cumming, London: Verso, 1979 (first published 1944).

Buchloh, B.H.D., 'Figures of Authority, Ciphers of Regression: Notes on the Return of Representation in European Painting', *October*, no.16, 1981, pp.39–68.

Buchloh, B.H.D., *Neo-avantgarde and the Culture Industry*, Cambridge, MA and London: MIT Press, 2000.

Cameron, D., 'Salle Days', *Artforum*, vol.xxxvii, no.9, May 1999, pp.154–9.

Chevrier, J.F., 'Between the Fine Arts and the Media', in B.H.D. Buchloh, J.F. Chevrier, A. Zweite and R. Rochlitz, *Photography and Painting in the Work of Gerhard Richter: Four Essays on Atlas*, Barcelona: Consorci del Museu d'Art Contemporani de Barcelona, 2000, pp.31–60.

Crimp, D., 'The End of Painting', *October*, no.16, 1981, pp.69–86.

Danto, A., *The Transfiguration of the Commonplace*, Cambridge, MA: Harvard University Press, 1981.

Duchamp, M., 'Apropos of "Readymades"' (1961), in M. Sanouillet and E. Peterson (eds), *The Writings of Marcel Duchamp*, New York: Da Capo Press, 1989, pp.141–2.

Foster, H., 'Between Modernism and the Media', in *Recodings: Art, Spectacle, Cultural Politics*, Seattle, WA: Bay Press, 1985, pp.33–57.

Gaiger, J., 'The Aesthetics of Kant and Hegel', in P. Smith and C. Wilde (eds), *A Companion to Art Theory*, Oxford: Blackwell, 2002, pp.127–38.

Gilmore, J., *The Life of a Style: Beginnings and Endings in the Narrative History of Art*, Ithaca, NY: Cornell University Press, 2000.

Grohmann, V., *Paul Klee*, Stuttgart: W. Kohlhammer, 1954.

Harrison, C. and Wood, P. (eds), *Art in Theory 1900–2000: An Anthology of Changing Ideas*, Malden, MA and Oxford: Blackwell, 2003.

Harrison, C., Wood, P. and Gaiger, J. (eds), *Art in Theory 1815–1900: An Anthology of Changing Ideas*, Oxford: Blackwell, 1998.

Hegel, G.W.F., *Aesthetics: Lectures on Fine Art*, 2 vols, trans. T.M. Knox, Oxford: Clarendon Press, 1975 (first published 1835–8).

Hegel, G.W.F., *Philosophy of Right*, trans. T.M. Knox, Oxford: Clarendon Press, 1967 (first published 1821).

Henatsch, M., *18 Oktober 1977: Das Verwischte Bild der Geschichte*, Frankfurt am Main: Fischer, 1988.

Hickey, D., 'Signs and the Times', *Artforum*, vol.xxxvii, no.9, May 1999, pp.154–9.

Huyssen, A., 'Kiefer in Berlin', *October*, no.62, 1992, pp.85–101.

Joachimides, C.M., Rosenthal, N. and Serota, N. (eds), *A New Spirit in Painting*, exhibition catalogue, Royal Academy of Arts, London, 1981.

Kracauer, S., 'Photography', in T.Y. Levin (ed. and trans.), *The Mass Ornament. Weimar Essays*, Cambridge MA and London: MIT Press, 1995, pp.47–63 (first published 1927).

Lütticken, S., 'Stripes, No Stars', *New Left Review*, no.20, second series, March/April 2003, pp.160–6.

Osborne, P., 'Painting Negation: Gerhard Richter's Negatives', *October*, no.62, 1992, pp.103–13.

Podro, M., *Depiction*, New Haven and London: Yale University Press, 1998.

Richter, G., *The Daily Practice of Painting: Writings 1962–1993*, ed. H.-U. Obrist, trans. D. Britt, London: Thames & Hudson, 1995.

Sanouillet, M. and Peterson, E. (eds), *The Writings of Marcel Duchamp*, New York: Da Capo Press, 1989.

Storr, R., *Gerhard Richter: Forty Years of Painting*, exhibition catalogue, Museum of Modern Art, New York, 2002.

Storr, R., *Gerhard Richter: October 18, 1977*, New York: Museum of Modern Art, 2000.

CHAPTER 4

Photography out of Conceptual Art

Steve Edwards

Introduction

The presence of photography in major museums and exhibitions is now commonplace. Over the last forty years, photographic work has gradually moved from the margins of contemporary art to its centre. For example, a photographic project – Allan Sekula's *Fish Story*, which will be examined later in this chapter – was, arguably, the centrepiece of 'Documenta 11', the huge international exhibition of contemporary art held in Kassel in 2002. The current prominence of photographic work can, in part, be put down to artistic and intellectual fashion. Many young artists now produce photographs as unquestioningly as they once made abstract paintings by the metre. The development of an economic market for photographic commodities has provided one important condition for this work.[1] But I will argue here that there is also an intellectually substantive reason for this turn to photography: it was with Conceptual Art that photography came in from the cold. In paying attention to the photographic tradition that stems from Conceptual Art, I hope to cast some light on work that can seem incomprehensibly banal. This will involve looking closely at the photographic document as a form and tracking some of its historical transmutations.

Photographs in Conceptual Art

Conceptual Art took language as its primary material, but its secondary form was the photograph. Looking through catalogues of Conceptual Art, it is striking how often photographs figure in the artworks. Almost invariably, the photographs employed were 'unaesthetic' documents (Plates 4.2 and 4.3). The blandness, anonymity and everyday associations attached to photographic documents were central to their appeal. Several relatively distinct uses of photography, all based on the premise that the photographic image could be employed as an artless or style-free document, can be identified in Conceptual Art.

Most straightforwardly, photography was used as a means of recording ephemeral works that would otherwise disappear without trace. The need to create residues, for galleries, of works that took place elsewhere, or which lasted for a short time, played an important role here; photographs could be marketed in a way that proved difficult for events, propositions or earthworks. Gilbert and George, for instance, mimed along to the tune *Underneath the Arches* in 1970 wearing identical suits and with their faces painted bronze. A photograph records this 'living sculpture' (Plate 4.4).

PLATE **4.1** (facing page) Jeff Wall, detail of *Picture for Women* (Plate 4.19).

PLATE **4.2** Installation view of the exhibition 'Information', Museum of Modern Art,
New York, 2 July–20 September 1970. (DIGITAL IMAGE © 2003 The
Museum of Modern Art, New York/Scala, Florence.)

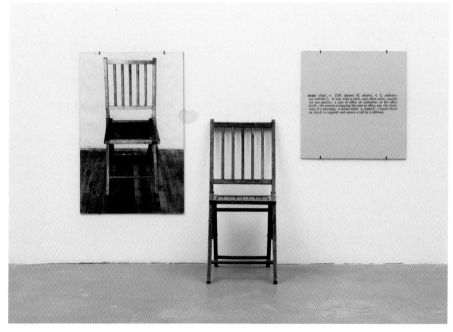

PLATE **4.3** Joseph Kosuth, *One and Three Chairs*, 1965, wooden folding chair,
photographic copy of a chair and photographic enlargement of a dictionary
definition of a chair: chair 82 × 38 × 53 cm; photograph panel 92 × 61 cm;
text panel 61 × 61 cm. (Museum of Modern Art, New York. Larry Aldrich
Foundation Fund. DIGITAL IMAGE © 2003 The Museum of Modern Art, New
York/Scala, Florence. © ARS, New York and DACS, London 2004.)

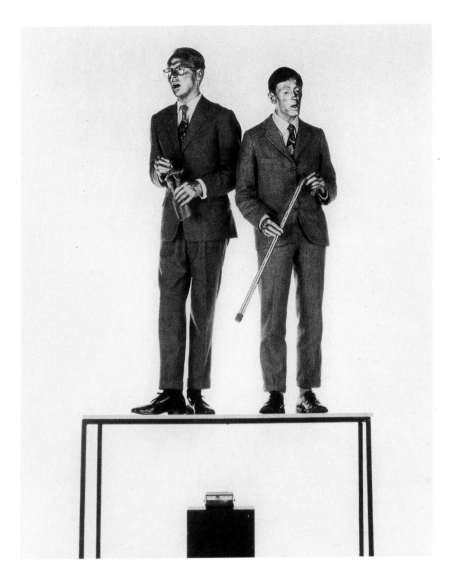

PLATE **4.4**
Gilbert and George,
The Singing Sculpture,
1970, photograph of
performance.
(Courtesy Jay Jopling,
Whitecube, London.
© The artists.)

A second use of photography can be identified with images resulting from actions explicitly staged or performed for the camera. In Bruce Nauman's *Self-portrait as a Fountain*, an action (spitting water) was undertaken in order to be photographed (Plate 4.5). It can often be quite difficult in instances like this to tell if the camera was employed to document an independent event, or if that event was staged in order to become an image. We can never be certain if the artwork is the action or the image, or both. In a variant of this second strategy, staging pictures for the camera made the recording process itself the subject of the work – often this involved a self-reflexive consideration of photography. In Dennis Oppenheim's *Reading Position for Second Degree Burn*, the artist transforms himself into a photosensitive plate (Plate 4.6). In this piece, the photograph substitutes for an event, but again its status as document was foremost. Oppenheim wrote that photographs 'were there simply to indicate a radical art that had already vanished. The photograph was necessary only as a residue for communication.'[2]

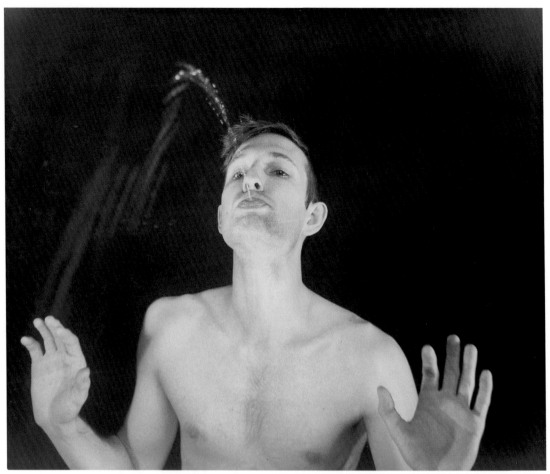

PLATE **4.5** Bruce Nauman, *Self-portrait as a Fountain*, from the series *Photograph Suite*, 1966–7/1970, chromogenic colour print, 51 × 61 cm. (Whitney Museum of American Art, New York; purchase 70.50.9. © ARS, New York and DACS, London 2004.)

In a third approach, Edward Ruscha, Dan Graham and Robert Smithson combined multiple photographs (sometimes in conjunction with extensive texts) to produce complex narratives (or anti-narratives) whose status as artworks was uncertain. These artists turned the instability of depicted object/ resultant image that is at the heart of photography into a self-conscious aesthetic project. This typology of photography in Conceptual Art is not meant to be exhaustive or exclusive – artists such as Nauman and Smithson produced photographic works in several of these categories, and often their boundaries are decidedly indistinct – but it does give some indication of the range of photographic work involved.

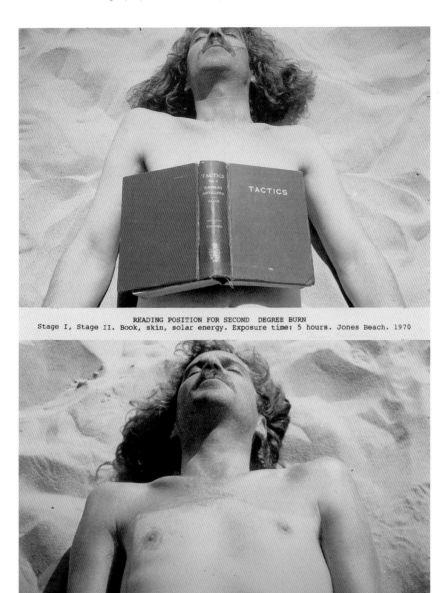

READING POSITION FOR SECOND DEGREE BURN
Stage I, Stage II. Book, skin, solar energy. Exposure time: 5 hours. Jones Beach. 1970

PLATE **4.6** Dennis Oppenheim, *Reading Position for Second Degree Burn*, 1970, Stage 1 and Stage 2, book, skin, solar energy, exposure time 5 hours, Jones Beach, New York, colour photography and collage, 216 × 152 cm. (Collection of the Irish Museum of Modern Art, Dublin, Ireland. Photo: D. Sundberg.)

Homeless documents

The artists involved with Conceptual Art were, more often than not, oblivious of the tradition of art photography; those who were aware of it set out to negate it. But Conceptual Art, no less than art photography, overwhelmingly took its mode of presentation from vernacular forms of information. While a generation of American photographers produced a photographic aesthetic out of an engagement with everyday images, artists working in the orbit of Conceptual Art stretched vernacular attention still further, often producing images resembling a motorcar manual more than they did the pictures by Walker Evans, Lee Friedlander or Garry Winogrand.[3] The most important of these works – books by Ruscha and magazine presentations by Smithson and Graham – all seem to belong to the category defined by the art critic Harold Rosenberg as 'anxious objects', by which he meant 'the kind of modern creation that is destined to endure uncertainty as to whether it is a work of art or not'.[4] These artists pursued vernacular appearance to the point of stark banality, while their interlocutors were required to work very hard in order to see any kind of aesthetic dimension in these odd publications. Graham has decided he does not want his magazine photo-essay 'Homes for America' of 1966–7 to be re-published, so I will focus on the work of Ruscha and Smithson.

Between 1963 and 1978, Ruscha made sixteen photographic books. Each one contains a series of bland images on a selected theme and text is kept to a bare minimum: a title and sometimes descriptive picture captions. The earliest of these works – *Twentysix Gasoline Stations* (1963) – consists of twenty-six black and white photographs of American petrol stations (Plate 4.7). In the later books, a few of which are in colour, the photographs are

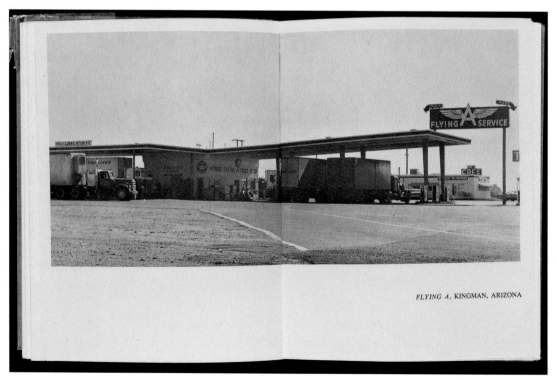

FLYING A, KINGMAN, ARIZONA

PLATE **4.7** Ed Ruscha, '*Flying A*, Kingman, Arizona', from *Twentysix Gasoline Stations*, 1963, closed size 18 × 14 × 0.6 cm. (© Tate, London 2003.)

interspersed with blank pages, and some books end with an incongruous image that does not seem to fit the series. *Various Small Fires and Milk* (1964), for instance, is made up of fifteen photographs of 'small fires' – a match, a stove burner, an ignited lighter and so on – to which a picture of a glass of milk is appended. The critics at the time were intrigued by these books, while not quite knowing what to make of them. One writer referred to them as Ruscha's 'perplexing publications'.[5] What the critics did see was that they had something to do with Marcel Duchamp. As early as 1963, Philip Leider compared Ruscha's book to the 'puns and issues raised by Duchamp's urinal'.[6] Two years later, John Coplans asked Ruscha about his relation to the readymade.[7] These writers glimpsed the correspondence between vernacular photographs and the readymade. Ruscha's vernacular photographs can be seen to present everyday objects – gas stations or fires – as artworks, but we could also see the appropriation of the everyday image itself as a readymade art object. 'My pictures are not that interesting', Ruscha claimed, 'nor the subject matter. They are simply a collection of "Facts".'[8] For him, the photography was not really important, it was just a means of presenting information. As Leider wrote, Ruscha's photographs 'are not professional – most of them are not even good'.[9] One of the pictures in *Twentysix Gasoline Stations* was taken by someone else and Ruscha claimed that he would have been happy to have obtained all his pictures from stock archives. He argued:

> Above all, the photographs I use are not 'arty' in any sense of the word. I think photography is dead as a fine art; its only place is in the commercial world, for technical or information purposes. I don't mean cinema photography, but still photography, that is, limited edition, individual, hand-processed photos. Mine are simply reproductions of photos. Thus, it is not a book to house a collection of art photographs – they are technical data like industrial photography. To me, they are nothing more than snapshots.[10]

What he wanted, he said, was a book with a 'commercial' or 'industrial' feel. Two things can be said about this vernacular mode of attention. First, as I have suggested, it is not clear if the viewer is supposed to concentrate on the photographs or the objects represented; Ruscha claimed he was interested in neither. Secondly, the books ape technical information but to no particular effect; it is not apparent what *Twentysix Gasoline Stations* is for. Looking at the book is so 'perplexing' because it involves contemplating an everyday form removed from its everyday uses.

None of this is meant to deny that Ruscha's books can be mined for references, allusions or 'content'. Indeed, an interpretive industry has developed around them. For example, the theme of the automobile and the road runs throughout Ruscha's work. In one important sense *Twentysix Gasoline Stations* represents his version of the road movie pared down and compressed to a few basic establishing shots. One commentator has noted that the last picture in the book depicts a Fina gas station, making a pun on the word *Fin* (or sometimes *Fine*), which often signalled the end of black and white films.[11] Ruscha was probably one of the very few artists working at this time familiar with art photography; he was taken with the spare imagery of signage and the iconography of the road in the books of Evans and Robert Frank.[12] His book parallels Frank's own documentation of the American road, but here vernacular style approaches its nadir. One key difference from earlier images

of the American road is that Ruscha seems barely to have left his car. At its most basic, *Twentysix Gasoline Stations* is structured around a journey across the USA from west to east, from Los Angeles to Oklahoma, and back, consuming thirteen tanks of petrol each way – one photograph for each full tank. The structure is, though, not quite so neat: as one critic pointed out, five of the pictures are out of sequence. Ruscha brought the two night shots together, for instance, and the work departs from its travelogue structure, since it ends with a picture taken in Texas. The Fina image was probably too good a joke to miss.[13] But behind all this blankness there may just be an allegory.[14] The critic Dave Hickey has gone some way to unpacking this conundrum:

> One afternoon in the late '70s I asked Ruscha about his 'Standard Stations' paintings: 'These are *standard* stations right? As in *standardized* stations?' Ruscha nodded. Then he said, 'Yeah, but they are also standard *stations*,' and a little bell went bing! Of course! Lapsed-Catholic Ruscha! *Standard stations of the cross!* Fourteen stations, minus the crucifixion. Thirteen stations from Los Angeles to the Calvary of Ed's hometown in Oklahoma – then thirteen stations back to Los Angeles, refusing that sacrifice. Perfect.[15]

What remains to be said is that this narrative is built on banality and everyday form. *Twentysix Gasoline Stations* rests on a work of massive vernacular reduction. In the process, the landscape of Hollywood and the middle-class, midwestern sensibility rooted in a booming aerospace industry and land speculation were stripped down and flattened out.[16] As Ruscha put it: 'What I was after was no-style or a non-statement with no-style.'[17] In the modernism prominent at the time, style was closely linked to an artist's individual personality. At its most debased it functioned as a kind of trademark that enabled the instant recognition that a painting was made by X rather than Y or Z. Ruscha used the ordinariness and familiarity of everyday documents in order to produce works that appeared styleless and therefore devoid of personality or individual statement. One reason his publications seemed so perplexing was that his negation of the usual norms of style meant that the works could not be explained by recourse to their maker. This 'no-style' has now, paradoxically, become one of the predominant styles for contemporary art.

Ruscha's books made a significant impact on artists working in the sphere of Conceptual Art. At the end of 1967, Robert Smithson published 'A Tour of the Monuments of Passaic, New Jersey' in the influential art magazine *Artforum* (Plate 4.8). Smithson's magazine piece consisted of black and white photographs of industrial sites from his home town of Passaic, along with a written narrative of his bus journey from New York. The text discusses his journey as well as commenting on art and art journalism, science fiction and time. The photographs, made with a simple instamatic camera, resemble pictures from a technical manual.[18] Smithson was particularly interested in entropy (the loss of energy) and decay taking place over time; his writing at this point also frequently mocked high modernist critics (particularly Michael Fried) and the art associated with them. In this work he seemed to parody much of the art then prominent – the industrial forms he photographed look like the welded metal sculpture, or even minimalist work, of the time. The identification of these ordinary industrial artefacts and installations from the American rust belt with art is made by designating these pictures 'monuments'.

nected Bergen County with Passaic County. Noon-day sunshine cinema-ized the site, turning the bridge and the river into an over-exposed *picture*. Photographing it with my Instamatic 400 was like photographing a photograph. The sun became a monstrous light-bulb that projected a detached series of "stills" through my Instamatic into my eye. When I walked on the bridge, it was as though I was walking on an enormous photograph that was made of wood and steel, and under-neath the river existed as an enormous movie film that showed nothing but a continuous blank.

The steel road that passed over the water was in part an open grating flanked by wood-en sidewalks, held up by a heavy set of beams, while above, a ramshackle network hung in the air. A rusty sign glared in the sharp atmos-phere, making it hard to read. A date flashed in the sunshine . . . 1899 . . . No . . . 1896 . . . may-be (at the bottom of the rust and glare was the name Dean & Westbrook Contractors, N.Y.). I was completely controlled by the Instamatic (or what the rationalists call a camera). The glassy air of New Jersey defined the structural parts of the monument as I took snapshot after snapshot. A barge seemed fixed to the surface of the water as it came toward the bridge, and caused the bridge-keeper to close the gates. From the banks of Pas-saic I watched the bridge rotate on a central axis in order to allow an inert rectangular shape to pass with its unknown cargo. The Passaic (West) end of the bridge rotated south, while the Rutherford (East) end of the bridge rotated north; such rota-tions suggested the limited movements of an out-moded world. "North" and "South" hung over the static river in a bi-polar manner. One could refer to this bridge as the "Monument of Dislocated Directions."

Along the Passaic River banks were many minor monuments such as concrete abutments that sup-ported the shoulders of a new highway in the process of being built. River Drive was in part bulldozed and in part intact. It was hard to tell the new highway from the old road; they were both confounded into a unitary chaos. Since it was Saturday, many machines were not working, and this caused them to resemble prehistoric crea-tures trapped in the mud, or, better, extinct ma-chines—mechanical dinosaurs stripped of their skin. On the edge of this prehistoric Machine Age were pre- and post-World War II suburban houses. The houses mirrored themselves into colorless-ness. A group of children were throwing rocks at each other near a ditch. "From now on you're not going to come to our hide-out. And I mean it!" said a little blonde girl who had been hit with a rock.

As I walked north along what was left of River Drive, I saw a monument in the middle of the river — it was a pumping derrick with a long pipe attached to it. The pipe was supported in part by a set of pontoons, while the rest of it ex-tended about three blocks along the river bank till it disappeared into the earth. One could hear

49 *The Bridge Monument Showing Wooden Sidewalks.* (Photo: Robert Smithson)

An essay published by Smithson in the following year might help to illuminate this odd work. He argued that, during the late 1950s and early 1960s, technology and industry became 'an ideology in the New York Art World'. During this period, he said, artists 'wanted to work like a "steel welder" or a "laboratory technician"'. He explicitly mentioned David Smith and Anthony Caro, whose work, he claimed, had 'led to a fetish for steel and aluminum as a medium'.[19] Smithson was not impressed by this celebration of industry in contemporary art, which he viewed as a preoccupation with 'technological miracles'.[20] Instead, he focused on rust as the primary characteristic of steel. The photographs in 'A Tour of the Monuments of Passaic, New Jersey' recast recent sculpture as decomposing forms. Smithson's response to this example of entropy was to produce what he called 'non-sites': geological deposits from locations outside the gallery transplanted into its space. 'The break up or fragmentation of matter', he said, 'makes one aware of the sub-strata of the Earth before it is overly refined by industry into sheet metal, extruded I-beams, aluminum channels, tubes, wire, pipe, cold-rolled steel, iron bars, etc.'[21] – in other words, before this matter was transformed into the materials and components of contemporary sculpture. 'A Tour of the Monuments of Passaic, New Jersey' is a non-site of printed pages, where photographs of decay and decomposition take up residence among pictures of bright metal art objects and speak of their transience and contingency.

The works we have been considering were overwhelmingly low-key presentations: Conceptual Art has much of the 'inexpert or amateurish' about it.[22] This was undoubtedly a calculated strategy, at least on the part of its more astute participants, intended to ruin high modernism's aesthetic. The 'anxious objects' considered here consciously sought a proximity to utilitarian or vernacular documents. Faced by the choice between the spectacular products of consumer culture or the worn-out expressive effects of the New York School, these artists rejected both and opted for what Jeff Wall described as a strategy of 'gaming with the anaesthetic'. Wall wrote:

> The anaesthetic found its emblem in the Readymade, the commodity in all its guises, forms, and traces. Working-class, lower-middle class, suburbanite, and underclass milieux were expertly scoured for the relevant utilitarian images, depictions, figurations, and objects that violated all the criteria of canonical modernist taste, style, and technique.[23]

Throughout the twentieth century, modern artists have repeatedly tried to renounce established competences and skills in order to escape accepted ways of doing things, finding, in the process, new energies and new forms for art. The 'low' forms that Wall mentions played a central role in this process of 'de-skilling' during the late 1960s and early 1970s. As Benjamin Buchloh notes, this project often entailed 'the programmatic effacement of camera skills'.[24] Ruscha and Smithson deliberately sought out instrumental and amateur modes of presentation as a way of escaping from what they believed had become an ossified formalist aesthetic. These artists employed the 'dull', the 'boring' and the 'insignificant' as part of a utopian project of escaping from art into some other space. The interest in the photographic document, however, incorporated a contradiction into the making of modern art. While Conceptual Art employed the visual indifference of the photograph against the modernist stress on the 'purely visual' or 'opticality', its dependence on photographic documents reinstated picture-making into contemporary art, because the photograph was simultaneously a form of raw information *and* an image.[25] The tension between these components of the photographic sign would, to a considerable extent, determine the field of photographic work thereafter.

A political turn

During the first half of the 1970s, a number of stragglers from Conceptual Art made a concerted attempt to politicise the presentation of documents. Two basic reasons can be identified behind this move. In the first place, this was a time of increased politicisation in society, identified with the upheavals of 1968 and its aftermath. Disgust at the Soviet invasion of Czechoslovakia, the Vietnam War and its international opposition, the inspiration of anti-colonial movements around the globe and widespread student unrest led to a resurgence of left-wing organisations, many of them informed by militant Maoism or Trotskyism. Alongside this growth of left-wing parties, new political projects developed: the Black Panther movement in the USA; the Women's Liberation movement; the Gay Liberation Front. Any artist not intent on 'sleeping through the deluge that threatens them' could not help but be touched by this wave of unrest.[26] Those that were awake often participated in these struggles as political subjects *and* as

artists. But the second factor stems from the internal mutation of the minimalist and conceptual artists' engagement with the framing conditions of art. Once the space of the gallery had come to be understood as a central condition for making and experiencing art, it was only a short step to widen attention to consider the gallery as an institution. The radical Art Workers' Coalition in New York, for instance, conducted a series of actions aimed at challenging the conservative presuppositions of the art establishment. As Graham put it: 'The art world stinks; it is made up of people who collectively dig the shit; now seems to be the time to get the collective shit out of the system.'[27] The Coalition called for improvements to the economic standing of artists and challenged the gendered and ethnically exclusive policies of museums.[28]

Under these conditions, some artists attempted to fill the seemingly neutral forms of Conceptual Art with politically charged subject matter. As I have suggested, a number of conceptual artists consciously used photographs to produce books or picture spreads that tested the viewer's ability to see the work as art. Politically contentious subjects or themes further strained the viewer's attention by eliciting a strong initial reaction that was likely to glide over the issue of form. Perhaps the best known of these projects is Hans Haacke's documentation of the profits made from rents on slum properties in New York. In a number of works dating from the mid-1960s, Haacke had investigated natural systems of change, working with ice and condensation. In response to the political situation, he increasingly focused on the institutions of art and social systems of wealth and power. As one critic said, the works that resulted, through their 'design austerity gain the look and "feeling" of real documents'.[29] The project in question here – *Shapolsky* et al. *Manhattan Real Estate Holdings, a Real Time System as of May 1, 1971* – consisted of 142 panels, each mounted with a black and white photograph and a typescript, and a series of charts (Plate 4.9). The

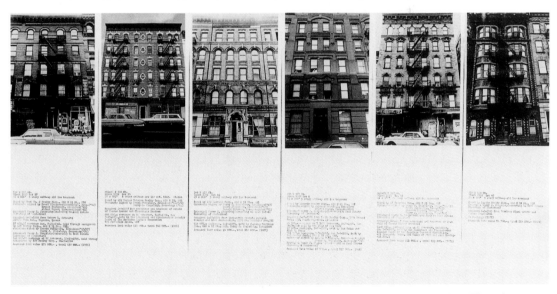

PLATE **4.9** Hans Haacke, detail of *Shapolsky* et al. *Manhattan Real Estate Holdings, a Real Time System as of May 1, 1971*, 1971, two enlarged photographs, 142 black and white photographs with typewritten data sheets, six charts and one explanatory panel: enlargements 61 × 51 cm each; photographs 25 × 46 cm each; sheets 25 × 46 cm each; charts 61 × 51 cm each; panel 61 × 51 cm. (Centre Pompidou-MNAM-CCI, Paris. © Photo: CNAC/MNAM Dist. RMN. © DACS, London 2004.)

photographs recorded, with minimal variation, rented properties in New York; the typescript sheets provided details of the buildings – ownership, previous ownership, mortgage details and assessed tax value; and the charts detailed the network of organisations that acted as smokescreens for the actual owners of the buildings. This work was scheduled to be shown in Haacke's exhibition at the Guggenheim Museum in New York, but before it opened the director of the museum, Thomas Messer, banned its display; he then fired the exhibition's curator, Edward Fry, when Fry sided with the artist and spoke out against censorship. Messer claimed that in choosing to concentrate on 'ulterior ends' Haacke contradicted 'the intrinsic nature of the work as an end in itself'. For him, Haacke's work displayed an 'aesthetic weakness' stemming from forcing art's boundaries. Messer's response indicates just how closed modernist thinking had become by this point. Work that did not focus on the 'intrinsic nature' of art was, he claimed, an 'alien substance' in the museum.[30]

Messer, working within a framework of formalist modernism, assumed that the 'content' of Haacke's project undercut its status as art. He could not see that the document was itself a form: one whose dependence on photographs tied it to 'content'. The *Shapolsky* project is an exemplary piece of information, or systems, art; dozens of these projects were exhibited at this time. The subject of a system's work was usually seen as insignificant – particular bodies of information provided the occasion for the artist to explore structure, system or series. What Haacke did was to deploy the procedures and forms of this analysis on a politically contentious subject. Pursuing the strategy of confusion sowed by artists like Ruscha and Smithson, Haacke left the interlocutor to ask 'is this a work of art or is it a display of political information?' If it is the latter, then it is strangely understated, since there is no explicit commentary or polemic in this work; it consists solely of publicly available information. Jack Burnham felt the 'elegance' of Haacke's work turned on this 'indirection'.[31] But if the exploration of an information system could count as art, then, irrespective of the *particular* subject it analysed, Haacke's project ought to have been acceptable to the art museum. By fixing on a contentious object of investigation, Haacke revealed that the modernist museum could not live by its own terms.

Unsurprisingly, the employment of documentation in Conceptual Art led a number of radicalised artists back to an exploration and critique of documentary photography. Documentary constitutes the privileged mode of the news media, but it had also always occupied an important place in the campaign work of the political Left. The faith in the ability of documentary imagery to reveal the truth of living conditions or poverty was often accepted uncritically.[32] Artists and theorists on the Left, however, began at this time to challenge the hegemony of the documentary tradition. There are two linked aspects to this criticism: on the one hand, documentary's objectivity and neutrality was challenged as an ideology, and, on the other, its depiction of victimhood was taken to be voyeuristic and dependent on an unacknowledged position of power.

While the photograph reproduces some of the features of its object, this does not mean that it can be taken for an objective copy of that object. It should be clear from your everyday experience that a framing text and context can be used to impart very different associations to the same image.

Newspapers provide an obvious example – by using anchoring headlines and captions that follow different editorial lines, the press often suggests very different readings for the same photograph. One group's mullah easily becomes cast as another's terrorist. Documentary photography, however, has traditionally been presented as a literal representation of events that can be immediately understood. At the core of this ideology is the belief that the photographer records things as they are, objectively and without bias or intervention. In its most basic form, this conception turns on obscuring the role of the apparatus in the production of meaning; the familiar instruction 'don't look at the camera' is significant in this respect. As Allan Sekula, one of the key figures in the rise of a critical account of photography during the 1970s, put it: 'the most general terms of the discourse are a kind of disclaimer, an assertion of neutrality; in short, the overall function of photographic discourse is to render itself transparent'.[33] The unwritten protocols of documentary consist of a series of negative injunctions: no colour (black and white); no cropping; no retouching; no posing, staging or introducing extraneous objects; no dramatic light effects and so on. Documentary's critics saw all this as an ideology of neutrality that allowed tendentious images to be passed off as unchallengeable truths.

This brings me to the second aspect of the Left's criticism. Documentary developed as a tool of the liberal state and reform movements at the end of the nineteenth century and has always had a tendency to point the camera 'downward, toward those with little power or prestige'.[34] The documentary image is typically intended not for the people depicted but for those in society who possess authority and influence. Consequently, society's victims are usually depicted in a manner intended to provoke pity and charity rather than solidarity or action. Sekula once called this the 'find-a-bum school of concerned photography'.[35]

I want to consider here two photographic projects that developed in relation to this critique. Martha Rosler's *The Bowery in Two Inadequate Descriptive Systems* (1974) consists of twenty-four panels – the first three contain single sheets of text and the remaining twenty-one pair photograph and text (Plate 4.10). The photographs all record sites in New York's Bowery district, an area renowned as the haunt of alcoholics and the homeless, and which Rosler noted held a 'magnetic' attraction for documentary photographers.[36]

PLATE **4.10** Martha Rosler, detail of *The Bowery in Two Inadequate Descriptive Systems*, 1974, 45 black and white photographs mounted on 24 mat-board panels, each panel 25 × 56 cm. (Courtesy Gorney Bravin + Lee, New York and the artist.)

The images are black and white and predominantly front-on pictures of store fronts, which play with the rhetoric of Evans's depression pictures. The texts consist of metaphors for drunkenness arranged into rough groups: for example, 'boozehound, juicehound, rumhound, gas hound, jakehound, boiled owl, whale'. The Bowery was a traditional stalking ground for the downward gaze of humanist documentary. With the exception of the last two images, however, Rosler's camera faces straight ahead. Her reaction to what she called documentary 'pornography' was to retain the vernacular form but to refuse its usual topics and points of view. She rigorously avoided representing the ostensible object of this work; the usual pitiable subjects of documentary are reduced here to a few traces: alcohol bottles, cigarette packets and a shoe. Stripped down to the document's most basic protocols, documentary emerges here as an empty marker rather than a site of plenitude. *The Bowery in Two Inadequate Descriptive Systems* is a work of denial and negation: an 'act of refusal', as Rosler put it.[37]

The second of these works, Sekula's *Aerospace Folktales* of 1973, took a different approach to the problem of documentary (Plates 4.11 and 4.12). This work is made up of a series of black and white photographs and texts documenting the lives of an unemployed aerospace engineer, his wife and children (the artist's parents and siblings), and taped interviews. *Aerospace Folktales* takes as a central theme the relation between industrial work (or its twin, industrial unemployment) and domestic labour. It explores the investments of workers in the military industries and the way that these values are shaken by

In the evening the engineer would write letters and straighten the lamps.

His wife would fix dinner.

PLATE **4.11** Allan Sekula, detail of *Aerospace Folktales*, 1973, 51 black and white photographs in 23 frames, 56 × 72 cm each, three red canvas director's chairs, three CD players and speakers, three simultaneous unsynchronised audiotape recordings: duration 17 min, 21 min and 23 min, edition 1 of 2. (Collection Generali Foundation, Vienna. Courtesy Galerie Michel Rein, Paris and Christopher Grimes Gallery, Santa Monica.)

unemployment. Sekula also rejected the downward social gaze of documentary, choosing to record the activities of his own white-collar family. This is a work that avoids the supposed neutrality of documentary, whose central ideology is the invisibility of the photographic apparatus. Working in cramped domestic conditions makes the participants highly conscious of the photographer's presence – this is one reason documentary has always preferred the life of the street where anonymity is readily found. Sekula claimed: 'I use "autobiographical" material, but assume a certain fictional and sociological distance in order to achieve a degree of typicality.'[38] *Aerospace Folktales* is built around this awareness of the camera. The text panels frequently draw attention to the act of photographing and the subjects' responses to it. The work documents the experience of unemployment, records gendered ideologies and reflects on the American industrial–military complex, but it also adopts a mode of presentation that proclaims its own construction. The presence of the camera and the differing points of view contained in text and interview are intended to produce what Bertolt Brecht called 'alienation effects' that make viewers continually aware that they are looking at a representation. *Aerospace Folktales* can be seen as one of the very first performative documentaries in which fictional staging and the participants' comportment towards the camera emphasise the production of meaning, rather than the neutrality of recording. Both *The Bowery in Two Inadequate Descriptive Systems* and *Aerospace Folktales* mark a shift away from classic street photography, while remaining attached to the document as form and project. These works can be seen as important milestones in the reinvention of the documentary tradition.

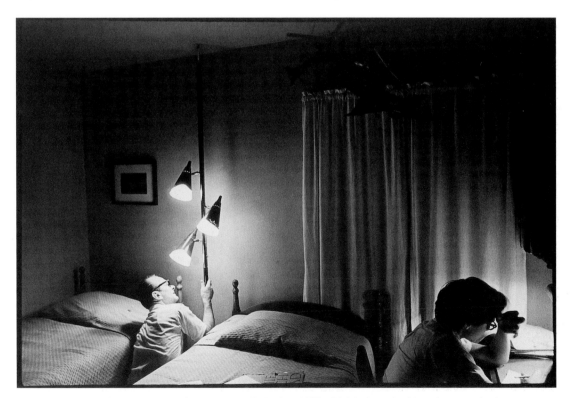

PLATE 4.12 Allan Sekula, detail of *Aerospace Folktales*, 1973, 51 black and white photographs in 23 frames, 56 × 72 cm each, three red canvas director's chairs, three CD players and speakers, three simultaneous unsynchronised audiotape recordings: duration 17 min, 21 min and 23 min, edition 1 of 2. (Collection Generali Foundation, Vienna. Courtesy Galerie Michel Rein, Paris and Christopher Grimes Gallery, Santa Monica.)

From the street to the stage

While the street played a central role in the modernist/documentary crossover, the subsequent critique of documentary provided a new impetus for studio-based photography. One prominent response from left-wing artists to the critique of documentary was to abandon documentation for work constructed in the studio that sought to explore the rhetoric of the mass media. The British conceptual artist Victor Burgin played a key role in this shift through his photographic work, writing and teaching. Burgin, working under the impact of the rediscovery of the revolutionary avant-garde and Structuralist theories of representation, argued that Conceptual Art had broken insufficiently with Clement Greenberg's modernism. According to him, Conceptual Art played a significant role in the disintegration of Greenberg's hegemony: it rejected 'medium-specificity'; turned away from hand-crafted images in favour of photography and video; and, in some important instances, stepped outside art's exclusive focus on form and re-engaged with society and history. But despite all this, Burgin felt, Conceptual Art remained trapped by modernist autonomy, isolated from use and cut off from the media representations that produced the ideologies, meanings and values that really mattered.[39] Burgin, in contrast, advocated abandoning art for the role of interventionist working on and in cultural representation: the pictures and books he produced concentrated on a critique of the mass media. A central plank of this work, shared with that of Sekula and Rosler, entailed the combination of text with photographs. As Charles Harrison argues in Chapter 2, Conceptual Art called into question the deep-seated idea that art and language belonged to distinct realms of experience, which had become part of the common sense of modernist theory and practice. Modernist photography as championed by John Szarkowski was, supposedly, a purely visual affair independent of natural language.[40] In opposition to this view, Burgin developed an image-text, or 'scripto-visual', practice.

Look at Burgin's *Today Is the Tomorrow You Were Promised Yesterday*, which comprises one panel from his work *UK76* (Plate 4.13). How would you explain the relation between image and text in this work? (The text is reproduced again below so that the content can be read easily.)

> The early-morning mist
> dissolves. And the sun shines
> on the Pacific. You stand like
> Balboa the Conquistador.
> On the cliff top. Among the last of
> the Monterey Cypress trees.
> The old whaler's hut is abandoned now.
> But whales still swim through the wild waves.
> Sea otters float on the calmer waters.
> Cracking abalone shells on their chests.
> Humming birds take nectar from the red hibiscus.
> Pelicans splash lazily in the surf.
> Wander down a winding path. Onto gentle sands.
> Ocean crystal clear. Sea anemones. Turquoise waters.
> Total immersion. Ecstasy.
>
> TODAY IS THE TOMORROW YOU WERE PROMISED YESTERDAY

The early-morning mist
dissolves. And the sun shines
on the Pacific. You stand like
Balboa the Conquistador.
On the cliff top. Among the last of
the Monterey Cypress trees.
 The old whaler's hut is abandoned now.
But whales still swim through the wild waves.
 Sea otters float on the calmer waters.
Cracking abalone shells on their chests.
 Humming birds take nectar from the red hibiscus.
Pelicans splash lazily in the surf.
 Wander down a winding path. Onto gentle sands.
Ocean crystal clear. Sea anemones. Turquoise waters.
Total immersion. Ecstasy.

TODAY IS THE TOMORROW YOU WERE PROMISED YESTERDAY

PLATE 4.13
Victor Burgin, *Today Is the Tomorrow You Were Promised Yesterday*, 1976, from the eleven-part series *UK76*, gelatin silver print on aluminium, 102 × 152 cm. (Christine Burgin Gallery, 13th Street, Chelsea, New York.)

The image is a black and white documentary photograph of a working-class housing estate. The point of view focuses attention on the dog crossing an otherwise empty space and simultaneously draws the viewer up against foreground detritus. A low horizon line boxes in the estate under a heavy sky, while the overhead cables lead the eye to a pylon, which blocks off the space and seems to impose an industrial presence over the whole image. The text, which appears to be unrelated to the image, seems to describe an exotic location somewhere on the west coast of the Americas (probably California). The mode of address adopted suggests it is taken from a tourist brochure (it may be the artist's parody of mass travel promotion). Sea otters and whales contrast with the depicted mongrel. Pacific sunshine and 'Turquoise waters' are set against a prosaic, predominantly grey, image of everyday life. This work seems to stress the difference between the enthusiastic rhetoric of the text (we instinctively know it is a sales pitch) and the very ordinariness of the world presented in the photograph. The final line of text – distinguished from the rest by spacing, size and capitalisation – reads like Burgin's addition. This line offers a reflection on the operation of ideology: a promise is held out to ameliorate the drab reality of the present, but it is endlessly deferred. Burgin's image-text piece is built around a series of contrasts: image/text, truth/ideology, fantasy/reality, here/there, today/tomorrow. Overall, the relation of image and text in this work might be characterised as ironical. (Irony is a rhetorical mode in which speakers mark their distance from what they actually say. The ironist says one thing, but means the opposite.) In this work, Burgin quoted the language of the tourism industry but ironised it – through his use of the image and last sentence – to place the viewer at a critical distance from its values. (Burgin subsequently rejected irony because it was rooted in what he saw as an untenable truth/falsehood opposition.) ■

During the 1970s, the traditions, innovations and devices of the revolutionary avant-garde were undergoing a revival in fortune. We might call the avant-garde practice predominant in the UK and France during this period 'neo-Brechtian'. This practice was most obviously identified with work of the film maker Jean-Luc Godard and theorised in, among other places, the British film journal *Screen*, but Brecht's ideas had a significant impact on artists, photographers and film makers who consciously produced work that combined an attention to political subjects, particularly gender, with formal devices intended to interrogate and disrupt the dominant conventions of the mass media. As Claire Johnston suggested: 'Any revolutionary strategy must challenge the depiction of reality ... so that a break between ideology and text is effected.'[41] Burgin made a significant contribution to this practice in the visual arts. Mass-media imagery, it was argued, encouraged an uncritical identification with the image by disguising its construction; these representations presented themselves as natural phenomena rather than as things assembled by men and women with interests and stakes in society. According to Burgin, socialist art practice should engage with these media 'codes' which 'present themselves, and thus ideology, as natural and whole; a socialist art practice aims to deconstruct these codes, to unpick the apparently seamless ideological surface they present'.[42]

Avant-garde artists and film makers in the 1970s took up the idea of 'foregrounding the device' – an approach Brecht adopted from the Russian Formalists. By introducing contradiction into their images, they intended to disrupt the common sense of the mass media. The pictures that made up Burgin's *UK76* all turn on this conception of disjuncture.

Burgin came to see this strategy of contrasting documentary images with social fantasy as itself a problem. This was due to a developing awareness that documentary was actually a form of representation and not a reflection of reality that could be counterposed to mystification. The problem with the approach adopted in *UK76*, he felt, was that it ultimately failed to interrogate documentary's claim to display social truths. In the end, the black and white photograph of the housing estate still appeared as a truthful representation from which the textual fantasy departed. But it was this ideology of documentary – the belief that these photographs showed things as they really were – that needed to be called into question if the power of the mass media was to be challenged. Disputing the supposed objectivity of the media was a condition for political critique. Along with many other artists and intellectuals at this time, Burgin rejected the idea that representation copied, reflected or distorted pre-existing reality, suggesting instead that mass-media images played a fundamental role in shaping the ways that people interacted with their world. In other words, what was usually seen as reality was an effect of the mass media's ability to articulate and secure as true a series of ideological values. From this perspective there was no 'real' world existing outside of representation, so a critique of the image – in theory and practice – seemed a pressing political priority.

Perhaps the best way to illustrate this argument is by considering representations of women. Mass-media images are frequently seen as distortions of the reality of women's lives: depicting women as sexually available; shrouding domestic labour and wage work in a cover of glamour and romance; encouraging the idea that fulfilment depends on marriage and children. Feminist critics, such as Griselda Pollock, however, reversed this

proposition, arguing that rather than thinking of images of women as distorting lived experience we should focus on the construction of woman as image. That is to say, rather than viewing these images as fictions that mask real conditions, Pollock suggested that representations produce female identities; what we experience as subjectivity and reality were deemed to be the result of our identification with representations and not the other way round.[43] Thinking about gender played a key role in this argument, but this conception rapidly expanded to encompass all areas of political representation and identity. Burgin put this argument succinctly when he said he was interested not in the 'representation of politics' but in 'the *politics of representation*'.[44] As a result of this postmodernist argument, the document came to be viewed as an ideological representation with no greater claim to truth than advertising or Hollywood movies. If anything, documentary was thought more deluded than other forms of representation because it claimed a direct access to reality, and more dangerous because the 'reality effects' it produced played a significant role in naturalising the values and interests of the powerful.

Under the impact of these ideas (particularly feminist psychoanalytic theory), Burgin abandoned the document for a practice based on the constructed photograph. Working in the studio allowed him and others to represent issues that seemed beyond the reach of the document, such as mass-media constructions of fantasy and sexual identity. As Burgin put it, a 'politics of representation has to be concerned with the phantasmic', which could not be considered 'a concern secondary to the political issues of the day' (Plate 4.14).[45] He subsequently pursued this project by constructing images that addressed the construction of gendered identity and the unconscious.

I'VEGNO PER MENARVI A L'ALTRA RIVA

PLATE **4.14**
Victor Burgin, *I'vegno per menarvi a l'altra riva*, 1984, one of seven panels from *The Bridge*, each panel 76 cm high. (Christine Burgin Gallery, 13th Street, Chelsea, New York.)

Work of this kind turned away from overt political representation to an engagement with sexuality and the pleasure of the image. In the process, it abandoned the blankness, banality and refusal that had characterised postconceptual photography from Ruscha to Rosler. It could be argued that as work of this kind became more and more engaged with the spectacular effects of the mass media, and increasingly tied up in the complexities of post-Freudian psychoanalysis, its critical potential dwindled. There is something about this move into the studio and into the unconscious that appears symptomatic of the academic retreat from the difficulties of public politics in the conservative climate that followed the election of Margaret Thatcher as British Prime Minister in 1979 and Ronald Reagan as President of the USA in 1980.

Staged photography did, however, prove to be very productive for a generation of female artists, allowing issues of identity to be explored in a controlled space. Among the most powerful of these staged or performative projects was Cindy Sherman's body of work, produced between 1977 and 1980, known as *Untitled Film Stills* (Plates 4.15 and 4.16). In these photographs Sherman staged images of herself in various costumes, guises and locations.

PLATE **4.15**
Cindy Sherman,
*Untitled Film
Still #27*, 1979,
black and white
photograph,
20 x 25 cm.
(Courtesy the artist
and Metro Pictures,
New York.)

The reference to 'film stills' suggests the publicity photographs produced to promote big-budget feature films, and her pictures do have the flavour of vaguely remembered movies watched on a wet Sunday afternoon. Sherman's work served as a powerful impetus for feminist thinking about constructions of gender and identity.[46] Informed by psychoanalytic theory and film theory, feminist theorists suggested that these pictures revealed that female subjectivity was produced in representation. It was significant that Sherman was always the model. The masks could not be stripped away to reveal the real 'Cindy', because each of the identities on display was only another representation of femininity. None of these identities was modelled on some authentic self; rather, femininity was produced by the particular codes and conventions of the image. As Judith Williamson argued, 'it seems as though there is a particular kind of femininity in the *woman* we see, whereas in fact the femininity is the image itself'. In each image, female identity was 'inseparable from the literal presentation of the image – lighting, contrast, composition, pictorial style'.[47] As feminist critics pointed out, what was important about these works was that by staging a range of powerful and prevalent images of femininity, Sherman revealed something of its ideological effects.

PLATE **4.16** Cindy Sherman, *Untitled Film Still #37*, 1979, black and white photograph, 20 x 25 cm. (Courtesy the artist and Metro Pictures, New York.)

This feminist account of Sherman's *Untitled Film Stills* has been very productive for thinking about her work and for developing a critical account of the way that gendered identity is formed and performed. It does, though, now look somewhat partial.[48] In important ways, the range of identities on offer in Sherman's pictures is necessarily restricted. Because Sherman based her work on her own body, her ability to transform herself into different female types was constrained to a limited number of easily changeable features: clothing, hair style and colour, and make-up. While the painter has much more scope for invention, the photographer is fundamentally tied to the way things appear. Throughout these images, Sherman's body shape and skin colour remain constant, and she ages naturally over the few years these pictures took to make. Her subsequent work has been celebrated for its exploration of themes of psychic horror, death and decay. However, it seems to be driven by her glimpsing the limitations of images based on her own body at least as much as it is by those issues. In order to represent bodies different from her own while continuing to act as the principal subject of her work, Sherman has increasingly employed elaborate costume, make-up and prosthetic additions. One consequence of this solution has been to shift her work away from the 'reality effects' of the film stills and towards an engagement with grotesque forms, abject effects and fairytale scenarios.

One of the features shared by Burgin and Sherman is that they take their models from pre-existing imagery, whether advertising, cinema or painting. At a time when many artists opposed modernist ideas of originality, some made work from pre-existing images with minimal alteration: a strategy known as 'appropriation'. As the artist Barbara Kruger said, this was a practice that 'consists of an appropriation or "taking" of a picture, the value of which might already be safely ensconced within the proven marketability of media imagery'. Reworking mass-media imagery, Kruger suggested, allowed these artists to 'question ideas of competence, originality, authorship and property'.[49] Perhaps the most extreme version of this work was produced by Sherrie Levine, who re-photographed images by modernist photographers such as Walker Evans and Aleksandr Rodchenko and exhibited the resulting prints under her own name (Plate 4.17). This was a simple gesture that called attention to the way that the terms in Kruger's list – 'competence, originality, authorship and property' – were intimately connected in the culture of late capitalism. Levine's pictures were often literally illegal since they contravened copyright law. The critic Hal Foster claimed of work in this mode that 'the artist becomes a manipulator of signs more than a producer of art objects, and the viewer an active reader of messages rather than a passive contemplator of the aesthetic or consumer of the spectacular'.[50] The work of Levine is not in any simple sense staged, but it shares with such work the idea of manipulating pre-existing representations. Appropriated imagery raised important issues about the power of the media in our society, but it tended to give the impression that other perspectives were impossible. Martha Rosler, in a searching critique of strategies of appropriation – and by extension at least some practices of staging – argued that this work provided no 'alternative vision' to the images offered by the dominant media: appropriationist strategies, she suggested, proved incapable of suggesting how things could be different.[51] According to Rosler, critical practice in photography entailed going beyond a restricted engagement with media images.

PLATE **4.17**
Sherrie Levine,
Untitled (after
Alexander
Rodchenko: 9), 1987,
gelatin silver print,
unframed 20 × 15 cm,
framed 74 × 64 × 3 cm.
(Courtesy Paula
Cooper Gallery,
New York.)

Documents and pictures:
two forms of realism

In the final section of this chapter, I want to focus on two artists with backgrounds in Conceptual Art who have pursued very different photographic projects. Allan Sekula has produced a body of work that continues to engage with the traditions of the document, however extended and reconceived, while Jeff Wall has created complex staged images. Through the contrast between these artists I want to draw attention to the distinction between documents and pictures – a distinction that has haunted photography from its beginning. Photographic documents play a prominent role in society, but these have always been images lacking in cultural prestige. The objectivity of documents has frequently led to the photographer being viewed as a mindless servant of a machine. The document is a low form, often identified metaphorically with workers, maidservants and slaves. Photographers who wanted to be seen as artists kept their distance from the document and

imitated, to the best of their abilities, the prevailing styles of art. As we have seen, the historical avant-garde took up photography in its low modes, what Wall called the 'art-concept of photojournalism'. For Wall, however, the contradiction in Conceptual Art between the document as pure information and as pictorial mode provided a way to reintroduce the 'picture' into contemporary art.[52]

From documents to pictures

Wall's own initial foray into photography took this low form. His *Landscape Manual* of 1969–70 is a work in appearance and conception similar to that of Ruscha or Smithson, which mixes low-key black and white photographs with a typed narrative scenario. But by the end of the 1970s, Wall had abandoned the document and departed from the strategies employed by postconceptual photographers in a number of significant ways. He rejected the image/text relation and the arrangement of images in grids or sequences in favour of the singular image. In scale (often more than two by four metres) and compositional complexity, these are images in the mode of the art of museums (Plate 4.18). Wall literally '"recomposes" what had caught his attention elsewhere; thus the process of composition replaces snapshot recording'.[53] In these works Sherman's dressing-up box was replaced by a form of staging that relied on the production model of the film industry: actors, make-up artists, costume designers, set designers, lighting technicians and so on. Wall has repeatedly claimed that he was interested in employing photography to resurrect 'the painting of modern life': the programme for the depiction of the particular details and types of contemporary life. This project attained its high point during the middle of the nineteenth century in the art of Édouard Manet and his followers. The painting of modern life – requiring figures set in illusionistic space – declined during the twentieth century when ambitious artists turned to abstraction or montaged fragments. Wall, though, was acutely aware that an art of modern life, with its capacity for reflecting critically on the capitalist ordering of experience, had in the twentieth century shifted

PLATE **4.18**
Installation view of the exhibition 'Documenta 8', Kassel, 1987, showing Jeff Wall, *The Storyteller*, 1986. (Image courtesy of Jeff Wall Studio. © Jeff Wall.)

from painting to film. In an attempt to make these concerns relevant again for art, he produced large-scale photographic transparencies mounted in light-boxes. The light-box is a display technique frequently used by advertisers in railway stations, airports and indoor shopping centres, in which a photographic transparency is illuminated from behind. Wall said that on seeing one of these illuminated signs he realised it provided the 'perfect synthetic technology for me'.[54] It was not cinema, nor painting, nor propaganda, but it resonated with the connotations of all three forms. By combining the highly detailed image produced by a large-format camera with the technique of the light-box, Wall generated effects 'comparable to the best cinematic absorption'.[55] In this sense, he aimed to draw the pleasures of the culture industry into a critical commentary on modernity.

In *Picture for Women* (1979), one of his first light-box works, Wall remade Manet's painting *A Bar at the Folies-Bergères* (1881–2) (Plates 4.19 and 4.20). Wall's picture was, he said, 'a theoretical diagram' made in 'an empty classroom'.[56] He wanted to explore the structure of Manet's picture *and* to make a work that examined similar issues for our own day. In T.J. Clark's persuasive account of *A Bar at the Folies-Bergères*, the reflection of the man at the top right-hand corner of the mirror behind the barmaid means that the (male) spectator perceives himself as occupying this role.[57] For Clark, the position this picture establishes for male beholders is likely to be troubling, because it was widely understood at the time that the women serving in these bars were, just like the commodities they purveyed, for sale.

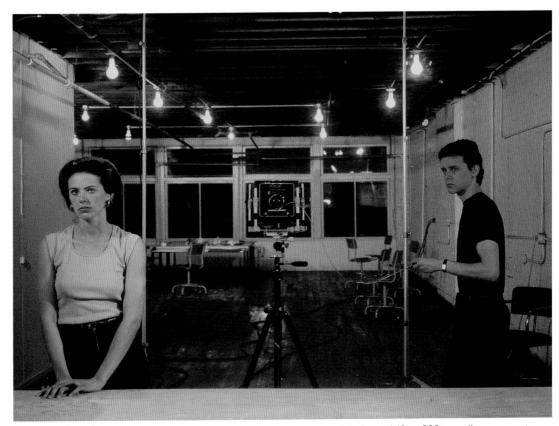

PLATE **4.19** Jeff Wall, *Picture for Women*, 1979, transparency in light-box, 163 × 229 cm. (Image courtesy of the artist. © Jeff Wall.)

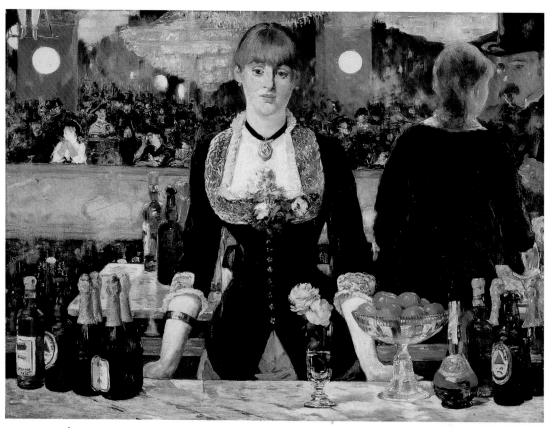

PLATE **4.20** Édouard Manet, *A Bar at the Folies-Bergères*, 1881–2, oil on canvas, 96 × 130 cm. (Courtauld Institute Gallery, London. Photo: AKG Images, London.)

Male spectators are met by the woman in *A Bar at the Folies-Bergères* with inscrutability and ennui. In this sense, Manet's painting works as a trap for a sexualised gaze. *Picture for Women* represents an attempt to reflect on the image of women in late capitalism, particularly the construction of femininity in cinema, through the mediating structure of Manet's picture.

In her important essay on woman as erotic spectacle in Hollywood cinema, which was published a few years prior to the production of Wall's image, Laura Mulvey analysed the overlapping relationships between three different 'looks': the look between the characters; the look of the viewer; and the camera's look. In mainstream movies, she suggested, women appear but men act. Women function as image outside the diegetic movement, while male characters carry the narrative. The effect of this, according to Mulvey, is to stitch the spectator's identification, regardless of gender, to the male character. The internal exchange of looks between characters operates to encourage the viewer's identification with them. Principally, the 'hero' is constructed as our surrogate within the narrative by a shot/reverse shot technique. The viewer's look takes place under the tutelage of the camera, which is at once invisible and all present, controlling our access to the scene.[58] This brief description of the orchestration of the gaze as discussed in Mulvey's essay must stand in here for a complex field of debate. It ought to be clear, though, that *Picture for Women* works with these three looks. This is, I take

it, why Wall referred to it as a 'theoretical diagram'. His picture, like Manet's, involves a mirrored reflection but, as Thierry de Duve argues, it departs from Manet's painting because both represented figures appear on the same side of the 'bar'. The entire visual field of this image is encompassed in the mirror. This must be the case because the artist is holding the cable release for the camera. De Duve suggests that because the woman now appears on the same side of the 'bar' as the photographer, she is also 'a viewer and no longer a figure who is simply looked at; hence, *Picture for Women* is a picture for women'.[59] That is to say, the picture attributes an active gaze to the female figure. But we should also note that the depicted figures do not exchange glances, rather they both look into the mirror. Their respective looks, in fact, converge on the space left open for the viewer. This is significant because it suggests *Picture for Women*, like Manet's *A Bar at the Folies-Bergères*, contains a reflection of the beholder: in Wall's picture, however, the viewer's self-image is not a bourgeois gentleman but a camera. *Picture for Women* is a picture for a feminist spectator not simply because it moves the female figure to the active register but also because it demonstrates the mediating role of the camera in focusing the spectator's attention on the image of woman. Wall reveals how cinema, and mass culture more generally, mechanise, direct and constrain patterns of sexualised looking.[60]

Like many artists working with photography during the 1970s and 1980s, Wall rejected the dominant aesthetic tradition of street photography. He was suspicious of this tradition's supposed neutrality as well as its detached, ironic gaze.[61] As a theorist acutely aware of Marxist accounts of alienation, he was also unconvinced by the supposed spontaneity of this work. Wall counterposed to street photography an art of the constructed photographic tableau. Like the modernist or documentary street photograph, Wall's pictures frequently derive from things seen on the street, but he rejected 'the role of witness or journalist, of "photographer"'. This was a role, he argued, which by 'masking the impulses and feelings of the picture maker' transformed the subject depicted into an 'object'.[62] Instead, he elected to re-stage these events, employing techniques, procedures and professionals from the film industry. The characters in his pictures are actors or acquaintances cast to play a 'role'; make-up, costumes and props are employed; sometimes elaborate sets are built in the studio, on other occasions suitable locations are scouted. He claimed that this technique of 'cinematography' demonstrated that the image was filtered through his subjectivity and 'literacy'.[63]

By staging an incident, Wall believed he could both amplify its social truth and develop it through the traditions of picture making. In *No* he created a scenario in which a well-dressed man appears to ignore the approach made to him by a woman (who the viewer surmises is probably offering sex for sale) (Plate 4.21). In looking at pictures, we always bring our knowledge of the world to bear; when presented with a scenario such as this, consciously or unconsciously we mobilise our experiences and our familiarity with other representations to posit an explanation for the events depicted. There are a number of clues here that suggest that this woman might represent a prostitute soliciting for custom: her dress and demeanour; the man's attitude; her approach from a dark corner; and the presence of a second woman in the doorway. None of these details unequivocally confirms this scenario, but

they do make it a plausible one. In a defensive gesture, the man's hand reaches for his coat as if to check that he is buttoned up and protected. This gesture is revealing – it seems to suggest an armouring of the body and a stiffening of the will against temptation. One writer has argued that the theme of this picture is 'temptation, guilt and denial'.[64] The picture seems built around this gesture, which encapsulates the man's struggle with himself. *No* is a picture of a simple observed incident, but it is also a conscious attempt to bring up to date the tradition of modern life painting. Wall, here, picks up on the theme of the prostitute as a central figure of modernity, a figure who embodies the idea of the self transformed into a commodity, and who characterises themes of social isolation and alienation. Wall has said that his form and technique 'have a hyper-organized rigid character, everything is strictly positioned. I want to express the existing unfreedom in the most realistic

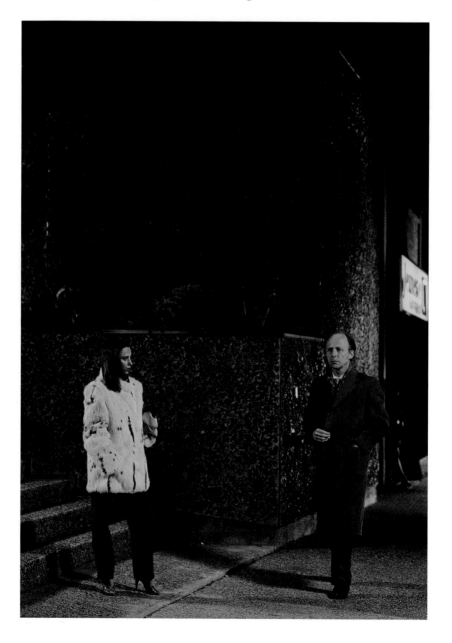

PLATE **4.21**
Jeff Wall, *No*, 1983, transparency in lightbox, 330 × 229 cm. (Image courtesy of the artist. © Jeff Wall.)

way.'[65] But *No* also reflects on the picture and modernity in a second way, since it is also concerned with a second act of soliciting – the propositioning of the viewer by pictures. The depicted approach, temptation and refusal imply a critical idea of beholding, in which the viewer recognises the seduction and pleasure offered by media images but retains an independence from this advance. The effect of this construction, however, is to cast the viewer as masculine and the temptations of pictures, or ideology more generally, as akin to feminine seduction.

Wall's pictures are related to Brecht's critical realism; a social truth is revealed through something 'built up, something artificial, posed'.[66] This is one important way in which these pictures conform to the tenets of modernism, since their evident construction – their rigidity – makes us conscious we are looking at an image rather than at an unmediated incident. Increasingly, Wall has emphasised the construction of his pictures by employing computer montage to generate grotesque or fantastic images. Computer montage allows artists to assemble individual photographed fragments into one relatively seamless image in which the scale of objects and figures can be changed and improbable effects of horror can be created. Wall has used this technology to create 'realistic', believable pictures populated with a cast of fantastic characters, such as vampires, giants and soldiers who converse despite having lost parts of their bodies. In these works, Wall has followed up other kinds of representation – the fantasy or horror film – which are able to produce their effects because the incredible events depicted take place in a believable realist framework of figures in deep space, characterisation, narrative effect and so on. The point of Wall's 'fantasy pictures', as he calls them, is that we are induced to suspend our disbelief and enter into the fiction, but the picture simultaneously calls upon us to engage critically with its fictitiousness. In *Dead Troops Talk* (Plate 4.22), for example, we witness the dialogue among the mortally wounded and know that these

PLATE **4.22** Jeff Wall, *Dead Troops Talk* (*A Vision After an Ambush of a Red Army Patrol Near Moqor, Afghanistan, Winter 1986*), 1992, transparency in light-box, 229 × 417 cm. (Image courtesy of the artist. © Jeff Wall.)

things cannot be true but, at the same time, we are prepared to entertain the fiction the picture presents. This moment of oscillation between belief and doubt is crucial to the picture's critical effect.

Wall's is a realism of a Brechtian sort, but unlike many radical artists and film makers of this moment he broke with the prevailing techniques of neo-Brechtian or Godardian practice: laying bare the device; breaking up diegesis; pictorial fragmentation; direct address to the beholder; displaying techniques by which the spectator was solicited by the image. By the mid-1970s, he claimed the 'look of this art had become so formulaic and institutionalized that it had completed its revolution'. Instead, Wall turned to the work of European film makers who, rather than interrogate the medium, attempted to develop critical ideas from within the 'classical codes of cinema'. These film makers accepted the conventions of cinema, 'technique, generic structure, narrative codes, problematics of performance and so on', but they 'brought new stories and therefore new characters into the picture'.[67] Wall's aim was to make a critical art that accepted the basic grounding conditions of the western pictorial tradition. This would be an art of new characters and new stories, an art that tried to depict the appearances and experiences of late capitalism.

But if Wall wanted to make pictures that kept their distance from the standard avant-garde formulas of fragmentation, discontinuity and rupture, the desire to do so with modern image technologies resulted in a contradiction, since the act of photographic framing is necessarily fragmenting. According to him, however, the aesthetic identity of photography had less to do with fragmentation than with producing a believable space for pictorial incident. In this respect, it is worth noting that Wall's pictures rarely emphasise the frame – his figures are centred and not interrupted by an edge. The model for Wall's photographs appears to be pre-twentieth-century painting rather than modernist photography. As he noted, there *is* a tradition in photography that has treated the 'picture as a whole construction'.[68] Wall was appealing here to the work of H.P. Robinson and others who, by composing pictures from multiple negatives, attempted to make photographs that imitated the prevailing conceptions of painting. This was work that was anathema to modernist proponents of medium-specificity. Wall's work can be seen as an attempt to remake Robinson's pictorialism as a critical practice. He has suggested that these early composite photographs were unconvincing, but that the advent of computer montage has enabled the production of believable, complexly constructed photographic pictures.[69]

Look at A Sudden Gust of Wind (after Hokusai) of 1993 (Plate 4.23) (which was based on Katsushika Hokusai's, Ejiri in Suruga Province – Plate 4.24). This picture was composed from a number of individual negatives using a computer. Can you detect any evidence that points to this form of construction?

There is something odd and unconvincing about the way these figures inhabit their space. The figure holding on to his white hat seems to stand out starkly from the ground, as if pasted on. Look at the left hand of the woman with the file – it too seems not to marry up with the ground it is set against, while the light source that picks out the edges of her legs does not tally with the shadow she casts. The pose of the central figure, turning rapidly to look for his disappearing hat, seems too studied – and where is his shadow? The hat

PLATE **4.23** Jeff Wall, *A Sudden Gust of Wind* (*after Hokusai*), 1993, transparency in light-box, 229 × 377 cm. (Image courtesy of the artist. © Jeff Wall.)

PLATE **4.24** Katsushika Hokusai, *Ejiri in Suruga Province*, c.1831–3, from *36 Views of Fuji*, 1830–3, colour woodblock print, 26 × 38 cm. (© The British Museum, London.)

itself is rather peculiar – it seems too clear for something so small, as if it has been photographed in close up and then miniaturised on the computer before being introduced to this picture. The sheer whiteness of the scattering paper also fails to convince; consider the single sheet that has blown across the stream to the opposite bank, which seems carefully placed in order to suggest the randomness of the gust's effect. Wall's picture is made by posing figures in the studio (perhaps with a wind-machine) and then combining them digitally with a photographed landscape or combination of landscape elements. The features that we have been observing here are the direct results of this process.[70] ■

These are all problems of the kind that Robinson's critics picked up on. What registered simply as Robinson's failure at the time can be seen in modernism's wake as a self-consciousness of picturing. The uneasy effects in a work like this generate a tension between the picture's form and content. Wall eschews medium-specificity but engages with pictorial self-consciousness by working with types of picture that he describes as 'pictorial typologies, generic structures, or laws which appear as modes of spatial organization, types of figure–ground relations and things like that'.[71] A certain rigidity and stageyness is observable in all of Wall's work. In this image the flatness and formality of the computer montage parallels the key characteristics of the Japanese print. *A Sudden Gust of Wind* (*after Hokusai*) is a modern life picture that updates the subject and characters of its model while employing its technique to reflect on the Japanese prints that so influenced the early modernist painters.

Documents again

If Wall rejected documentary work and the techniques and devices of the avant-garde in order to maintain an avant-garde critique of everyday life, Sekula opposed an art of staged photography – what he has called a 'theatricalized epistemological skepticism' – in order to deepen and extend the project of critical documentary.[72] In a comment very similar to one made by Wall, he suggested: 'The old myth that photographs tell the truth has succumbed to the

PLATE **4.25** Allan Sekula, 'Detail. Inclinometer. Mid-Atlantic', 1993, from *Fish Story*, 1987–95, Richter Verlag, Düsseldorf, Middle Passage, chapter 3, plate 27. (Collection Museum Boijmans van Beuningen, Rotterdam. Courtesy Galerie Michel Rein, Paris and Christopher Grimes Gallery, Santa Monica.)

new myth that they don't.'[73] Sekula, however, came to see staged work as a 'wink' in the direction of those knowing viewers who subscribed to this new myth.[74] For him, documentary, at least since Szarkowski's 'New Documents' exhibition in 1967, had turned into a mannerist activity that displayed an 'ironic and fatalistic relationship to the world'.[75] As we have seen, Sekula's response initially involved attempting to revitalise documentary photography through mixing forms and media, and working with the relation between staging and documentation. But, as scepticism at documentary's truth claims became increasingly prevalent, he claimed he wanted to run in the opposite direction: towards the 'bad object of contemporary art' – documentary.[76]

I want to concentrate here on what I take to be one of the most important artworks in any medium produced during the 1990s: Sekula's *Fish Story*, which he developed over six years to document the maritime economy (Plates 4.25–4.28). This project was conceived as both an exhibition and a book. The exhibition consists of 105 colour photographs, twenty-six text panels and two slide sequences, and has been exhibited in various parts since 1992. The book contains 96 colour photographs interleaved with pages of text, organised in seven chapters; it also includes two wide-ranging theoretical essays.[77] In words and photographs, *Fish Story* documents the central, if barely visible, place of the sea in the modern global economy by bringing together images from the world's port cities.[78] The photographs record unemployment and dilapidation in the old industrial powers, West and East; the capitalist pursuit of cheap labour around the globe; the arduous work of seafaring; and the rise of new shipbuilding powers in Asia. According to Buchloh, *Fish Story* amounts to no less than a 'detailed account of the general political and economic transformation brought about by the globalization of late capitalist rule'.[79]

PLATE 4.26 Allan Sekula, 'Panorama. Mid-Atlantic', 1993, from *Fish Story*, 1987–95, Richter Verlag, Düsseldorf, Middle Passage, chapter 3, plate 28. (Collection Museum Boijmans van Beuningen, Rotterdam. Courtesy Galerie Michel Rein, Paris and Christopher Grimes Gallery, Santa Monica.)

The maritime world, Sekula believes, is depicted in contemporary culture as an anachronism, some vague remnant of an earlier system of trade. Seafarers and port workers once occupied a central place in the imaginative life of capitalism but now barely figure in representation. For most people, the sea is something to dip one's toe into or to fly over. In this context, he noted, *Fish Story* could seem like a 'grotesque triple funeral', a 'memorial service for painting, socialism and the sea'.[80] But, despite this fantasy of a dematerialised economy that flows through the airwaves, the vast bulk of the world's goods are transported as ships' cargo. The invisibility of the sea in modern culture is paradoxical, since the profits and lifestyles of those in the affluent economies depend on the maritime world.

The metropolitan ruling class may have a vested interest in leaving all this unsaid, but the invisibility is also closely related to the process of containerisation that generated modern maritime conditions. The development of container shipping in the USA during the late 1950s – in which bulk goods in metal containers are loaded by crane directly from trucks to the ship or vice versa – played a fundamental role in speeding up the loading and unloading of goods and thereby massively increased the volume of shipped trade. Containerisation both broke organised dock labour in the industrial countries and enabled 'companies to become restless and search out cheaper labor' around the world.[81] Vast tracts of land are needed for the storage and movement of these boxes, which meant that ports had to move out of cities to waterfront areas at some distance from population centres. The ports of New York and Los Angeles are the biggest in the Americas, but both are located outside the urban centres and remain relatively invisible.[82] *Fish Story* is dedicated to overcoming the 'cognitive blindness' that removes the sea and seafaring from the gaze of metropolitan elites, insisting, against 'postmodern' prophets of the 'information age', that the sheer materiality of transporting cargo by sea is at the centre of the modern capitalist globalisation.[83]

Fish Story is a significant project of documentation and an important contribution to the critique of globalisation. It is also a subtle work of, and on, representation that employs modernist self-consciousness to reveal underlying social conditions. In this sense, Sekula's work, like Wall's, should be thought of as a Brechtian enterprise, but he departs from the consensus on the necessity for staged photography that developed during the 1980s. Sekula has said that *Fish Story* 'can be described as a hybrid, "paraliterary" revision of social documentary photography' that sought to dissolve the distinctions between essay writing, the 'poetics' of sequential photographs and research in cultural, economic and social history.[84] Since the early 1970s, Sekula has been interested in impure photographic forms: slide projections; image and text combinations; and the use of sound recordings. Unlike Wall's work, *Fish Story* contaminates photography with words. Szarkowski's modernism may have turned its back on language, but the predominant social uses of photography have always been tied to words. As I have suggested, in the news media words are employed to fix the meaning of images that are frequently ambiguous. According to Roland Barthes, captions 'anchor' the meanings of photographs, transforming semantic openness into easily digestible messages (Sekula spotted the nautical metaphor).[85] *Fish Story*

employs descriptive captions, but it also includes texts that do not conform to either of the standard relations between image and text, such as anecdotes, observed details and connections, as well as essays on the depiction of the sea. These texts echo with the images rather than pin them down. Sekula also pays attention to the codes of photography, deliberately mixing distinct photographic styles and conventions and allowing the different histories of the medium's use to reverberate in narrative sequences, thereby thickening meaning and association. As Buchloh put it, Sekula does not employ a 'singular photographic model', but juxtaposes a range of photographic conventions so that the work seems as much an examination of the 'rhetoric' of photography as a record of maritime activity.[86]

The idea of 'sequential montage' is at the centre of *Fish Story*. These pictures are not intended to be viewed as single images, but as carefully edited narrative sequences. Sekula's response to Brechtian arguments for construction, or the set-up, was to create picture sequences that call attention to the editing process while keeping a distance from the fashionably staged shot.[87] I want to look at a section of *Fish Story* called 'Middle Passage' to illustrate this idea of sequential montage and consider Sekula's use of different representational conventions. The term 'Middle Passage' refers to the journey made by slave ships across the Atlantic Ocean from the west coast of Africa to the West Indies or the Americas. The title is probably intended to recall this voyage as a founding moment of an earlier phase of capitalist globalisation. It also suggests that modern maritime labour is a form of 'wage slavery' (it may further allude to the traditional low standing of the documentary tradition). The sequence opens with a juxtaposition of a detail from a ship's inclinometer (which measures the degree of tilt on the wave) and a panorama. This juxtaposition contrasts two fundamental ways of representing maritime space: the tightly cropped detail and the expansive view. The extensive space of the panorama suggests an optimistic, even transcendental, view of world trade. Here the prow of the ship, which appears to be nothing but floating containers, ploughs heroically forward into seeming infinity. For Sekula, the panorama is typical of an official, romanticising view of seafaring. It is also, as Buchloh notes, an anti-modernist form, providing infinite pictorial space and a lateral expansion beyond the frame.[88] Set against the optimistic panorama, the technical image insists on the materiality of life at sea. The next three images in the sequence all take a different view of seafaring: the experience of working in confined spaces. Sekula identifies this vision with the proletarian experience of claustrophobic life in the engine room (or gun turret), where the worker's body meshes with inorganic machines. This is a much more dystopian conception of life at sea than that of the panoramic space.[89] Working in these confined spaces in swelling seas is not an enviable task (Plate 4.27). The remaining sixteen frames in this sequence (with the exception of one frame discussed below) narrow the view to these confined spaces, only broadening out again in the last image, when the ship is seen from land after reaching its destination.[90]

This sequential organisation parallels filmic montage, but it departs from what Sekula calls the 'unilinear dictatorship of the projector'. That is to say, unlike the relentless forward thrust of filmic narrative, these sequences can be revisited and reconsidered.[91] Probably the best way to see them is as

PLATE **4.27**
Allan Sekula, 'Third Assistant Engineer
Working on the Engine while
Underway', 1993, from *Fish Story*,
1987–95, Richter Verlag, Düsseldorf,
Middle Passage, chapter 3, plate 31.
(Collection Museum Boijmans van
Beuningen, Rotterdam. Courtesy Galerie
Michel Rein, Paris and Christopher
Grimes Gallery, Santa Monica.)

extremely slowed down film sequences. Sekula's work seems to me, in this sense, a critical engagement with film form. Walter Benjamin claimed that in film 'Discontinuous images replace one another in a continuous sequence.'[92] Whereas film editing often makes connections between images and points of view seem entirely natural, Sekula holds the edit apart, encouraging the viewer to consider the relationship between the parts. In the process, we see just how tendentious film montage often is.

In the three pictures from 'Middle Passage' captioned 'Conclusion of the Search for the Disabled and Drifting Sailboat *Happy Ending*', the editing process is employed to establish a relationship between individual images (Plate 4.28). While the first image is not strictly panoramic, it retains the open horizon and lateral extension of the panorama. In it the container vessel *Sea–Land Quality* is decentred, shifting the pictorial emphasis from its forward thrust towards the horizon on to a small speck in the middle distance, which is the sailboat *Happy Ending*. In a shift in viewpoint, characteristic of cinematic editing, the second image tips the camera downwards to look over the side of the ship. The distance between the two boats has been traversed and we are now right up against the sailboat. The horizon has been displaced and the

PLATE **4.28**
Allan Sekula,
'Conclusion of the
Search for the
Disabled and Drifting
Sailboat *Happy
Ending*', 1993, from
Fish Story, 1987–95,
Richter Verlag,
Düsseldorf, Middle
Passage, chapter 3,
plates 32–4.
(Collection Museum
Boijmans van
Beuningen, Rotterdam.
Courtesy Galerie
Michel Rein, Paris and
Christopher Grimes
Gallery, Santa Monica.)

oblique look downwards, combined with filling the frame with the sea, establishes an effect of rolling on the swell. This sensation is increased in the third image, which brings the small boat closer still, while rotating the image through 90 degrees. The overall effect of the sequence is to move from the optimistic expansiveness of the first frame to a dizzying perspective. The final frame of this sequence can be seen as an ironic take on avant-garde photography of the 1920s and 1930s. The high point of view looking down on boats in a marina or harbour was a prominent theme in the photographs of László Moholy-Nagy and others. Sekula repeats this point of view, but substitutes a disabled and smashed vessel for the boat as an icon of bourgeois leisure and flight. These three frames offer a microcosm of the larger narrative of 'Middle Passage', which deals with the hardship and isolation of life at sea determined by powerful material forces beyond human control. For those on board the sailboat there was no happy end to this story.[93]

Conclusion

The works of Sekula and Wall represent distinct responses to the legacy of Conceptual Art and its use of the document. But it ought to be apparent that both projects are rooted in this history. Sekula's work is a concerted attempt to revitalise the tradition of documentary photography as a highly conscious and critical form of representation. As Buchloh observes, this project represents an unfashionable engagement with the narrative form and an iconography of labour, and it refuses many of the prevailing artistic conceptions of late modernity: the simulacrum, psychoanalytic models of subjectivity and substitution of the politics of signification for the signification of politics.[94] Wall, in contrast, in picking up on the paradoxical position of the photograph in Conceptual Art, abandoned the tradition of the low document for making individual, staged pictures. It is noticeable, though, that Buchloh's characterisation of the prevalent models of contemporary art are as inapplicable to Wall's work as they are to *Fish Story*. Both artists can be thought of as engaging the Realist tradition critically, both work with Brechtian ideas and both reject the postmodern consensus that emerged during the 1980s. But the difference between these projects is also crucial – the distinction between documents and pictures continues to structure contemporary work in photography.

Notes

1 Sekula, *Photography against the Grain*; Crimp, 'The Museum's Old/The Library's New Subject', pp.32–7.

2 Quoted in Goldstein and Rorimer, *Reconsidering the Object of Art*, p.188.

3 I discuss the works of these photographers in Chapter 8 of *Varieties of Modernism*.

4 Rosenberg, 'De-aestheticisation', p.28.

5 Coplans, 'Concerning "Various Small Fires"', p.25.

6 Leider, 'Books Received', p.57.

7 Coplans, 'Concerning "Various Small Fires"', p.25. Ruscha's response at the time was to deny the connection; somewhat later he was more forthcoming, noting that he had seen the pioneering Duchamp exhibition put together by Walter Hopps (Pasadena Museum of Art, 1963), and stating that Duchamp 'discovered common objects and showed you could make art out of them'. See Armstrong, 'Interviews with Ed Ruscha and Bruce Connor', pp.55–6.

8 Ruscha, in Coplans, 'Concerning "Various Small Fires"', p.25.

9 Leider, 'Books Received', p.57.

10 Ruscha, in Coplans, 'Concerning "Various Small Fires"', p.25.

11 Christopher Knight, quoted in Hickey, 'Edward Ruscha', p.61.

12 Brougher, 'Words as Landscape', p.158; Rosenzweig, 'Sixteen (and Counting)', p.180; Engberg, 'Out of Print', p.44.

13 Phillpot, 'Sixteen Books and then Some', p.63.

14 Allegory can be defined as an aesthetic mode in which often hidden layers of meaning sit behind a literal presentation of information. The peculiar nature of the photographic sign makes it particularly suited to allegorical presentation, where literal depiction exists alongside other kinds of reference.

15 Hickey, 'Edward Ruscha', pp.60–1.

16 Brougher, 'Words as Landscape', pp.158–9.

17 Phillpot, 'Sixteen Books and then Some', p.77.

18 Smithson's project had little to do with Duchamp, whom he detested (regarding him as a sanctifier of alienated objects and a purveyor of 'joke art') – see Smithson, 'Robert Smithson on Duchamp: An Interview with Moira Roth' (1973), in Holt, *The Writings of Robert Smithson*, pp.197–9.

19 Smithson, 'A Sedimentation of the Mind: Earth Projects' (1968), in Harrison and Wood, *Art in Theory 1900–2000*, VIIB3, p.878.

20 *Ibid.*, p.879.

21 *Ibid.*

22 See Art & Language, 'Memories of the Medicine Show. 1', pp.32–9; Art & Language, 'Memories of the Medicine Show. 2'; Art & Language, 'Moti Memoria', p.60; for a discussion of the amateur in Conceptual Art and photography, see Roberts, 'Photography, Iconophobia and the Ruins of Conceptual Art'.

23 Wall, '"Marks of Indifference"', p.261. Extracts from this essay can be found in Gaiger and Wood, *Art of the Twentieth Century*, III.6.

24 Buchloh, 'Structure, Sign, and Representation in the Work of David Lamelas' (1997), in *Neo-Avantgarde and Culture Industry*, p.326.

25 Wall has formulated an argument somewhat like this in his '"Marks of Indifference"'. Extracts from this essay can be found in Gaiger and Wood, *Art of the Twentieth Century*, III.6.

26 Adorno, 'Commitment' (1965), in Bloch *et al.*, *Aesthetics and Politics*, p.177.

27 Graham, Presentation to an Open Hearing of the Art Workers' Coalition (1969), in Harrison and Wood, *Art in Theory 1900–2000*, VIIC2, p.916.

28 Art Workers' Coalition: Statement of Demands (1970), in *ibid.*, VIIC6, pp.926–7.

29 Burnham, 'Steps in the Formation of Real-Time Political Art', p.134.

30 Messer, quoted in Haacke, *Framing and Being Framed*, p.138.

31 Burnham, 'Steps in the Formation of Real-Time Political Art', p.140; Crow, *The Rise of the Sixties*, p.181.

32 The obvious exception is the argument put forward by Bertolt Brecht, discussed in Chapter 13 of *Art of the Avant-Gardes*.

33 Sekula, 'On the Invention of Photographic Meaning' (1974), in *Photography against the Grain*, p.6.

34 Sekula, 'Dismantling Modernism, Reinventing Documentary (Notes on the Politics of Representation)' (1976/1978), in *ibid.*, p.59.

35 *Ibid.*, p.62.

36 Rosler, 'In, Around, and Afterthoughts', p.71.

37 *Ibid.*, p.79.

38 Sekula, 'Dismantling Modernism, Reinventing Documentary (Notes on the Politics of Representation)' (1976/1978), in *Photography against the Grain*, p.70.

39 Burgin, from 'The Absence of Presence' (1984), in Harrison and Wood, *Art in Theory 1900–2000*, VIIIB5, p.1070.

40 As I suggested in Chapter 2 of *Varieties of Modernism*, Burgin's essays were central in demonstrating the extent to which the work of Winogrand and others from Szarkowski's stable depended on linguistic metaphors for their effects.

41 Johnston, 'Women's Cinema as Counter-Cinema', p.215.

42 Burgin, from 'Socialist Formalism' (1976), in Harrison and Wood, *Art in Theory 1900–2000*, VIIC13, p.940.

43 Pollock, 'What's Wrong with "Images of Women"?'; Pollock, 'Woman as Sign'; Pollock, 'Missing Women'.

44 Burgin, from 'The Absence of Presence' (1984), in Harrison and Wood, *Art in Theory 1900–2000*, VIIIB5, p.1070.

45 Godfrey, 'Sex Text Politics', p.26.

46 Williamson, 'Images of "Woman"'; Mulvey, 'A Phantasmagoria of the Female Body'; Jones, 'Tracing the Subject with Cindy Sherman'. For a very different account of this work, see Krauss, 'Cindy Sherman'.

47 Williamson, 'Images of "Woman"', p.102.

48 It has increasingly been argued that this account of female subjectivity is rather pessimistic, closing off the possibility of women creating ways of living that might be more liberating. Some feminist theorists have come to argue, instead, that while the available representations of femininity create powerful models of selfhood, women do not simply accept these models, rather they negotiate them in complex ways, inflecting them to refashion new forms of behaviour. Gill Perry gives an account of this process of negotiation in Chapter 2 of *Art of the Avant-Gardes*.

49 Kruger, '"Taking" Pictures' (1982), in Harrison and Wood, *Art in Theory 1900–2000*, VIIIA9, p.1042.

50 Foster, 'Subversive Signs' (1980), in *ibid.*, p.1038.

51 Rosler, 'Notes on Quotes', p.72.

52 Wall, '"Marks of Indifference"', p.266. Extracts from this essay can be found in Gaiger and Wood, *Art of the Twentieth Century*, III.6.

53 Chevrier, 'The Spectres of the Everyday', p.167.

54 Barants, 'Typology, Luminescence, Freedom', p.99.

55 Wallace, 'Jeff Wall's Transparencies', p.5.

56 Barants, 'Typology, Luminescence, Freedom', p.96.

57 Clark, *The Painting of Modern Life*, pp.205–58. Clark published an earlier version of this text in 1977.

58 Mulvey, from 'Visual Pleasure and Narrative Cinema' (1975), in Harrison and Wood, *Art in Theory 1900–2000*, VIID10, pp.982–9. Gill Perry discusses this essay in Chapter 2 of *Art of the Avant-Gardes*.

59 De Duve, 'The Mainstream and the Crooked Path', pp.30–1.

60 For some interesting, and different, comments on the role of the camera and the feminist spectator in this image, see Wallace, 'Jeff Wall's Transparencies', p.11.

61 Barants, 'Typology, Luminescence, Freedom', p.100. For a summary of Wall's view on straight photography, see Chevrier, 'The Spectres of the Everyday', p.165.

62 Pelenc, 'Arielle Pelenc in Correspondence with Jeff Wall', p.17.

63 *Ibid*.

64 Wallace, 'Jeff Wall's Transparencies', p.16.

65 Barants, 'Typology, Luminescence, Freedom', p.101.

66 Brecht, quoted in Benjamin, 'A Small History of Photography' (1931), in *One Way Street and Other Writings*, p.255.

67 Pelenc, 'Arielle Pelenc in Correspondence with Jeff Wall', p.11. Wall's list of these film makers is: Robert Bresson, Luis Buñuel, Eric Rohmer, Pier Paulo Pasolini, Ingmar Bergman, Rainer Werner Fassbinder and Jean Eustache.

68 *Ibid*., p.9.

69 Wall, '"I am Not Necessarily Interested in Different Subject Matter" ', p.27.

70 I refer to H.P. Robinson's composition pictures and to A.H. Wall's critique in Chapter 13 of *Art of the Avant-Gardes*. For a related account of Jeff Wall's modernism, see Joyce and Orton, '"Always Everywhere"'.

71 Barants, 'Typology, Luminescence, Freedom', p.97.

72 Sekula, 'Allan Sekula', p.20.

73 Sekula, 'On "Fish Story"', p.51; Wall's similar point is to be found in '"Marks of Indifference"'. I discuss Wall's comment in Chapter 13 of *Art of the Avant-Gardes*.

74 Risberg, 'Imaginary Economies', pp.239–40.

75 Sekula, 'Allan Sekula', p.21. I discuss Szarkowski's 'New Documents' exhibition in Chapter 8 of *Varieties of Modernism*.

76 Risberg, 'Imaginary Economies', p.237.

77 Sekula, *Fish Story*. The two long essays in the book version reflect the attention to representation, spanning representation of the sea from Dutch marine painting to minimalism and Hollywood. In the process, Sekula reflects on a wide range of topics: the transformation of Dutch panoramic depictions linking sea and land to the ship as unattached wandering vessel in Turner and Conrad; the figure of the sailor and the theme of mutiny in modernist film, photography and literature; Hollywood's fantasies of the sea; the ship as machine; Popeye; and the ship in the cultural imaginary of left-wing thinkers and military planners.

78 There are photographs from California and New York, Liverpool, Glasgow and Tyneside, The Netherlands, Hong Kong, Italy, Mexico, Poland, Portugal, Spain and South Korea.

79 Buchloh, 'Allan Sekula', pp.198–9.

80 Sekula, *Fish Story*, p.48.

81 *Ibid*., p.49.

82 *Ibid*., p.55.

83 *Ibid*., p.54.

84 *Ibid*., p.52.

85 Barthes, 'Rhetoric of the Image' (1964), in *Image–Music–Text*, pp.38–41; Risberg, 'Imaginary Economies', p.250.

86 Buchloh, 'Allan Sekula', pp.194–5.

87 Sekula, 'On "Fish Story"', p.49.

88 Buchloh, 'Allan Sekula', p.196 n.10.

89 Sekula develops this idea from a reading of Theodore Plivier's revolutionary novel *The Kaiser's Coolies*, published in 1930; see Sekula, *Fish Story*, pp.111–12.

90 This final image represents a return to the seventeenth-century maritime painting where the ship is connected to land rather than severed from ties to it. It becomes, in this sense, a commercial vessel.

91 Sekula, 'On "Fish Story"', p.57.

92 Benjamin, 'The Formula in which the Dialectical Structure of Film Finds Expression' (1935), in *Selected Writings*, vol.3, p.94.

93 Brigitte Wernburg observes that the pilot of *Happy Ending* was found dead on board, and that his wife was lost at sea (Wernburg, 'In der Bucht von Vigo', p.82).

94 Buchloh, 'Allan Sekula', p.191.

References

Armstrong, E., 'Interviews with Ed Ruscha and Bruce Connor', *October*, no.70, fall 1994, pp.55–9.

Art & Language, 'Memories of the Medicine Show. 1: Recollections of Conceptual Art', *Art-Language*, second series, no.2, 1997, pp.32–9.

Art & Language, 'Memories of the Medicine Show. 2: We aimed to be Amateurs', *Art-Language*, second series, no.2, 1997, pp.40–9.

Art & Language, 'Moti Memoria', in Roberts, *The Impossible Document*, pp.54–69.

Barants, E., 'Typology, Luminescence, Freedom: Selections from a Conversation with Jeff Wall', in *Jeff Wall: Transparencies*, Munich: Schrimer/Mosel, 1986, pp.95–104.

Barthes, R., *Image–Music–Text*, trans. S. Heath, London: Fontana, 1977, pp.32–51.

Benezra, N. and Brougher, K. (eds), *Ed Ruscha*, exhibition catalogue, The Hirshhorn Museum and Sculpture Garden, Washington, DC and The Musuem of Modern Art, Oxford, 2000.

Benjamin, W., *One Way Street and Other Writings*, London: Verso, 1985.

Benjamin, W., *Selected Writings*, vol.3: *1935–1938*, trans. E. Jephcott, Cambridge, MA: The Belknap Press of Harvard University Press, 2002, pp.94–5.

Bloch, E., Lukács, G., Brecht, B., Benjamin, W. and Adorno, T.W., *Aesthetics and Politics*, translation editor R. Taylor, London: New Left Books, 1977.

Brougher, K., 'Words as Landscape', in Benezra and Brougher, *Ed Ruscha*, pp.157–75.

Buchloh, B.H.D., 'Allan Sekula: Photography between Discourse and Document', in Sekula, *Fish Story*, pp.189–200.

Buchloh, B.H.D., *Neo-Avantgarde and Culture Industry: Essays on European and American Art from 1955 to 1975*, Cambridge, MA and London: MIT Press, 2000.

Burnham, J., 'Steps in the Formation of Real-Time Political Art', in Haacke, *Framing and Being Framed*, pp.127–43.

Chevrier, J.-F., 'The Spectres of the Everyday', in de Duve *et al.*, *Jeff Wall*, pp.164–89.

Clark, T.J., *The Painting of Modern Life: Paris in the Art of Manet and his Followers*, London: Thames & Hudson, 1984.

Coplans, J., 'Concerning "Various Small Fires": Edward Ruscha Discusses his Perplexing Publications', *Artforum*, vol.3, no.5, 1965, pp.24–5.

Crimp, D., 'The Museum's Old/The Library's New Subject', *Parachute*, no.22, 1981, pp.32–7.

Crow, T., *The Rise of the Sixties*, London: Everyman Art Library, 1996.

De Duve, T. 'The Mainstream and the Crooked Path', in de Duve *et al.*, *Jeff Wall*, pp.26–55.

De Duve, T., Wall, J., Pelenc, A. and Groys, B. (eds), *Jeff Wall*, Oxford: Phaidon, 2002.

Edwards, S. and Wood, P. (eds), *Art of the Avant-Gardes*, New Haven and London: Yale University Press in association with The Open University, 2004.

Engberg, S. (ed.), *Edward Ruscha: Editions 1959–1999*, vol.2: *Essays, Entries, Information*, catalogue raisonné, Walker Art Centre, Minneapolis, 1999.

Engberg, S., 'Out of Print: The Editions of Edward Ruscha', in Engberg, *Edward Ruscha: Editions 1959–1999*, vol.2, pp.14–49.

Gaiger, J. and Wood, P. (eds), *Art of the Twentieth Century: A Reader*, New Haven and London: Yale University Press, 2003.

Godfrey, T., 'Sex Text Politics: An Interview with Victor Burgin', *Block*, no.7, 1982, pp.2–26.

Goldstein, A. and Rorimer, A. (eds), *Reconsidering the Object of Art: 1965–1975*, exhibition catalogue, Museum of Contemporary Art, Los Angeles, 1995.

Haacke, H. (ed.), *Framing and Being Framed: 7 Works 1970–75*, Halifax: The Press of The Nova Scotia College of Art and Design, 1975.

Harrison, C. and Wood, P. (eds), *Art in Theory 1900–2000: An Anthology of Changing Ideas*, Malden, MA and Oxford: Blackwell, 2003.

Hickey, D., 'Edward Ruscha: *Twentysix Gasoline Stations*, 1962', *Artforum*, vol.35, no.5, January 1997, pp.60–1.

Holt, N. (ed.), *The Writings of Robert Smithson*, New York: New York University Press, 1979.

Johnston, C., 'Women's Cinema as Counter-Cinema', in W. Nichols (ed.), *Movies and Methods*, Berkeley, CA: University of California Press, 1976, pp.208–17.

Jones, A., 'Tracing the Subject with Cindy Sherman', in A. Cruz and E.A.T. Smith (eds), *Cindy Sherman: A Retrospective*, London: Thames & Hudson, 1997, pp.33–53.

Joyce, L. and Orton, F., '"Always Everywhere": An Introduction to the Art of Jeff Wall (a Ventriloquist at a Birthday Party in October, 1947)', in *Jeff Wall, Photographs*, exhibition catalogue, Museum Moderner Kunst, Vienna, 2003, pp.8–33.

Krauss, R., 'Cindy Sherman: Untitled', in *Cindy Sherman 1975–1993*, New York: Rizzoli, 1993.

Leider, P., 'Books Received', *Artforum*, vol.2, no.3, September 1963, p.57.

Mulvey, L., 'A Phantasmagoria of the Female Body: The Work of Cindy Sherman', *New Left Review*, no.188, July/August 1991, pp.136–50.

Pelenc, A., 'Arielle Pelenc in Correspondence with Jeff Wall', in de Duve *et al.*, *Jeff Wall*, pp.8–23.

Phillpot, C., 'Sixteen Books and then Some', in Engberg, *Edward Ruscha: Editions 1959–1999*, vol.2, pp.58–78.

Pollock, G., 'Missing Women: Rethinking Early Thoughts on Images of Women', in C. Squiers (ed.), *The Critical Image: Essays on Contemporary Photography*, London: Lawrence & Wishart, 1990, pp.202–19.

Pollock, G., 'What's Wrong with "Images of Women"?', in R. Parker and G. Pollock (eds), *Framing Feminism: Art and the Women's Movement 1970–1985*, London: Pandora, 1987, pp.132–8.

Pollock, G., 'Woman as Sign: Psychoanalytic Readings', in G. Pollock (ed.), *Vision and Difference: Femininity, Feminism and the Histories of Art*, London and New York, Routledge, 1988, pp.120–54.

Risberg, D., 'Imaginary Economies: An Interview with Allan Sekula', in A. Sekula, *Dismal Science: Photo Works 1972–1996*, exhibition catalogue, University Galleries of Illinois State University, Normal, 1999, pp.236–51.

Roberts, J. (ed.), *The Impossible Document: Photography and Conceptual Art in Britain 1966–1976*, London: Camerawords, 1997.

Roberts, J., 'Photography, Iconophobia and the Ruins of Conceptual Art', in Roberts, *The Impossible Document*, pp.7–45.

Rosenberg, H., 'De-aestheticisation', in *The De-Definition of Art*, Chicago: University of Chicago Press, 1972, pp.28–38.

Rosenzweig, P., 'Sixteen (and Counting): Ed Ruscha's Books', in Benezra and Brougher, *Ed Ruscha*, pp.178–88.

Rosler, M., 'In, Around, and Afterthoughts (on Documentary Photography)', in *3 Works*, Halifax: The Press of The Nova Scotia College of Art and Design, 1981, pp.59–86.

Rosler, M., 'Notes on Quotes', *Wedge*, no.2, fall 1982.

Sekula, A., 'Allan Sekula: réalisme critique/The Critical Realism of Allan Sekula', interview with Pascal Beausse, *Art Press*, November 1998, pp.19–26.

Sekula, A., *Fish Story*, Dusseldorf: Richter Verlag, 1995.

Sekula, A., 'On "Fish Story": The Coffin Learns to Dance', *Camera Austria*, nos59/60, 1997, pp.49–59.

Sekula, A., *Photography against the Grain: Essays and Photo Works 1973–1983*, Halifax: The Press of The Nova Scotia College of Art and Design, 1984.

Smithson, R., 'A Tour of the Monuments of Passaic, New Jersey', *Artforum*, vol.6, no.4, December 1967, pp.48–51.

Wall, J., '"I am Not Necessarily Interested in Different Subject Matter, but Rather in Different Types of Picture": Jeff Wall Interviewed by Martin Schwander', in M. Schwander (ed.), *Jeff Wall, Restoration*, exhibition catalogue, Kunstmuseum, Luzern/Kunsthalle, Dusseldorf, 1994, pp.22–30.

Wall, J., '"Marks of Indifference": Aspects of Photography in, or as, Conceptual Art', in Goldstein and Rorimer, *Reconsidering the Object of Art*, pp.247–67.

Wallace, I., 'Jeff Wall's Transparencies', in *Jeff Wall: Transparencies*, exhibition catalogue, Institute of Contemporary Arts, London/Kunsthalle, Basel, 1984, pp.3–17.

Williamson, J., 'Images of "Woman" – The Photographs of Cindy Sherman', *Screen*, vol.24, no.6, November/December 1983, pp.102–16.

Wernburg, B., 'In der Bucht von Vigo: Ammerkungen zu Allan Sekulas "Fish Story"/At Vigo Bay: Comments on Allan Sekula's "Fish Story"', trans. S. Steinacher, *Camera Austria*, nos59/60, 1997, pp.81–7.

Wood, P. (ed.), *Varieties of Modernism*, New Haven and London: Yale University Press in association with The Open University, 2004.

CHAPTER 5

I/*Eye*/Oculus: performance, installation and video

Kristine Stiles

Introduction

Performance, installation and video are interdisciplinary media that developed in response to the unprecedented cultural and social conditions following the Second World War. However, whereas performance and installation have antecedents in modernism and roots in the aesthetic foundations of western art, the technology of video entered the art context only in 1965. The rapid development of these three media in the 1960s reflected the anti-commercial values of mid-century alternative cultures, and they remained marginal with respect to traditional visual art discourses until the late 1970s and early 1980s. In the absence of scholarly attention and institutional support, artists theorised their own work. But, by the 1980s and 1990s, scholars had begun to embrace performance, installation and video for the ways in which they embodied and recuperated the social and political aims of the historical avant-garde in a period increasingly characterised by the commercialisation of art. With its ephemeral presentational form, performance was more difficult to exhibit than installation and video, which (because of their status as objects) were easier to integrate into conventional art contexts than actions. Ironically, performance remains more frequently encountered in documentary photography, film and video than in live events. Moreover, the time-based aspects of these media complicated reception, as they frequently included viewers in the work of art itself, and often entailed kinesis (actual or virtual movement). With the augmentation of the real, performance, installation and video could be seen to undermine mimesis (imitation and illusion), the primary communicative means of traditional visual art.

Paradoxically, while these media must be dated to the twentieth century, the aim to overcome mimesis and introduce kinesis in the static visual arts is ancient. For example, the fifth-century BC Greek painter Zeuxis was legendary for having painted a canvas with grapes so realistic that birds attempted to eat them. Several centuries later, this kind of hyperrealism, along with the wish to represent movement, became the distinguishing mark of Hellenistic art. The realism of Pompeiian mural painting, renowned classical sculptures such as *Laocoön*, and the myth of Pygmalion could also be seen as attempts to move away from mimesis toward the real in art. In other words, artists have long sought to transmute inert matter and metaphorical representation into animated embodiment. This aim reached a new threshold in the Baroque in such works as Gianlorenzo Bernini's *Ecstasy of Saint Theresa* (1645–52), which presented art and religion at the intersection of theatre in the veritable union of mimesis and kinesis.

PLATE **5.1** (facing page) Gordon Matta-Clark, detail of *Conical Intersect* (Plate 5.15).

With the invention of photography in the nineteenth century, the new technology freed artists from the effort to produce mimetic images and they invented ever-more unexpected ways to connect art to the real world. For example, the nineteenth-century artist Edgar Degas attached all manner of extra-artistic materials, including a wig, a ribbon and a dancer's tutu, to his bronze sculpture *Little Dancer of Fourteen Years* (1880–1). Performance and installation were only a short step from such a work of art, and modernist movements from Cubism and Futurism to Dada, Surrealism and the various Russian avant-gardes included some aspect of both. By 1928, the German artist Oskar Schlemmer was even teaching a class he called 'Man' at the Bauhaus, in which he identified the body itself as appropriate material for visual art experimentation. This course reflected Schlemmer's belief that, 'We shall observe the appearance of the human figure as an event … with a certainty that is automatic, each gesture and each movement is drawn into the sphere of significance.'[1] The Dutch artist Piet Mondrian attempted to unite his painting practice with his social aims, and organised his studio/ apartment in various changing installations that demonstrated how his aesthetic principles extended from painting to social spaces. In an essay entitled 'Home– Street–City', he argued that 'Neo-Plasticism views the home not as a place of separation, isolation or refuge, but *as part of the whole, as a structural element of the city*.'[2]

The hiatus of the Second World War halted such aesthetic innovation, but a resurgence of hybrid artistic practices re-emerged internationally in the 1950s and early 1960s. At the same time, there appeared such publications as Robert Motherwell's *The Dada Painters and Poets* (1951), Robert Lebel's biography *Marcel Duchamp* (1959), and the travelling exhibition 'Dada: Documents of a Movement', which opened in Düsseldorf in 1958. These texts helped artists develop assemblages, environments, performances and installations from their sources in the traditional arts of painting and sculpture.[3] In the USA, Allan Kaprow, a pioneer of 'happenings', succinctly summarised this history when he wrote:

> The pieces of paper curled up off the canvas, were removed from the surface to exist on their own, became more solid as they grew into other materials and, reaching out into the room finally filled it entirely. Suddenly, there were jungles, crowded streets, littered alleys, dream spaces of science fiction, rooms of madness, and junk-filled attics of the mind.[4]

Kaprow's text must be read as a veritable genealogy of 'happenings', and it describes his own move from the production of self-contained objects to socially engaged events. This practice was influenced by Mondrian's social aims, the subject of Kaprow's master's thesis in Art History at Columbia University.

This brief summary of artists' attempts to move away from mimesis and stasis into the movement and reality of life reflects how performance, installation and video have radically changed, while being deeply embedded

in, the canons of visual art. In order to grasp the significance of *what* these new media have contributed to visual art, it is necessary to consider *how* they augmented metaphor (as the primary communicative vehicle of traditional visual art) with metonymy. Let us go back to mimesis to think through this issue. Mimesis operates through metaphor, or the illusion and representation of one thing (for example, a bird) in the form of another (a painting of a bird). As the philosopher and linguistic theorist Paul Ricoeur has pointed out, metaphor 'signifies both "*is not*" and "*is like*"'.[5] While performance, installation and video all use metaphor, their most distinctive and socially relevant quality is that they also communicate through metonymy. Metonymy specifies something by using the name of another thing with which it is *directly connected*. One could say metonymy signifies both '*is connected to*' and '*is like*'. For example: a person's shadow is a metonym of his or her body; a crown can be a metonym of the monarch. Thus, in the phrase 'The crown spoke to the parliament', the king or queen (one and the same with 'the crown') spoke to the parliament. Metaphor can express distance and difference from objects, nature and other beings, but is not a direct metonymic connection. Performance, installation and video reintroduced direct connection in art, by presenting human subjects who were doing real things similar to the actual human subjects viewing them, often in real-time situations and contexts actually linked to viewers. Metonymy, which undermined the traditional separation of the artwork from what it represents, is what made these media so difficult to write about and institutionalise. This is despite the fact that suspicion and discontent with metaphor in art – linked as it has been to mimesis and stasis – had existed for millennia. It could also be claimed that metonymy gave art the opportunity to enter into, and act upon, actual cultural, social and political situations, as it functioned in the new structures of art to link artists and viewers directly to real-time events and experiences. This important lineage enables appreciation of how art accommodates to the perpetually changing demands of cultural time with new forms, media and structures for communication.

We need to understand two apparently contradictory concepts when considering the history and contributions of performance, installation and video. First, these media are the result of artists' aims to produce a living art long sought after in painting and sculpture. Second, these media represent a relatively new aesthetic response to changed historical conditions, social practices and political divisions of space, as well as to changing natural environments and radical new technologies of representation and reproduction. It could also be argued that these are responses to an increasing urgency for responsible social action and interaction.

This chapter considers the overlapping and intersecting histories of these three media, beginning with provisional definitions of each. It moves to a discussion of their historical reception. Finally, it takes up specific examples of individual artist's works, while throughout thinking about how performance, installation and video all expand the capacities of visual art while remaining within its traditions.

Definitions

Performance

Performance is particularly indebted to painting, especially action painting, but also has roots in sculpture, music, dance, poetry, photography and new media technologies. Performances may have complex or simple structures, include narrative and scripts, or consist only of silent body actions and gestures that attend to the phenomenological conditions of place, time, space and interaction with objects. Performances often involve acute attention to kinesthetic and auditory relations (light, sound and motion). They may comprise socially motivated acts that engage large public issues and political experiences. Performance may be undertaken before a viewing public, may be participatory, interactive and collaborative, or it may be a solitary, private action. Performances are rarely given as mime, but may approximate theatre or stand-up comedy, even while focusing on the concept and identity of the artist. Performances often resemble ritual, psychological and sexual self-analysis or psychodrama, and in them artists enact the simple conditions and relations of everyday life and behaviour. Performances may be undertaken live and witnessed or performed for video, and they may be documented in still photographs, video, film and texts. They may even remain undocumented and circulate only in stories and rumour that lead to the production of myth.

The two most significant aspects of performance art are that the artist's body serves as the primary medium and that it communicates through both presentational and representational means. As representation, performance remains an aesthetic object of contemplation. But as presentation, performance exhibits actual subjects who associate with viewers in a subject-to-subject relationship. Such communication between human subjects increases the possibility for the social, cultural and political agency of art, artists *and* viewers. Moreover, emphasis on the artist as both a subject and an object renders the conventional art-historical fixation with biography and originality redundant. In effect, performance draws perception back to the act of making, and in so doing highlights an artist's particular imaginative processes. Reforming the very terms of the aesthetic exchange, performance illuminates the relationship between presentation, representation and reception in the formation of aesthetic meaning. In these ways, performance affirms the inextricable interrelationship between private experiences (biography) and the social production of art.

Installation

Installation art requires viewers to look beyond isolated objects to see the context within which a work is produced, presented *and* received. Because installations are situated in discrete cultural contexts, often relating to, or being inspired by, their direct environments, they draw art into a dialogue with the immediate material, historical and social contexts. One might think of installations as inhabiting sites, using media and often entailing a relationship to architecture. Installations investigate visual, perceptual and contextual

intersections of an unlimited range of subjects, objects, spaces and materials. While installations may include paintings and sculptures, they typically employ and assemble ordinary industrial, readymade, found and recycled objects and materials, as well as organic substances, natural elements like sound, light and movement, and various forms of technology (most often film, video or some form of multimedia). Installations may be permanent or temporary, situated in interior or exterior spaces, and are often interdependent with architectural contexts or natural environments. They are frequently site specific and responsive to, or determined by, a place. A distinction needs to be made between site-specific installation and non site-specific installation, in so far as installations may be self-contained works that do not refer to the actual physical characteristics of the particular location in which they are situated. Because of the infinite variety afforded by the materials and sites of installation, within and beyond art contexts, installation has become an increasingly popular and effective form for the expression of artists' aesthetic, social and political aims and values. Hybrid and adaptable, its versatility enables artists to use any material, situate the work in any locale, and have the flexibility to alter a work at any time. In this regard, installation can be a subversive medium able to communicate only with those who already understand its codes in a particular context.

Video

Video is a time-based electronic imaging technique, typically involving cameras for input, magnetic or digital media for storage, and monitors or projectors for display. Video may be used in real time to monitor or record and subsequently play back images, may consist of abstract or figurative forms, and may be displayed on closed-circuit systems, individual monitors, video walls and projections, or broadcast via commercial public access networks. Video art can take the form of a sculptural object, can be architecturally determined and responsive, can record a performance, can be utilised as documentary or can form a part of multimedia and interactive installations and performances. Video may also be used in conjunction with communication satellites, analogue or digital editing, storage and retrieval, and so forth. Many artists in the early days of video art believed that video, especially two-way video in which viewers might also be producers, had the potential to decentralise television and wrest control of content from corporate commercial programming and its one-way broadcasting model of distribution and consumption.

Performance, installation and video often appear together in a single work of art, and all three media share common characteristics that may be summarised as follows. First, the content, form and structure of these, often time-based, media require artists and viewers to engage in and observe temporal changes and duration over time. Second, they include a wide spectrum of aesthetic practices from representation to abstraction, as well as an infinite range of styles. Third, they engage viewers in situations in so far as they often entail a consideration of, or attention to, the experience of a person or place, and they enhance reciprocity between art and viewer as interrelated subjects.

Performance

Performance's early history

Compared with installation and video, performance art has met with a complicated and uneven reception. An understanding of the historical genealogy of the term 'performance' and how it came to denote a wide range of styles helps to explain its troubled history. Although the word 'performance' is now a generic referent for presentational art, artists (especially in the 1950s and 1960s) proposed many different labels to describe their performance practices: 'happenings', demonstrations, rituals and ceremonies; body, event, action, live and destruction art – to name just a few. Through these various appellations, artists sought to distinguish different stylistic expressions of, and conceptual orientations to, the body and its psychological, phenomenological, sociological and political situations and conditions of being. This proliferation of terms should *not* be misunderstood, however, as an inability to define the new corporeal art, but as signifying the rich variety of theoretical and formal qualities embodied in performance and its resistance to unifying theories.

Some examples will clarify this point. In 1955, the Japanese Gutai group chose the word 'Gutai' (meaning 'concrete') to reflect an aesthetic value that emerged from the group's desire to render art more material by transforming action painting into performance and installation. Kazuo Shiraga's *Challenging Mud* (Plate 5.2), in which the artist literally wrestled with the viscous earthy material, extending the act of painting into a physical event, exemplified this aim. Another group, the Situationist International (SI), aimed to reform urban experience by creating 'situations' that incited critical rethinking of the normative conditions of everyday life. Artists of Viennese Actionism, including Hermann Nitsch (Plate 5.3), Otto Mühl, Günter Brus and Rudolf Schwarzkogler, used the term 'action' to denote art with the capacity to intervene directly in and alter experience. Fluxus emerged in the milieu of 'happenings', new music, avant-garde dance and 'concrete' poetry in the late 1950s, and Fluxus artist Dick Higgins coined the term 'intermedia' to describe its new kind of hybridity.[6] Fluxus intermedia, moreover, stands at the intersection of art, culture, religion, politics and the most banal everyday life. An event by Alison Knowles – *Identical Lunch* (Plate 5.4) – is such a work. Described as her 'noonday meditation', Knowles (and other Fluxus artists) ate the same lunch, at the same time, at the same place, each day for an indeterminate period: 'a tuna fish sandwich on wheat toast with lettuce and butter, no mayo and a large glass of buttermilk or a cup of soup'.[7]

The term 'happenings' deserves special attention in the history of performance art. It first appeared in the title of an essay by Kaprow in 1958, and in the title of his event *18 Happenings in 6 Parts* (1959). Within five years, the term had entered Webster's Dictionary, where it was defined as 'a spontaneous, fortuitous, exciting and stimulating event, process, and occurrence'. The rapid cultural assimilation of this term is evidence of the success of Kaprow's aim to make art a paradigm for social engagement and political change, especially in the politically charged Cold War climate of the USA in the 1950s. Furthermore, 'happenings' could be considered practice for how to recognise,

PLATE **5.2** Kazuo Shiraga, *Challenging Mud*, 1955. (Courtesy of Hyogo Prefectural Museum of Art.)

responsibly enter into and appreciate the consequences of experience, as
well as aesthetic training for how to endow human activity with meaning.
'Happenings' also provided a politically engaged model for the development
of performance over the next thirty years. For example, performance art
became *the* primary political art in countries formerly behind the Iron Curtain,
in apartheid South Africa, in countries under military regimes in South and
Central America, and, after 1985, with the advent of the economic expansion
and social changes that accompanied globalisation, in China and south-east
Asia. Moreover, in China, where artists called their performances *xingwei
yishu*, or behaviour art, to emphasise their psychological origin and character,
the Chinese state, in retaliation, adapted the same term in an attempt to
manipulate its meaning by stigmatising these artists as socially and
psychologically maladjusted.

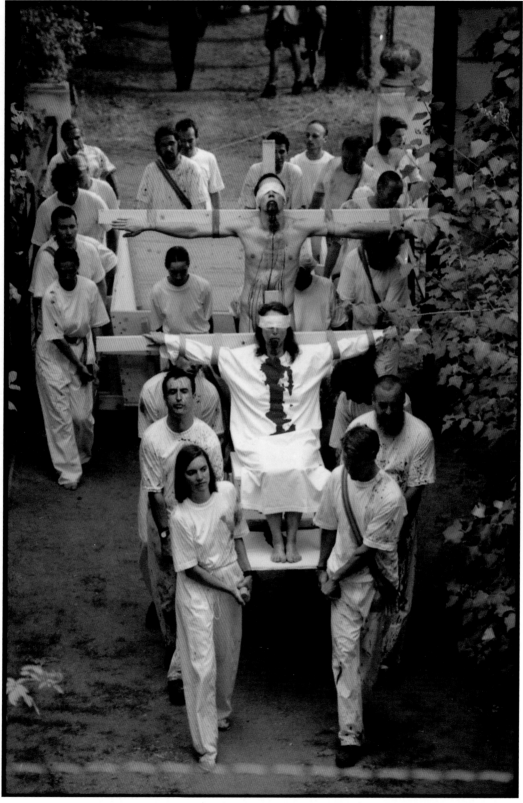

PLATE **5.3** Hermann Nitsch, *6-Play of the Orgies Mysteries Theater*, 3–8 August 1998. (Archiv
Cibulka/Heinz Cibulka. © DACS, London 2004.)

TUNA FISH
COMPLIMENTS OF
Star-Kíst Foods, Inc.
STEPHEN VARBLE PERFORMS
THE IDENTICAL LUNCH

PLATE 5.4 Alison Knowles, *Identical Lunch*, 1969, silkscreen prints, 43 × 43 cm. (Courtesy of the artist.)

This brief history vividly demonstrates why and how the term 'performance' inadequately describes the wide variety and complexity of live art. The term 'performance' also unfortunately aligns presentational art with entertainment, rather than with visual art in which the body becomes a medium for personal action in social and political circumstances.

I/Eye: performance in the 1960s

Works by Robert Morris and Carolee Schneemann (Plates 5.5 and 5.6) offer two early 1960s examples of the appearance of the body in art that provide a foundation for thinking about performance over the following four decades. In the late 1950s, Morris participated in Ann Halprin's avant-garde dance troupe in San Francisco. This moved to New York in 1960, where it became influential in the development of the Judson Dance Theater. Morris also belonged to the proto-milieu of 'happenings' and Fluxus, producing objects in a neo-Duchampian mode. His *I-Box* is a small, rectangular, plywood cabinet painted sculptmetal grey, in the middle of which is a hinged, wooden I-shaped door painted pink. When opened, the door reveals a photograph of Morris, head high, feet apart, hands at his sides, stark naked with a prominent, flaccid penis. Many of Morris's early works, like *I-Box*, make implicit reference to Marcel Duchamp's life-long discourse on the physiological and psychosexual aspects of perception, and reflect Duchamp's play with the voyeuristic and exhibitionistic conditions of corporeal display that often shape modernist viewing. But while the exterior of *I-Box* asserts the social self, linguistically presented as an ego-centred 'I',

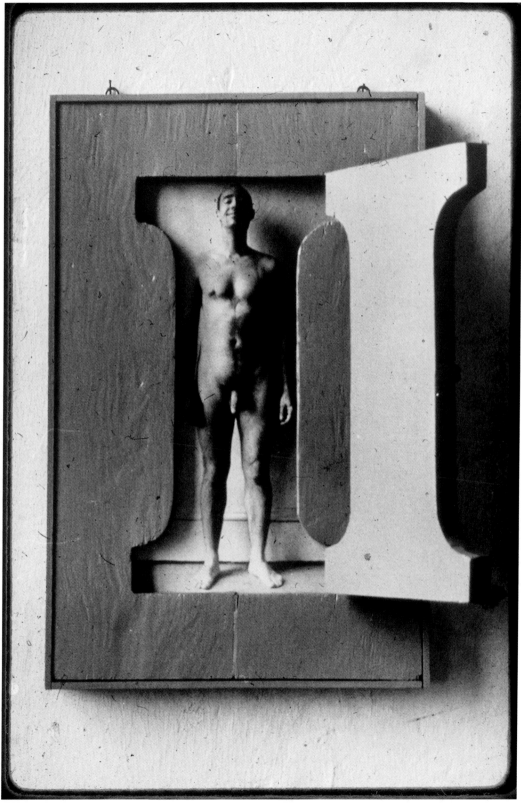

PLATE **5.5** Robert Morris, *I-Box*, 1963, mixed media, 48 × 32 × 4 cm. (Courtesy of the artist. © ARS, New York and DACS, London 2004.)

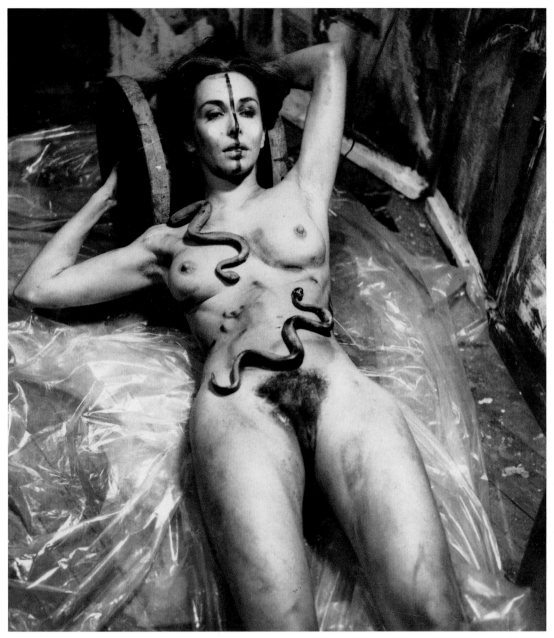

PLATE **5.6** Carolee Schneemann, *Eye Body – 36 Transformative Actions*, 1963. (Courtesy of the artist. Photo: Erro. © ARS, New York and DACS, London 2004.)

the interior space exposes a naked interlocutor to the viewer. In this way, Morris highlighted the close relationship between maker, made and viewer, for *I-Box* points to the interchangeability of subject/object positions across fields of viewing. Maurice Berger has described this operation as a decentred and arbitrary situation, hinging on the act of opening the door and the perpetual possession of the viewer's eye by the other 'I'. This work also reveals how fundamental to performance the exchange of subjectivities between artist and viewer always is.[8] In both ways, Morris's *I-Box* raises questions about changing conditions of subjectivity that compare to Schneemann's *Eye Body*.

Schneemann began as a painter in the 1950s and subsequently worked in every medium from drawing and printmaking to performance, multimedia installation, photography, film and video. *Eye Body* was a private performance she created in the intimate space of her studio-loft. Her friend, the Icelandic artist Erró (a.k.a. Férro, born Gudmundur Gudmundsson), photographed her performing *Eye Body*. Both *Eye Body* and *I-Box* exhibit photographic representations of nude artists, who directly engage viewers' eyes. But while both artists' performances ended in finite works of art – Morris's assemblage and Schneemann's series of photographs – the similarity ends there. For in *Eye Body*, Schneemann created a time-based work, physically immersing herself in an installation and surrounding herself with her own assemblages. Moreover, she adopted various positions for the camera such that her body became an aesthetic and erotic element in real time, and she changed positions quickly in order to enhance the unpredictability of her interaction with materials.

The images of *Eye Body* suggest many art-historical references, especially the predominance of female nudes in seductive poses, such as those in William-Adolphe Bouguereau's licentious paintings of the nineteenth century. But while early 'happenings' often employed the female nude as an erotic object, and Schneemann presented herself in this traditional mode, she also sought to produce an image of primal and archaic matriarchal force, challenging canonical representations of women by being 'AN IMAGE-MAKER' also capable of 'CREATING HER OWN SELF-IMAGE'.[9] In the most notoriously erotic photograph of the *Eye Body* suite, two rubber snakes crawl on Schneemann's belly and breasts, conjuring the canonical Minoan 'Snake Goddess' (c.1600 BC). Schneemann's pudendum and clitoris are visible in this intimate picture of female anatomy seldom seen outside pornography.[10] Schneemann gazes directly out from the picture in the unabashed manner of the young courtesan in Édouard Manet's *Olympia* (1863). In yet another photograph, she appears with a black line painted down the centre of her face, suggesting Henri Matisse's portrait of his wife, *The Green Stripe* (1905). The black line also refers to African masks and Pablo Picasso's prostitutes in *Les Demoiselles d'Avignon* (1907). Schneemann reinforced the Cubist reference in the only photomontage of the *Eye Body* series, in which she collaged repetitious photographic fragments of her face in order to shatter, extend and repeat her image. In another photograph, she reclines on her back, her legs protruding in a position similar to the female nude in the right corner of Paul Cezanne's *Large Bathers* (1898–1905). As a painter, Schneemann had long considered how Cezanne's interlocking passages *appear* to extend the body into real space. In *Eye Body* (and many subsequent performances), she sought to make that extension *actual* by transferring action from the illusory space of the picture plane to the real space of the room. To accomplish this, she overpainted her body and literally entered into the picture-as-installation in her studio, merging three previously differentiated viewing spaces – picture/body/real space. We might consider this as what I have called elsewhere the *'aesthetic of the transitive eye'*,[11] where eye/body unite the picture space and the viewer's space through the picture maker's projection of her body.

While Morris concerned himself as a maker, boxed into a naked interchange of egos (or 'I's) with the viewer, Schneemann attended to the spatial interstices of sight, surround and connection. She refused to accept disconnected autonomous objects and experiences in the manner that many critics of her period theorised as the project of modernism. Thus, while Morris's 'I' retains a subject–object relation inherent in conventional art, Schneemann drew the eye back to the body that also sees *in* the context of the 'scene' of the work, stating: 'What is seen is a scene wrapped around the body.'[12] Schneemann envisaged a similar 'scene' to be seen in her performance *Up to and Including Her Limits* (Plate 5.7), performed at the University Art Museum in Berkeley on 11 April 1974. This mixed-media event, including performance, installation and video, began when the museum opened and ended with its closure. During much of the day, Schneemann hung naked from a swing, perpetually moving in space, and drew and wrote on paper that she had installed on the floor and the wall around her. She envisioned her marks as hypnotic tracking devices, an automatic writing or trance form of drawing that transcribed her sensations and thoughts into words and images, and mapped her artistic and physical processes in time to feelings, sensations and needs that she could also communicate to the viewing public. Establishing the museum as an architectural extension of her life, Schneemann both

PLATE **5.7** Carolee Schneemann, *Up to and Including Her Limits*, 1973–6, performance: crayon on paper, rope and harness suspended from ceiling. (Courtesy of the artist. Photo: Shelley Farkas. © ARS, New York and DACS, London 2004.)

politicised *and* personalised this public space by treating the museum simultaneously as home, studio and public exhibition space, in a manner that recalls Mondrian's concept of 'home–street–city' cited above. Schneemann, who remained naked throughout the day, took breaks from her work in the harness to walk through the museum to attend to her personal needs and to interact with viewers, just as if she had been in the privacy of her studio-loft (as she had been in *Eye Body*). Intensifying the intimacy of the public space, she included Kitch, her eighteen-year-old cat, as a regular part of the installation. In this work, Schneemann sought to reduce the theatrical elements of performance by eliminating the proscenium (with its fixed audience), altering the fixed duration of performance (with its sequential development), foregoing rehearsals and the use of other performers (except Kitch), and abandoning a thematic metaphor. Rather than displaying or representing the body as merely 'a body', an emphasis that is all too often mistaken to be the aim of performance art, Schneemann sought to bring viewers into intimate contact with her artistic process in the actual production of her art. Thus, she invited the audience to witness her – literally up to and including her personal and social limits – in a direct and unguarded act of making, which wrapped 'a scene' to be seen around her body and metonymically connected to viewers, who also inhabited her performance space.

Performance in the 1980s–1990s

While performances in the 1960s and early 1970s emphasised the role of the body as a tool in making art, by the late 1970s performance appeared to have lost its critical edge. It was increasingly absorbed into the commercial markets for art, caricatured in Hollywood films and even sarcastically dubbed 'perfotainment'. This debased situation did not last long, for in the late 1980s and the 1990s performance was suddenly at the centre of 'the culture wars', when many countries, especially the USA, attempted to control and regulate artistic display of the body. During this period, artists used performance as a compelling mode to address the explosion of the world epidemic of HIV-AIDS, to comment on the state's attempt to control public expressions of sexuality and gender, and to protest war, among other things. A good example of the latter is Marina Abramovic's *Balkan Baroque* (Plate 5.8). Abramovic, who was born in Belgrade, dressed in a white floor-length ball gown and sat washing huge bloody bones that increasingly stained her beautiful dress. The aesthetic simplicity of her act sustained the sorrowful content of her lament for the violence of the Balkan wars.

From its inception, performance has been efficacious in visualising the circulation, surveillance, institutionalisation and control of bodies, even as its visual aesthetics remain largely misunderstood or ignored. In fact, performance is the only visual art medium to have been consistently suppressed by governments throughout the world, and the only visual art form for which artists have been continually arrested, jailed and fined. While many performances have been ridiculed as narcissistic and criticised as entertainment, I would argue that performance art remains the *only* art able to evade complete absorption in global capitalism. For, when the body becomes a primary material subject of representation, the personal becomes

PLATE **5.8** Marina Abramovic, *Balkan Baroque*, 1997, performance and video installation. (Courtesy of Sean Kelly Gallery, New York. © DACS, London 2004.)

the political, as feminists in the 1960s pointed out. The artist may use his or her body literally to reshape artistic discourse, while also contesting the cultural and political status quo.[13] Moreover, the efficacy of performance as a counter-hegemonic mode of social practice has drawn artists who use action in art to address race, class, the politics of sex and gender, and many other political topics, such as post-colonialism and globalisation. Finally, performance even became a model for what academics theorised as their own mode of critical 'resistance', as the plethora of publications on the subject of 'the body' that appeared in the 1990s suggests. However suspect, in cultural studies (particularly in the USA) academics even attempted to appropriate the political effect of performance by claiming that in 'performing the text' their writing became a performative mode of 'postmodern transgression'.[14]

Any discussion of the history, reception and political potency of performance must acknowledge the key role that feminism played in its development. Women artists have made major contributions to all styles of performance, especially to discourses of the body and the presentation of female-defined subject-positions with positive images of agency. They have aggressively countered representations of women as passive subjects and victims, and have made domination and violence against women and its traumatic aftermath a central theme in visual art. The Austrian artist Valie Export is a prime example. A founding member in 1967 of the Austrian Filmmakers Cooperative and a noted feminist artist, Export worked across media from

performance and installation to film and video, creating art informed by semiotics, structuralism and psychoanalysis. Export's early association with Viennese Actionism is exemplified in the physical stress of *Eros/ion* (1971), a performance during which she rolled nude over broken glass to signify the destructive and painful experiences of patriarchy for the bodies of women. Writing on the role of feminist performance art (which she refers to as 'actionism'), Export explained:

> Just as action aims at achieving the unity of actor and material, perception and action, subject and object, Feminist Actionism seeks to transform the object of male natural history, the material 'woman,' subjugated and enslaved by the male creator, into an independent actor and creator, object of her own history. For without the ability to express oneself and without a field of action, there can be no human dignity.[15]

Similarly, women performance artists, such as the American artists Adrian Piper and Coco Fusco, have attended to the deconstruction of race and otherness. Women have used performance to address such social questions as reproductive and genetic engineering, the construction of transgenic and cloned beings, and the cyborg prosthetic and post-biological body. The French feminist artist, Orlan, for example, has undergone numerous cosmetic operations to transform her face and body into a hybrid, and in the early twenty-first century she petitioned the French government to assign her body the new identity she had created based on its technological and artistic transformation. Women have not been alone in using performance to consider new technologies and scientific advances. For over thirty years, Stelarc, a Cyprus-born Australian artist, has dedicated his work to redesigning the body through the use of artificial intelligence and robotics, and has designed various prosthetic devices (like *The Third Arm*) that augment the body. Stelarc performed *Ping Body* (1995), an Internet performance that permitted Internet users to access, view and activate his body via a computer-interfaced muscle-stimulation system. This was the first electronic linkage to, and manipulation of, a body, whose muscles moved involuntarily through the interaction of remote participants. Stelarc's research explores how the external ebb and flow of Internet data may stimulate the body's proprioception and musculature, rather than the body being activated by its internal nervous system. As such work suggests, performance can serve as research on the body of the future. Performance consistently presents the body as the centre from which life may be imagined and lived differently.

Installation origins

The controversial history that distinguishes performance does not burden installation art, but shifts in the nomenclature related to installation art reflect ideological, technological and aesthetic changes in the medium throughout the twentieth century. Antecedents for installation before 1945 include Kurt Schwitters's *Merz* environments or assemblages of found commerical debris (1919–48), El Lissitzky's *Proun Room* (1923) and various installations by

Duchamp. One of the earliest postwar examples is Lucio Fontana's *Ambiente Spaziale* (1949), a temporary installation of ultraviolet light in the Galleria del Naviglio, Milan. This work was described at the time as an 'environment'. The term 'installation' only came into use with Minimal Art in the early 1960s, where it was introduced to distinguish it from the art-into-life ethos represented by assemblage, environments and 'happenings'. Minimalist installation included the display of a wide range of experimental media in abstract and non-figurative forms, installations that anticipated the style of much Conceptual, process, body and anti-form art installations.[16] The return of figuration in painting in the late 1970s ushered in a different style of installation, coinciding with the politics of identity that emerged out of the Civil Rights, women's and gay activist movements in the 1960s and early 1970s. This stage of installation presented a flexible mode for the display of otherwise seemingly incompatible media, a pluralism that also made possible the unification of widely divergent styles that often included images of or references to the figure. Installation in the 1980s and 1990s was increasingly characterised by networks of operations involving the interaction among complex architectural settings, environmental sites and extensive use of everyday objects in ordinary contexts. With the advent of video in 1965, a concurrent strand of installation evolved through the use of new and ever-changing technologies, and what had been simple video installations expanded to include complex interactive, multimedia and virtual reality environments.

Environments into installation: the 1950s and 1960s

Artists working in very different styles and media produced a host of environments in the 1950s and early 1960s, and shared an interest in using elements of popular culture in their work. These artists included the British Independent Group, the German Zero group, the French Nouveaux Réalistes and the international exponents of Fluxus (Plates 5.9 and 5.10). In 1966, Niki de Saint Phalle constructed a proto-feminist environment, *Hon* (*She*) (Plate 5.11), in the Moderna Museet in Stockholm. The interior of *Hon* consisted of an enormous (82 feet long, 20 feet high and 30 feet wide[17]) reclining female figure that the public entered through a staircase/vagina. Inside, *Hon* contained multiple environments, including a cinema for Greta Garbo movies, an aquarium, a planetarium and restaurants, such as a milk bar positioned inside one breast. This environment accustomed viewers to interact with and appreciate broader contexts for the production and construction of art. Such installations were temporary and often had interactive elements that resembled 'happenings'.

In 1966, at the height of the market for environments and assemblage, and the very year that Kaprow's influential book *Assemblage, Environments, and Happenings* appeared, the Jewish Museum in New York launched 'Primary Structures: Younger British and American Sculptors'. This exhibition marked the historical shift to installation that was characterised, in the early 1960s, by minimalist objects. Despite this shift, overlaps between the earlier 'happening'-like environments and the new reserved, geometric forms occurred, as with

PLATE **5.9** Yves Klein, *The Void*, Galerie Iris Clert, Paris, April–May 1958. (© Yves Klein, ADAGP, Paris and DACS, London 2004.)

Morris's *Column* (1961). Measuring two feet square by eight feet high, this hollow, plywood, grey-painted column was designed to contain Morris, who planned to perform inside it at a fundraising event for the proto-Fluxus publication *An Anthology*, published in 1963.[18] But after Morris was injured during rehearsals, *Column* performed on its own. Standing alone at the centre of an empty stage, it remained upright for approximately three minutes before falling to the floor (toppled by an invisible cord), where it lay prone for three minutes before the lights went out. *Column* was simultaneously an event, an object and a surrogate for the body. *Column* bridged Morris's dance and Fluxus work and his minimalist art, a transition that was complete by late 1964/early 1965 when Morris installed a range of plywood, grey-painted geometric forms in two exhibitions at the Green Gallery, New York (Plate 5.12), installations that many consider to mark the beginning of

PLATE **5.10**
Arman, *Full Up*, 1960. (Courtesy Arman Studio, New York. © ADAGP, Paris and DACS, London 2004.)

minimalism. In an influential essay, the artist Donald Judd described such works as 'specific objects' and argued that they dictated the perceptual processes of viewing by activating space through the distribution and interrelation of objects.[19] Two years later, in his essay 'Art and Objecthood', the modernist critic Michael Fried argued that the 'theatrical' effect of specific objects 'include[d] the beholder ... in a situation'.[20] Literalist art, as Fried called minimalism, was, according to him, a new genre of theatre 'at war' with modernism. We may now understand Fried's consternation as a rejection of the new metonymic association that enabled art to connect with the viewer – to be 'situational'. Fried argued that 'literalist' or 'situational' art threatened the status of static objects (a view he inherited from his mentor Clement Greenberg), and he rejected the politics implicit in art that reached beyond autonomous objects into the social and cultural conditions of the viewer's everyday life.

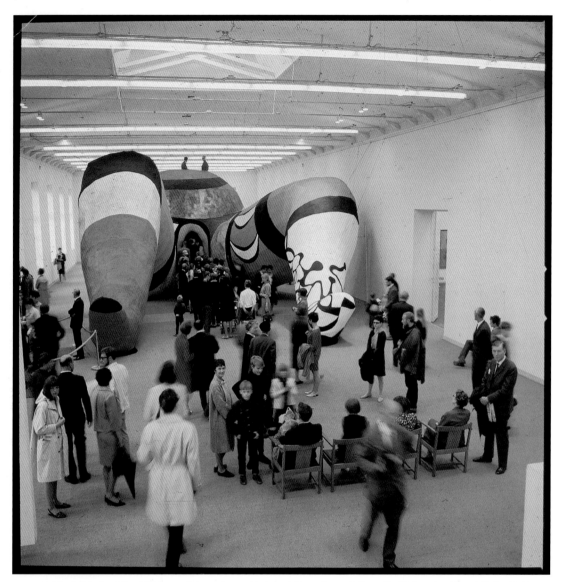

PLATE 5.11 Niki de Saint Phalle, collaboration with Jean Tinguely and Per Olof Ultyedt, *Hon (She)*, 1966.
(Photo: © Hans Hammarskiöld. © ADAGP, Paris and DACS, London 2004.)

By 1970, installation had become so prevalent and multifaceted that the French artist Daniel Buren would observe: 'Hasn't the term *installation* come to replace [the term] *exhibition*?'[21] His observation reflected the numerous international exhibitions that had featured installation, an explosion of styles that overlapped minimalism with process art, earthworks, sound pieces and even performance, all of which the American critic Lucy Lippard chronicled in her book on this vigorous period, *Six Years: The Dematerialization of the Art Object from 1966 to 1972*. Ironically, through installation art minimalism expanded into various styles associated with 'anti-form', which retained much of the disordered aesthetic of 'happenings' and Fluxus that minimalism had sought to displace. Such overlaps are succinctly revealed in the following

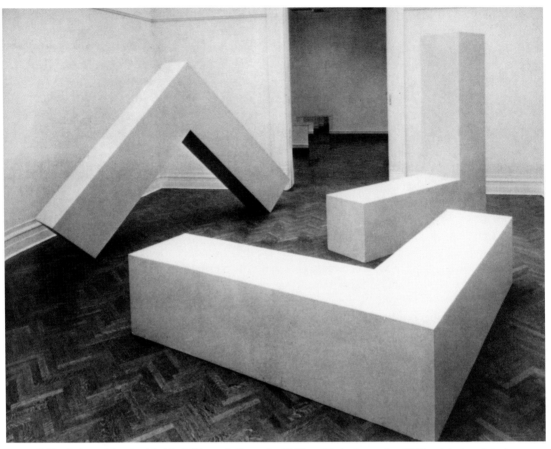

PLATE **5.12** Robert Morris, *Untitled* (Three L-Beams), 1969, refabrication of a 1965 original, painted
plywood, three units, each 244 × 244 × 61 cm. (© ARS, New York and DACS,
London 2004.)

brief history of 'digging a hole'. In 1956, in 'Outdoor Gutai Art Exhibition',
which took place in a park in Ashiya, Michio Yoshihara dug a hole in the
ground where he partially buried an electric light. Yoshihara's installation,
entitled *Discovery*, anticipated by eleven years Claes Oldenburg's *Placid Civic
Monument* (1 October 1967), where workmen dug and then filled in a
temporary hole in New York City's Central Park.[22] While each work belongs
to its own historical and social context and assumes a different physical
form, they both exhibit the fluidity of artistic practices between installation
and performance. Art-historical divisions into stylistically distinct movements
often obscure the fluidity between mediums and styles. Thus, minimalist
installation overlapped with many apparently different modes of production
and fused formalist concerns with different ideological, philosophical and
theoretical positions from Marxism to Structuralism, psychoanalysis and
phenomenology. Minimalism (and its related developments from Conceptual
Art to process art) also reflected the radical political positions of the New
Left of the 1960s, which rejected the heroic, poetic discourses of Abstract
Expressionism and existentialism, and emphasised communal anti-materialism.
Broadly speaking, such concerns are revealed in the so-called 'poor' material

of the Italian Arte Povera movement[23] and exemplified by Jannis Kounellis's installation of twelve live horses in the Galleria L'Attico in Rome (Plate 5.13). Other examples include the many public installations by Buren, consisting of uniform stripes, the work of dissident artists in South America, Eastern Europe and the former USSR and the installation art produced by feminists and artists of colour, especially coming out of the American Civil Rights Movement in the 1960s.

No corpus of work fused performance, installation and video with minimalist forms, expressionist aesthetics and political activism better than that of the German artist Joseph Beuys, and none has become more internationally renowned. Beuys came to public attention with his theory that sculpture (practised in the experimental forms of performance, installation and video) epitomised how the process of making art renders transparent the relationship between thought, behaviour and social systems. His comprehensive practice became a model for how art may be understood as a spatial metaphor for societal structures and how it can contribute to remaking cultural and political relations. Such thinking has become a hallmark and a veritable convention of installation. Beuys grounded all his work in highly charged performances, presentations whose content derived from his experiences as a participant in the Second World War fighting on the side of Nazi Germany. He used the material residue of what he called his *aktionen* (performed actions) to construct installations and objects. For example, in *Felt TV*, created in association with the German film maker Gerry Schum in 1968, Beuys covered

PLATE **5.13** Jannis Kounellis, *Cavalli*, 1969, Galleria L'Attico, Rome, 1969. (Courtesy of the artist.)

the screen of a television set with felt that blocked out the image but permitted sound to be heard. He transformed the visual into an audible experience and highlighted the key role of radio in transmitting Hitler's voice during the Third Reich. Wearing a felt suit and listening while facing the blank felt screen of the television, he began to hit his head with a pair of boxing gloves. Next he cut off hunks of a very large Blütwurst (German sausage) and then groped at the covered television screen with the Blütwurst. Then, using it in the manner of a 'Samurai sword' (his term), Beuys pressed the Blütwurst against the white walls of the space in which the action took place. A freestanding sculptural installation with the residual material objects resulted from this action. Such a work indicates how Beuys translated his relationship with the Third Reich into a work of art. He took up this theme again in *The End of the Twentieth Century* (1983), a large installation of twenty-one basalt blocks, each of which had a carved circle at one end. Installed carefully around a room, the massive stones lie atop each other and side by side. The configuration as a whole suggests dead bodies, an impression reinforced by the circular element carved at the top of each stone, which resembles an abstract face for the immobilised 'body'. This sober installation memorialises the millions of dead and the violence of the twentieth century, whose wars and regional conflicts included agents of mass destruction (from mustard gas and gas chambers to nuclear weapons and biological warfare), as well as genocide (from the Armenians and the Holocaust to the Balkans, the Kurds and Rwanda). The work demonstrates how, in installation art, the juxtaposition of carefully selected elements and materials can evoke powerful and moving impressions with minimal means.

Installations and alternative spaces: oculus

The alternative space movement was an important aspect of the development of installation art, and was aligned with resistance to the commercialism of galleries in the late 1960s and 1970s. Increasingly institutionalised in the 1990s, alternative spaces were originally housed in industrial buildings unrelated to the official artworld. These places were able to accommodate unconventional works of art and afforded artists freedom to exhibit all kinds of materials and to perform any sort of action. A good example of such installation practices is David Ireland's *Restoration of a Portion of the Back Wall and the Floor of the Main Gallery of the Museum of Conceptual Art*, 1976. The artist Tom Marioni founded the Museum of Conceptual Art, San Francisco in 1970, and mandated that all art made there must add to the history of the building without erasing its visual character. When an artist over-painted parts of the space in white, Ireland meticulously restored the interior walls and floor to their original worn, discoloured and mottled appearance. During the same period, Ireland also restored his own home, *500 Capp Street* (Plate 5.14), to its original condition, over time turning the nineteenth-century dilapidated frame building in San Francisco into a permanent installation and work of art. Such an installation anticipated decades of artists' interest in the interrelation of architecture and social experience.

Also an active participant in the alternative space movement, the American artist Gordon Matta-Clark literally cut into abandoned buildings to expose layers of the lived interiors of the built environment. Positioning installation in the context of New Left political ideals, he believed his 'cuts' might serve as a 'trigger to involve "the people" in ... the neighbourhood and the culture'.[24] Matta-Clark trained as an architect at Cornell University, worked as an artist, and matured in a social and conceptual milieu that contributed to the formation of his unique temporary installations in derelict and abandoned buildings. Matta-Clark sliced through large sections of walls and floors to reshape the interior spaces of warehouses and residences, admitting exterior light into dark industrial interiors through eccentrically shaped openings. After altering both the conceptual and physical experience of architecture, he photographed his work. The photographs reveal the uncanny sight lines and spatial paths he 'unbuilt' by cutting through space to dramatically reshape depth perception. 'The very nature of my work with buildings', Matta-Clark observed, 'takes issue with the functionalist attitude [which] has failed to question or re-examine the quality of life being served.'[25] Recuperating the 'throwaway environment' from its 'sad moment of history', Matta-Clark's cuttings examined urban renewal and redevelopment and addressed the quality of urban life.[26] In what is perhaps his most famous installation, *Splitting* (1974), Matta-Clark transformed a condemned suburban two-storey house in Englewood, New Jersey. He sliced vertically down its middle from roof to ground, suggesting not only its future demolition but the psychological conflicts of home as place and space. In the late 1960s and early 1970s, Matta-Clark participated in the urban renewal of New York's SoHo area. He played an

PLATE **5.14** David Ireland, *500 Capp Street*, 1975. (Courtesy of Jack Shainman Gallery, New York and Paule Anglim Gallery, San Francisco.)

important role in the influential alternative space 112 Greene Street, which hosted performance, installation, Conceptual Art and video art. He belonged to a circle with which he co-founded Anarchitecture, a group interested in transitional and non-instrumental aspects of architecture, which challenged conventional building practices.

Conical Intersect (Plate 5.15), Matta-Clark's contribution to the ninth annual Paris Biennale, displays many of these concerns. For this temporary installation, he secured two modest townhouses in the First Arrondisement built in 1699 and slated for demolition. They stood conveniently adjacent to the Musée National d'Art Moderne, Centre Georges Pompidou (Beaubourg), then under construction. These townhouses were among the oldest standing

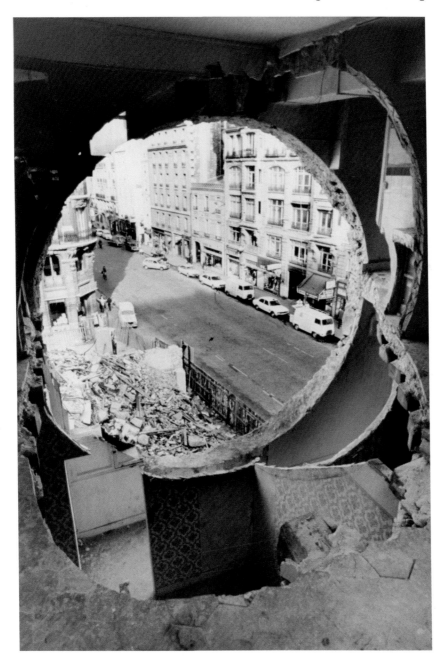

PLATE **5.15**
Gordon Matta-Clark, detail of *Conical Intersect*, 1974, triptych: three colour prints, 41 × 51 cm. (Courtesy of the estate of Gordon Matta-Clark and David Zwirner, New York. © ARS, New York and DACS, London 2004.)

buildings in Les Halles–Plateau Beaubourg district, whose small side streets had served as a hideout for students and workers during the uprisings of May 1968, and whose ancient cobblestones had offered convenient objects to hurl at Parisian riot police. Although urban redevelopment of Les Halles had been planned some twenty-two years earlier, the site of the Centre Pompidou had been carefully selected both to centralise contemporary culture in Paris *and* to quell the decentralising zeal of the 1968 student and worker revolutionaries. Under the pretext of breaking down the boundaries between elite ('high') and popular ('low') art by democratising culture, the Centre Pompidou centralised a range of cultural resources, including the national collection of modern art, a public library, a centre for industrial design, cinemas and a music centre.[27] The juxtaposition of Matta-Clark's work and the Centre Pompidou unveiled the destructive effects that historical progress sometimes entails. *Conical Intersect* became an architectural organ of sight, an oculus, providing a view of the industry of culture where it met the power of the state and where the interchange between architecture and the body is always social and political. Matta-Clark's twisted, cone-shaped cuts in the Parisian townhouses enabled viewers to gaze through the spiralling oculi to the Centre Pompidou (designed by Richard Rogers, Renzo Piano and the engineering group Ove Arup), exposing the corporate state centralisation behind the building.[28] (The shapes themselves were inspired by Anthony McCall's film-installation *Line Describing a Cone* (Plate 5.16), in which McCall projected a beam of light through a thin mist, making it possible to see how the light developed gradually from a line into a large cone as he drew a circle with light.)

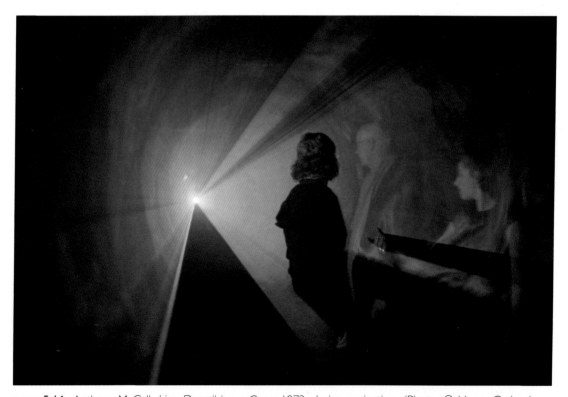

PLATE **5.16** Anthony McCall, *Line Describing a Cone*, 1973, during projection. (Photo: © Henry Graber.)

Installation and pluralism

From the 1980s to the present, installation art has increasingly included figuration as a vehicle for communicating the pluralism of identity politics, and many artists turned to figuration as a means to emphasise their difference from the previous minimalist-inspired generation. Some champions of minimalism and anti-form installation art vehemently opposed the inclusion of figuration for ideological reasons, arguing that the return to figuration represented a capitulation to viewers' demands for the recognisable, and therefore constituted a mentality vulnerable to the regressive authoritarian tendencies of the past associated with social realism.[29] This argument, however, failed to acknowledge how historical change alters critical contexts and how the figure had come to best communicate a wide variety of social concerns, from sexism, racism and homophobia to questions of national identity, memories of the Holocaust, as well as the interconnection between biological and environmental concerns. These topics and the implementation of the figure in all media led increasingly toward an aesthetic of inclusion and a commitment to diversity on the part of both artists and art institutions.

Installation art lent itself to this eclectic, activist programme and to the multiculturalism demanded by feminism. The first Feminist Art Program, founded in 1970 by Judy Chicago and Miriam Schapiro in Fresno, California, became a model for the development of women's art internationally. In 1972, together with many feminist artists, they established the programme 'Womanhouse' in Los Angeles in a building that housed many temporary installations focused on culturally neglected female experiences and women's issues. These included Chicago's *Menstruation Bathroom*, Sandy Orgel's *Linen Closet* and other woman-specific topical installations. Two years later, Chicago embarked on her massive installation *The Dinner Party* (Plate 5.17) at the San Francisco Museum of Modern Art. This collaborative work engaged some 400 artists in the creation of a triangular-shaped table set for thirty-nine guests and sited on a platform on which the artists had inscribed the names of 999 mythical and historical women. Each place setting comprised a ceramic plate, goblet and dinnerware, set on a place mat embroidered with the name of the goddess or woman it represented. The dinner plates themselves stirred extensive controversy for their butterfly/vaginal imagery.[30]

The Dinner Party, a canonical artwork of first-generation feminism, is often cited as 'essentialist' for its body-centred visual representations of female forms and symbols based on sexual difference and women's work and social roles. In this regard, Schapiro and Melissa Meyer coined the term 'femmage' in 1977 to identify the collage processes that women employed in domestic environments throughout the centuries, such as quilting, paper lace-making, and the use of quills, beads, scraps of cloth, photographs, birthday cards, valentines and clippings of all sorts in their work.[31] These subjects inspired numerous forms of installation, including some by male artists such as Mike Kelley, whose installations sometimes featured hand-sewn sock dolls, stuffed animals, handmade afghans and blankets. Kelley's installations invite interpretation as representations of male adolescent abjection and trauma. Ironically, while artists like Kelley learned and appropriated concepts from first-generation feminists, second-generation feminists committed themselves

PLATE **5.17** Judy Chicago, *The Dinner Party*, 1979, mixed media, 1,463 × 1,280 × 91 cm. (Collection of The Brooklyn Museum of Art, Gift of The Elizabeth A. Sackler Foundation. Photo: © Donald Woodman. © ARS, New York and DACS, London 2004.)

to deconstructing these very differences and values. Barbara Kruger, Jenny Holzer and Mary Kelly, for example, reshaped the identity politics of an older generation into an intellectual commentary on such topics as how patriarchal language constructs identity and gender. Moreover, women of colour began to criticise the fundamentally white feminist discourse and brought the discussion of 'otherness' into the debates. Adrian Piper, Lorna Simpson, Carrie Mae Weems, Sonia Boyce and many others questioned the racial constructs of language and bodies in performance, installation and video to deconstruct and reveal the underlying cultural assumptions deriving from colonialism and racism (Plate 5.18). In the 1990s, a third generation of feminists emerged, who often attempted to assimilate the best aspects of all these positions. New subcultures that fused feminism with environmentalism produced hybrid varieties such as eco-feminism, in which both male and female feminists have sought to extend the critique of patriarchal power relations to considerations of our relation both to the environment and to

PLATE **5.18** Adrian Piper, *Cornered*, 1988. (Courtesy of the artist.)

animals. The American artist Bonnie Sherk's *Crossroads Community*, better known as *The Farm*, 1974–80, anticipated such third-generation eco-feminism. In *The Farm*, Sherk installed a functioning farm in the middle of the main freeway interchange leading up to San Francisco in order to provoke a critical view of the relationship of the modern environment to that of traditional agriculture.

Installation has long been a medium used to address the environment, beginning with land art and earthworks and including research on light, sound and other perceptual phenomena. Such work often requires decades of planning. For example, James Turrell took over thirty years to design and realise his installation *Roden Crater* (Plate 5.19). Roden Crater is a cinder volcano situated on the south-western edge of the Painted Desert in northern Arizona. In 1972, Turrell began an installation in the crater that will eventually contain numerous underground chambers, ramps, staircases and a tunnel that leads to the crater bowl (3,000 feet in diameter), sculpted as an observatory and shallow celestial vault. 'The natural beauty of light used as sculptural material', Craig Adcock has written, 'will be conjoined with the physical power and spatial amplitude of the desert landscape in Turrell's interactive approach to light and his attention to the site-specific relationships of interior and exterior spaces.'[32] When finished, *Roden Crater* will be a permanent desert installation for the exploration of the perception of light and for philosophical and spiritual speculation on the cosmos.

PLATE 5.19 James Turrell, *Roden Crater*, the Painted Desert, Arizona, 1972 to the present. (© James Turrell. Photo: James Turrell. Courtesy Dia Center for the Arts, New York.)

Christo and Jean-Claude have also worked for decades using the environment in large-scale installations. Their work involves temporary wrappings of the landscape or the built environment and is often sited in metropolitan centres. *Wrapped Reichstag* (Plate 5.20), for example, took twenty-four years to realise, working with national, state and local government, and historical, environmental and cultural government and civil institutions. The Reichstag building was commissioned by the German Chancellor Otto von Bismarck to represent the history of modern Germany. It was completed in 1894 and housed the German Parliament (Reichstag). Although Hitler despised the Reichstag as a symbol of the Weimar Republic, during the Third Reich the German Luftwaffe used the building. With the liberation of Berlin in 1945, the Russians flew the flag of the USSR on the Reichstag, symbolising victory over Nazism. During the Cold War, the Reichstag represented the division of Germany, but with the fall of the Berlin Wall on 9 November 1989 and German reunification in 1990 it was renovated, and the German government returned to the building in 1999. Thus, the temporary wrapping of this historic building confronted the transformation of history, and the politics of place enacted in and through architecture across time.

Roden Crater and *Wrapped Reichstag* represent the versatility of installation as a medium in both natural and urban environments, and they show how installations may serve as 'oculi' for viewing the world. Once focused on the framing device of a building or a built environment, the viewer's eyes negotiate relationships between identity and place, whether place means the material conditions of history or a metaphysical conception of the universe.

PLATE **5.20** Christo and Jean-Claude, *Wrapped Reichstag*, 1971–95. (Photo: Wolfgang Volz. © Christo.)

Video

Woody Vasulka, the Czech film maker and early practitioner of video, once observed that technology has changed from being a specific tool to being an entire technological environment that suggests new creative potential for human discourse and opens new epistemic space for the construction of knowledge. One of the most significant ways video art has accomplished this potential has been to democratise the production of images, by virtue of being a medium free from canonical traditions and without a critical establishment. Because anyone could pick up a camera and make this form of art, video held the potential for cultural critique and, from the beginning, was understood as a technology for the production of anti-establishment imagery. '[Video] is television turned against itself.'[33]

Emerging at the height of the Vietnam War amid global political and cultural transformations, video's capacity for two-way communication and its rapid and inexpensive reproducibility promised to disrupt the hegemonic control of public and corporate-controlled media. Two-way communication encouraged interactivity and linked video with the goals of other experimental media (such as 'happenings' and installation), by offering examples of how to intercede in commercial media. Two examples of the ways in which artists accomplished this aim are provided by Douglas Davis in *Video Against Video*

and Martha Rosler in *Born to be Sold: Martha Rosler Reads the Strange Case of Baby S/M* (Plates 5.21 and 5.22). In *Video Against Video*, Davis asked viewers to participate by laying their hands on their television screens in an effort to reach across the technological divide to touch his hands within the monitor. Broadcast on Austrian television, Davis attempted to break through the normative one-way communication of television to provide a model for interactivity and responsible engagement in this medium. Fourteen years later, Martha Rosler created *Born to be Sold* in collaboration with Paper Tiger Television (a non-profit, volunteer, video collective, founded in 1981 for the purpose of exposing and critiquing corporate control of the media). For this work, Rosler appropriated television coverage of the highly publicised case of Mary Beth Whitehead, the surrogate mother of Baby S/M, who sued to keep custody of the child she had contracted to conceive through artificial insemination.[34] Rosler spliced together her own rigorous examination of public media, the American court system, and class and gender bias with media interviews of the principal parties and network news coverage of the dispute. *Born to be Sold* is an art performance that combines installation as a mode of social and political public address, and utilises video as the technology of transmission. These artists' works suggest new conditions for art practice in which video may have a direct impact on historical events and contribute to alternative ways of thinking and producing knowledge.

The pre-history of video dates from the nineteenth century, with the invention of photography and film, while the cathode ray tube, which made television

PLATE **5.21** Douglas Davis, *Video Against Video*, 1975. (Courtesy Electronic Arts Intermix (EAI), New York.)

images possible, was invented in 1907. London witnessed the first televised broadcast in 1936. In 1945, there were fewer than seven thousand television sets in homes in the USA, but by 1952, twenty million viewers had television sets. Colour television arrived in 1965 and, less than four years later, on 20 July 1969, millions of viewers around the world could watch the astronaut Neil Armstrong walk on the moon. At the same time, they could also view the body bags containing dead soldiers returned to the USA from Vietnam. In 1964, in the middle of this tumultuous period, Nam June Paik (working in Japan with Shuya Abe) developed the hand-held Sony Portapak camera. The following year, he acquired his first non-broadcast, portable, half-inch video recorder, a Sony video camera, in New York. On his way home from making this purchase, Paik videotaped Pope Paul VI's visit to New York City and showed the tape that night at the Café a Go Go during a series of Fluxus performances. This was the first use of video in an art context, and an example of Paik's belief that artists should use video to engage directly in society and real-time politics. Paik wanted to capture the vibrant quality of popular culture. Paik's now-classic video *Global Groove* (Plate 5.23) is a vivid montage of images and a video manifesto on the media-saturated world of Marshall McLuhan's 'global village'.[35] It includes people such as the artist Charlotte Moorman, the composer John Cage, the beat poet Allen Ginsberg and the then President of the USA Richard Nixon juxtaposed with pictures from

PLATE **5.22** Martha Rosler and Paper Tiger Television, *Born to be Sold: Martha Rosler Reads the Strange Case of Baby S/M*, 1988. (Courtesy Electronic Arts Intermix (EAI), New York.)

PLATE **5.23** Nam June Paik, *Global Groove*, 1973, picturing Charlotte Moorman. (Courtesy Electronic Arts Intermix (EAI), New York.)

Japanese television commercials, Korean folk dancers and dancers syncopated to rock 'n' roll, among other images. In what Paik termed 'Participation TV', a voiceover asks viewers to open or close their eyes to subvert the smooth flow of television sequencing, narrative and temporality.

In its sense of timing, *Global Groove* exhibits Paik's training as a composer of avant-garde music and his early association with the new music milieu of Fluxus, in which he became a key participant. A brief look at this early history also grounds the origins of art video in the German avant-garde, new music and Fluxus circles. Paik matured in the context of the international avant-garde in Germany in the late 1950s, where, in 1958, Wolf Vostell first began to use technical and electronic devices and flickering television screens as sculpture. Vostell introduced Paik to Fluxus and to the use of television as an artistic medium, while both individuals belonged to the circle of Cage and Karlheinz Stockhausen, then teaching in Darmstadt. In 1963, Paik staged his first exhibition of televisions at the Galerie Parnass in Düsseldorf. He acknowledged the influence of Karl Otto Götz, an experimental film maker and exponent of *Art Informel*, who taught at the Düsseldorf Art Academy and whose work had motivated Paik to think about kinetic images.

Götz's films are considered by some critics to be significant historical links to avant-garde experimental films and, thus, to video art. They anticipated the important contribution to the history of video made by the German artist Gerry Schum. In September 1967, Schum encountered an exhibition at the

Galerie Lohr in Cologne of impermanent, apparently unsaleable process-works, using water, air and sand, by artists including Jan Dibbets, Barry Flanagan, Richard Long and Bernard Höke. Trained as a film maker, Schum immediately began to conceive the idea of a 'TV gallery' (the Fernseh Galerie, based in Berlin) by means of which he would broadcast specially made works of art on mainstream television. Schum worked with Ursula Wevers on this project, the most important result of which was *Land Art*, a fifty-minute programme consisting of a sequence of artworks conceived for the medium of television. This was shown on West German television without commentary in April 1969. Following on from this, Schum organised two, one-man television exhibitions, *Self-Burial* by Keith Arnatt and *TV as Fireplace* by Jan Dibbets. The Arnatt piece consisted of unannounced insertions into the normal evening television broadcast of West Deutsche Rundfunk III, each lasting several seconds, of still images from a sequence of the artist being buried in the ground in a standing position. The Dibbets piece appeared at the end of the evening's viewing each night for a week, for a duration of three minutes. After the regular broadcast ended, an image of a fireplace filled the screen. At the beginning of the week, the fire slowly began to burn, by mid-week it was in full blaze, and at the end of the week it burned down.

The broadcasts of *Self-Burial* and *TV as Fireplace* exemplify guerrilla television in the way they subverted regular programming and introduced avant-garde concepts and images on television. While Schum hoped to engage a broad audience in avant-garde art, other artists with whom he worked were divided about this aim. A 1979 sampling of their views expresses the diversity of opinion held by the very artists who were instrumental in early practices of video. Buren, for example, insisted that Schum's television gallery 'proved all over again that only those people who were already interested in the most recent manifestations of visual art had any interest in this [Schum's] gallery'. Richard Serra argued that 'art is not suitable for mass communication, except when it is especially made for that purpose', and Hamish Fulton believed that 'Gerry Schum presented alternative ways of making and of showing contemporary art to a large public, and … [that] any expansion of possibilities regarding the studio-gallery-collector triangle must be good.'[36]

The democratic promise of video did not, however, prevent it from becoming an aesthetic commodity, just as commercial television's utopian potential did not save it from becoming a primary vehicle for advertising. Artists themselves took advantage of the commercial aspects of video. Schum sold his own and other artists' videotapes (artists such as John Baldessari and Bruce Nauman) from his Düsseldorf gallery. The art dealer Nicholas Wilder made the first sale of an artist's video in Los Angeles when he sold Nauman's *Video Pieces A–N* (1968–9) to a European collector in 1969. In 1971, the New York dealer Howard Wise founded Electronic Arts Intermix, a non-profit organisation to support video as a means of creative expression. During this period, several museums also took an interest in video, culminating in the Everson Museum of Art in Syracuse, New York establishing a video department in 1971 that housed a public closed-circuit viewing gallery. The same year Woody Vasulka and Steina Vasulka (a violinist from Iceland) founded The Kitchen, a uniquely interdisciplinary alternative space for video, experimental art (performance and installation), and experimental music and dance in New York City.

Like Paik, the Vasulkas were among the first artists to explore the inherent properties of video as a medium, investigating analogue and digital processes and developing electronic imaging tools that enabled them to experiment with various qualities and conditions of perception. *Noisefields* (Plate 5.24) is an example of this research. It comprises a constantly changing, vibrating circular sphere that appears streaked with electronic fuzz on the rectangular ground of the monitor, which is itself aglow with electronic snow. At times, the circular shape appears as a black or white figure on the contrasting black or white ground of the monitor; at other times, it appears as a coloured sphere on a different coloured ground. Image and ground flicker in a rapidly changing rhythmic interplay between image and sound, resembling flicker films that explore luminous motion. A recurring beat accompanies the high-speed flicker and keeps time with the constantly self-modifying real-time image. The visual simplicity and yet rapid vibration of the circular form on the monitor's square visual field, together with the richly changing colour variations, result in a hypnotising, mandala-like visual meditation. 'We look at video feedback as electronic art material', Woody Vasulka has pointed out. 'It's the clay, it's the air, it's the energy, it's the stone … It's the raw material that you … build an image with.'[37]

Video enabled artists to reflect on images of themselves and on their relationship with the camera. This self-reflexivity made video an excellent medium to use as live feedback to document performance and body art.

PLATE **5.24** Woody Vasulka and Steina Vasulka, *Noisefields*, 1974. (Courtesy of the artists.)

These qualities prompted Rosalind Krauss to view artists' performance videos as a kind of 'narcissism'.[38] Vito Acconci's *Air Time* (1973) suggests why. During the video performance, Acconci sat between the video camera and a large mirror, conducting a thirty-five minute monologue with himself, and addressing the 'I' and 'you' of his own image. While Acconci intentionally conjured the narcissistic effect (made possible by video), this is just one of many uses of video. Many video installations, for example, engage viewers in the production of imagery itself. Dan Graham's installation *Opposing Mirrors and Video Monitors on Time Delay* (1974) positioned a series of mirrors, television monitors, cameras and recording decks in such a way that viewers could explore the process of viewing and being viewed, could consider the relation between surrounding architecture and illusionary space, and could focus on the time-present transmission of the medium.

Moreover, with the advent of new electronic technologies, video became more complex, as represented by Bill Seaman's multimedia installation *The World Generator/The Engine of Desire* (Plate 5.25). This work uses computer-based virtual reality, video and computer-controlled laser-disc to enable viewers to combine texts, sounds and image units in what Seaman calls 'recombinant poetics'. Discussing the 'profound technological changes that impact upon how people communicate, share knowledge, and learn', Seaman believes that 'by being interwoven [with] … and expanded [from] computer-based environmental semiotics', such technologies are changing working methods, ways of seeing, the environment and, ultimately, the future.[39] Seaman's work trains and stimulates viewers to interact differently with representational systems in the technological environment. Such use of technology shifts attention to electronically mediated and enhanced bodies, highlighting the trope of interactivity that runs throughout twentieth-century art at the juncture of performance, installation and video. Moreover, as bandwidth has increased and video and voice have become part of everyday computer communications, video conferencing has also become common, while text-based information increasingly includes video. Finally, the convergence of telephone, television and the computer disrupts historical distinctions between computing, communication and mass media, while digital and electronic media render more explicit and transparent the pervasiveness of how lens culture can affect notions of truth and evidence. Video is, and will continue to be, central to these concerns, especially as we move toward becoming a surveillance society.

PLATE **5.25** Bill Seaman, *The World Generator/The Engine of Desire*, detail of one potential constructed world, 1996 to the present. (Bill Seaman with Gideon May Programmer.)

Surveying *I/Eye*

As the use of technology by artists has continued to advance, an increasing number of institutions have been founded to study and exhibit this art. The Media Museum of the Centre for Art and Media (Zentrum Medium Kunst), founded in Karlsruhe in 1999, was the first museum of interactive art in the world, showing art at the intersection of technology, media and information technology. The Austrian artist Peter Weibel, its first director, began as poet before associating with Viennese Action artists with whom he did performances. Later, Weibel (together with Export) explored the expansion of film – or 'expanded cinema' – into video and installation. Weibel's career exemplifies the thirty-year interconnection and interdependence of the history of performance, installation, film and video as avant-garde media. It should therefore come as a surprise that the first video installation collected by the Metropolitan Museum in New York was Bill Viola's *The Quintet of Remembrance* (Plate 5.26) and that this purchase occurred only in 2000. This delay demonstrates the conservative climate for art and technology, particularly in the USA, and prompts us to ask why it took so long for the Metropolitan Museum to add video to its collection, and why it acquired this particular work.

The Quintet of Remembrance comprises a central figural group that resembles Renaissance painting in its visual precision, frontal composition, pyramidal formation of figures, crisp, clearly defined shapes and jewel-like colours. The figures press close to the foreground and appear in stark, bright light against a dark background, a compositional device that attests to Viola's interest in Carravaggio's dramatic use of *tenebroso*, or the shadowy settings that envelop figures in much seventeenth-century painting. Viola's video shows three women and two men of different ethnic backgrounds, ages and stages of mid-life, who seem to belong to the middle and working classes of the late twentieth-century USA. They look thoughtful and concentrate on something happening outside the picture frame. They seem intelligent and self-reflective. While the picture initially appears to be static, it changes imperceptibly. Astonished viewers suddenly discover that the tightly clustered group moves

PLATE **5.26**
Bill Viola, *The Quintet of Remembrance*, 2000, video installation. (Photo: Kira Perov.)

and that each individual slowly reveals emotions, ranging from joy, fear, shock and confusion to anger, sorrow and mourning. Viola used a high-speed, 35-mm film camera (the WillCam), able to shoot at 160 frames per second. He filmed the action at 140 frames per second, and then slowed it to run on a continuous loop for sixteen minutes and nineteen seconds. Movement is so infinitesimal that every gesture and facial expression becomes monumental.

As a time-based medium, video calls attention to the perceptual and psychological tensions in various qualities of time, not only past, present and future, but in duration from continuance, persistence and transience to synchronism, permanence, recurrence and frequency, among a host of other temporal modalities. Time in video also requires emotional and physical engagement such as anticipation, expectation and preparation. Cause and effect, destiny and memory are factors in temporal expressions, as are different experiences of duration from the definite to the endless. In a similar way to *The Quintet of Remembrance*, Douglas Gordon's *Monument to X* (1998) and Andrea Bower's *Waiting* (1999) anticipated this use of time. *Waiting* is a forty-five second, laser-disc video projection in which an adolescent figure skater crouches on the ice motionless on hands and knees, waiting for the music of her routine to begin. The drama of the scene occurs in a barely perceptive act when she lifts her cold hands from the ice, curling her fingers to warm them. Only then does the condition of her physical reality – and our sense of time – make Bower's otherwise static Degas-like image into a moving picture, a video. The artist captivates attention through anticipation, and draws out empathy through gesture. Similarly, in his fourteen-minute video projection *Monument to X*, Gordon extends a kiss in time, arousing erotic responses in viewers-turned-voyeurs, who watch the timeless theme unfold in slow motion. Gordon has long explored problems of duration in a variety of different applications and installations of video. All three artists (Viola, Bowers and Gordon) use time to augment the intimacy of watching and feeling, watching feeling and feeling oneself watching. Viola has explained: 'I was always fascinated by the paradox that the closer you get to look into another eye, the larger your reflected image becomes on that eye, blocking the very view within you were trying to see.' 'Looking into the eye', he continued, 'is the original feedback image, frames within receding frames, the original self-reflection.'[40]

The primary appeal of *The Quintet of Remembrance*, however, is the experience of surprise, an entrapment based on the thrill of spectacle supported by the video's visual splendour. The difference between Viola's work and more experimental video is exemplified in Acconci's *Open Book* (Plate 5.27), a work that also employs slow motion for its effect. Acconci appears close up, the camera is fixed on his face, and the production value is grainy footage. When Acconci speaks, only his mouth, lips, teeth and tongue show. His utterances cannot be understood even when the text of his discourse is provided on an adjacent panel: 'I'll prove that I'm open: I'll show you. But if I don't tell you, you won't understand. But now, if I talk, you can't make out the words. But then, if you could make them out, you'd see I'm closed up. You'll never believe me again.' Acconci drones on and on in what has become a hallmark of his narrative style, distancing viewers from identification with him in a manner that suggests the theories of the German

PLATE 5.27
Vito Acconci,
Open Book, 1974.
(Courtesy Electronic
Arts Intermix (EAI),
New York.)

playwright Bertolt Brecht. Brecht's notion of *verfremdungseffekt* ('alienation effect') was a strategy *and* a method for creating critical detachment in his viewers. Many video artists, especially those questioning the one-way communication of commercial television, used Brechtian techniques to prompt audiences to exercise their critical judgement. In precisely the opposite of spectacle, Acconci sought to uncouple viewers from his message and disrupt the supposed intimacy of thinking that one might read another as an 'open book'.

Gary Hill's video installation *Tall Ships* (Plate 5.28) also employs a Brechtian mode of estrangement. It consists of a completely dark, carpeted corridor that measures 10 x 10 x 89 feet. Sixteen, four-inch black-and-white video monitors with angled projection lenses are mounted approximately every ten feet in the space, alternating from side to side along the ceiling's centreline. The last projection appears on the back wall. Like *The Quintet of Remembrance*, *Tall Ships* is silent and pictures a variety of ordinary people. But here all resemblance ends. Rather than the sharp-focus colour images in *The Quintet of Remembrance*, the figures in *Tall Ships* fleetingly appear in a blurred blue vapour, a colour that is the result of the acute angle of the video projections. Movements by viewers trigger a sequence of mechanisms in the installation that cause the figures themselves to move. As a result, they appear to respond to viewers and, in fact, slowly advance from a distance to come close and then fade like spectres that evaporate from existence. Hill permits only transitory moments of communion. The work suggests that, like the tall ships that inspired Hill with their silent majestic passing, so people pass in and out of each other's lives without speaking or knowing one another, evoking the haunting phrase, 'ships passing in the night'.

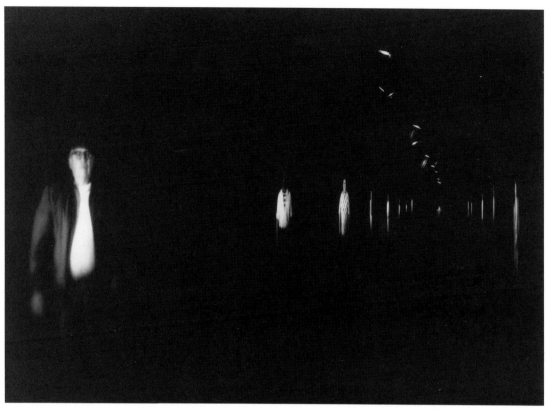

PLATE **5.28** Gary Hill, *Tall Ships*, 1992, sixteen-channel video installation. (Courtesy Donald Young Gallery, Chicago. Photo: Dirk Bleicker.)

Hill often explores the phenomenology of experience, situating the body between technology and corporeal gestures at the centre of the enigma of human relationships. In this regard, *Tall Ships* could be said to relate to his video installation *DISTURBANCE (Among the Jars)* (1988), in which the philosopher Jacques Derrida appeared. Grappling with the experience of seeing himself in *DISTURBANCE*, Derrida wrote: 'Perhaps the video event, among others, reveals precisely the problematic fragility of this distinction between an internal determination and an external determination.'[41] Derrida's comments may have inspired *Tall Ships*, wherein the figural phantoms vividly simulate the mystery and strange intimacy of interpersonal encounters that fleetingly conjoin internal emotion with external encounter. In *Tall Ships*, Hill fabricates the ephemeral experience of transitory familiarity, at the same time as he frustrates any real connection between viewer and image. While Hill's work is often known for its exploration of the interrelationship between language and image in the construction of meaning, *Tall Ships* abandons verbal language to vague and haunting bodily encounters with spectral strangers. Indeed, the hush in which *Tall Ships* unfolds imbues the work with one of its most powerful qualities. For multimedia video installations are

rarely silent, and it is the quiet through which these mute figures move as determined illuminated presences that is so spellbinding. Comparisons with painting seem apt. Recalling the silent engagement of a portrait gallery, vision is drawn into an image whose synchronous affect prompts feelings and associations that exceed the ability of language to describe, leaving one with an eerie emotional bond to a figure that does not exist. The difficulty of stating how meaning is produced in such brief corporeal exchanges calls to mind Ludwig Wittgenstein's comment that, 'What we cannot speak about we must pass over in silence.'[42]

While the exchange between viewer and ethereal presence in *Tall Ships* is strange, it is not as uncanny as the sinister records of human activity produced in and videotaped by surveillance society. Video artists have been increasingly concerned with surveillance and how it renders the public stable and submissive. For example, Jordan Crandall uses surveillance to expose the very systems of power, control and voyeurism that support such a use of video. In *Drive* (1998–2000), a seven-part video series that includes a two-channel video installation and DVD, Crandall deploys multimedia, interactive installations to explore the spectacle of the panoptic eye, refusing viewers a comfortable association between the new technologies of visualisation and painting. Viewers are bombarded in *Drive*, plunged into what Crandall describes as proprioceptive engagement in which they will realise how technology invades embodied space and renders it disembodied. *Drive* undermines the age of information and communication by demonstrating how bodies collide with machines in the twenty-first century without knowledge or permission. To accomplish the visual impact of surveillance technology that lurks in urban spaces, Crandall exposes viewers to random images, moving between slow and fast shots, flashes of things, activities, places without apparent relation: a wrist flexes, colourful urban streetscapes appear, bodies move, a teenager runs down a dark alley, an eye blinks. To enhance this uncanny, even creepy, sensation of being watched, Crandall incorporates the strange green tinge of the telescopic crosshairs and infrared of military tracking technology. *Drive* must be understood within the state's paradigm of 'productivity, efficiency, and economy', as Casey Ruble notes. It betrays 'a world busily decoding the genome, engineering handguns and personal computers (that can instantaneously recognise their owners), and biochemically altering groceries that (for customer convenience) are now available for purchase on-line'.[43]

Matthew Barney's epic five films of the *Cremaster Cycle* (1994–2002) cannot be overlooked in this context. The series of *Cremaster* films has its origins in Barney's multimedia performance, installation and video works, and the early films were made as videos. Barney designed the *Cremaster* sets, which unfold cinematically as well as in photographs, drawings, sculptures and installations. He also directed the films, and performed a myriad of roles and hybrid identities, ranging from a satyr and a ram to the escapologist Harry Houdini and the infamous serial murderer Gary Gilmore, whose celebrated 1976 court case caused a nationwide debate in the USA over the use of the death penalty. The conceptual departure of Barney's highly personal, hermetic and self-enclosed aesthetic system is the cremaster, a muscle that controls testicular

contractions according to bodily temperature, external stimulation or fear. The cycle includes many allusions to the body and sexuality and employs striking contrasts, especially of various kinds of sport with surrealistic sets and costumes. History, mythology and Barney's own autobiography inform this combination, especially his experience of playing football and of modelling. Moreover, the films are set in a wide array of locales. For example, the final work in the series *Cremaster 3* takes place in the Chrysler Building and the Guggenheim Museum in New York, as well as at the Saratoga racetrack (upstate New York), the Giant's Causeway (Ireland) and Fingal's Cave (the Scottish isle of Staffa). This visual spectacle is woven through Barney's rich and dense cosmology and layered, interconnected themes, and serves to exhibit his increasingly dark meditation on the violence of technology, sports and sexuality in the post-biological age.

In very different ways, both Barney and Crandall document how the body is now mapped as pure information in order to be located within networks of anonymous authority and domination. They also explore how scopophilia (the desire to look at sexually stimulating scenes) is tied to these technologies to create an increasingly invasive physical environment. Video vividly depicts our mechanical, technological and psychological fate, which appears foreboding.

Conclusion

Viola has observed that, 'these things called eyes exist and ... they can perceive the world around us ... Eyes [are also] "condensates" of the environmental field over eons of time, in the way that a thorn on a bush presumes the existence of something that is going to eat or harm the bush.'[44] Performance, installation and video are all media through which the surveying eye of conventional aesthetics simultaneously turned inward on the existential 'I' and out beyond the traditional frame of art as an oculus on the world. This chapter has presented performance and video as time-based media through which the personal ego (and its linguistic representation as 'I') engages the embodied 'eye' directly and immediately. Video and installation have been discussed as aesthetic and technological media able to deploy the image of the body as an oculus surveying and constructing the social world in the built environment. Together, performance, installation and video are part of the evolution of art as it adapts the I/*eye*/oculus to unprecedented technologies and cultural experiences of the last and current centuries. This is what Viola meant when he wrote that the eyes are the '"condensates" of the environmental field over eons of time', evolving visual survival tactics for the dynamic interaction of art in life. Thus does the personal 'I', whose 'eye' views the world, construct its habitat and political territory in its own image as an oculus on and of the world. Thus do performance, installation and video function as bridge media, underlining the need for responsible social interaction as they link traditional art to new historical and political conditions, to changing natural environments and to radical new technologies of representation.

Notes

1 Schlemmer, 'Theater'(1925), in *The Theater of the Bauhaus*, p.92.

2 Mondrian, 'Home–Street–City' (1926), in *Mondrian*, p.11.

3 Assemblage is a three-dimensional development from the two-dimensional practice of collage. 'Environments' is the term used into the late 1950s to designate assembled spaces and constructed sites in which both sculpture and 'happenings' took place.

4 Kaprow, *Assemblage, Environments, and Happenings*, p.165.

5 Ricoeur, *The Rule of Metaphor*, p.7.

6 Higgins, 'Intermedia' (1965), in *foew & ombwhnw*, pp.11–29.

7 For an in-depth discussion of *Identical Lunch*, see Stiles, 'Between Water and Stone'.

8 Berger, *Labyrinths*, p.37.

9 Schneemann, *More Than Meat Joy*, p.194.

10 Gustave Courbet, *L'Origine du monde* ('Origin of the World') (1866) in the Musée d'Orsay, Paris is often seen as an exceptional – and controversial – representation of the subject in 'high art'.

11 Stiles, 'The Painter as an Instrument of Real Time', p. 4.

12 Schneemann, *More Than Meat Joy*, p.167.

13 Milan Knizak, the first artist to make 'happenings' in the former Czechoslovakia, was arrested and incarcerated over 300 times between 1959 and 1989. Nitsch, Brus and Mühl were all repeatedly arrested in the 1960s and 1970s in Austria, and many others practising performance have had encounters with the police and the state.

14 Austin, *How to Do Things with Words*.

15 Export, 'Aspects of Feminist Actionism', p.71.

16 See Chapter 1.

17 The works of art discussed in this chapter were produced using imperial measurements (feet and inches) rather than metric measurements. Since the relationship of the objects to the spaces between them is often important, and involves whole-number ratios, the original measurement system has been retained.

18 Young, *An Anthology*.

19 Judd,' Specific Objects' (1965), in Harrison and Wood, *Art in Theory 1900–2000*, VIIA5, pp.824–8.

20 Fried, 'Art and Objecthood' (1967), in Battcock, *Minimal Art*, p.125.

21 Buren, 'The Function of the Studio', p.56.

22 De Maria, 'Meaningless Work' (March 1960), in Young and Mac Low, *An Anthology*; reprinted in Stiles and Selz, *Theories and Documents of Contemporary Art*, p.526.

23 See Chapter 1.

24 Matta-Clarke's widow, Jane Crawford, email to the author, 18 July 2000.

25 Gordon Matta-Clark interviewed by Donald Wall, in Wall, 'Gordon Matta-Clark's Building Dissections', p.76.

26 Lee, *Object to be Destroyed*, p.142.

27 See Baudrillard, *L'Effet Beaubourg*; Barker, *Contemporary Cultures of Display*, pp.41–2; Michael Baldwin, in 'Beaubourg', television programme for the Open University course A315, *Modern Art and Modernism: Manet to Pollock*, 1982.

28 On this point, see Graham, 'Gordon Matta-Clark'.

29 See Buchloh, 'Figures of Authority'.

30 Although exhibited on three continents, this massive (58 × 42 × 30 feet), historic installation did not find a permanent home until 2002 when the Brooklyn Museum in New York purchased it.

31 Schapiro and Meyer, 'Waste Not Want Not: An Inquiry into What Women Saved and Assembled – FEMMAGE' (1977–8), in Stiles and Selz, *Theories and Documents of Contemporary Art*, pp.151–64.

32 Adcock, 'The Roden Crater Project'. See also Adcock, *James Turell*.

33 Hall and Fifer, 'Introduction', p.19.

34 'S' and 'M' stand both for the two different first names the baby was given by her birth mother (Sara) and her adoptive parents (Melissa) and for the abusive legal and social investigation into the child's future.

35 For McLuhan, the notion of the 'global village' stood for the eventual breakdown of current geographical boundaries of social life. He posited this visionary theory long before the existence of the Internet and what is today called 'globalisation'.

36 Artists quoted in *Gerry Schum*, pp.75–6.

37 Quoted in Yalkut, 'Electronic Zen', pp.340–3.

38 Krauss, 'Video'.

39 Seaman, 'Recombinant Poetics'.

40 Viola, 'Conversation', p.154.

41 Jacques Derrida, 'Videor' (1990), trans. P. Kamuf, reprinted in Morgan, *Gary Hill*, p.21. Derrida borrowed the term *videor* from Nancy's *Ego Sum*, pp.71–2.

42 Wittgenstein, *Tractatus Logico-Philosophicus*, proposition n.7, p.74.

43 Ruble, 'Jordan Crandall'.

44 Viola, 'Conversation', p.149.

References

Adcock, C., *James Turell: The Art of Light and Space*, Berkeley, CA: University of California Press, 1990.

Adcock, C., 'The Roden Crater Project' (online), available from http://home.sprynet.com/~mindweb/page38.htm [accessed 17 December 2003].

Austin, J.L., *How to Do Things with Words*, Cambridge, MA: Harvard University Press, 1962.

Barker, E. (ed.), *Contemporary Cultures of Display*, New Haven and London: Yale University Press in association with The Open University, 1999.

Battcock, G., *Minimal Art: A Critical Anthology*, New York: E.P. Dutton, 1968.

Baudrillard, J., *L'Effet Beaubourg: implosion et dissuasion*, in the series *Collections Débats*, Paris: Éditions Galilée, 1977.

Berger, M., *Labyrinths: Robert Morris, Minimalism, and the 1960s*, New York: Harper & Row, 1989.

Buchloh, B.H.D., 'Figures of Authority, Ciphers of Regression: Notes on the Return of Representation in European Painting', *October*, vol.16, spring 1981, pp.39–68.

Buren, D., 'The Function of the Studio', *October*, vol.10, fall 1979, pp.51–8.

Export, V., 'Aspects of Feminist Actionism', *New German Critique*, vol. 47, spring–summer 1989, pp.69–92.

foew & ombwhnw, New York: Something Else Press, 1968.

Gerry Schum, exhibition catalogue, Stedelijk Museum, Amsterdam, 1980.

Graham, D., 'Gordon Matta-Clark', in *Rock My Religion: Writings and Art Projects 1965–1990*, Cambridge, MA and London: MIT Press, 1993, pp. 201–4.

Hall, D. and Fifer, S.J., 'Introduction: Complexities of an Art Form', in *Illuminating Video: An Essential Guide to Video Art*, New York: Aperature and Bay Area Video Coalition, 1990, pp.13–27.

Harrison, C. and Wood, P. (eds), *Art in Theory 1900–2000: An Anthology of Changing Ideas*, Malden, MA and Oxford: Blackwell, 2003.

Kaprow, A., *Assemblage, Environments, and Happenings*, New York: Harry N. Abrams, 1966.

Krauss, R., 'Video: The Aesthetics of Narcissism', *October*, vol.1, spring 1976, pp.50–64.

Lebel, R., *Marcel Duchamp*, New York: Grove Press, 1959.

Lee, P.M., *Object to be Destroyed: The Work of Gordon Matta-Clark*, Cambridge, MA and London: MIT Press, 2000.

Lippard, L., *Six Years: The Dematerialization of the Art Object from 1966 to 1972*, New York: Praeger, 1973.

Mondrian, intro. H. Holtzman, exhibition catalogue, Pace Gallery, New York, 1970.

Morgan, R.C. (ed.), *Gary Hill*, Baltimore, MD: Johns Hopkins University Press, 2000.

Motherwell, R., *The Dada Painters and Poets*, New York: Wittenborn Schultz, 1951.

Nancy, J.-L., *Ego Sum*, Paris: Flammarion, 1979.

Ricoeur, P., *The Rule of Metaphor: Multi-disciplinary Studies of the Creation of Meaning in Language*, Toronto: University of Toronto Press, 1977.

Ruble, C., 'Jordan Crandall' (online), available from http://www.ps1.org/cut/java/essays/ruble.html [accessed 15 September 2003].

Schlemmer, O., *The Theater of the Bauhaus*, Baltimore, MD: Johns Hopkins University Press, 1996.

Schneemann, C., *More Than Meat Joy*, New Paltz, NY: Documentext, 1979.

Seaman, W., 'Recombinant Poetics' (online), available from http://faculty.risd.edu/faculty/bseamanweb/web/webreadytexts/recombinant.html [accessed 15 September 2003].

Stiles, K., 'Between Water and Stone: Fluxus Performance, a Metaphysics of Acts', in E. Armstrong and J. Rothfuss (eds), *In The Spirit of Fluxus*, Minneapolis: Walker Art Centre, pp.62–99.

Stiles, K., 'The Painter as an Instrument of Real Time', intro. to C. Schneemann, *Imaging Her Erotics: Essays, Interviews, Projects*, Cambridge, MA and London: MIT Press, 2001, pp.2–16.

Stiles, K. and Selz, P. (eds), *Theories and Documents of Contemporary Art: A Sourcebook of Artists' Writings*, Berkeley, CA: University of California Press, 1996.

Viola, W., 'Conversation', in *Bill Viola*, New York: Whitney Museum of American Art and Paris: Flammarion, 1998, pp.143–65.

Wall, D., 'Gordon Matta-Clark's Building Dissections', *Arts Magazine*, vol.50, no.9, May 1976, pp.74–9.

Wittgenstein, L., *Tractatus Logico-Philosophicus*, trans. D.F. Pears and B.F. McGuinness, London: Routledge & Kegan Paul, 1974 (first published 1921, English translation 1961).

Yalkut, J., 'Electronic Zen: The Alternative Video Generation', unpublished manuscript, 1984.

Young, L.M. and Mac Low, J. (eds), *An Anthology*, New York: George Maciunas and Jackson Mac Low, 1963.

Dream houses:
installations and the home

Gill Perry

Introduction

In 1997, the French-born artist Louise Bourgeois[1] first exhibited her installation *Passage Dangereux* in St Gallen, Switzerland (Plates 6.2–6.6). The outer shell of this strange, suggestive work is a long corridor made of chain-link fencing, intersected by smaller compartments on either side. This architectural arrangement, with arched doors at either end of a central passage, evokes the structure of a cathedral or basilica, in which the transepts and side chapels break the plan of the nave. The enclosure could also suggest an animal cage, a prison or a small-scale house, filled with intriguing objects. Visible through the metal fencing are chairs, tables, mirrors, glass bowls and ornaments, bits of faded upholstery and other domestic bric-a-brac. Many objects are strangely juxtaposed or metamorphosing into weird corporeal forms. A glass bowl contains bones; wooden and metal rods are attached to cast-metal feet; moulded objects that resemble intestines sit on tables; a piece of marble appears to be growing rabbit ears; six tiny shelves hold starched white cuffs detached from their shirts and marked with the name 'Bourgeois' (Plate 6.5).

The work, for which there are an infinite number of viewing positions, presents a confusing visual spectacle. The chain-link fencing breaks down the barriers between inside and outside; the normally private, enclosed spaces of the inside of a house can be seen by the spectator on the outside. Confronted with a mountain of possible allusions and puzzling references, some clearly personal and abstruse, the viewer is invited to make an emotional and psychic engagement with the work, to speculate on its possible meanings. *Passage Dangereux* also offers the spectator a range of tactile experiences. The assembled objects reveal many varied textures and surfaces: wood, metal, glass, wire mesh, upholstery, leather, cotton fabric, plaster and marble are among the materials used. Some of these, such as metal or plaster, appear to mimic softer, fleshy, corporeal forms.

Like many of Bourgeois's installations constructed for modern galleries, *Passage Dangereux* raises questions about the role and meanings of modern sculptural objects. Her *Cell* series (Plates 6.7 and 6.8) are similarly constructed like rooms or enclosed spaces, which the viewer can enter or see into, and which are filled with assemblages of domestic junk and mini-sculptures. Although usually referred to as 'installations', works like these have also been described as 'sculptural installations' or 'architectural sculpture',[2] indicating the imprecise nature of this grouping. As Kristine Stiles has shown in Chapter 5,

PLATE 6.1 (facing page) Louise Bourgeois, detail of *J'y suis, j'y reste* (Plate 6.27).

PLATE 6.2 Louise Bourgeois, *Passage Dangereux*, 1997, mixed media, 264 × 356 × 876 cm. (Hauser & Wirth Collection, St Gallen, Switzerland. © Louise Bourgeois/VAGA, New York/DACS, London 2004.)

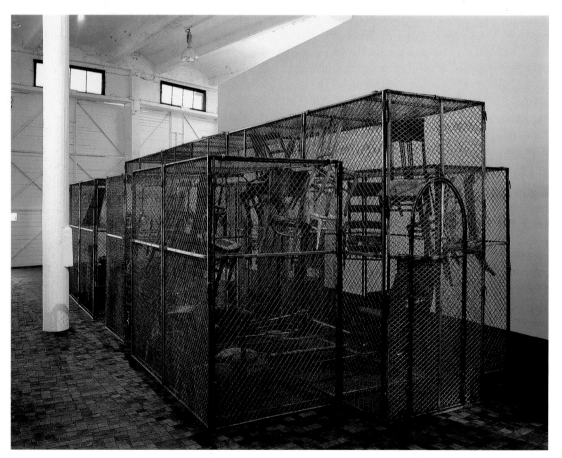

PLATE 6.3 Louise Bourgeois, detail of *Passage Dangereux* showing main corridor, 1997, mixed media. (Hauser & Wirth Collection, St Gallen, Switzerland. © Louise Bourgeois/VAGA, New York/ DACS, London 2004.)

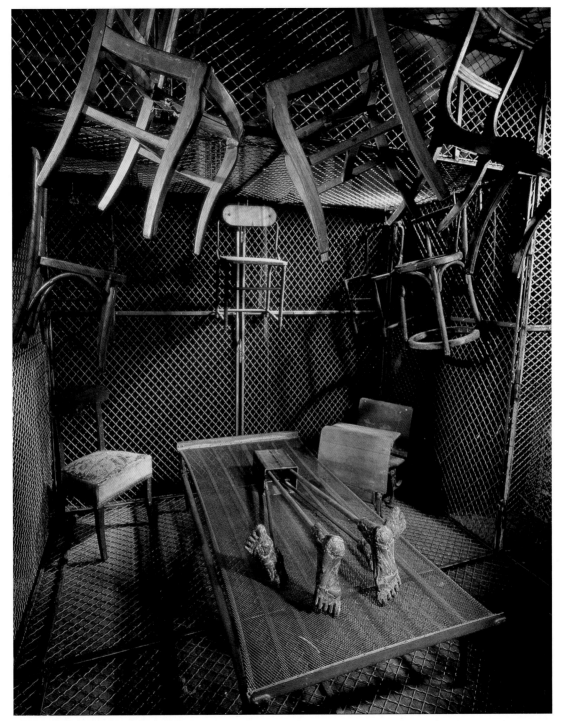

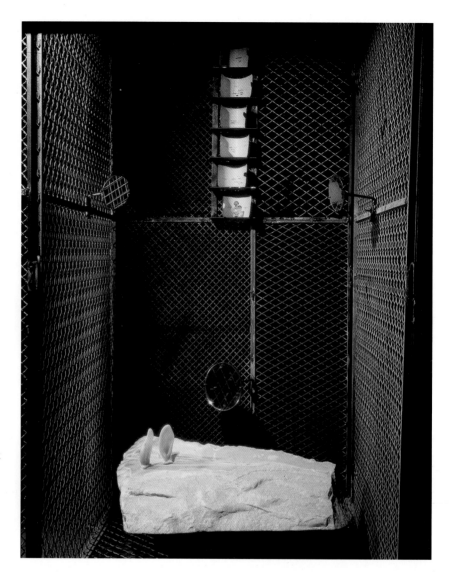

PLATE **6.5**
Louise Bourgeois,
detail of *Passage
Dangereux* showing
shirt cuffs and piece
of marble with 'rabbit
ears', 1997, mixed
media. (Hauser &
Wirth Collection, St
Gallen, Switzerland.
© Louise Bourgeois/
VAGA, New York/
DACS, London 2004.)

it is sometimes difficult clearly to mark the boundaries between installation and other forms of contemporary art, such as minimalist objects, performance and video. Today the term 'installation' is often used to describe radical forms of art practice from the late 1960s and the 1970s, which encouraged a critical awareness of ideological contexts and relationships between viewers and objects, although it has also become a broad, descriptive category for many forms of gallery-based mainstream art.[3] Stiles considers the ways in which installations can shape spatial and perceptual relations aesthetically; such works encourage the viewer to reflect on his or her changing relationship with the objects in the display, and on the ways in which those objects might affect viewers' perceptions of the environment.

Although there is no use of performance in *Passage Dangereux*, it invites the spectator to respond kinaesthetically. Each individual experiences the work through time as he or she continually changes viewing positions, looking

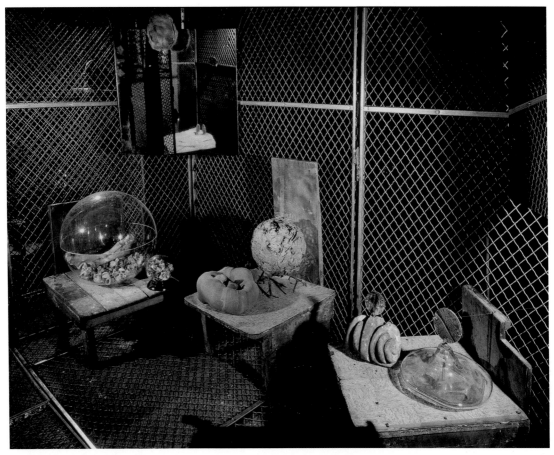

PLATE **6.6** Louise Bourgeois, detail of *Passage Dangereux* showing transparent globes, small chairs and bones, 1997, mixed media. (Hauser & Wirth Collection, St Gallen, Switzerland. © Louise Bourgeois/VAGA, New York/DACS, London 2004.)

from different angles within and through the architectural structure and its objects, and exploring the different surfaces and materials. This involves what we have been describing (in this book) as a temporal, embodied form of looking. Alternatively, the spectator can stand back in the gallery – or observe through the medium of the static photographic print – and view the arrangement of bric-a-brac as a kind of modern tableau, as a complex sculptural object composed of intersecting verticals and horizontals, strange contrasts of line and volume, contained – and framed – within a wire mesh 'skin'. Although this installation does not seem to offer any fixed or clear meanings, its complex, cluttered forms could be seen to invoke what has been called 'an overdose of narrativity'.[4] In other words, the wealth of possible references (personal, sculptural, cultural) suggested by this crowded collection of objects invites the spectator to find stories that will somehow explain the work. It has also been proposed that the actual process of viewing constructs its own 'narrative'. As spectators move in and around the work, they explore different viewpoints – and explanatory stories – as they go along.[5]

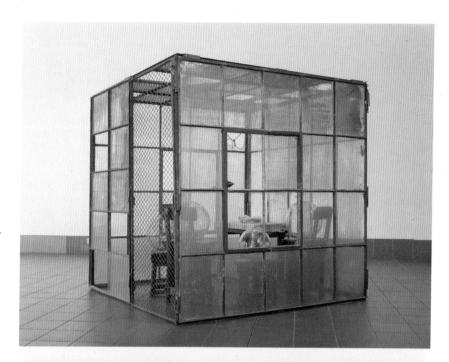

PLATE **6.7**
Louise Bourgeois,
*Cell (Glass Spheres
and Hands)*, 1990–3,
glass, marble, wood,
metal and fabric,
218 × 218 × 211 cm.
(Leslie Moira
Henderson Bequest,
1994. National
Gallery of Victoria,
Melbourne. © Louise
Bourgeois/VAGA,
New York/DACS,
London 2004.)

PLATE **6.8**
Louise Bourgeois,
Cell (Clothes),
1996, wood, glass,
fabric, rubber and
mixed media,
211 × 442 × 366 cm.
(Fondazione Prada,
Milan. Photo: Attilo
Maranzano. © Louise
Bourgeois/VAGA,
New York/DACS,
London 2004.)

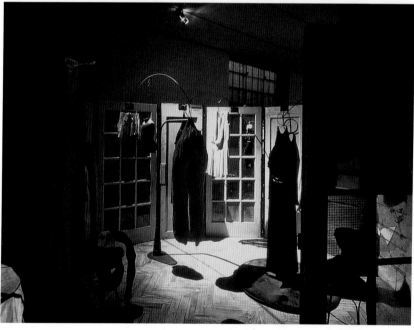

The tensions produced by different viewing positions will feature prominently in what follows. I will suggest possible routes for understanding both the contradictions inherent in recent adaptations of installation art, and some of its most compelling aspects. I will also explore the problem of interpreting works like *Passage Dangereux* that are difficult to read.

Another aim of this chapter is to examine the ways in which several contemporary women artists, among them Bourgeois, Doris Salcedo, Mona Hatoum, Rachel Whiteread and Cornelia Parker, have deployed this form of art. In particular, I want to explore the possible significance of gender issues in

the production, viewing and understanding of such practices. Over the last twenty to thirty years, improved cultural, educational and curatorial opportunities for women have contributed to their increasing engagement with installation art, often involving expensive, large-scale and ambitious forms of production and organisation. Such developments have significantly shifted contemporary perceptions of the postmodern 'sculptor'. As Alex Potts has written:

> If anything, some of the more powerful recent work, which plays on the tension inherent in ambitious sculpture between a public and a more intimate or individual mode of address, has been by women artists, a situation, however, that has more to do with shifts in the gender politics of society at large than with anything specific to sculptural practice.[6]

There are many ways in which gender issues, or, more precisely, our understanding of how feminine and masculine identities are constructed, could inform our reading of *Passage Dangereux*. We could argue that, as a woman artist who worked for much of her career in an environment in which the most successful producers of installation art were generally men (this was especially the case in the 1960s and 1970s), Bourgeois is likely to express some distinct and gendered experiences through her work. In her writings she has often described her feelings of 'frustration' or 'powerlessness' as a woman in her chosen vocation.[7] Throughout her career she has chosen to reference the home: that intimate, private space in which (historically) women have spent much of their time, and which is often associated with the 'feminine'. Many of the installations I consider in this chapter share the character of 'architectural sculpture' that refers to (ambiguously) enclosed spaces, often those of the home. I argue that each reveals some of the tensions and contradictions involved in the public, sculptural and material display of more private, domestic concerns.

I am using the term 'home' to denote a more personalised environment than the idea of a house or building. Houses are units that define and bring together people and families, and their social and sexual interactions. When inhabited they become 'homes'. A home can thus signify an enclosed dwelling or shelter which is familiar, comforting and secure. The spaces in which we live and work are more than just architectural constructions of bricks and mortar, concrete, metal or wood; they are also systems of representation, along with paintings, films, photographs, television. They are constructed for, and inhabited by, male and female bodies, and as such they are not just material objects with fixed meanings as mere constructions. Gender relations and the relative roles, status and identities of men and women are inscribed in the design, organisation and content of our houses. A home does not simply specify where you live; it can also signify who you are (socially, economically, sexually, ethnically) and where you 'belong' (geographically, culturally). And a house or dwelling is full of the traces of its occupants' corporeality, of sleeping, eating, loving: of its existence as a home. Moreover, a house contains evidence of the intimate relationship between space and time. While the space of the constructed building may shelter people or families over long periods of time, the evidence of more transitory individual lives is visible in traces in and on the building and its furniture. These 'traces' may take the form of damage, dirt, dust, decorations, scratches, repairs, alterations and so on. As Walter Benjamin memorably wrote: 'To live is to leave traces.'[8]

Gender and interpretation

Of particular interest to me in this chapter are the ways in which structures and objects can both represent the home as the site of the 'feminine' *and* also confuse such traditional gendered associations. Historically, femininity – especially middle-class femininity – has been closely identified with the private, domestic sphere of the home, in contrast with the supposedly more public spheres of masculine, professional culture. In Chapter 5, Stiles introduced the concept of 'femmage', coined in the late 1970s to represent the collage-like techniques adopted by some feminist artists who have drawn on domestic materials, objects and practices in their installation works, often in order to explore the ideas of 'women's practice' and 'feminine spaces'. *Passage Dangereux*, along with many of the works I discuss below, could be seen to emerge out of this tradition, or at least to reveal a more sculptural reworking of the household scavenging that underpins the idea of femmage.

An engagement with domestic themes has been identified as a distinguishing feature of the practice of many women artists working in the UK at the end of the twentieth century, including Whiteread, Hatoum, Parker, Tracy Emin and Sarah Lucas.[9] I shall suggest that, in the work of some of these British-based artists, the deployment of domestic iconography is also tied to a wide range of sculptural and experiential concerns, some of which were less pressing for an earlier generation preoccupied with improving the visibility and status of women artists. However, I am not proposing that because of their experiences women have some sort of exclusive right to this iconography. Many male artists have also used household imagery in their installations, revealing similar concerns with architectural sculpture and relationships between public and private spaces. In Chapter 5, Stiles showed how Gordon Matta-Clark often used his installations to explore and expose the private interiors of the public built environment (see Plate 5.15). In Chapter 1, Paul Wood described one of Ilya Kabakov's claustrophobic interiors filled with domestic rubbish and intended as a reflection on lived 'normality' in the decline of the USSR. I am concerned here to explore both why and how domestic themes appear frequently in the work of women artists at the end of the twentieth century, and what issues – gendered, cultural, political, aesthetic and metaphorical – such uses might raise.

Bourgeois's *Passage Dangereux* references her gender partly through the suggestion of intimate memories. She has used her work as a kind of creative repository of objects that refer to personal memories from her childhood and beyond. Born in 1911, she is one of many twentieth-century artists who have become familiar with the analytical power of psychoanalysis. She has provided narratives (in the form of diaries, letters, interviews, notes attached to drawings and short texts[10]) that enable the viewer to interpret her work as an obsessive autobiographical project, which continually makes associations with her childhood traumas, in particular her difficult relationship with her father. With this knowledge we can read the musty bits of fabric and old furniture, mirrors, semi-corporeal sculptures and so on as souvenirs that carry personal memories or evoke specific traumatic events. For example, in *Passage Dangereux* the white cuffs labelled 'Bourgeois' (Plate 6.5) provide a reference to her father and her memories of his starched, laundered shirts;

in another part of the installation, an empty bottle of Shalimar is decorated with one of the artist's bracelets. Other possible associations are even more oblique, as with the child-size chairs and secret compartments, which may relate to childhood experiences in the home. In order to access specific psychic meanings, or at least to speculate about them, we need some knowledge of biography and artistic intention.

This raises again the problem of how we interpret such works. Does this installation reveal specific stories or narratives that the spectator must learn to read? Can we only understand the work if we have biographical knowledge? Clearly, this would exclude a large part of the audience that views Bourgeois's work in galleries and public spaces. I would argue that some biographical knowledge can inform our understanding of how the artist's psychic drives might interact with the world around her, and may help us to interpret some of the strange juxtapositions of objects, but that such knowledge is not a necessary condition for reading the work. The arrangement of objects may evoke different associations for different viewers, depending on their cultural baggage, backgrounds, aesthetic interests and so on. *Passage Dangereux* is a complex sculptural construction, which offers many imaginative possibilities and tactile experiences to the viewer who is prepared to engage with it. It is not surprising that such works have attracted the interest of feminist art historians who are especially involved with psychoanalytic models of interpretation. Although Bourgeois's writings and statements continually emphasise the autobiographical nature of her artistic production, she has also claimed that this influence was often an unconscious process. She has explained that she is often taken by surprise by her own work, that it only reveals itself to her as a 'self-portrait' after she has made it.[11] While this sense of the unconscious drives behind her art invites psychoanalytic readings, it also signals the Surrealist legacy in Bourgeois's work.

Bourgeois was close to members of the Surrealist movement in the 1930s and 1940s, and shared some of their views about the significance of unconscious urges in artistic creation. She has produced exhibits that juxtapose strange or seemingly incompatible objects, which appear to be both sexual and mechanically constructed or sculpted. Such works can set in play a chain of associations (bodily, domestic, dreamlike and so on), echoing the effects of painted and sculpted objects by earlier Surrealist artists. Bourgeois's works have often been seen to refer to the ironic and sexually provocative combinations of objects produced by the Surrealist artist Meret Oppenheim (Plate 6.9). These oddly arranged or metamorphosing objects invite (and were intended to produce) readings that privilege unconscious desires and sexual undercurrents. For example, by covering a cup and saucer with fur, Oppenheim combined the sensuality and corporeal associations of fur (in this case gazelle fur) with those of a mass-produced manufactured object. The cup and the spoon suggest oral pleasures — a key concern of Freudian theories of sexuality — which, in combination with the fur, may provoke repressed sexual desires or fears.[12] Many of Bourgeois's sculptural objects engage in similarly provocative ways with female sexuality and the fetishistic potential of parts of the female body, although the scale, shape and sheer physical presence of some these works takes them beyond the historical and aesthetic preoccupations of Surrealism.

Bourgeois does not restrict the iconographic and psychoanalytic possibilities of her work to an interrogation of female sexuality. Like many women artists working over the last thirty to forty years, she has explored (often playfully) the phallic imagery of male sexuality, most notoriously perhaps in her *Fillette* series from the late 1960s, in which she produced dramatically scaled-up latex sculptures of male genitalia (Plate 6.10). More significantly, she has often used strategies of juxtaposition and metamorphosis to create sexually ambiguous sculptures that merge male and female sexual organs (Plates 6.11 and 6.12). In 1974, she commented:

> Sometimes I am totally concerned with female shapes – clusters of breasts like clouds – but I often merge the imagery – phallic breasts, male and female, active and passive. This marble sculpture – my *Femme Couteau* – embodies the polarity of woman, the destructive and the seductive. Why do women become hatchet women? They were not born that way. They were made that way out of fear. In the *Femme Couteau* the woman turns into a blade, she is defensive. She identifies with the penis to defend herself.[13]

Bourgeois's writings and statements can offer us a seductive narrative for interpreting the psychic meanings of her art. It is tempting to take away a largely autobiographical reading, in which gender and the symbolic powers of her work resonate in our memories. But we should be wary of attaching too much importance to one aspect of the artist's declared intention. In fact, in spite of the many autobiographical and psychic clues that Bourgeois offers us, she has reported her suspicion of (psychoanalytic) theory. She has claimed: 'I distrust the Lacans and Bossuets because they gargle with their own words. I am a very concrete woman. The forms are everything.'[14] We are thus reminded that the works discussed so far were also produced as sculptures or installations engaged with debates about the material status of the object and its formal integrity. In fact, the tendency to read Bourgeois's work largely in psychoanalytic terms has been relatively recent.[15] As Rosalind Krauss has pointed out in her discussion of *Fillette*: 'The extraordinary thing about the

PLATE **6.10**
Louise Bourgeois,
Fillette, 1968,
latex over plastic,
60 × 28 × 19 cm.
(Museum of Modern
Art, New York. Gift
of the artist in memory
of Alfred H. Barr, Jr.
DIGITAL IMAGE © 2003
The Museum of
Modern Art, New
York/Scala, Florence.
© Louise Bourgeois/
VAGA, New York/
DACS, London 2004.)

PLATE **6.11**
Louise Bourgeois,
Janus Fleuri, 1968,
bronze golden patina,
26 × 32 × 21 cm.
(Courtesy Cheim &
Read, New York.
Photo: Christopher
Burke. © Louise
Bourgeois/VAGA,
New York/DACS,
London 2004.)

PLATE **6.12** Louise Bourgeois, *Femme Couteau*, 1969–70, carved pink marble, 9 × 67 × 12 cm. (Jerry and Emily Spiegel Family Collection, New York. Photo: Allan Finkeleman. © Louise Bourgeois/VAGA, New York/DACS, London 2004.)

reception of Louise Bourgeois's sculpture from its first appearance at the end of the 1940s up to the late 1980s is that it was consistently described as abstract, abstract in the sense of a modernist formal logic.'[16] Krauss argues that although there was nearly always an admission of the erotic connotations or sexual associations of works such as *Fillette* (Plate 6.10) or *Janus Fleuri* (Plate 6.11), accounts tended to focus on the sculptural medium and its formal logic. Krauss maintains that the issues were 'firmly placed in the territory of the sculptural',[17] rather than engaged with social or psychic concerns.

Passage Dangereux belongs to a later period of Bourgeois's work, when she concentrated increasingly on large-scale installations, located within a different set of contemporary debates. This particular installation is replete with associations that can be seen (with a little help from the artist) to reference her gender and her childhood traumas. But it is also a complex construction of interlocking objects and tactile forms, which engage our attention as an artwork and which (as we have seen) may evoke other sculptural or architectural associations. It invites us constantly to reposition ourselves, and to consider the role of sculpture and the form of its display within an expanded field of contemporary art practice.

Another aspect of Bourgeois's practice that could involve a discussion of gender issues is her preoccupation with household junk and bodily waste. Works such as *Passage Dangereux* can appear messy, disordered and full of rubbish, despite their architectural references. This characteristic is often

contrasted with the 'cleaner' lines and more geometric forms of installations by some of the (largely male) minimalist artists. Some feminist artists and art historians have explored the interconnections between the roles and preoccupations of women in artistic production and the production of waste, garbage or mess in our culture. For example, Jo Anna Isaak has discussed the work of the 'garbage girls' (the critic Lucy Lippard's term for women artists who worked with waste and trash) in the USA in the 1990s, arguing that a disproportionate number of artists working with garbage, pollution and the social factors associated with waste are women.[18] Within the history of twentieth-century art, there are many precedents for this relationship between art and rubbish or discarded objects, from Marcel Duchamp's readymades to the work of the Italian Arte Povera group in the 1960s and early 1970s. The more recent engagement of many women artists with various forms of 'garbage' has been seen as part of an anti-aesthetic – and often feminist – interest in those aspects of our culture which are believed to be transient or decreasing in value, or which need to be cast out and ejected (such as bodily waste). There are many cultural and symbolic associations of women with this category. The historical associations of femininity with household concerns and management have often placed women closer to the organisation of domestic waste. And in biological and cultural terms, women are often seen to pass their 'sell-by date' more rapidly than men.[19] Moreover, Julia Kristeva has argued that, from a psychoanalytic point of view, the discourse on waste plays an important role in the formation of identity. In *Powers of Horror: An Essay on Abjection* (1982), she develops a theory of the 'abject', which refers largely to the social and symbolic ordering of the female body, in particular the maternal body. By controlling the body, and separating oneself from its dirty or chaotic waste products, the self is constructed as separate from others.[20] According to this argument, 'horror' is generated through fear of the return of rejected waste. Kristeva's theories have influenced many feminist theorists and artists who are concerned with the gendering of waste and rubbish in our culture, offering models of interpretation for seemingly opaque and disorderly installations such as *Passage Dangereux*.

Installations, monuments and memorials

In a recent interview with the art historian Lisa Tickner, the British artist Cornelia Parker suggested that the idea of installation art might have a 'feminine' aspect to it:

> the whole idea of formal issues to do with the lump or the anti-lump is somewhat gendered. The idea of installation art is quite feminine. It's a feminine art form because it's inclusive and you walk into it, it's not going to the centre just to look at this lump in the middle. And I think the air around, the leaves on the trees and blades of grass, this fluid, atmospheric sense of the relations and exchanges between things, is a model of the way I think, and I think it's quite a feminine way of thinking. It's always this anti-centre thing.[21]

Parker's idea of 'the lump' is a reference to a more conventional sculptural object with some kind of 'centre', which is best observed from a particular viewing position. In contrast, she describes what is now widely seen to be one of the distinguishing characteristics of installation art: that it requires a more active involvement on the part of the spectator. Apart from the different visual responses evoked as we walk around an installation, we may also be asked to respond to sound, smells and forms or objects that we can touch. This invocation to participate in various types of sensory experience has been seen to be at odds with the now traditional exhibition culture of the 'white cube', in which works are displayed for primarily visual absorption of clearly defined art objects. Parker is suggesting that the participatory and fluid nature of our experiences of installation art constitutes a 'feminine' way of both thinking about and responding to art.

This claim raises the problem of how we define 'feminine' and 'masculine' experiences of art. It might be argued that to separate out the experiences in this way actually perpetuates gendered stereotypes of how men and women respond to art, implying that men have a more directed, intellectual mode of response, and women a more fluid, 'feminine' sense of exchange. This separation can lead to essentialist tendencies to identify distinct biological characteristics of the 'feminine'. But we could also argue that, despite the essentialist implications, Parker is seeking a more positive notion of the 'feminine', based on the idea that, through cultural and biological conditioning, women have developed and refined certain sensory skills that are well suited to the production and experience of installation art.

PLATE **6.13** Cornelia Parker, *Cold, Dark Matter: An Exploded View*, 1991, garden shed and its contents in Chisenhale Gallery before explosion. (Courtesy Cornelia Parker and Frith Street Gallery, London.)

Another way of looking at these issues is to place Parker, and many of the artists discussed in this chapter, within the historical and cultural context of the artworld of the 1990s. The politically engaged concerns of earlier generations of (British and American) feminist artists, such as, for example, Judy Chicago, Mary Kelly and the performance artist Carolee Schneemann, had helped to influence an artistic culture in which women were becoming more visible as producers of large-scale and ambitious commissions and gallery installations. Although Parker (and others including Whiteread) deny any direct identification with feminist positions, I would argue that some of the professional and aesthetic opportunities that were available to them were enabled by the interventions and developments of earlier artists concerned with feminist issues in the exploration of different aesthetic practices. For example, some of the key concerns of early installation and performance art, including the blurring of the relationship between private and public, and between the object and the viewing subject of art, were key issues for many feminist artists working in the 1970s.[22]

Parker's claim that installation art has a 'feminine' aspect was voiced in a discussion of her work *Cold, Dark Matter: An Exploded View* of 1991 (Plates 6.13 and 6.14). This installation began as a garden shed, packed with tools, household junk, old toys and some carefully chosen books, including Marcel Proust's *Remembrance of Things Past* and a memoir called *The Artist's Dilemma*. After being photographed, the shed was blown up by the

PLATE **6.14** Cornelia Parker, *Cold, Dark Matter: An Exploded View*, 1991, a garden shed and contents blown up for the artist by the British army, the fragments suspended around a light bulb. (Courtesy Cornelia Parker and Frith Street Gallery, London.)

British army, and the pieces were reassembled and suspended from the ceiling of the Chisenhale Gallery in East London. In the centre of this collection of suspended fragments, Parker placed a 200-watt light bulb, which lit the surrounding debris like a sun in a remote, burnt-out galaxy. So, despite her declared desire for an 'anti-lump' or decentred work in this installation, Parker still retains some sense of a 'centre', albeit one that radiates light around and through the shattered and blackened remnants of the shed and its contents. The gendered associations go beyond the home as a site of the feminine. The idea of the garden shed as a tool-filled space where men potter around doing bits of DIY has become part of traditional British postwar domestic culture. As Tickner has suggested: 'The shed was a bolt-hole, it was a masculine rite of passage to grow to adult-hood and have a shed of your own. We know this from our childhoods but it's also evident in the hobby-magazines of the post-war period.'[23]

By blowing up the shed and suspending its remains, Parker could be seen to undermine the ideas both of the shed as a masculine space and of a sculptural monument as a static commemorative object in a fixed space. She has stated: 'For a long time my work has been about trying to erode monuments, to wear them away and to digest them, and then create a moment, a fleeting thing. I had monuments falling.'[24] The 'fleeting', temporal nature of this work clearly goes against the idea of a permanent monument and raises the problem of where artistic practice begins and ends. If the original explosion is part of the work, then we could argue that some sort of performance is involved. But, as with most forms of performance art, that activity is now represented only through a photographic archive (Plates 6.13 and 6.14), which substitutes for, or has become, a part of the work.[25] However, *Cold, Dark Matter* is now in the Tate collection in its 'permanent' form as a gallery installation. While the effect of the blast could be seen to negate the idea of the contained sculptural object, the reassembled pieces, seemingly porous and glistening seductively in the light, take on a formal integrity of their own as they cluster around the central bulb (Plate 6.14).

Modern installations have often been characterised by the way in which they situate the spectator within the frame, confusing the sense of space between the object and its viewer. We saw with Bourgeois's *Passage Dangereux* that the spectator can feel drawn into yet also displaced by the assembled objects and the chain-link fencing – both inside and outside at the same time. Yet Parker's glistening, charred pieces are suspended around a containing light source that helps to define the work and suggests an alternative frame. We can move around the installation, admiring its complexity and the multiple angles for viewing it, while at the same time maintaining a clear sense of its physical limits and its formal centre or focal point. *Cold, Dark Matter* appears as both a centred work *and* a decentred spectacle, offering shifting views and suggesting an ambivalent relationship with tradition.[26]

A critical engagement with the problem of a work's centre and its 'frame', with its inside and outside, is evident in several installations from the 1990s by Mona Hatoum, a Lebanese-born artist who has lived in London since 1975. She also explores the effects of fleeting light sources in two installations, *Light Sentence* and *Current Disturbance* (Plates 6.15 and 6.16). In *Light Sentence*, Hatoum constructed an oblong frame of wire-mesh lockers placed

down the centre of a gallery space. A suspended light bulb propelled by a motor moves slowly up and down the space, throwing constantly changing grid-like shadows across the gallery walls. *Current Disturbance* is a large, wooden four-walled structure, covered in thin wire mesh to create 228 cages, each containing a light bulb. A computer, which runs power randomly through the different bulbs, controls a fluctuating current accompanied by amplified crackling and humming sounds.

From the illustrations of *Light Sentence* (Plate 6.15) and *Current Disturbance* (Plate 6.16) and the descriptions provided above, discuss the ways in which these two installations might be seen to confuse ideas of a work's centre and its 'frame'. What other associations (gendered or otherwise) seem to be evoked by these works?

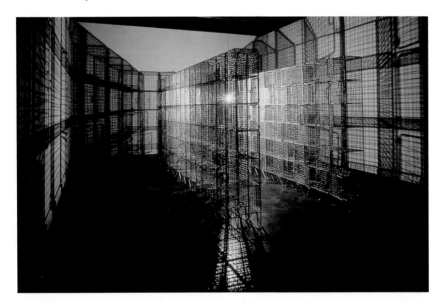

PLATE **6.15**
Mona Hatoum,
Light Sentence,
installation, Chapter,
Cardiff, 1992,
wire-mesh lockers,
slow-moving
motorised light bulb,
198 × 185 × 490 cm.
(Courtesy Jay Jopling/
White Cube, London.
Photo: Edward
Woodman. © Mona
Hatoum.)

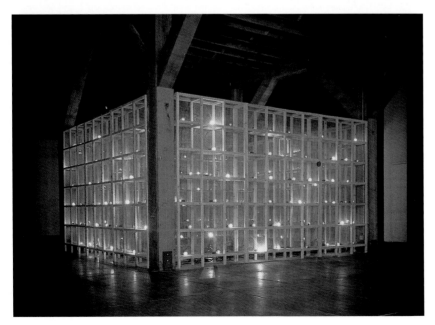

PLATE **6.16**
Mona Hatoum,
Current Disturbance,
installation, Capp St
Project, San Francisco,
1996, wood, wire mesh,
computerised dimmer
switch and light bulbs,
279 × 550 × 504 cm.
(Courtesy Jay Jopling/
White Cube, London.
Photo: Ben Blackwell.
© Mona Hatoum.)

In both pieces, the moving light source creates shadows that fall unpredictably around the gallery walls, confusing both the physical and the optical boundaries of these works and encouraging the viewer to respond kinaesthetically. As in *Passage Dangereux*, the use of wire-mesh fencing suggests a prison-like cage, which is also open or visible. In *Light Sentence*, there is a single light source, but since this moves it undermines any sense of a fixed centre to the work. For the spectator the experience of each work is full of contradictions: the wire enclosures and architectural structures suggest containment, but the flickering lights and moving shadows confuse our sense of where the enclosures might begin or end. In this respect, the works could be seen to frame the viewer, rather than vice versa.

The wire-mesh cages evoke many possible associations. Animal cages, internment camps, school lockers and even domestic vegetable racks are among the references they suggest for me. From your knowledge that she was born in Lebanon, you might be able to make connections to the political experiences of Hatoum's native country. You may also have observed that the geometrical form of the grid was a motif explored and reworked in American Minimalist Art (a source that has often been seen to have influenced Hatoum's work). Whatever political or domestic meanings we seek to identify, they are enmeshed with our perceptions of the work's aesthetic legacy – the abstract patterns, the shadowy grids and strange luminous sense of flux produced by each. ∎

Many of Hatoum's earlier works from the 1980s, especially her video and performance art, engaged with political themes of war and imprisonment, including the war in the Lebanon and the massacre of Palestinian refugees in camps outside Beirut in 1982. The motif of wire fencing recurs in her works from this period, and that knowledge can inform our reading of these works from the 1990s, particularly in view of a title such as *Light Sentence*. It might even provide grounds for identifying these installations as forms of memorial. It is important to remember, however, that these political meanings are suggested by association rather than through any clear narrative clues, and once again the viewer is assisted in this interpretation through knowledge of artistic intention.

We have seen that Parker was keen to undermine a conventional notion of the sculptural monument. Monuments can have different functions: they may be tombs, or demonstrations of triumph, authority, power or property. When they are dedicated to – or commemorate – a public figure, a group of people or a historical event, they take the form of a memorial. As Tickner has written: '"Monumental" means massive and permanent, historically prominent, conspicuous, enduring. Monuments are "masculine" (with rare exceptions). First, men make them.'[27] Although critics have often used the term 'monumental' to describe the powerful forms of some of Hatoum's large-scale installations, including *Current Disturbances*,[28] her work also reveals an ambivalent relationship with the idea of a massive, enduring monument. Hatoum's two installations discussed above also contain oblique references to lived experiences, including themes of imprisonment, although such meanings are not directly commemorative of a specific person or persons. Over the last twenty years, many women artists have produced works and won commissions that could be seen as reworkings of the traditional idea of the monument or memorial, including (apart from Hatoum) the British artist Rachel Whiteread, in works such as *House* (1993) (Plates 6.23 and 6.24) or

Holocaust Memorial (2000) (Plate 6.17), and the Colombian artist Doris Salcedo, in works such as the *Unland* series (1995–8) (Plates 6.18 and 6.19).

Some recent writing on sculptural monuments in contemporary art has explored the contradictions behind the idea of a memorial, especially the problem of how a 'memory' of a person or historical event can be alluded to in a visual sculptural form. Memorials generally perform a contradictory function of commemorating that which is lost or absent. They act as a focus for mourning and collective memory, and as such can easily idealise or evoke nostalgia, producing a glorifying or propagandist historical narrative. Since memorials are publicly displayed and often monumental, they are frequently seen to speak with authority, to symbolise a cultural experience. As forms of representation, they raise many questions about the functions of art. In an article on Salcedo, Charles Merewether has posed the questions thus: 'how does art allude to something absent or something that cannot be said? What is the purpose of monuments – do they enhance our historical understanding of the past or displace our connection to it, serving amnesia rather than remembrance?'[29] One way in which contemporary artists have dealt with this problem of representing a memory is, of course, to refuse conventional forms of evoking history through depiction. Obvious examples of such forms, which are visible in towns and cities all over Europe, are sculpted figures of soldiers on monuments to the dead of the First and Second World Wars.

PLATE **6.17** Rachel Whiteread, *Holocaust Memorial*, Vienna, 2000. (Courtesy Anthony d'Offay Gallery, London. Photo: Werner Kaligofsky.)

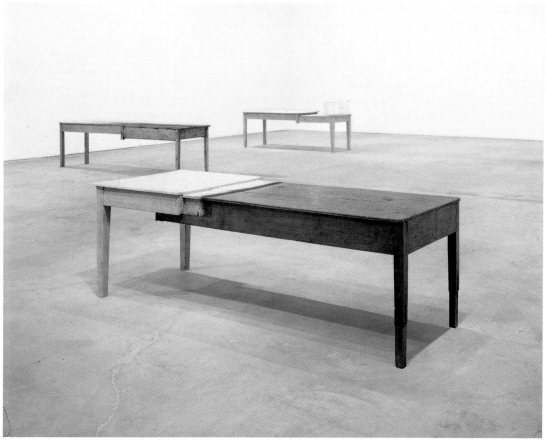

PLATE 6.18 Doris Salcedo, *Unland*, installation view, Site, Santa Fe, 1998. (Courtesy Alexander and Bonin, New York. Photo: Herbert Lotz.)

In contrast, works such as Whiteread's *Holocaust Memorial* (Plate 6.17) or Salcedo's *Unland* (Plates 6.18 and 6.19) are both objects, or groups of objects, that seem to relate obliquely – or metonymically – to the events they commemorate or reference. While *Holocaust Memorial* takes the form of an inverted library, *Unland* consists of groups of kitchen tables that reveal symbolic traces (such as marks and hair) of victims of war.

Whiteread's monument, a memorial to the 65,000 Austrian Jews who died at the hands of the Nazis, has been identified with a genre of 'anti-memorials' that have rejected sculpted bodies, in whatever configuration or degree of schematisation, as inadequate to represent the enormity and horror of the mass genocide involved in the Holocaust. Engaging with this problem, Whiteread produced a grounded, virtually plinth-free object in concrete, reminiscent of a mausoleum. It follows a grid-like structure, with its outside walls cast as shelves packed with copies of the same book. It was designed for the Judenplatz, a small square in the old Jewish centre of Vienna and the site of a synagogue that was destroyed in a pogrom of 1421. Whiteread's memorial references the immediate Viennese environment of largely residential, stuccoed townhouses (Plate 6.17) and Jewish history. Many features of this evocative 'library' echo the features of the bourgeois interiors that surround it, including the panelled doors and cornices, and the dimensions

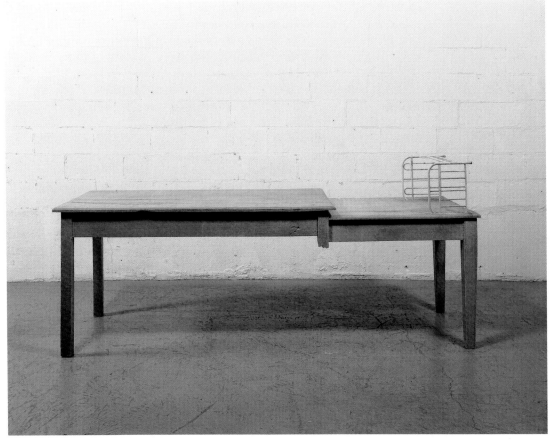

PLATE **6.19** Doris Salcedo, *Unland* (*Irreversible Witness*), 1995–8, wood, cloth, metal, hair. (Courtesy Alexander and Bonin, New York. Photo: David Heald.)

of the work are similar to those of a typical nineteenth-century Judenplatz apartment.[30] The library is a reference to the fact that the Jewish people are known as 'the people of the book'. The book and its written word can symbolise tradition and learning, and, of course, can document suffering; they represent a history and culture that endures despite the upheavals, traumas and loss of diaspora. But the books in Whiteread's work are closed and unidentified, without visible spines, and the double doors are sealed, enclosing a frustratingly inaccessible space. Both the nameless books and the sealed void suggest the lives lost in an ultimately inaccessible history. As a 'memorial', Whiteread's heavy material structure is replete with ambiguities and uncanny associations. Unlike her earlier work *House* (which I discuss in a later section), *Holocaust Monument* is not cast from a single building or object, but is made up of imaginatively conceived elements that combine to convey the power and physicality of a sculpted object, while also evoking loss and history, and the iconography of a domestic interior.

Salcedo's *Unland* (Plates 6.18 and 6.19), a group of sculptures intended as a memorial to the victims of the civil war in Colombia, is even less easily accommodated within the category 'memorial'. While Whiteread's work asserts the significance of place, and derives some of its meaning from its site, Salcedo has produced a gallery-based installation without a fixed home,

a theme echoed in the title *Unland*, which suggests homelessness or loss of place. Although intended as a reference to the homelessness of Colombians, the theme was partly inspired by the writings of the exiled Jewish poet Paul Celan, who survived the Holocaust. The work consists of three tables or joined parts of tables, each of which have been named separately (Plate 6.19). The first of these, *The Orphan's Tunic*, combines two tables of different sizes (Plate 6.20). One is covered in a silk mesh, held in place by individual human hairs, threaded through tiny holes in the table. The wooden surface thus appears to be wrapped in a fine gauze, a web of silk and hair. Salcedo has explained this work as inspired by her encounter with a six-year-old girl who had been traumatised by witnessing the murders of both her parents. The girl, still wearing a dress made by her mother, was unable to recall anything in her life before the trauma.[31] The artist assumed the role of a witness to this story and produced a work she intended to stand for the child's tragic experience. As viewers we are invited to respond to the assembled tables as discrete objects arranged in a gallery space and (with a little help from the artist and her critics) to read their evocative possibilities, to identify their metaphorical meanings as testimonials to victims of political oppression.

PLATE **6.20** Doris Salcedo, *Unland, The Orphan's Tunic*, 1997. (Courtesy Alexander and Bonin, New York. Photo: David Heald.)

Memory and uncanny objects

Salcedo's work continually confronts us with the problem of how memory might be evoked by an installation that seems so far removed iconographically from the events or figures it is intended to commemorate. To understand Salcedo's political meanings we need some knowledge of artistic intention. However, the *Unland* series presents an evocative juxtaposition of objects and tactile surfaces that can set in train a series of possible associations. In so far as the table is a domestic object, a focus of familial experiences and interactions, we could identify some possible metaphors and associations relevant to a child's experiences and memories. For example, the woven skein of hair and silk threaded through the surface of the table adds a corporeal trace, although not that of a particular person. The woven surface could stand for the fabric of the girl's dress, or the relationship between inanimate objects, which silently (or metaphorically) witness trauma, and the physical victims of that trauma. The threads of hair that weave in and out of the table and the silk could also suggest the stitching of a wound, or the process of remembering, which periodically retrieves memories from the void (the holes in the table). The point to take away from these possibilities is that *Unland*, perhaps even more markedly than Whiteread's *Holocaust Monument*, carries no *fixed* architectural or commemorative meanings. The artist herself sought to explain this issue in an interview in 1998:

> Over the past few years the question of memory has been abused and exhausted as a theme. Given that mourning is a permanent presence in my work, the notion of memory is also ambiguous, since it is always confronted with a doubt, with an aporia. One struggles between the necessity of being faithful to the memory of the other, to keep that loved one alive within us, and with the necessity of over-coming that impossible mourning with forgetting.
>
> My work deals with the fact that the beloved – the object of violence – always leaves his or her trace imprinted on us. Simultaneously, the art works to continue the life of the bereaved, a life disfigured by the other's death … I would say that the only way in which I confront memory in my work is to begin with the failure of memory.[32]

Salcedo seems to be arguing that, for her, memory is inextricably bound up with mourning. Of course, claims by an artist that his or her work is expressive of something do not guarantee that such a work will inevitably convey those meanings to its audience. That said, the knowledge that *Unland* was produced by an artist with a strong sense of the impossibility of being able to retrieve an actual event (i.e. what she calls 'the failure of memory') can encourage the viewer actively to explore the many evocative and metaphorical possibilities that such a 'memorial' – or anti-monument – might offer its spectators.

Salcedo's use of familiar household objects, which reference private, domestic lives and which metamorphose into alien forms, echoes Bourgeois's use of oddly juxtaposed pieces of furniture and sculpture in *Passage Dangereux*.

In a series of installations by Salcedo called *La Casa Viuda* (1992–5) (Plates 6.21 and 6.22), chairs collide with or merge into doors, objects that signify the structure of domestic space. Doors help to create both the boundary and the point of access between the (private) interior and the (public) exterior of a house. Literally translated, 'La Casa Viuda' means 'The Widow's House' –

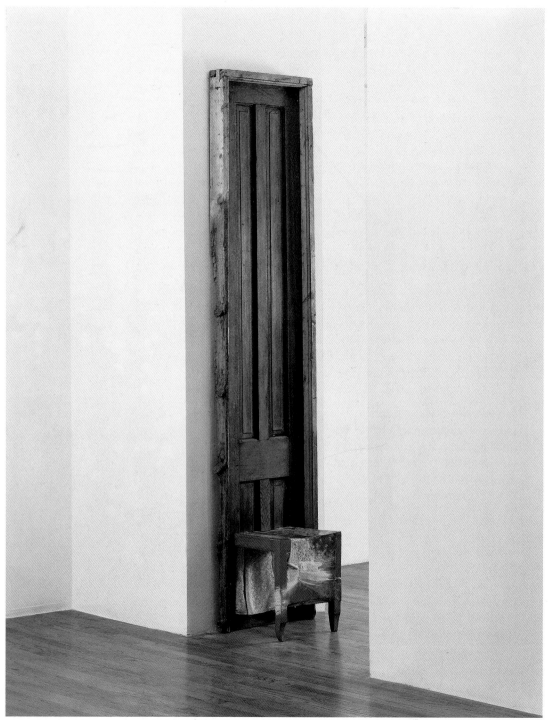

PLATE **6.21** Doris Salcedo, *La Casa Viuda I*, 1992–4, wood, fabric. (Courtesy Alexander and Bonin, New York. Photo: D. James Dee.)

or what we might describe as her 'home'. But the empty, ominous and sad associations of the objects in this series jar with the comforting feeling of home. Such defamiliarising effects are often described as 'uncanny'. In his 1919 essay 'The Uncanny', Sigmund Freud identified the uncanny – *unheimlich* in German – as an aesthetic property that can make the familiar appear frightening or strange. Although Freud developed the idea in the context of his theory of repression, in which uncanny sensations were experienced in certain forms of neurosis, the term has been appropriated to describe the aesthetic effects of the presentation and juxtapositions of objects in recent art, or even to serve as a metaphor that describes some of the disturbing effects of late twentieth-century life in general. Freud explored the etymology of the word *unheimlich*, which is derived from *das Heim* ('the home'), noting that the comforting, friendly concept of *heimlich* ('belonging to the house') 'develops in the direction of ambivalence, until it finally coincides with its opposite, *unheimlich*'.[33] The idea of the uncanny is especially relevant to an analysis of the iconography of the home. Invested with feelings of security and the familiar, *das Heimliche* ('the homely') is particularly vulnerable to being destabilised or rendered strange. When displaced or transformed, simple everyday objects can evoke feelings of uncertainty or confusion. Thus, Bourgeois's chairs hanging ominously from a wire-mesh ceiling, or Salcedo's seats metamorphosing into doors, lose their comforting associations and become a source of puzzlement and discomfort.

In Salcedo's works, uncanny effects are often deployed to reinforce metaphorical possibilities. In *La Casa Viuda I* (Plate 6.21), half a chair is pushed against a tall, narrow door, which itself stands against a wall, creating a kind of double barricade. Over the seat of the chair, and hanging like a skirt against the door, is a pale, lacy fabric, possibly part of a woman's dress. On the seat and sides of the chair the lace is thin and worn; it appears to be merging with the wood, an evocative trace of a living body that might have sat on the chair. In *La Casa Viuda VI* (Plate 6.22), three free-standing, narrow, ageing doors appear folded onto the floor. One of these is attached by a metal pipe

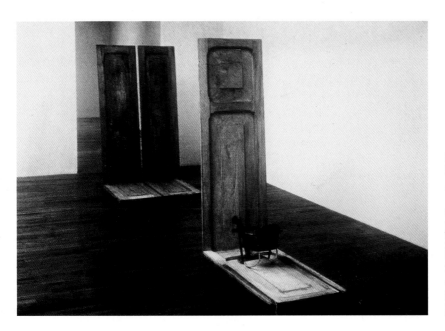

PLATE **6.22**
Doris Salcedo, *La Casa Viuda VI*, 1995, wood, bone, metal. (Israel Museum, Jerusalem. Gift of Shawn and Peter Leibowitz, New York to American Friends of the Israel Museum. Photo: © Israel Museum.)

and handle to a metal seat, rather like a bicycle seat. But the seat is immovable, locked in position by the metal bar and the closed door. The closed doors, leading nowhere and preventing movement from inside to outside or vice versa could suggest imprisonment – perhaps within a domestic, furnished space. We have seen that metaphors of imprisonment and being barricaded in were also evoked (and intended) by Hatoum's work and the claustrophobic cages of *Passage Dangereux*. Bourgeois, however, has encouraged her audience to relate these to personal trauma, in contrast with the political associations intended by Salcedo and Hatoum.

Whatever the specific meanings suggested by each work, these artists have produced installations that evoke the home in contradictory ways. Such works can confuse the divisions between private and public space, between the idea of a familiar home and an alienating prison. Salcedo's empty houses are both public and hidden (or barricaded) at the same time. They are also confined within the gallery space, suggesting a double containment. Salcedo plays on this relationship by placing some of her doors up against the gallery walls. This device reminds us of the role of the exhibition hall itself, which both defines the physical boundaries of the work, and proclaims its status as 'art' to be viewed by the public. In fact, it might be argued that the gallery context gives these otherwise 'ordinary' objects from everyday life a portentousness that they might not otherwise hold, that they are rendered more supposedly 'meaningful' through such positionings. In response to these suggestions, we could argue that the strange, uncanny components of these installations actually invite their audience to reflect on both the constraints and the effects of the gallery context.

'When a house is not a home'

In 1993, Rachel Whiteread produced an installation that engaged directly with the theme of home, but in a site-specific, non-gallery context. *House* was a partial cast of the inside of 193 Grove Road in Bow in the East End of London, then one of the few remaining houses of a Victorian terrace scheduled for demolition (Plates 6.23 and 6.24). Whiteread and her assistants cast the inside of the outer structure of this house with sprayed concrete to produce a sealed, negative form of the building, which was itself intended for demolition after a limited period of several months. Completed on 25 October 1993, *House* began to attract vociferous local and national interest and growing numbers of visitors. The work was sponsored by the arts charity Artangel, Becks brewery and the construction company Tarmac, and became one of the most controversial public sculpture projects to be commissioned in postwar Britain. In response to the work, increasingly polarised debates engaged the artworld, the local community, neighbourhood councillors and national newspapers. The area around Grove Road had been scarred by Second World War bombing, social unrest and housing shortages, issues that featured prominently in public debates. While local opposition focused on housing policies in the East End, balking at the £50,000 cost of Whiteread's 'concrete capers',[34] many artworld figures, institutions and journalists rose to the defence of *House*, citing its innovative status as a haunting, site-specific installation that evoked memories of domestic lives – of 'home'. Even Sydney

Gale, the last occupant of 193 Grove Road and a 'war hero',[35] entered the fray, with regular 'soundbites' in local newspapers and tabloids. His confident assertion 'If this is art then I'm Leonardo da Vinci' made the headlines of the *East London Advertiser* shortly after the cast was completed.[36] Debates shifted within and between the different arenas implicated, including the politics of local housing, race and neighbourhood identity in the East End of London, government funding for the arts, iconoclasm and aesthetic values. Critics, punters and politicians struggled to control the language that would define the meanings of *House*. Some of those struggles were incisively written into social and institutional history on 23 November 1993 when Bow neighbourhood councillors voted (by a casting vote of one) to demolish the work rather than extend its display for a limited period. On the same day, the jurors of the annual British art competition, the Turner Prize, voted to give Whiteread the award. She was the first woman to win the prize since its establishment in 1984.

Although *House* was an object that appeared so solidly grounded, it did not seem to offer its audience any fixed meanings. Positioned within the contentious arena of public art, it was especially vulnerable to controversy. Its insecure status as a 'memorial' (was it commemorating a model of communal terraced housing – or was it an aestheticised 'memory' of such buildings?) was further confused by the work's evocation of the supposed privacy and intimacy of the home. The traces in the concrete cast of painted and papered walls, fireplaces, cupboards, doors and electric cables conjure up comforting domestic activities. But by turning the space inside out,

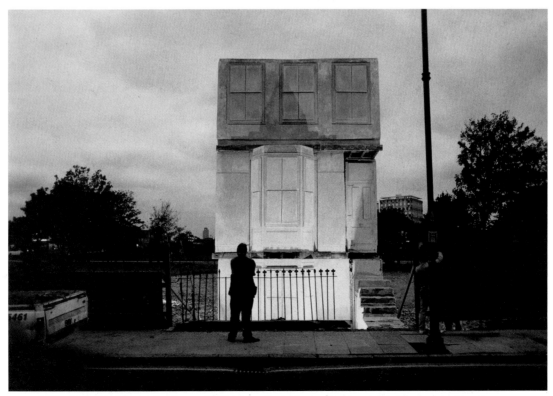

PLATE **6.23** Rachel Whiteread, *House*, 1993, view from Grove Road, gelatin silver print. (Courtesy Artangel, London. Photo: Nick Turpin.)

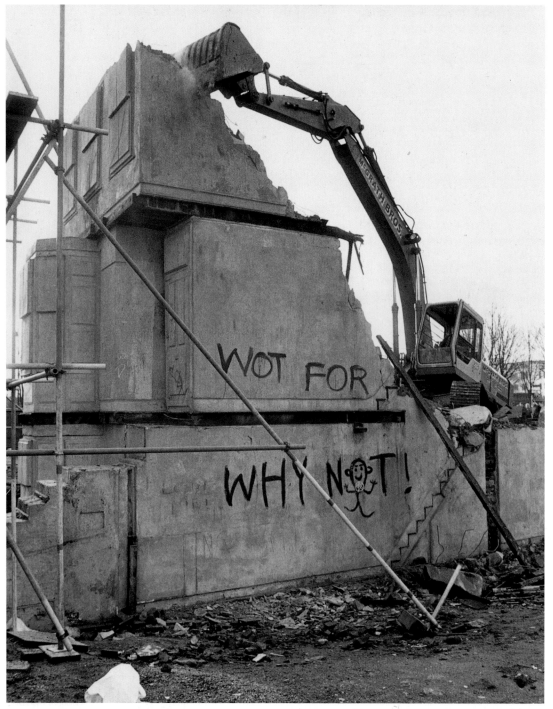

PLATE **6.24** Rachel Whiteread, *House*, demolition, 11 January 1994. (Courtesy Artangel, London. Photo: Stephen White.)

Whiteread also defamiliarised that traditionally private sphere. The geographer Doreen Massey has written:

> This sculpture was not called *Home*; it was called *House*. And this naming, it seems to me, reinforces mightily the impact of all other challenges to sentimentalized notions of the domestic which it works so well. It immediately distances us, it uses a word somehow from the public sphere to designate a work which is so evidently redolent of what we customarily think of as private, and a word, too, which refers more to the physicality of the walls and roof, which have been removed, which now no longer are, than to the space of social interaction which, in contrast, has now physically been both exposed and filled in.[37]

Another lost aspect of this building that had signalled the 'home' was its position in a terrace with neighbours on either side. With the rest of the terrace demolished, *House* appeared oddly alone on a stretch of Grove Road that had once been busy with domestic activity. This isolation was reinforced by both the newly established surroundings of Mile End Park, and the marked absence (loss) of such nineteenth-century terraces in the immediate area beyond Grove Road. The vertical lines of Whiteread's cast were echoed by the heavy forms of East End tower blocks, themselves controversial monuments to postwar public housing policies. Further confusing and extending its metaphorical possibilities, Whiteread's house was closed – sealed with concrete. Thus, the comforting family spaces of the kitchen or the front room were rendered inaccessible, creating another uncanny effect. The private, interior world of the house was both exposed to public view and locked away, as if to undermine attempts clearly to separate the categories of public (masculine) and private (feminine). Massey argues: 'It is not merely physical space which it turns inside out but the whole burden of meaning and metaphor which this space has so often had to carry (the actual bearing of the burden usually predominately being done by the women who lived in those spaces).'[38] These contradictions and uncertainties remind us of the complexities that underpin any notion of 'home' and its possible gendered associations.

Recognition of the potent ambiguities evoked by *House* was not reserved for the artworld cognoscenti. Its potential for journalistic punning and mischievous word play clearly inspired sub-editors across the country, producing predictably glib headlines such as 'Home Truths' (*Guardian*, 22 November), 'Politicians Who Give No House Room to Art' (*Guardian*, 25 November), 'House Calls' (*Sunday Times*, 5 December), 'When a House is Not a Home' (*East London Advertiser*, 28 October).[39] As the relentless media coverage suggests, *House* became its own story, offering endless material for the construction of historical narratives and mythologies. After its demolition, the memories of local people, Whiteread's friends, artworld supporters, councillors and journalists, combined with reports of incidents such as graffiti on the walls (Plate 6.24), empty milk bottles found on the front doorstep and spoof advertisements placed by estate agents to construct a vivid oral history of the work. As Jon Bird has written: '*House* lives on as a focus for story-telling … It has become a work that marks a moment – creates a space – beyond the confines of the art world, spilling over into the general culture to become an icon of popular reference and symbolic meaning.'[40]

However, before being razed to the ground, *House* had been the product of a long and complex sculptural process. A six-month search by Whiteread and Artangel to find a suitable property was followed by lengthy technical discussions on the problems of realising a cast of a complete terraced house, aided by one of its sponsors, Tarmac. In 1990, Whiteread had made a plaster cast of the inside of a Victorian living room, taken from a terraced house at Archway, north London (Plate 6.25). *Ghost* petrified and turned inside out a unit of terraced domestic space, a project that *House* continued on a larger scale. *Ghost* was cast in panelled sections, which were then fixed onto an armature in their original arrangement. A different system, known in the construction trade as 'gunniting', was adopted for *House*. This involved spraying a layer of concrete between the inside wall of the house and a wire-mesh frame, to form a shell. Although 193 Grove Road was in a poor state of repair, it was decided that the infrastructure of the building – the load-bearing timbers and masonry – were strong enough to support this project. However, the redistribution of weight required new foundations at the base of the building and extra bolts to stiffen existing floors. Each room was carefully prepared and stripped of extraneous decorations and recesses that might disturb the surface of the mould, and walls were coated with a preparatory debonding agent. To prevent the sprayed concrete from breaking the glass, windows were lined with plywood. Concrete was sprayed through the wire mesh in several layers and cured for ten days. The outer structure was then carefully removed room by room to reveal a negative cast of the original house.

The production of *House* involved a complex synthesis of techniques of sculptural moulding, structural engineering and archaeological preservation. As the original material object is now lost and the demolition dust has long since settled, its powerful symbolic and mythological potential has inevitably dominated recent historical narratives. The photographic documentation, which freezes its history into 'snapshots', has informed and shaped those narratives.[41] The spectator can no longer study the actual physical surface of *House*, cannot walk around it, touch it and puzzle over how the concrete was cast or how it could produce such strange imprints of wires and windows, mortified in a solid mass. Thus, the complicated artistic and technical feat of *making* the work has tended to attract less attention than its iconic status as a focus of artistic and social debate. Its complex relationship with preceding sculptural and artistic tradition raises further related issues for debate and discussion.

Are there any formal and technical aspects of *House* (Plates 6.23 and 6.24) that seem to you to be informed by, or to rework, preceding concerns in European and American art? You may wish to draw on material provided in this and preceding chapters of this book.

Perhaps one of the most interesting features of *House* is the way in which it is related to some of the concerns of minimalism and recent installation art, and even, perhaps, to aspects of Conceptual Art, yet is not adequately described by any of these loose groupings. It is debatable whether *House* actually belongs within the category of 'installation', if we take Stiles's definition (from Chapter 5) that installations typically involve assemblages or groupings of materials/objects, and apart from its theme it seems to have little in common with the forms of *Passage Dangereux*. In some respects, *House* appears more like a conventional form of a sculptural monument, although as a cast

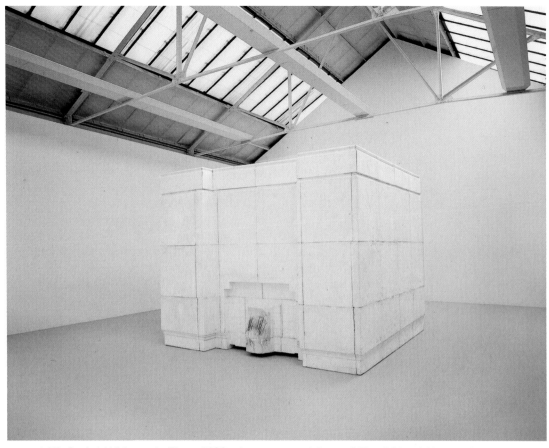

PLATE **6.25** Rachel Whiteread, *Ghost*, 1990, plaster on steel frame, 269 × 356 × 318 cm. (Courtesy Anthony d'Offay Gallery, London.)

of an ordinary building that was subsequently demolished it had an insecure and contested status as a 'monument'. It does seem to relate to minimalist preoccupations with well-built objects made from industrial materials, which have simple, geometric, rectangular or loosely cubic forms, exemplified in work by, for example, Carl Andre or Donald Judd. However, the literalism of its references (to a house) are different from the vaguely abstract nature of many minimalist objects. The ephemeral nature of the work and its intended demolition could also be related to some of the concerns of earlier performance and Conceptual Art which sought to undermine the idea of the artwork as a unique, autonomous object. What now remains of *House* is an extensive photographic and textual archive. We might argue that the archive is now the work. Thus, the photographic 'memory' of Whiteread's *House* has become a substitute for the sculptural object that was itself replete with traces and memories. ■

House also relates directly to a series of plaster casts of the spaces under chairs, shelves and boxes made by Bruce Nauman in the mid-1960s in which negative space is given a positive volume. However, what has been called the 'inside out' character of Whiteread's work actually involves a more complex structural and archaeological process than was involved in Nauman's negative casts. *House* has no internal mass – it is empty inside, but sealed.

Moreover, Whiteread's meticulous attention to surface detail and the traces that are congealed there has been seen to take her work beyond the idea of the solid concrete or plaster cast towards a more indexical form, that is, a form that, like a death mask or a photograph, resonates with evidence of the object in life from which it has been taken.[42]

Protected by the body of the house

While the strange concrete forms of *House* invite the spectator to struggle to understand its relationship with the home, Bourgeois's houses are full of references to personal experiences that took place within, and are identified with, a home. Domestic objects and buildings are (according to the artist) redolent with painful memories that, in later life, she has sought to process, repair and, perhaps, exploit. It has often been suggested that she uses the process of artistic making as a means of working through childhood trauma, for 'attaining self-knowledge and protection'.[43] In psychoanalytic terms, to reconstruct a house-like form that is resonant with painful memories can help the process of recovery. It is argued that by building a sculptural frame or room, which she then fills with an assemblage of significant objects, Bourgeois seeks to control those memories. In the 1960s, the French philosopher and theorist Gaston Bachelard explored the psychology of the house in his now much-quoted and influential book *The Poetics of Space*. He argued that the 'house is our corner of the world'. It shelters daydreaming and imagining and thus helps to construct memories. It acts as both a physical and an imaginative space. Those daydreams, fantasies of childhood, remain with us in later life 'and a great many of our memories are housed, and if the house is a bit elaborate, if it has a cellar and a garret, nooks and corridors, our memories have refuges that are all the more delineated'.[44] Influenced by both French phenomenology and psychoanalytic theories, Bachelard's book is a poetic and imaginative (some might argue eccentric) attempt to explore the psychological effects of objects. He argues that the house offers a range of literal and symbolic possibilities around which to focus associations and dreams. For example, he describes the opposition between the extremes of the cellar and the attic. While the former can be dank, dark and irrational, the latter, which is closer to light and the sky, can signify a more rational, clear-thinking state of mind. I would add that the attic can hold other meanings and evocative possibilities, especially in relation to Bourgeois's houses or cells. The attic is where household rubbish is traditionally stored. Cases and boxes full of old memorabilia, letters and clothes, ageing furniture and toys that children have outgrown all have their mythical 'home' in a dusty roof space; family and childhood memories become jumbled up together in a state of confusion that echoes psychic disorder. *Passage Dangereux* could be seen to evoke precisely these disorderly imaginative possibilities.

Bourgeois's houses also suggest anthropomorphic meanings. Early in her career she produced drawings and single sculptures that referenced the (female) body and bodily organs, provoking the spectator to see associations between the two. In a series of drawings from the 1940s, *Femmes Maisons* (for example, Plate 6.26), nude female bodies have houses or rooms as torsos or heads.

Parts of the body such as limbs appear cut or amputated to accommodate the structure of the house. The theme of bodily amputation as an integral part of sculptural construction recurs throughout Bourgeois's work, and is visible in the (apparently) amputated feet merged with metal rods in *Passage Dangereux*. In a work from 1990, *J'y suis, j'y reste* (Plate 6.27), amputated pink marble feet are contained within a glass house. In each of these images, the architecture of the house appears to contain or sever parts of the body. In Bourgeois's work, then, the house can evoke multiple meanings and symbolic associations: it can symbolically provide shelter from trauma, but also imprison and control that trauma; it can protect the body but also damage it. As the mother it can stand as a metaphorical body that can nurture, or as the father it can protect, but it can also hide abuse or private misery.

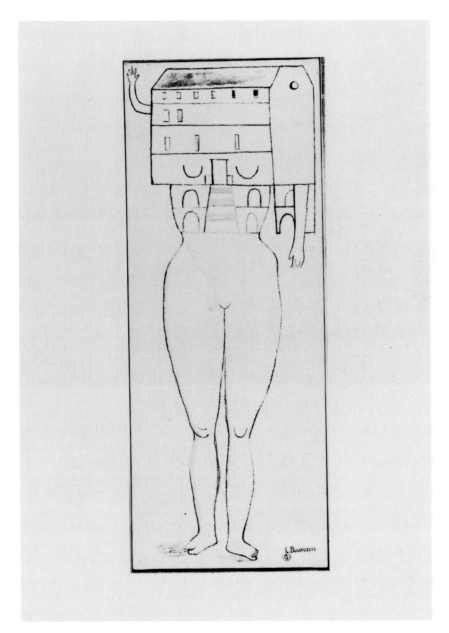

PLATE **6.26**
Louise Bourgeois, *Femme Maison*, 1946–7, ink on linen, 91 × 36 cm. (Collection Ella Foshay. Photo: Donald Greenhaus. © Louise Bourgeois/ VAGA, New York/ DACS, London 2004.)

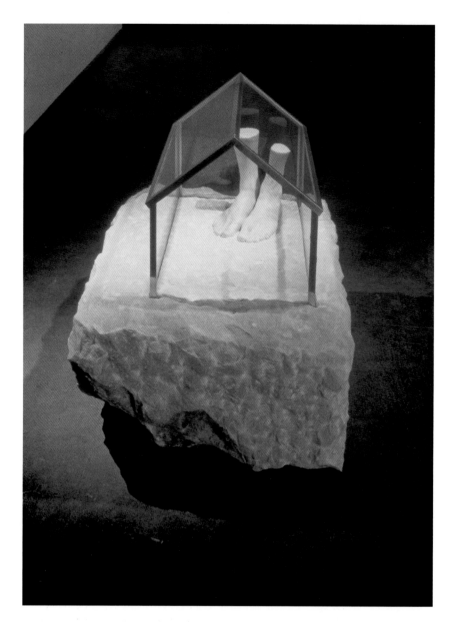

The material properties of these (metaphorical) bodies provide further sources of puzzlement. In the 1960s, domestic objects that transform into bodily forms and works that evoke organic, bodily qualities became identifiable characteristics of Bourgeois's oeuvre, along with those of several other women artists working in the USA during the period, including Eva Hesse. They often used modern and traditional sculptural materials, such as steel or latex, marble or plaster, to mimic fluid or soft forms we associate with the body and its erotic and sexual 'zones', as in Bourgeois's notorious *Fillette* (Plate 6.10). Such 'soft sculptures', have subsequently been identified as 'postminimalist' because of the complexity of their shapes and textures and their almost excessive, corporeal materiality.[45] In viewing Bourgeois's sculptures, we are often confused as to whether the object is wet or dry, hard or soft, slippery or firm, confounding our sense of what the object is made of. Such ambiguities confuse our tactile expectations; they can also offer a challenge to the

traditional sculptural vocabulary for representing the female (and male) body and its erotic potential.

The anthropomorphic, organic potential of these works has often been placed in opposition to the cleaner lines and more pared down surfaces of 1960s minimalism. But such category distinctions do not adequately represent the complexity of the installation works we have discussed thus far. For example, Whiteread's *House*, although more clearly related to the uniform blocks or structures of minimalist sculpture, has also been seen to have anthropomorphic possibilities. The cracks, fissures, channels and openings that were visible on the surface of the concrete have been described as 'liminal orifices', metaphors of the body.[46] The layer of concrete that encases a closed interior could thus represent the body's outer layer of skin and muscle, betraying its cuts, scars and orifices on the outside, but hiding the internal organs. Moreover, the idea of the house as a maternal – even womb-like – nurturing and protective form could be suggested by the (apparent) solid mass of *House* with its heavy, monumental form.

The motif of a woman's body as a container has a long mythic and psychoanalytic history. In *The Poetics of Space*, Bachelard recognised the potential of the house for symbolising a maternal body[47] and Freudian theory has encouraged us to identify the possibility of everyday objects symbolising the mother's body or womb. Freud often used spatial or architectural imagery to represent the iconography of dreams. Such dream imagery is seen to mask or conceal unconscious memories or libidinal urges, including those associated with desire for and anxiety about the female body. Feminist theory has drawn on psychoanalytic theory to demonstrate that such psychic formations may be manifest in our wider culture, including forms of 'high' and mass culture. Laura Mulvey, for example, has shown how cinematic imagery draws on metaphors and metonyms of the female body to express the collective anxieties and desires of a social group or gender. Film narrative often takes place within the literal and psychological spaces of the home, which are heavy with this metaphorical potential.[48] This symbolic power reaches beyond film and is, of course, embedded in other forms of cultural discourse. It may help to explain the anxieties and confusions that some art installations on this theme have evoked. While Bourgeois's work, replete with weird, dream-like references to domestic life, seems to offer itself up to such psychoanalytic readings, *House* appeared as a relatively closed and self-referential object. But the expectations of its familiar theme, combined with its uncanny, anthropomorphic sculptural effects, contributed to the sense of (psychic) unease that the work seems to have produced within some of its audiences.

Home furnishings

Traces of the body in concrete or cement are also to be found in works by Salcedo, for whom anthropomorphic references are often deliberately written into her intended narratives. During the 1990s, she produced a series of installations called *Untitled* (Plates 6.28 and 6.29), in which parts of wooden furniture, such as drawers, cupboards, shelves and hanging spaces, were filled with cement, with the surfaces visibly smoothed or scraped with hand tools.

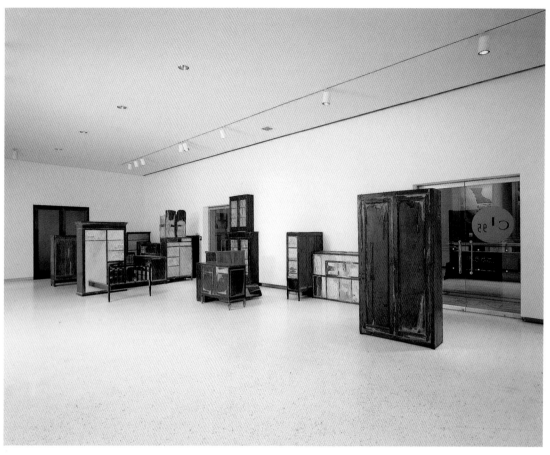

PLATE **6.28** Doris Salcedo, *Untitled*, installation view of Carnegie International, 1995. (Courtesy Alexander and Bonin, New York. Photo: Richard Stoner.)

Many of these surfaces also reveal remnants or imprints of clothing. Bits of crumpled shirts or dresses seem to emerge from the concrete, as if both frozen and ephemeral. The imprint of a lacy flower pattern may act as a trigger for the imagination, suggesting a missing female body. When partially filled with cement, wardrobes and chests acquire a momumentality or fullness which is itself more suggestive of bodily form. There is a tension between the tactile complexity of the surface and the heavy mass of the filled wardrobe or cupboard, reminiscent of Whiteread's *Ghost* or *House*. Empty beds and chairs, the shapes of which are structured to support sitting or sleeping bodies, also assume anthropomorphic characteristics. In her *Untitled* series, Salcedo often used old beds with head- and footboards, providing further reference to absent parts of the body. Such items of furniture are rarely presented as isolated objects. Beds often merge into cupboards and wardrobes, with key parts of their wooden structures disappearing into cement-filled drawers (Plates 6.28 and 6.29).

Apart from the obvious anthropomorphic associations, domestic objects, crowded and merged together, evoke a range of symbolic possibilities, including intertwined family relationships. Worn out, distressed, marked and

PLATE **6.29** Doris Salcedo, detail of *Untitled*, 1995, wood, cement, cloth and steel. (Courtesy Alexander and Bonin, New York. Photo: Richard Stoner.)

disappearing furniture could refer to past human use, and also to the absence or loss of human activity. Of course, such possibilities of meaning are encouraged by, although not dependent upon, a knowledge of artistic intention. Bachelard has singled out 'drawers, chests and wardrobes' as some of the most powerful signifiers of intimate, domestic lives. In his characteristically poetic style he wrote:

> Wardrobes with their shelves, desks with their drawers, and chests with their false bottoms are veritable organs of the secret psychological life. Indeed, without these 'objects' and a few others in equally high favour, our intimate life would lack a model of intimacy. They are hybrid objects, subject objects.[49]

We could argue that Salcedo's *Untitled* series takes the idea of the 'hybrid object' a step further as beds, cupboards and chairs literally merge with other pieces of household furniture. I take Bachelard's notion of a 'subject object' to mean a (household) object that is so loaded with personal, intimate associations and experiences that it takes on (symbolically) part of the subject's identity. Needless to say, an understanding of this notion involves a kind of poetic faith in our psychic and emotional capacities for investing in and identifying with inanimate objects. But this idea is close to the metonymic associations that Salcedo intended her works to convey, albeit with more specific political meanings attached.

PLATE **6.30** Rachel Whiteread, *Untitled* (*Ten Tables*), 1996, plaster, 73 × 240 × 478 cm. (Courtesy Anthony d'Offay Gallery, London. Photo: Mike Bruce.)

Along with this poetic dimension, which may escape or frustrate some observers who seek more concrete meanings, these works — like those of Whiteread discussed so far — betray physical and tactile evidence of the complex sculptural processes involved in their making. Apart from signs of the working and smoothing of the cement surfaces, metal pins are often inserted into cupboards, chairs and chests to reinforce the wooden structures to hold the increased weight. The pins are visible on or above the moulded surfaces, creating their own formal patterns and reminding us of the structural imperatives of the works. These formal projects also involve imaginative investigations of sculptural space. Both Salcedo and Whiteread have explored the boundaries of an object's mass or volume in their casts of the negative or empty spaces inside and underneath pieces of domestic furniture, such as chairs, tables and beds (Plates 6.30 and 6.31). Whiteread's *Untitled (Black Bed)* of 1991 (Plate 6.31) is a fibreglass and rubber cast of the underside of an old, sagging folding bed. Before making the cast, the artist attached a sheet of hessian to the underside of the bed. The cast reveals both the weave of the cloth, and a projecting ridge that formed in the space of the fold, speckled with traces of hair and dirt, indexical signs of the original object. I want to suggest that, in the case of both artists, it is precisely these complex sculptural processes, revealed in tactile form, that give their works some of their most haunting qualities. Traces and marks of the casts and their structures, bits of hair, dust, clothing or wallpaper that got caught up in the making process, the strange textures and tones left by

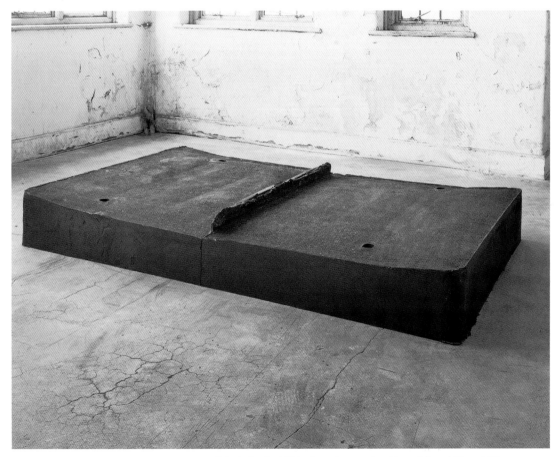

PLATE **6.31** Rachel Whiteread, *Untitled (Black Bed)*, 1991, fibreglass and rubber, 31 × 188 × 137 cm. (Courtesy Anthony d'Offay Gallery, London. Photo: Sue Ormerod.)

the concrete, cement or rubber mix, help to construct the evocative 'subject object' that supposedly inhabits Bachelard's house of dreams.

Household furniture, including that of the kitchen, is the subject of Mona Hatoum's work *Homebound*, installed at Tate Britain in 2000 (Plate 6.32). In between two barriers of horizontal wires, stretched across the full width of the gallery space, she arranged a combination of tubular steel and plastic furniture, kitchen utensils, lamps, a small animal cage and a toy train. Each object is connected to another by an electric wire carrying an intermittent current. Light bulbs lurk under colanders and sieves, in wire cabinets, in a cage, bucket and bowl, flickering on and off in an apparently random sequence, controlled by a software program. As different lights glow and fade, the amplified noise of the current crackles and hums around the installation. *Homebound* – unlike the silent immobility of Whiteread's *House* or Salcedo's *Unland* – invites the viewer to experience a changing performance of sight and sound, almost a modern 'son et lumière'. Through the selection of metallic, unupholstered furniture, characterised by metal bars and grids, the comforting associations of the home are rendered disturbing and uncanny. The constantly changing and flickering light effects can both seduce and alienate the onlooker, who is barred from entering the space by the horizontal wires. Echoing the themes of some earlier works, *Homebound* evokes both a home and a prison. Metaphors of entrapment and containment are suggested through the many assembled objects – in the metal bars, the wire fence, the mesh cupboards, the trapped bulbs and perhaps in the intermittent electrical current reminiscent of methods of torture.

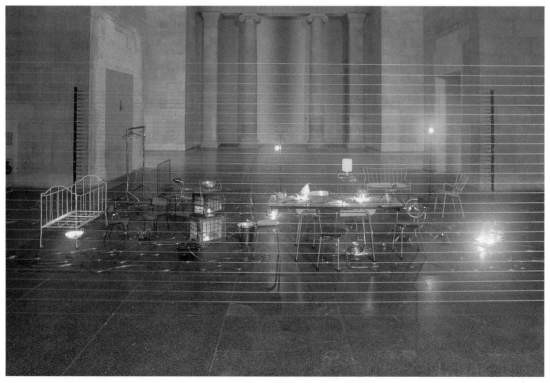

PLATE **6.32** Mona Hatoum, *Homebound*, 2000, kitchen utensils, furniture, electric wire, light bulbs, computerised dimmer switch, amplifier, speakers, installation, dimensions variable. (Courtesy Jay Jopling/White Cube, London. Photo: Edward Woodman. © Mona Hatoum.)

Hatoum sought to destabilise the familiar and gendered associations of the home. She has explained her intention to

> shatter notions of wholesomeness of the home environment, the household, and the domain where the feminine resides. Having always had an ambiguous relationship with notions of home, family and the nurturing that is expected out of this situation, I often like to introduce a physical or psychological disturbance to contradict those expectations.[50]

She claims that having being raised in Beirut (she came to London in 1975) in a culture in which women are taught cooking as part of their qualification for marriage, she felt especially antagonistic towards this idea of the home. Hence the many pieces of kitchen equipment collected in this work. Through their disturbing juxtapositions and positionings, popular household gadgets, the tools of the 'ideal home', can become potential instruments of torture, symbols of physical or psychological fear. Moreover, within a postwar western culture, housework, traditionally performed by women, was one means to transform Bachelard's houses of dreams into 'dream houses'. The 'feminine' domestic culture of cleaning, hoovering, dusting, polishing, cooking and so on has offered another fantasy construction of the house as 'spotless', beautiful and coveted. As we have seen in this and preceding chapters, such domestic fantasies have been challenged and reworked by some of the photographic, sculptural and painted interventions of many feminist artists of the last thirty years.

Conclusion

Hatoum's house – or kitchen – with its metal gadgets and streamlined tubular steel and plastic furniture from the 1950s and 1960s appears clean, clinical and polished, despite its apparently haphazard arrangement. Not so the dusty junk, fading materials and strange corporeal forms of Bourgeois's *Passage Dangereux* with which I began this chapter. Both works could be seen to invite the 'overdose of narrativity' mentioned earlier. Yet I have suggested that both artists have used their seemingly cluttered installations to construct the home as a site of psychological disturbance and alienation, and as an ambiguous and unstable physical environment, which the viewer explores slowly and kinaesthetically. I have discussed several ways in which such works may invite gendered readings: through the artists' choice of subject matter, and through the associations evoked by their sculptural manipulations and juxtaposition of objects. Knowledge of the artists' intentions, their engagement with autobiographical, political, psychoanalytic or feminist themes, may contribute to and inform our interpretations, but (as I have argued) it should not be pursued to the exclusion of other sources of meaning. I have sought to emphasise that these memorials, 'dream houses' and houses of dreams are also the work of what Bourgeois herself called 'a very concrete woman',[51] artists engaged with formal, sculptural, tactile and architectural processes of making, constructing, casting, assembling – or scavenging and exploding – some of them rooted in minimalist and postminimalist concerns. I have suggested that the combination of such processes with an intimate iconography of the home has contributed (in varying degrees) to both the aesthetic complexity and the imaginative possibilities of some recent forms of installation art.

Notes

1 Born in Paris in 1911, Bourgeois lived and worked in France until she married the art historian Robert Goldwater in 1938 and moved to New York.

2 Works like *Passages Dangereux* have frequently been described in these terms. See, for example, essays by Jerry Gorovoy and Danielle Tilkin, Mieke Bal and Jennifer Bloomer in Bourgeois, *Memory and Architecture*.

3 Some of these issues are discussed in Chapter 4 of *Frameworks for Modern Art*. A useful collection of essays can be found in Bird, *On Installation*.

4 Bal, *Louise Bourgeois' Spider*, p.3.

5 Bal has discussed the different deployments of 'narrative' in her analysis of Bourgeois's *Spider* (see *ibid.*).

6 Potts, *The Sculptural Imagination*, p.357.

7 Bourgeois, *Destruction of the Father*. In 1972, Bourgeois wrote: 'The inner necessity of the artist has everything to do with gender and sexuality. The frustration of the woman artist and her lack of immediate role as an artist in society is a consequence of this necessity, and her powerlessness (even if she is successful) is a consequence of this' (p.99).

8 Benjamin, *Reflections*, p.155. For some interesting articles on the relationship between gender, sexuality and architectural and domestic space, see Colomina, *Sexuality and Space*.

9 In his influential account of British art in the 1990s, *High Art Lite*, Julian Stallabrass described 'the turn to the domestic' as a factor that has helped the increased visibility of women in contemporary British art (p.158). For a fuller discussion of the reasons for this visibility, see Perry, *Difference and Excess in Contemporary Art*.

10 See Bourgeois, *Destruction of the Father*.

11 *Ibid.*, p.313: 'It is only afterwards that you see the work, and you say, "Oh, my goodness! I know what I meant … It is a self-portrait."' Although this statement was made in the context of a discussion of her drawings, its implications for Bourgeois's work as a whole are echoed throughout her published writings.

12 These issues are discussed in relation to theories of the fetish in Perry, *Gender and Art*, pp.252–5.

13 Bourgeois, *Destruction of the Father*, p.101.

14 *Ibid.*, p.16. The reference is to the psychoanalyst Jacques Lacan and the theologian and philosopher Jacques-Bénigne Bossuet.

15 See, for example, Nixon, 'Bad Enough Mother'.

16 Krauss, *Bachelors*, p.55.

17 *Ibid.*, p.54.

18 Isaak, 'Trash'.

19 This point is explored in *ibid.*, pp.176–7.

20 Kristeva suggests that it is primarily the maternal body, which is closest to the infant and his or her residues, that is the prototype for 'abjection'.

21 Tickner, 'Interview with Cornelia Parker', pp.368–9.

22 These issues are discussed in Chapter 4 of *Frameworks for Modern Art*.

23 Tickner, 'Interview with Cornelia Parker', p.369.

24 *Ibid.*, p.370.

25 The relationship between performance art and photographic archives is discussed in Chapter 4 of *Frameworks for Modern Art*.

26 In his book *The Sculptural Imagination*, Alex Potts explores the possible parallels between aspects of traditional free-standing, object-based sculpture, such as the neo-classical work by Canova, with more recent works by sculptors such as Constantin Brancusi and Barbara Hepworth, which are designed to produce a changing and visually intriguing spectacle as the viewer circulates around the object (see esp. 'Introduction: The Sculptural Imagination and the Viewing of Sculpture' and chapter 1, 'Classical Figures', pp.1–59). The ambiguity between a sculpture being perceived as a centred shape and as a complex shifting spectacle that one can circle around seems to be a central issue in Parker's installation.

27 Tickner, 'Mediating Generation', p.35.

28 Guy Brett, for example, has described *Current Disturbances* as a work in which Hatoum uses wooden columns to 'create a monumental, imposing work' (Brett, 'Mona Hatoum', p.83).

29 Merewether, 'To Bear Witness', p.16.

30 These parallels are discussed in Schlieker, 'Pause for Thought', p.59. See also Schlieker's account of the conception and making of the work in 'A Book Must be the Axe for the Frozen Sea Within Us'.

31 Reported in Merewether, 'To Bear Witness', pp.22–3.

32 Interview with Charles Merewether, 1998, in Princenthal, Basualdo and Huyssen, *Doris Salcedo*, p.140.

33 Freud, 'The Uncanny' (1955), in *Art and Literature*; quote p.364.

34 *East London Advertiser*, 28 October 1993, p.1.

35 According to the local newspaper (*ibid.*).

36 *East London Advertiser*, 4 November 1993, quoted in Sinclair, 'The House in the Park', p.22.

37 Massey, 'Space–Time and the Politics of Location', p.42.

38 *Ibid.*

39 A selection of these articles from the national and local press is included in Lingwood, *Rachel Whiteread: House*.

40 Bird, 'Dolce Domum', p.112.

41 A wide selection of photographs of the construction process and the finished work, many of them collected by Artangel, is reproduced in Lingwood, *Rachel Whiteread: House*.

42 This indexical character of Whiteread's work is discussed in Krauss, 'Making Space Matter', p.34, and in Krauss, 'X Marks the Spot'.

43 Gorovoy and Tilkin, 'There's No Place Like Home', p.17.

44 Bachelard, *The Poetics of Space*, p.8.

45 This status as 'soft sculpture' and 'postminimalist' has been explored by Briony Fer in her essay 'Objects Beyond Objecthood'.

46 See, for example, Bird, 'Dolce Domum', p.123.

47 He references this aspect, along with the symbolic status of houses as 'nests', 'shells' ('bits of man and bits of woman': Bachelard, *The Poetics of Space*, p.114), and what he calls 'the phenomenology of roundness' (*ibid.*, chapter 10).

48 Mulvey has explored the metaphorical potential of the myth of Pandora's Box within this context, arguing that this story of the first woman of classical mythology is heavy with psychic possibilities, particularly around the idea of a box or container of feminine secrets or mysteries, which might act as 'signifiers of the anxieties installed in the patriarchal psyche in its rendering of the symbolisation of sexual difference'. See Mulvey, 'Pandora'; quote p.60.

49 Bachelard, *The Poetics of Space*, p.78.

50 Interview published in French as 'Entretien avec Jo Glenross' in the broadsheet for an exhibition at Centre d'Art Contemporain, Thiers, 1999. Cited (and translated) in Wagstaff, 'Uncharted Territory', p.32.

51 Bourgeois, *Destruction of the Father*, p.16.

References

Bachelard, G., *The Poetics of Space*, trans. M. Jolas, Boston: Beacon Press, 1994 (English translation first published 1964).

Bal, M., *Louise Bourgois' Spider: The Architecture of Art-Writing*, Chicago and London: University of Chicago Press, 2001.

Benjamin, W., *Reflections*, New York: Schoken Books, 1986.

Bird, J., 'Dolce Domum', in Lingwood, *Rachel Whiteread: House*, pp.110–25.

Bird, J. (ed.), *On Installation*, special issue, *Oxford Art Journal*, vol.24, no.2, 2001.

Bourgeois, L., *Destruction of the Father. Reconstruction of the Father: Writings and Interviews 1923–1997*, London: Violette, 1998.

Bourgeois, L., *Memory and Architecture*, exhibition catalogue, Museo Nacional Centro de Arte Reina Sofia, Madrid, 2000.

Brett, G., 'Mona Hatoum', in M. Archer, G. Brett and C. de Zegher, *Mona Hatoum*, London: Phaidon, 1997, pp.32–87.

Colomina, B. (ed.), *Sexuality and Space*, Princeton, NJ: Princeton University Press, 1992.

Fer, B., 'Objects Beyond Objecthood', *Oxford Art Journal*, vol.22, no.2, 1999, pp.25–36.

Freud, S., *Art and Literature*, Pelican Freud Library, vol.14, trans. and ed. J. Strachey, Harmondsworth: Penguin, 1985.

Gaiger, J. (ed.), *Frameworks for Modern Art*, New Haven and London: Yale University Press in association with The Open University, 2003.

Gorovoy, J. and Tilkin, D., 'There's No Place Like Home', in Bourgeois, *Memory and Architecture*, pp.15–18.

Krauss, R., *Bachelors*, Cambridge, MA: MIT Press in association with *October*, 1999.

Krauss, R., 'Making Space Matter', *Tate Magazine*, no.10, winter 1996, pp.32–6.

Krauss, R., 'X Marks the Spot', in *Rachel Whiteread*, exhibition catalogue, Tate Liverpool, 1996–7, pp.74–81.

Kristeva, J., *Powers of Horror: An Essay on Abjection*, trans. L.S. Roudiez, New York: Columbia University Press, 1982.

Isaak, J.-A., 'Trash: Public Art by the Garbage Girls', in S. Adamas and A. Gruetzner Robins (eds), *Gendering Landscape Art*, Manchester: Manchester University Press, 2000, pp.173–85.

Lingwood, J. (ed.), *Rachel Whiteread: House*, London: Phaidon with Artangel, 1995.

Massey, D., 'Space–Time and the Politics of Location', in Lingwood, *Rachel Whiteread: House*, pp.34–49.

Merewether, C., 'To Bear Witness', in *Doris Salcedo*, exhibition catalogue, SITE Santa Fe, 1998, pp.16–24.

Mulvey, L., 'Pandora: Topographies of the Mask and Curiosity', in Colomina, *Sexuality and Space*, pp.52–71.

Nixon, M., 'Bad Enough Mother', in R. Krauss *et al.*, *October: The Second Decade, 1986–1996*, Cambridge, MA: MIT Press, 1997, pp.156–78.

Perry G. (ed.), *Difference and Excess in Contemporary Art: The Visibility of Women's Practice*, Oxford: Blackwell, 2003.

Perry, G., *Gender and Art*, New Haven and London: Yale University Press, 1999.

Potts, A., *The Sculptural Imagination: Figurative, Modernist, Minimalist*, New Haven and London: Yale University Press, 2000.

Princenthal, N., Basualdo, C. and Huyssen, A., *Doris Salcedo*, London: Phaidon, 2000.

Schlieker, A., 'A Book Must be the Axe for the Frozen Sea Within Us: Rachel Whiteread's "Holocaust Memorial"', in S. Wiesenthal (ed.), *Projekt – Judenplatz Wien: zur Konstruktion von Erinnerung I*, Vienna, Paul Zsolnay, 2000.

Schlieker, A., 'Pause for Thought: The Public Sculptures of Rachel Whiteread', in *Rachel Whiteread*, exhibition catalogue, Serpentine Gallery, London, 2001, pp.58–65.

Sinclair, I., 'The House in the Park: A Psychogeographical Response', in Lingwood, *Rachel Whiteread: House*, pp.12–33.

Stallabrass, J., *High Art Lite: British Art in the 1990s*, London: Verso, 1999.

Tickner, L., 'Interview with Cornelia Parker', in Perry, *Difference and Excess in Contemporary Art*, pp.364–91.

Tickner, L., 'Mediating Generation: The Mother–Daughter Plot', *Art History*, vol.25, no.1, February 2002, pp.23–46.

Wagstaff, S., 'Uncharted Territory: New Perspectives in the Art of Mona Hatoum', in *Mona Hatoum: The Entire World as a Foreign Land*, exhibition catalogue, Tate Gallery, London, 2000, pp.27–41.

Art and globalisation

Niru Ratnam

'Documenta 11', Kassel 2002

During the 1980s, two major exhibitions were responsible for stimulating renewed debate about the relations between the western modern movement and the visual cultures of the rest of the world. The first, ' "Primitivism" in Twentieth Century Art', held in 1984 at the Museum of Modern Art in New York, occasioned considerable criticism for the way it replayed classic modernist assumptions about avant-gardist formal borrowings as well as about the notion of a 'primitive' art itself, in a period when these were becoming widely contested. The second exhibition, 'Magiciens de la terre', mounted at the Pompidou Centre in Paris in 1989, in some ways defined itself *against* the 'Primitivism' show, but nonetheless ran into criticism too. This was partly for the implicit idealism underlying the idea of a global colloquy of artist-magicians, partly for the superficial look-alike contest it invited between examples of western avant-garde art and the products of entirely different cultural circumstances, and partly for the ideological assumptions about art that were laid bare when artefacts produced by 'non-western' people were suddenly transplanted into a western 'high art' context. A number of exhibitions that followed 'Magiciens de la terre' built on these debates and focused on issues such as the cultural origins of artists, the legacy of the colonial relationship between West and non-West, the history and legacy of slavery in the USA and the notion of 'otherness'. These questions continued to gather force throughout the 1990s, and became particularly apparent in the exhibition 'Documenta 10', held in Kassel, Germany in 1997. Catherine David, the curator of 'Documenta 10', described its aim as being to bring out the continuing critical nature of contemporary art 'in the age of globalisation and of the sometimes violent social, economic and cultural transformations it entails'.[1] Despite its global ambition, however, 'Documenta 10' was also criticised for continuing to draw the overwhelming majority of the artists represented from the traditional western European/North American heartlands of the avant-garde. The critical argument was that 'Documenta 10' continued to view globalisation from a western perspective.

It is with this kind of history in mind that we should approach the massive 'Documenta 11' exhibition held in Kassel in 2002, which was explicitly devoted to further exploring the idea of globalisation in relation to the multifarious practices of the visual arts. The exhibition opened on 8 June and, like all the previous 'Documenta' exhibitions, lasted 100 days. The first 'Documenta' exhibition had been inaugurated in 1955 in order to survey the field of modern and contemporary art. The initial 'Documenta' can be viewed as part of a Cold War project designed, in a period prior to the construction of

PLATE **7.1** (facing page) Öyvind Fahlström, detail of *World Map* (Plate 7.14).

the Berlin Wall, to showcase western capitalist culture to those living under Stalinist rule. The first of these exhibitions re-examined the work of the pre-Second World War avant-garde that had been repressed under the Nazi regime, while the next 'Documenta' gave prominence to the work of the American Abstract Expressionists. Although the first 'Documenta' was conceived as a one-off event, it soon became established as a five-yearly exhibition and has developed into the most important, regular survey of contemporary art. To varying extents, all the 'Documenta' exhibitions have been international in their scope, but 'Documenta 11' was the first to appoint a non-western artistic director – Okwui Enwezor – and to focus almost exclusively on debates and issues gathered together under the label of globalisation.

What is globalisation? And what light can discussion of the debates that have grown up around the process of globalisation shed on the contemporary practice of art? These are the questions that this chapter attempts to address. Since they were also formative questions for 'Documenta 11', it is with a consideration of two artworks from this exhibition that I will begin.

In 1992, Lebanese security agents are said to have set up a series of cameras along the Corniche, Beirut's seaside promenade, a place that was renowned as 'a pleasant place to walk, talk and jog', but also as the 'favourite meeting place of political pundits, spies, double agents, fortune tellers and phrenologists'.[2] The cameras were supposedly hidden inside minivan cafés that dotted the strip at regular intervals. Eight years later, the New York-based Atlas Group claimed to have received a six-minute video that consisted of sunsets filmed from one of these cameras. The tape was exhibited in 'Documenta 11' with the title *The Operator # 17 File: I Think It Would Be Better If I Could Weep* (Plate 7.2). Viewers could watch the footage of various sunsets that were dated, timed and given a sector number and which formed an oddly incongruous set of romantic, indeed, almost clichéd, images of a burning sun dipping over the horizon of the sea. Occasionally the camera captured the outlines of one or two figures strolling along the sea-front, or pausing for a moment by the fence. In addition to showing the video, the Group provided information detailing the tape's supposed origin, which was printed in the exhibition catalogue.

The Atlas Group was founded by the New York-based Lebanese artist Walid Raad 'as an imaginary foundation to research and document the contemporary history of Lebanon'.[3] The art produced under the aegis of the Atlas Group has involved the creation of fictionalised 'documentation' of the civil war and political conflict in Beirut. Another videotape produced under the aegis of the Atlas Group and exhibited at 'Documenta 11' presented what purported to be an interview with a Lebanese man who had been held hostage in Beirut along with a group of western captives (Plate 7.3).[4] According to the information in the catalogue, after 'careful study' the Atlas Group concluded that the tape of sunsets consisted of footage taken from one of the eighteen security cameras. Upon further research, we are told, the Group found out that the cameraman responsible for Camera 17 had been dismissed in 1996 for training his camera on the sunset every afternoon, although he was allowed to keep his footage. In the 'interview' attributed to the camera operator, he claimed that he only filmed the sun when it was about to set and subsequently went back to his operations, and added that in so doing he was fulfilling a

18.8.96 nxp.c23. sector 45.23/lw8

PLATE 7.2
Atlas Group/Walid Raad,
The Operator # 17 File: I Think It Would Be Better If I Could Weep,
2000, video, transferred to DVD, colour, silent, 6 min 28 sec. Stills taken from film. (© Courtesy Anthony Reynolds Gallery, London. © The artist.)

PLATE **7.3** Souheil Bachar (Atlas Group/Walid Raad), *Hostage: The Bachar Tapes (English Version)*
17 and # 31, 2001, video, transferred to DVD, colour, sound, 18 min 28 sec.
Still taken from film. (© Courtesy Anthony Reynolds Gallery, London. © The artist.)

childhood dream: when growing up in East Beirut he had always yearned to
watch the sun set from the Corniche in West Beirut. These works are clearly
multi-layered, playing games with our expectations about fact and fiction, the
boundaries of imaginative art and documentary truth. One of the things
Raad seems to achieve in them is to open up such large questions by carefully
calculated ambiguities or minor deviations from the norm: shifts that it is all
too possible to overlook, but if we do, the point is missed, and we are
misled. Thus, the *Hostage* tape plays with the consequences of substituting a
Lebanese national for the hostages who were actually all westerners, while
the 'sunsets' tape confuses expectations about clichés of art and beauty and
the non-aesthetic literalism we expect from security cameras. By slightly
making strange his fictionalised realities, Raad can be seen to follow in an
avant-garde tradition of using the devices of art to highlight the contradictions
of reality: contradictions that it is the work of mass culture and ideology to
conceal.

In another part of the exhibition, the black British artist Steve McQueen
exhibited the film *Western Deep*, which is set in the world's deepest gold-
mines: the Tautona mines of South Africa. This film takes the viewer on a
journey into the depths of the mine. The film contains long periods of darkness
punctuated by violently loud noises that emanate from the descending lift
cage and drilling equipment, and which alternate with periods of silence.
Shot on 8 mm film, *Western Deep* is experienced by many viewers as
frighteningly claustrophobic. Moments of intense, bright light are followed

by a return to the darkness of the mine, which in turn is occasionally broken up by the flash of a miner's lamp. It is evident that working conditions in the mine are bleak, and the non-linear sequence of McQueen's film is intended to be disorientating and disturbing, to jolt the viewer with a kind of equivalent to the discomfort revealed by the imagery. Before the final sequence, the miners are barely seen, often only appearing in silhouette or as disembodied limbs. When, finally, they are revealed to the viewer, they are shown as slumped, emotionless figures in a canteen watching television. In the closing section of *Western Deep*, the barely clad miners are put through a series of intense and repeated physical exercises apparently designed to test their suitability for the work. McQueen's film mixes the devices of avant-garde film – such as repetition, fragmented narrative and attention to the characteristics of the medium – with a highly political subject – the condition of black workers in South Africa – in a way that seeks to develop a heightened attention both to the film's form and the activities it depicts.

As the sociologist Anthony Giddens pointed out in his 1999 Reith Lectures, the very term 'globalisation' was hardly used in either academic literature or everyday language up until the late 1980s.[5] Yet by the turn of the twenty-first century, the concept was being debated by business leaders, politicians, sociologists, economists, geographers and cultural theorists. Its effects were also discussed and opposed by a series of popular anti-capitalist protest movements around the world. An initial definition of globalisation, as applied specifically to the visual arts and based on descriptions of the two works considered so far, might contend that it designates a broadening of focus onto the emphatically international character of contemporary modernity. Both the Atlas Group and McQueen's films offer visions of the non-western world, and they bring these concerns into view through the procedures and forms of contemporary art. As Enwezor put it in his introduction to the catalogue accompanying the 'Documenta 11' exhibition, the post-colonial demand for 'full inclusion within the global system' now 'shatters the narrow focus of Western global optics and fixes its gaze on the wider sphere of the new political, social, and cultural relations that emerged after World War II'.[6] 'Documenta 11', then, under Enwezor's curatorship, set out to explore what he called 'new relations of artistic modernity not founded on Westernism'.[7]

A provisional definition of globalisation understood in a more general sense might point to a series of effects that result from the world becoming more interconnected through increased volumes of international trade, the movement of currencies and peoples, and of related cultural interchange. Enwezor argues that post-colonial subjects and cultures play a crucial role in this new conjuncture because they embody the 'representation of nearness as the dominant mode of understanding the present condition of globalization'.[8] That is to say, from the perspective he outlines, the world's cultures, peoples and places no longer seem distant and discrete from each other but increasingly overlap through the movement of peoples and their cultural habits. Secondly, the emergence of post-colonial subjects in the West (through processes such as mass migration) has made it increasingly difficult to ignore non-western political, social and cultural histories as well as the role of empire in the construction of western economies. To quote Enwezor again, the post-colonial condition now makes 'empire's former "other" visible and present at all times'.[9] The activities of artists such as Raad and McQueen

in the centres of western art production now mean that concerns associated with a non-western perspective are increasingly visible to a European and American gallery-going public. In this sense, these artworks are not only representations of global political and economic realities, but their existence is also an effect of those same conditions. McQueen's *Western Deep*, for instance, probably owes a great deal to the fact that he now resides in Amsterdam: the conjuncture of the Dutch colonial legacy in South Africa crosses the artist's ethnic background to make the subject of the film particularly vivid. The title of McQueen's film is itself revealing in this respect. Raad, in contrast, mixes local knowledge with a consciousness of modernist conventions and traditions to produce a work that seems perplexing from all possible positions of interpretation.

Before curating 'Documenta 11', Enwezor was the artistic director of the 1997 Johannesburg Biennale, an exhibition that was even more overt with regard to the purported links between post-colonial theory and the emergent field of globalisation. The exhibition, called 'Trade Routes: History and Geography', was, he claimed, 'sited around the axial vector of economic globalisation'[10] and focused on the circulation of goods, peoples and ideas through colonial trade and the post-colonial aftermath. For Enwezor, the

PLATE **7.4** Pavel Brãila, *Shoes for Europe*, 2002, 16 mm film shot on DV, transferred to DVD, colour, sound, 26 min. Still taken from film. (Directed by Pavel Brãila. Camera: Radu Zara, Vadim Hancu. Commissioned by Documenta 11. © Pavel Brãila.)

Johannesburg Biennale was intended to act as an open network bringing together different forms of cultural activity, each open to translation by their proximity to other works, mirroring the effect that migrant cultures have on host cultures. Enwezor drew parallels between colonialism and globalisation, arguing that colonialism created new communities and cultures in a way that prefigured globalisation. Thus, for Enwezor, it was crucial to explore concepts that had arisen through the study of colonial discourse and the articulation of post-colonial theory (such as 'hybridity' and 'diaspora') in order to begin to articulate how globalisation might be understood. Many of these features remained central to the later exhibition. Some of the artworks exhibited, for example, focused on the global movement of people and commodities: Pavel Brãila's film *Shoes for Europe* (Plates 7.4 and 7.5) reveals the labour involved in moving goods by rail across European borders (Moldova/Romania); the multimedia installation *Solid Sea 01: The Ghost Ship* (Plates 7.6 and 7.7) by the group Multiplicity explores the death at sea of 283 Pakistani, Indian and Sinhalese refugees who had attempted to enter Italy, and considers the Mediterranean as a place 'trafficking in fixed identities'.[11] Chantal Akerman's installation *From the Other Side* (2002), which mixed a real-time video link and film on multiple screens and monitors, took as its

PLATE **7.5** Pavel Brãila, *Shoes for Europe*, 2002, 16 mm film shot on DV, transferred to DVD, colour, sound, 26 min. Still taken from film. (Directed by Pavel Brãila. Camera: Radu Zara, Vadim Hancu. Commissioned by Documenta 11. © Pavel Brãila.)

PLATE **7.6** Multiplicity, *Solid Sea 01: The Ghost Ship*, 2002, multimedia installation.
(© multiplicity 2002.)

PLATE **7.7** Multiplicity, *Solid Sea 01: The Ghost Ship*, 2002, multimedia installation.
(© multiplicity 2002.)

subject economic migration across the Mexican/American frontier. In all of these works, the border figures as a powerful metaphor for political and economic connection and separation. As noted in Chapter 4, Allan Sekula's *Fish Story* was assigned a prominent place in 'Documenta 11' because it illuminated the global networks of trade that seemed to hold the exhibition together. What the diverse works that made up 'Documenta 11' apparently share is a concern with place in a world that is becoming increasingly interconnected. Thus, some artists explicitly took the theme of hybridity as the basis of their works, mixing the traditions and artefacts of different cultures to create new conjunctures and fusions. By the same token, others chose to represent extreme reactions *against* cultural mixing in the form of acts of genocide and 'ethnic cleansing' in Chile, Rwanda, Uganda and the former Yugoslavia.

The curatorial project of mixing in one exhibition artists working in diverse geographical locations seems like an analogue for the process of globalisation itself. At the beginning of the twenty-first century, Tate Modern in London mounted an ambitious exhibition looking back over the art of the twentieth century organised around the centrality of the urban experience to the production of modern art. 'Century City', as the exhibition was called, included traditional centres of avant-garde activity such as Paris and New York. But the exhibition's defining feature was the expansion of its catchment to include work produced in Rio de Janeiro, Tokyo, Lagos and Mumbai, mixing forms such as architecture, popular culture, religious imagery and film posters with the traditional media of art. In 'Documenta 11', the process was even more advanced. Thus, work by Destiny Deacon, an Indigenous Australian artist, appeared next to Igloolik Isuma Productions (an Inuit film collective), while the room containing the film *An Estranged Paradise* (1997–2002) (Plate 7.8) by the Chinese artist Yang Fudong opened off a space displaying photographs by David Goldblatt (South Africa) and Jeff Wall (Canada). The prominence of film and video works in 'Documenta 11', with their attendant soundtracks in many different languages, meant that moving from room to room could be experienced as a repeated shock, a continuous switching of channels. 'Documenta 11' seems consciously to have set out to render the foremost international exhibition of modern art an experience of globalisation in action.

PLATE **7.8**
Yang Fudong, *An Estranged Paradise*, 1997–2002, 35 mm film, transferred to DVD, black and white, sound, 76 min. Still taken from film. (Courtesy of ShangArt Gallery, Shanghai.)

One way that 'Documenta 11' attempted to address the contemporary situation and to link it to current art practice was to open up the structure of the exhibition. Instead of presenting the exhibition as complete within itself, the Kassel event was designed as the fifth part of a series of 'platforms' that took place around the world from 15 March 2001 onwards. The initial four platforms consisted of public discussions, debates, conferences, workshops, and film and video programmes. They were held in Vienna, Berlin, New Delhi, St Lucia and Lagos.[12] The sites were chosen to typify particular aspects of globalisation – for example, the notion of *créolité* was explored in St Lucia.[13] However, according to one of Enwezor's co-curators, Ute Meta Bauer, the most important role of the platforms was to ensure that 'Documenta not only expanded its territory, but also abandoned it.'[14] The implication of this statement is that to imagine globalisation solely from one point of view or location in the world is reductive, and, given the legacy of western colonialism, perhaps dangerously so when it is done from one of the traditional centres of modern art. Investigations into globalisation have to recognise the dangers of looking from a single perspective and attempt to acknowledge multiple viewpoints. The expanded curatorial framework of 'Documenta' can also be understood as an attempt to articulate the importance of the specificities of the local: what globalisation means might be experienced in a very different way in Lagos from how it is in London. The decision to open up the exhibition through the five platforms can also be seen as acknowledging that there is little to be gained from studying globalisation solely with regard to art production. Instead, an adequate account of art and globalisation needs to acknowledge the interweaving of art with wider social, economic and political issues, while not reducing any one of these terms to the others.

What is globalisation?

'Globalisation' is a term – not unlike the related concept of 'postmodernism' – that emerged in the late twentieth century and has rapidly entered common currency without achieving any widely accepted theoretical definition. It is one of those ideas that is 'in the air' and is as likely to crop up in conversation, in newspaper, magazine and television discussions, as it is to be the subject of academic debate or university courses in sociology and economics. It is easy to point to events such as the end of the Cold War, the fall of the Berlin Wall, the collapse of communism in the former Soviet bloc, the rise of the so-called Asian 'tiger' economies and the embrace of a modified form of capitalism in China and to conclude that a new international situation has come into being. Moreover, advances in communication technology, such as mobile phones, satellite television and the Internet, all seem to bring these and other epochal happenings around the globe into the domestic orbit of those to whom they would once have appeared remote, exotic or even irrelevant.

In academic debate, a variety of positions have emerged on the subject of globalisation. These range from a wholehearted embrace of the idea that we have entered a new phase in human history, revealed not least by the apparent obsolescence of the traditional nation state and the emergence of a truly multinational capitalism, to a rejection of the idea that anything fundamentally

new is happening: that the nation state remains the cornerstone of the organisation of the world, that the invention of the telegraph in the nineteenth century did more to effect the shrinking of the globe than the Internet, and that even the major economic migrations that are bringing people to the West are modern versions of much older phenomena. Furthermore, both perspectives engage positive and negative stances. Thus, after the end of the Cold War many advocates of liberal capitalism foresaw an end to the most glaring divisions in international relations and predicted that a global economy based on the market would usher in a new age of prosperity and freedom for all. Others regarded the global force of 'empire' as a new opponent for the multitudes it oppressed around the world. Still others regarded celebration of an apparently new situation as a distraction from the continuing imperialism-by-another-name of the leading western nations (a view that the actions of the USA in the Middle East in the early twenty-first century have done little to dispel).

To an extent, of course, these starkly counterposed positions represent stereotypes. In reality, policy-makers and academics alike are engaged in continual, far more nuanced attempts to understand the global economy, and indeed its cultural economy. One important characteristic of the contemporary situation is the blurring of the boundaries between the once apparently distinct spheres of economics and culture. As the sociologist Hugh Mackay has written: 'Whatever globalisation has been achieved … can be seen as a result of the growing significance of the symbolic, of the power of the cultural.'[15]

One thing that is generally agreed on as central to the contemporary situation is a massive expansion of global trade. The system of 'free trade' is, of course, nothing new – having been one of the main instruments of British imperialist expansion in the nineteenth century. But a new twist has seen the extension of the free trade principle to international currency and finance dealing since the post-Second World war financial system came to an end in the late 1970s (together with renewed protectionism in other areas). As one commentator, himself a fund manager and financial writer, puts it: 'The gradual extension of free trade ideology into financial instruments, has led to the evolution of the global financial architecture. The speed and volume of financial flows have ballooned, compounding the market's force and complexity.'[16]

Having said that, although it is often analytically useful to distinguish 'economic' from 'cultural' globalisation, it is far too simplistic to regard the former as all 'cause', the latter as merely a series of 'effects'. Cultural and economic moments are almost always intertwined and interdependent. This can be seen in three particularly pressing areas of debate. First, there is technology. Whereas the development of new technology is clearly part of the strategy of capitalist corporations to maximise profit, the spread of television to the developing countries (the erstwhile 'Third World') is inseparable from a range of cultural effects. Partly this can be seen as aiding the spread of a predominantly American cultural imperialism. But studies also show how the consumption of television in India or Africa can also generate powerful resistance to western cultural norms and the affirmation of regional identities. The question of technology can thus be related to another key area of debate: homogenisation. This is

the developmental tendency whereby parts of the world are seen to lose traditional identities in a flood of western products across the board, from fashion to music to food and drink: the litany of MTV, Gap, Nike, Starbucks, McDonald's and so on. However, once again it would be an oversimplification to regard the populations of places subject to powerful cultural invasion as merely the passive recipients of a western agenda. The cultural interface is more often marked by negotiation or even rejection – and subsequent translation – of the values that come with the clothes and the soap operas. Even the rise of militant Islam can be seen as a defensive reaction to the relentless export of western – principally American – values around the globe. A third area that is characterised by the compacting of 'the economic' and 'the cultural' concerns the flows of migration that mark the contemporary global economy. While these flows may be initially determined by economic imperatives at their most naked, they immediately impact both upon the cultures of the host nations and, no less significantly, on the emergence of new cultures of diaspora.

Globalisation, then, can be thought of as naming a process or a situation which is the focus for a number of complex but related debates about the state of the world at the end of the twentieth century and the beginning of the twenty-first. These constitute ongoing areas of interest in spheres as different as economics, politics and the social sciences. The very complexity and open-endedness of this debate, however, inevitably prompts the question: what has this to do with contemporary art? In fact, the question of what globalisation might mean for particular cultural activities such as art-making was posed by Enwezor in the 'Documenta 11' exhibition catalogue:

> Almost fifty years after its founding, Documenta finds itself confronted once again with the spectres on yet another turbulent time of unceasing cultural, social, and political frictions, transitions, fissures, and global institutional consolidations … How do we make sense of these rapid changes and transformations, which call upon all practitioners for new, inventive models of enabling transdisciplinary ideas within the contemporary global public sphere?[17]

In effect, Enwezor is saying that contemporary artists have no choice. As the reality of globalisation increasingly transformed the modern world, including art production and exhibition, artists inevitably began to use their work to reflect on these profound changes. Artists from places traditionally outside the network of the international production and exhibition system are drawn into it, and equally inexorably, the conditions in which they work become subjects they work *upon*. If art can be regarded as a form of knowledge, as a way of gaining some critical purchase upon the condition of modernity, then the form that modernity takes naturally becomes the subject matter of a new art; equally and crucially, it results in unforeseen transformations *of* art. Making a painting of a satellite dish would be an anachronism of the order of a Victorian artist carving a sculpture of a train in marble. For an artist to *use* satellite communications, or a CD or the Internet to address the condition of globalisation is a different matter altogether: it has the air of inevitability.

It had become clear by the end of the twentieth century that increasing numbers of artists, both from the erstwhile western centres of art production and from elsewhere in the world, were making work either overtly addressed

to the phenomenon of globalisation, or comprehensible in terms of the debates that were growing around the concept, even if they did not explicitly engage with it. This second type of activity would include the Indigenous Australian art shown at 'Magiciens de la terre', and in many international exhibitions since. Such work engages with the conditions of Indigenous Australian life and traditions, but is drawn into the international artworld through the globalisation of the exhibition and market system (Plate 7.9). Representative examples of the kind of art that addressed globalisation head-on could be found at another of the great international festivals of contemporary art, the Venice Biennale of 2001. Here the French artist Matthieu Laurette presented *Help Me Become a U.S. Citizen*. Part of the work was initially an Internet database (www.citizenship-project.com) that provided information on how legally to obtain citizenship as well as information on immigration resources. Additionally, Laurette (demonstrating the power of the internationally accredited artist in an age of global spectacle) had the director of the exhibition write officially to the ambassadors or permanent representatives of the 112 member countries at the United Nations that were not represented in the Biennale, offering Laurette as an artist to represent them in return for citizenship. Only three countries replied,

PLATE **7.9** Ramingining Artists, *The Aboriginal Memorial*, 1987–8, natural pigments on wood, installation of 200 hollow log coffins, height to 327 cm. (Purchased with the assistance of funds from National Gallery admission charges and commissioned 1987. National Gallery of Australia, Canberra. © DACS, London 2004.)

and none of them positively, but Laurette was able to exhibit copies of his letters of rejection as documentation of the project. At the same exhibition, the Spanish artist Santiago Sierra carried out a project involving immigrant workers from Senegal, Bangladesh, China and elsewhere, whose impromptu street stalls in Venice offer fake designer goods to the cultural tourists drawn by the Biennale. For a fee of 120,000 lire paid to each immigrant, Sierra dyed their hair blond.

Both artists may thus be seen to address the structure of the Biennale itself, since the traditional centre of the exhibition is a garden of national pavilions, each of which exhibits a specific country's representative artist or artists. With certain national borders – such as those within the European Union – becoming more porous as a result of the workings of multinational firms, a structure predicated on discrete national spaces has begun to look increasingly archaic. Yet at the same time, other borders are becoming ever more vigorously guarded, as for example European Union states' attempts to deter economic migrants from the former Soviet bloc or the Far East. In the Venice Biennale of 2003, Sierra continued to address such issues by using a forbidding breeze-block wall to close off the Spanish national pavilion to all visitors who did not hold a Spanish passport (Plate 7.10). Those visitors who were Spanish citizens were allowed past a guard at the back of the pavilion only to find the detritus of the exhibition that had been held there in 2001 (Plate 7.11).

PLATE 7.10 Santiago Sierra, *Palabra tapada*. Pabellón español. Bienal de Venecia, Venecia, Italia, 2003. Empleando plástico negro y cinta americana de embalar, se tapó la palabra España que existe como relieve a la entrada del pabellón (*Covered Word*. Spanish Pavilion. Venice Biennale, Venice, Italy, 2003. Black plastic and masking tape were used to cover the word Spain set in relief over the entrance to the pavilion), black and white photograph. (Courtesy Galerie Peter Kilchmann, Zurich.)

The point the artist seemed to be making was that national purity has always been a fantasy based on an imagined and necessarily ruined past.

A work with comparable preoccupations was *Stateless Nation* (Plate 7.12), in which Sandi Hilal and Alessandro Petti distributed around the Biennale site ten large-scale replicas of passports belonging to Palestinians. Each of these passports had been issued by different states, including Israel, Italy and Jordan. The stateless condition of the Palestinians revealed by this work cast a decidedly critical light on the nationalism underlying the Biennale organisation. Fred Wilson, who was chosen to represent the USA, used his pavilion to draw attention to the black presence in Venetian art and culture. By collecting together images from paintings, popular cultural products and films, Wilson thereby called attention to the tendency to overlook this presence. The director of the 2003 Biennale himself, Francesco Bonami, decided to work with a curatorial team rather than simply imposing an individual vision, arguing that: 'My attempt to convey this new panorama was to create a polyphony of voices and ideas.'[18] Examples of this approach included Catherine David's curating of a section devoted to 'Contemporary Arab Representations'. Gilane Tawadros curated a collection of contemporary African art under the title 'Fault Lines'. Hou Hanru assembled 'Z.O.U./Zone of Urgency', where loud and dynamic video works and installations combined to evoke the experience of a non-western metropolis. Carlos Basualdo compiled a section on 'The Structure of Survival' which focused on strategies for living in shanty towns and in urban poverty.

PLATE **7.11** Santiago Sierra, *Muro cerrando un espacio*. Pabellón español. Bienal de Venecia, Venecia, Italia, 2003 (*Wall Enclosing a Space*. Spanish Pavilion. Venice Biennale, Venice, Italy, 2003), black and white photograph. (Courtesy Galerie Peter Kilchmann, Zurich.)

PLATE 7.12
Sandi Hilal and
Allessando Petti,
Stateless Nation,
2003, billboard,
mixed media, Venice
Biennale, 2003.
(Photo: Stefano
Graziani.)

It is significant that such works do not passively represent, let alone depict, aspects of globalisation. Rather, they take a more active, even interventionist, role in addressing its problems, often re-enacting and parodying, and thereby aspiring to subvert, mechanisms associated with it, as in the case of transnational movements of people and attempts by nation states to control such movement. As the art historian Julian Stallabrass has argued, art practice does not stand outside or apart from the processes of globalisation, commenting upon them from a position of neutrality, but instead has a series of complex relationships to those processes. These simultaneously involve both implication in and profit from the mechanisms of an international market, and the need for self-differentiation and definition within it:

It is possible to see free trade and free art not as opposing terms but rather as forming respectively a dominant practice and its supplement. The supplement may appear to be an inessential extra to what it supplements but nevertheless, like the foreword to [a] catalogue or the footnotes to an essay, has a role in its completion and shares its fundamental character. On this schema, free art has a disavowed affinity with free trade, and the supplementary minor practice is in fact central to the operation of the major one.[19]

The works discussed here are not therefore to be regarded merely as illustrations to theoretical arguments about globalisation. Instead, a more nuanced relationship exists between the works of art and the ideas and theories that have been proposed. Ideally, each may inform the other. In fact, the unresolved and contradictory processes of globalisation, which pose problems for the more analytical requirements of other disciplines, may be something that art can highlight through its more elliptical methods, such as allegorisation and irony. Dummy applications for citizenship or dyeing someone's hair make little sense as contributions to social science. However, they may well serve to dramatise and to call attention to the myriad inequities of a changing world.

From the post-colonial to the global

A concern with globalisation in the visual arts did not spring from nowhere. It is noticeable that many of the preoccupations and strategies of such art exhibit traces of continuity with earlier practice and theory exploring the legacy of European colonialism. It is hardly surprising that this should be so, given the close relationship of the two processes. Globalisation is not the same as colonialism (however justified may be the suspicions of those on the receiving end of western cultural expansionism). But it is hard to imagine globalisation taking place in a world that had not experienced the retreat of the classic western empires and the succeeding post-colonial condition. Part of the complexity of globalisation can be attributed to the opening up of new centres of capital generation – in countries ranging from Nigeria to South Korea – as well as the relationship of those centres both to the established metropolitan capitals in the West and to their own subject populations. The precondition for this was the end of 'classic' European imperialism on the nineteenth- and early twentieth-century model, and the entry into a contradictory post-colonial condition. Many of the most intractable tensions between ethnicity, gender and class can be traced to this change. It was, accordingly, a short step for artists interested in exploring post-colonial situations, both in terms of the effects on subjective identities as well as more objective historical and economic processes, to turn their attention to globalisation. In this section, I will examine a shift that took place in a number of intellectual disciplines away from exploring the legacies of the European empires of the nineteenth and twentieth centuries towards articulating the new forces associated with globalisation. I will then go on to look at how artists, curators and art historians have attempted to address the constellation of changing conditions.

It is conventionally accepted that the field of post-colonial studies was opened up by the publication of Edward Said's book *Orientalism* in 1978. It was Said's revolutionary contention that post-Enlightenment European culture *produced* a discourse of 'the Orient' – in effect, that is to say, of the rest of the world – in order to manage it, 'politically, sociologically, militarily, ideologically, scientifically, and imaginatively'.[20] Said was careful to allow that this notion of the Orient was more than just an idea, but rather a complex of beliefs and practices that was both produced by and, at the same time, helped to reinforce the hegemony of the West over 'the rest'. Orientalism was, so to speak, an unequal partner, but a crucial one, in the production of an idea of Europe: 'a collective notion identifying "us" Europeans as against all "those" non-Europeans'; a contrast that was 'precisely what made that culture hegemonic both in and outside Europe: the idea of European identity as a superior one in comparison with all the non-European peoples and cultures'.[21] Said goes on to argue that

> within the umbrella of Western hegemony over the Orient during the period from the end of the eighteenth century, there emerged a complex Orient suitable for study in the academy, for display in the museum, for reconstruction in the colonial office, for theoretical illustration in anthropological, biological, linguistic, racial, and historical theses about mankind and the universe.[22]

All of this was based on 'a sovereign Western consciousness out of whose unchallenged centrality' that image of the rest of the world emerged.[23] Before the emergence of the concept of globalisation, the exploration of the implications of these insights in the 1980s and early 1990s was described as the field of 'post-colonial studies' in intellectual disciplines as diverse as Anthropology, Sociology and Art History, and, of course, in related developments in the practice of art itself.

Said readily acknowledged his debt to the work of Michel Foucault, particularly to his development of the notion of a 'discourse' as an interrelated web of ideas and practices in which material and intellectual factors worked together to produce what he called systems of 'power-knowledge' in the world. Said was not alone in drawing on this intellectual resource. The influence of French 'post-structuralist' thought was equally evident in the work of other post-colonialist theorists such as Gyatri Spivak and Homi Bhabha, who wrote on concepts of 'alterity' and 'hybridity'. In fact, the crossover between post-structuralist theory and post-colonial theory is widely held to have stimulated the move away from notions of discrete ethnic, or indeed psychic, identities towards a set of more reflexive and more complex categories. The sociologist Paul Gilroy put this clearly in his book *The Black Atlantic*:

> if this appears to be little more than a roundabout way of saying that the reflexive cultures and consciousness of the European settlers and those of the Africans they enslaved, the 'Indians' they slaughtered and the Asians they indentured were not, even in situations of the most extreme brutality, sealed off hermetically from each other, then so be it.[24]

Instead of 'cultural nationalism' and the idea of 'immutable ethnic differences', Gilroy presents his alternative as

> the theorization of creolization, métissage, *mestizaje*, and hybridity. From the viewpoint of ethnic absolutism, this would be a litany of pollution and impurity. These terms are rather unsatisfactory ways of naming the processes of cultural mutation and restless (dis)continuity.[25]

These closely related ideas concerning forms of mixed identity, which emerged from the field of post-colonial studies, became key reference points for those attempting to think through the newly emergent concept of globalisation. Furthermore, the emergence of the consolidation of post-colonial communities and individuals in the West has meant that it has been increasingly difficult to ignore the presence of non-western political, social and cultural histories in the construction of contemporary identities. In this sense, it could be argued that the post-colonial leads towards globalisation. In fact, Enwezor argues along these lines in his essay in the 'Documenta 11' catalogue. For him, as we have seen, 'nearness' represents the key characteristic of globalisation;[26] that is, the world's cultures, peoples and places are no longer distant and discrete from each other, but increasingly overlap through the movement of peoples and their cultural habits.

This account of a relatively straightforward evolutionary development from colonialism, through post-colonialism, to globalisation is not, however, uncontested. Arguably the most influential treatment of globalisation that has emerged to date has taken a radically different approach. Michael Hardt and Antonio Negri argued in their book *Empire*, first published in 2000, that there is a significant rupture between the post-colonial condition and globalisation. Hardt and Negri insist that the terrain has shifted since the 1970s and that the supposed object of post-colonial critique has mutated into something quite different from the old world order. For them, post-colonial theory (and, indeed, much of postmodernism more generally) celebrates concepts such as difference, circulation, mobility and mixture, apparently unaware that these are the same concepts that the world market and corporate capital also now value. They have gone so far as to argue that 'Postmodernism is indeed the logic by which global capital operates.'[27]

For Hardt and Negri, power no longer resides in the targets at which post-colonial theorists are still taking aim: for example, the structures of nation states. Instead, they argue that a new form of global power is at work, which they term 'empire', something conceptually distinct from traditional notions of imperialism rooted in a dominant nation state. 'Empire' is a depersonalised, deterritorialised, amorphous structure that attempts to regulate all social relations and exchanges. For Hardt and Negri, 'the postcolonialist perspective remains primarily concerned with colonial sovereignty',[28] which means that while it is suitable for analysing history, it is not able to theorise contemporary global structures.[29] It is perhaps a mark of how rapidly the situation is evolving that the neo-imperialist adventures of the USA in the Middle East in the early twenty-first century already suggest a need for care with the thesis of a supranational force defining the process of globalisation.

The links between colonialism, post-colonialism and globalisation are still being debated. Hardt and Negri, and thinkers like them, argue that there is something radically new and different about the forces of globalisation, whereas Enwezor seems to suggest that there are a number of links between the post-colonial and globalisation. Hardt and Negri's critique of post-colonial theory indicates that some of the themes celebrated by this theory surprisingly dovetail with the interests of global capital: something that may well suggest the need for a certain caution when the once-radical becomes fashionable. For one thing that unites advocates of different viewpoints in the field of contemporary socio-cultural study is the commitment that theory be formulated in the service of emancipation from the more malign aspects of globalisation. One of Hardt and Negri's key themes is that 'empire' has no outside. Enwezor suggests that new forms of subjectivity that have emerged in the post-colonial situation (and that have been conceptualised in post-colonial theory) may correspond to the figures of resistance identified by Hardt and Negri as 'the multitude': figures who live and work within empire, but against it. The sense of a new conjuncture is palpable in writing that celebrates the way 'new figures of struggle and new subjectivities [are] produced in the conjuncture of events, in the universal nomadism, in the general mixture and miscegenation of individuals and populations'.[30] In the next section, I will look at some examples of how artists have explored and articulated these characteristics of an emerging global culture and economy.

Artists and globalisation

One of the most potent visual symbols we have is the map. Ranging from street maps of particular cities, through specialised maps showing physical, industrial or agricultural characteristics of a place, to political maps of the whole world, these are immensely complex and coded symbolic representations which we use on a frequent basis, most often without reflection. One of the effects of increasing globalisation has been to open up these representations of spatial relations to cultural and artistic analysis. Thus, it has become something of a commonplace to note that maps of territory should be read as 'signs and myths',[31] in order to help decode the various interests hidden behind a supposedly objective representation. With the benefit of hindsight, perhaps the most notorious of these representations is the Mercator projection of the world, which inflates the size of land masses the further away they are from the equator. Of course, any rendering of three dimensions into two will result in some inaccuracy, some form of abstraction, but in this case – a result not least of our propensity to equate size with significance – the Mercator projection reinforced the economic and political domination of the globe by European powers. Basic points, such as the increased size of Europe relative to, say, Africa, and the centring of the projection on Greenwich (then, of course, located at the heart of the empire that controlled most of the world), had the effect of apparently naturalising or seeming to render objective a historically contingent state of affairs.

The Mercator projection was developed to aid navigation in the early days of European global expansion, but in the twentieth century, certain radical artists also had recourse to the notion of mapping in order to signify their

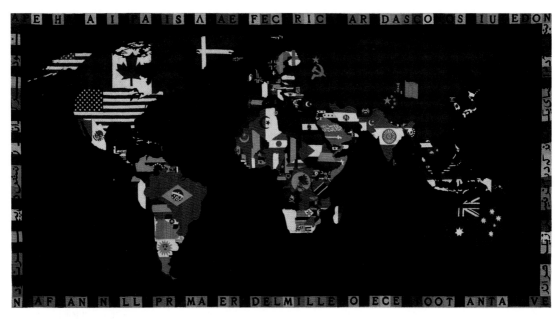

PLATE **7.13** Alighiero Boetti, *Map of the World*, embroidery on fabric, 118 × 223 cm. (New York Museum of Modern Art, New York. Scott Burton Memorial Fund. 1253.1999. DIGITAL IMAGE © 2003, The Museum of Modern Art, New York/Scala, Florence. © DACS, London 2004.)

distance from and criticism of the status quo of global power. An early example of this is the Surrealist world map of 1929. Among other features, this magnified the size of the USSR and Mexico, made Ireland larger than England, lost France completely except for Paris, which was relocated to Germany, and contrived to make the USA disappear entirely. In the aftermath of 1968, the Italian artist Alighiero Boetti produced maps of nations involved in war, printed in isolation as apparently 'abstract' shapes, on newspaper-sized copper sheets. Beginning in 1970, and continuing at intervals until his death in 1994, Boetti also produced a series of world maps on which each territory was indicated by that country's national flag (Plate 7.13). Boetti did not personally make the maps: they were tapestries woven to his designs by craftswomen from Afghanistan. The result was simultaneously a blurring of the distinctions between 'high art' and craft, and a questioning of the conventions of individual authorship of the artistic work, but also, when several of the maps made over a period of years are considered together, they become a telling representation of the mutability of political power relations in the world.

In the early 1970s, the Brazilian-born Swedish artist Öyvind Fahlström also turned to the process of mapping in an attempt to describe what he perceived as an emerging new world order. His painting *World Map* (Plate 7.14) depicts a number of economic trends that affected the USA and the non-western world around the 1970s. Fahlström said of it:

> *World Map* ... is a historical map of the world, approx. 1970. Most of it is about the Third World: economic exploitation, repression, liberation movements, USA: the recession economy. Europe is represented by a Swedish manual for diplomats' wives (the chapter 'In the event of revolution'). – The shapes of the countries are defined by the data about them. It is a medieval type of map.[32]

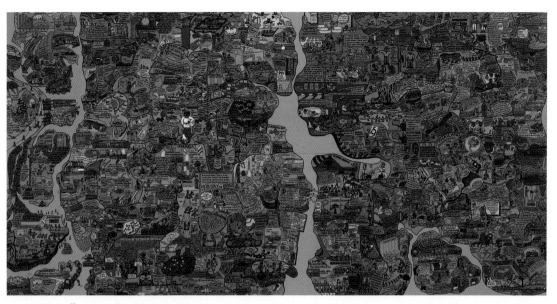

PLATE **7.14** Öyvind Fahlström, *World Map*, 1972, acrylic and Indian ink on vinyl mounted on wood, 92 × 183 cm. (Private collection. © DACS, London 2004.)

Fahlström's map does, indeed, have the appearance of a medieval document rather than a modern projection of the world. Its most immediately noticeable feature is the way he has 'lost' both the Atlantic and Pacific Oceans. The world is divided into three land masses running from top to bottom of the map, and divided by narrow areas that look more like rivers than seas. Within the continents, the various countries retain their approximate positions, but only approximately. Thus, South America, Brazil, Paraguay, Chile and so on are all more or less where they should be. But while Europe is also where we might expect to see it, within it Northern Ireland abuts Italy, and both are close to south-east Asia, which has been pushed up and around from its actual position. Falhström was one of the first artists to work with sociological information published about financial and political processes, which now is an increasingly common tactic within contemporary art production. Each country featured is allotted an area that is split into multicoloured boxes that often contain information about that country's political situations or information about their economies. Much of this information pertains to loans made by the World Bank to those countries or trade agreements (and sanctions) with the USA. For instance, the viewer learns that 13 per cent of the land in Puerto Rico is owned by the American military. The World Bank loans come 'with strings' to Ceylon (now Sri Lanka). The average worker's income in the Philippines is $600. Any literate sceptic of the existing world order will be familiar with such depressing litanies, yet Fahlström's map is incongruously and improbably jaunty. Cartoons of politicians, such as Chairman Mao, pop up waving and smiling, and the pigs and chickens used to illustrate the point that fish-meal is used to fatten them for export from Peru to the West are carefully rendered in play-school fashion. There is a stark discrepancy between what the tiny bits of text say and the jollity of the map, for Fahlström was not only one of the first artists to articulate the power of global capital,

he was also quick to realise an absurd aspect of the inequalities that could arise from it. As the Swedish ambassadors' wives were reminded, when the revolution did come it would be important to 'Serve coffee and ask people to help with chores. Save yourself. Do as little as possible. Save your strength.' The revolution, of course, never arrived.

One thing that Fahlström's map does indicate is that although the theorisation of globalisation was a phenomenon of the 1990s and after, the processes that set it in train had been at work for some decades, certainly since the 1960s (or in a longer view, perhaps even since the Second World War). As we have seen, not all commentators agree that globalisation is radically different from social and economic formations that preceded it, and, in particular, some have argued that capitalism has always operated as a world economy. However, it is increasingly widely accepted that the global market-place changed considerably during the second half of the twentieth century, that the level of world trade is much higher than it ever has been before and that finance and trade flows have been revolutionised by the transfer of electronic money. Falhström's painting attempts to chart the emergence of some of these new factors but, using the form of a map, does so in a way that is historically linked to trade and domination. Fahlström's work thus stands as a kind of precursor for the kind of claim made by Hardt and Negri in respect of their concept of empire: that 'in its ideal form there is no outside to the world market'.[33] They argue that capitalism has always attempted to incorporate all areas, but it is only with the advent of global capitalism that this possibility can and is being realised. This prompts the question: 'is there still a *place* from which we can launch our critique and construct an alternative?'[34] Fahlström's use of the map form points to the possibility that if global capitalism cannot be subjected to criticism from a space outside it, then perhaps the answer is to find spaces within it from which to question or undermine it. By redeploying a form originally tied to the history of trade and capital but to a different end, Fahlström might be said to be using the networks and forms of global capital against itself.

In a similar fashion, the Brazilian artist Cildo Meireles also engaged in a critique of global capitalism at the beginning of the 1970s. For his work *Insertions into Ideological Circuits: Coca-Cola Project* (Plate 7.15), Meireles purchased a number of Coca-Cola bottles and printed the sentence 'Yankees Go Home' onto them, just below the Coca-Cola logo. He then put these altered bottles back into circulation within Brazil, a country that at the time was subject to strict censorship. Like Fahlström's map, Meireles's work operates by subverting the system out of which it is constituted, rather than seeking some sort of outside to the circuits of global capital. Meireles's subversion of Coca-Cola's logo offers a contrasting approach to that of many American and British Pop artists who used commercial products in their art in the 1960s. It is, in fact, more closely related to the strategies associated with the culturally revolutionary activities of the Situationists in the build-up to the events of May 1968.[35] Indeed, one legacy of Meireles's work can be seen in 'adbusting' and 'culture jamming' – the popular tactic of late 1990s anti-globalisation protestors who defaced billboards and other media to subvert the advertised products' messages.[36]

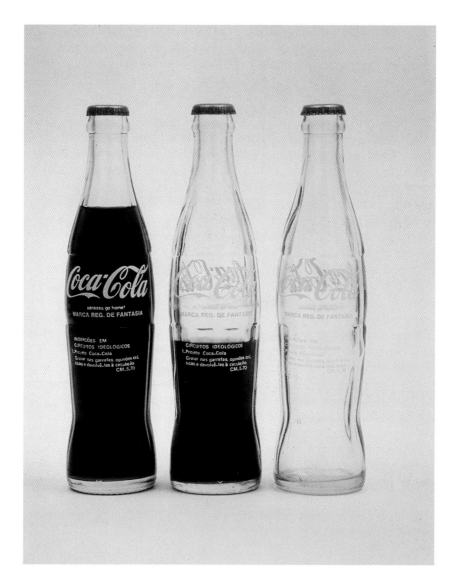

PLATE **7.15**
Cildo Meireles,
*Insertions into
Ideological Circuits:
Coca-Cola Project*,
1970, Coca-Cola
bottles, transferred
text, height 18 cm,
unlimited samples.
(Image © New
Museum of
Contemporary Art,
New York. Courtesy
of the artist and
Galerie Lelong,
New York.)

For and against internationalism

In April 1984, a conference titled 'Global Visions: Towards a New
Internationalism in the Visual Arts' was held at the Tate Gallery in London to
mark the foundation of the International Institute of Visual Arts. This was an
organisation devoted to exploring what the word 'international' might signify
in the field of contemporary visual culture. It grew out of debates in the
British artworld in the 1970s and 1980s between figures who described
themselves as 'Black Artists' in order to draw attention to what they perceived
as their marginalisation by white institutions and curators. Many of the debates
in the British artworld of this period concerned the idea of multiculturalism
and the legacies of colonialism in relation to both the ex-colonised and the
ex-colonisers. However, by the 1990s it was clear that it was no longer
possible to debate ethnicity and cultural origins without taking into account

shifts that were occurring on a global level. The organiser of the conference, Gavin Jantjes, wrote:

> The concept of New Internationalism is inclusive as opposed to the exclusive, modernist internationalism of old. Its thesis is the contemporary work of artists from all over the world, with emphasis on the art neglected by art history because of race, gender and cultural difference … What this means in terms of policy is that the national culture is being placed in relationship to the global.[37]

This shift away from local arguments around multiculturalism within the UK to more global concerns was reflected in the composition of the conference, which included artists and art historians from around the world. Yet one of the most striking features of the papers delivered by non-western delegates was their repeated scepticism about the theme of the conference itself. The Mexican artist and curator Guillermo Santamarina stated, 'I would like to make obvious my scepticism about the qualitative changes that western art history is possibly undergoing at the moment as a reaction to the dynamics of art from the "peripheries" attempting to establish themselves in the "centres".'[38] The Indian art historian Geeta Kapur argued that the drive towards the international was in part driven by 'western attempts to dismantle national economies through *mala fide* legislation, embargoes and economic sanctions', and that what was needed was a reconsideration of the national in a more 'rational and secular' manner.[39] The Nigerian artist Olu Oguibe argued that 'A new internationalism can only be proposed as an alternative if its object of negation is western internationalism.'[40]

Many of the speakers, particularly those who were working outside the West, saw the idea of a 'New Internationalism' as simply another western construct linked to the West-driven project of globalisation. The concept of a 'New Internationalism' was subsequently dropped, and in a small but significant change in 1997, the organisation was renamed as the Institute of International Visual Arts (inIVA). The scepticism about a 'New Internationalism' and the subsequent name change reflects a widely held view that cultural globalisation represented little more than another form of 'westernisation', 'Americanisation' or simply cultural imperialism. The belief that cultural imperialism inevitably leads towards a global monoculture is one that seems to receive confirmation from the rapid spread of American companies such as McDonald's, Starbucks and Gap. Yet, as we have seen, the idea of cultural globalisation being little more than cultural imperialism and necessarily leading towards a homogenous cultural sphere has also been subject to criticism as a too simplistic description of a more complex situation. As the historian John Tomlinson has argued:

> Culture simply does not transfer in this unilinear way. Movement between cultural/geographical areas always involves interpretations, translation, mutation, adaptation and 'indigenization' as the receiving culture brings its own cultural resources to bear, in dialectical fashion, upon cultural imports.[41]

The work of the South African-born artist Candice Breitz can be approached in the light of Tomlinson's objections to the idea of a 'unilinear' cultural imperialism. At the 1999 Istanbul Biennial, Breitz first exhibited *The Babel Series* (subsequently installed in Linz and New York) (Plate 7.16). In a former Byzantine church, Breitz installed seven monitors each showing clips from MTV of western pop stars such as Madonna, George Michael and Prince. Breitz had isolated each singer intoning a monosyllable extracted from a song, which sounded like the early words babies learn. This monosyllable was repeated on a loop. Madonna was thus to be seen singing 'Pa-Pa-Pa-Pa-Pa' from the song 'Papa Don't Preach', while George Michael intoned 'Me-Me-Me-Me-Me-Me'. Breitz has said of her work:

> Globalisation is the backdrop to my work, the stage on which all of my work takes place. I don't see how it's possible to ignore globalisation at this point in time. In the context of my practice as an artist, thinking about globalisation means thinking about the way in which culture is packaged, distributed and consumed by those economic powers that have the resources to export their visions and ideals into our every waking moment.[42]

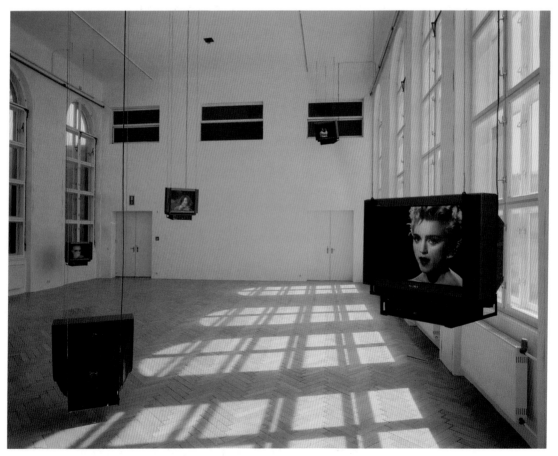

PLATE **7.16** Candice Breitz, *The Babel Series*, 1999, DVD installation (seven looping DVDs) at the O.K. Center for Contemporary Art, Linz, May 2001. (Courtesy aspreyjacques, London. Photo: Jason Mandella.)

It is possible to argue that Breitz's method of working in this piece reveals something of how the receivers of global culture dissect and reassemble it in unexpected ways. In subsequent works, Breitz has used the same method of sampling and reconfiguring, drawing attention to meanings that were not apparent in the original selection. This idea was also addressed by Sarat Maharaj in a paper he delivered at the inIVA conference in which he spoke of 'the scene of translations'.[43] In that paper, Maharaj describes the way that Sri Lankans re-use the litter of western tourists, turning discarded bottles, cans and jars into objects of everyday use such as colanders, mugs and toys. These objects are then, in turn, frequently bought by western tourists as souvenirs of the 'local' culture (Plate 7.17). Maharaj goes on to discuss an exhibition of these objects that took place in Stuttgart and was subsequently shown at the 1993 Sydney Biennale, thereby blurring and subverting the established distinction between avant-garde art and popular culture or *kitsch*. This process of localising objects of global culture and thus changing the way they are perceived and used is termed 'creolisation'. Such practices of negotiated reception and refunctioning do much to qualify any overly simplistic thesis of cultural imperialism as a process of the passive absorption by non-western people of western norms and assumptions.

An installation by the Egyptian artist Wael Shawky, *Sidi el Asphalt's Moulid*,[44] exhibited at the Cairo Biennale in 2001 (Plate 7.18), can also be understood in relation to 'creolisation'. This installation consisted of two interconnected rooms, drenched in asphalt and liquid tar, the basic oil products that have been so central to the formation of the complex contemporary identity of

PLATE 7.17 *Recycled Tin Can Toys*, Antananarivo, Madagascar. (© Chris Hellier/CORBIS.)

PLATE **7.18** Wael Shawky, *Sidi el Asphalt's Moulid*, 2001, installation. (Courtesy of the artist.)

the Middle East. The first room was filled with concrete-grey window-panes and balconies, forming an Egyptian urban alleyway. A cabinet with Egyptian sweets was on one side of the room and a screen showed a video, initially of a belly-dancer and then of a woman in a headscarf swinging her head from side to side. She is following the movements of an Egyptian holy man, a so-called 'whirling dervish', who can be seen in front of her. Gradually the viewer perceives that she is one of a number of people following the dervish's actions. Yet the music that the viewer hears is not traditional Egyptian music, but the song 'Super Star' by the American hip-hop group Cyprus Hill. Despite this, the dervish's movements and those of his followers seem to follow the rhythms of the song exactly. This odd congruency suggests that the song's effect on listeners has some sort of parallel with the trance-like state that the followers of the dervish are in, or that there is some unexplained link between the modern song and the traditional effects of the dervish's movement upon his followers. This is not to say that the one causes the other, but merely that hip-hop's insistent beats might be understood in different ways in places far removed from the conditions that gave birth to that type of music.

In the second room there is a mural with the figure of a camel on it, rendered in the style of tourist art, but dotted with embedded loudspeakers. The work seeks to articulate the way in which both traditional practices, such as the religious festival involving the dervish, and the products of cultural globalisation, from MTV music to tourist art, are translated and transformed through contact with each other, and can operate together within the same sphere. Although early anti-globalisation writers and activists argued that the products of cultural globalisation were incompatible with many local cultures, the unexpected

continuities between the whirling dervish, his followers and the Cyprus Hill song point to a different conclusion: that unanticipated congruences can be produced at a local level without destroying traditional forms, and that the traditional can co-exist alongside the effects of cultural globalisation.

Whereas a number of artists, including Shawky and Breitz, have offered nuanced representations of the phenomenon of globalisation, it is important to remember that others have been more unambiguously negative. The identification of globalisation as a form of cultural imperialism has produced a powerful counter-current. This is often mistakenly termed the 'anti-globalisation' movement, though it would be more accurate to say that its supporters are opposed to the globalisation of capitalism, rather than to globalisation as such. As Stallabrass has noted, both liberal advocates of globalisation and so-called anti-globalisation protestors share certain key assumptions:

> There is something that unites those who run the global neo-liberal economy and those who oppose it: the existence of such a phenomenon, and the global consciousness it produces. Their struggle takes place over a global ideal, one founded upon free trade, transnational corporations and the existing forms of liberal democracy; the other on equality, the protection of the environment and the extension of democracy.[45]

This is something that I am going to explore in the next section as I look at ways in which artists have reacted against global capital and some aspects of the globalisation process. In particular, I shall be concerned with the role of performance and of art, or art-like strategies, within the anti-globalisation movement.

Politics, protest and art

Between 7 and 28 May 1999, the Slovenian critical theorist Slavoj Žižek exhibited a text entitled 'Against the Double Blackmail' at the Cubitt Gallery in London. The English text had been sent by e-mail to the gallery, who then enlarged it for presentation on the wall. In addition to the gallery installation, the text was also broadcast via a radio transmitter set up by the American artist Gregory Green. Žižek's text was concerned with the consequences of NATO's bombing of Serbia, then under the leadership of Slobodan Milosevic. It concerned in particular an agreement to protect the foreign interests of multinational companies in Serbia, the selective media coverage of the war and the need to refuse what Žižek called 'the double blackmail'.[46] This, for Žižek, is the kind of falsely black and white choice foisted upon people in times of war (for example, in the Balkans and the Middle East) and most recently typified by George W. Bush's slogan of the 'war on terror' of 2002–3, 'You're either with us or against us'. Žižek rejects the underlying assumption that one has to be either *for* the liberal democracy offered by the 'global capitalist New World Order' or *for* a range of despotic fundamentalists who are defined as the opposition to that 'New World Order'.[47] Instead, he argues that the latter are in fact symptomatic of the former, having been propped up for years by the West for short-term gains, before being later turned into 'the embodiment of evil'.[48] In his conclusion to 'Against the Double Blackmail', Žižek argued that:

> The way to fight the capitalist New World Order is not by
> supporting local proto-fascist resistances to it, but to focus on the
> only serious question today: how to build *transnational* political
> movements and institutions strong enough to seriously constrain
> the unlimited rule of capital and to render visible and politically
> relevant [the fact] that the local fundamentalist resistances against
> the New World Order … are part of it?[49]

Thus, for Žižek, resistance to globalisation has to be global itself, and perhaps
this is why his piece takes the form of a document e-mailed to a gallery so that
it can be installed and transmitted by radio. Communications, formerly analogue
and latterly electronic and digital, have played a constitutive role in the spread
of globalisation. However, they have also played a crucial role in the rise of the
anti-globalisation movement, as the writer Noreena Hertz recounts: 'I first
learnt about the Genoa protests through the Net, as did most of those who
gathered there. A chain letter sent to thousands and forwarded to thousands
more.'[50] This underlines the point by Stallabrass cited above, that proponents
and opponents of globalisation are using the same tools to create different
versions of a global consciousness. Moreover, this re-utilisation of globalisation's
own methods as a means of resistance to it also links back to Hardt's and
Negri's argument that there is no more 'outside': that the tools of 'empire'
have to be turned against empire itself.

The anti-globalisation movement came to widespread attention through a
series of protests against the leading institutions of international capital at
the beginning of the twenty-first century. Large numbers of protestors
disrupted trade talks between superpowers at cities such as Seattle, Genoa,
London and Washington, coordinating their plans via the Internet and e-mail.
One notable feature of the 'movement' was the absence of a resolved
ideological core on the lines of a traditional political party. Instead, groups
with often divergent views came together to form temporary alliances. Rather
than having a stable political organisation, anti-globalisation protestors operated
as a hybrid cultural–political network linked by electronic communication.

It is this aspect of the movement that makes it relevant to being considered
within the remit of the expanded field of contemporary art history. As Jean
Fisher has noted, many of the protests have been characterised by the use of
the 'carnivalesque', that is, forms of expression that are communal, anti-
authoritarian, and originate in popular culture.[51] The use of humour, and the
staging of interventions on a popular, communal level has also been evident
in art that responds to the anti-globalisation movement or dovetails with its
interests. One of the key factors at work here is the way in which the forces
of globalisation have worked to undermine the boundaries between traditional
practices of politics and culture.

It can also be argued that these new political movements draw extensively
on the traditions and techniques of the artistic avant-garde. Ideas that originated
with the Dadaists, the Situationist International or Conceptual artists are as
likely to inform these protests as the writings of Lenin or Mao. There is an
increasing fusion of artistic and political radicalism in the anti-globalisation
movement. When, for instance, Nike offered purchasers of their sports shoes
the opportunity to have an individualised name or phrase added to their
trainers, one critic of the company requested the word 'sweatshop'. The
furore that resulted when the company refused was used to publicise

opposition to the use of cheap labour in 'developing countries' by multinationals. Political campaigners have increasingly understood that in an era of media politics, the devices and practices of the avant-garde provide invaluable resources for bringing their concerns into public view. Key antecedents for this condensation of the cultural and political in urbanised, quasi-theatrical actions can be found in the varied Situationist activities of the 1960s. Indeed, many of the interventions surveyed here may be regarded as a self-conscious politics of 'counter-spectacle'. In addition, the performative aspect of the globalisation protests have roots in a wide range of postmodernist art practices such as performance and body art, as well as in related critical theory. I will explore these links further by focusing on Mexican social protest and its relationship to performance and art practice.

One of the localised, grassroots protests that fed into the anti-globalisation movement was the Zapatista insurrection on 1 January 1994, when rebels took over the city of San Cristobal de las Casas and several other small villages in Chiapas province. The Mexican-born artist Guillermo Gómez-Peña has commented:

> What made the Zapatista insurrection different from any other recent Latin American guerilla movement was its self-conscious and sophisticated use of the media. From the onset, the EZLN was fully aware of the symbolic power of their military actions. They chose strategically to begin the war precisely on the day the Free Trade Agreement went into effect. And since the second day of the conflict, they placed as much importance on staging press conferences and theatrical photos as on their military strategy. The war was carried on as if it were performance.[52]

Gómez-Peña argues that the Zapatista movement was characterised by its use of performative strategies: for example, the wearing of black ski masks and, in particular, the use of the masked disguise by one of the leaders, Sub-Commandante Marcos. The disguise Marcos used was a blend of styles and props from sources such as Che Guevara, Zorro and the character of the Mexican movie wrestler 'El Santo'. In Mexican wrestling, each performer assumes a fantastical identity that is conveyed through mask, costume and behaviour. Mexican social activists adopted these wrestling personae in order to protest against a variety of abuses. For example, an activist known as Superbarrio first emerged in the wake of the 1985 earthquake. Dressed like Superman and wearing a wrestling mask, Superbarrio resisted evictions of the poor of Mexico City and, according to the curator Cuauhtémoc Medina, 'came to represent the wide network of movements of social resistance in the inner cities that were battling against the pressures of neoliberal modernization'.[53]

In the case of Sub-Commandante Marcos, the use of disguise can be seen as a pragmatic attempt to avoid detection by repressive authority. But it is also about the performance of an identity that deliberately courts the idea of the super-hero as an imagined 'other' who becomes a focus for popular protest against authority. Gómez-Peña notes that Marcos cultivated his persona very deliberately and quickly became a media phenomenon both in and outside Mexico. Publications such as *Der Spiegel*, the *New York Times* and *Vanity Fair* were given interview access in the Chiapas jungle; in effect, Marcos's performance created the media story, which in turn advanced the underlying political content.

In his own work, Gómez-Peña utilises costumes and drag, often referring to cultural stereotypes through props such as a mariachi sombrero. In so doing, he foregrounds the performative aspect of identity that has also been of such interest to recent critical theorists. Writers such as Stuart Hall and Judith Butler have argued that identity is not primordial, stable and unchanging, but rather an ongoing process of identifications and misidentifications. By utilising a variety of references that range from Mexican popular culture to objects of American kitsch, Gómez-Peña's performances seek to highlight the hybrid nature of identities – particularly at the borders of countries, such as the one between the USA and Mexico. Moreover, Gómez-Peña's practice, especially his use of drag, suggests that borders themselves are permeable.

From this perspective, the identity of the subject is regarded as a process of continual construction, being renegotiated and repositioned, with each moment of stabilisation seen as contingent and temporary. The work of the Mexican-born, Dutch-based artist Carlos Amorales can be understood in this way. Amorales, whose original name was Carlos Aguirre Morales, also utilises the tradition of the Mexican masked wrestler in his work (Plates 7.19 and 7.20), but often in order to call his own identity into question. In a number of performance pieces, he has used a design based on his own face to create the persona 'Amorales'. Sometimes he has worn a mask himself, but more often he has 'lent' the persona to others who, wearing the mask and a sober business suit, then become 'Amorales' for the duration of the performances. He has also staged wrestling bouts, which have involved two characters, both performing as Amorales, fighting each other, or as a tag

PLATE **7.19** Carlos Amorales, *Amorales vs Amorales*, Turbine Hall, Tate Modern, London, 9 May 2003. (Courtesy: the artist, Yvon Lambert Gallery and Tate Modern. Photo: Jeremy Hilder.)

team fighting another team of wrestlers. The imbrication of culture and politics is nowhere more evident than in a wrestling match staged on 19 January 2001 in Tijuana between two Amorales figures and two legendary Mexican wrestlers. During the bout, the crowd were against the Amorales pair, but this can partly be explained by the fact that the other wrestlers were local, popular heroes. We also need to take into account that Carlos Amorales, who took the role of manager of the 'Amorales' pair, was dressed like the unpopular Mexican president:

> So when the fight was introduced to the audience it was already a postmodern drama: a social representation of the spectacle of global strife between Mexican low class rogues and just arrived modern foreigners. And when the Amoraleses came into the Sports Hall they were accompanied by a third Amorales, their creator, manager and 'second', who, on top of that, was the perfect image of the Mexican villain par excellence, the 1990s promoter of global integration, President Carlos Salinas.[54]

In 1997, Amorales invited Superbarrio and the politician Marco Rascón, who is closely linked to the work of Superbarrio, to deliver three lectures in Amsterdam. The final lecture dealt specifically with the relationship between art, local political resistance and global political resistance. By using these examples of contemporary cultural practice and politics in Mexico, I am not trying to suggest that there is a clear 'influence' of ideas from critical theory, through art practice, to anti-globalisation protest. However, given the shifting

PLATE **7.20** Carlos Amorales, *Amorales vs Amorales*, Turbine Hall, Tate Modern, London, 9 May 2003. (Courtesy: the artist, Yvon Lambert Gallery and Tate Modern. Photo: Jeremy Hilder.)

and unstable nature of such activities, there are clearly elements of continuity and cross-fertilisation. For example, the economic forces of globalisation have accelerated the movement of peoples around the world. This has stimulated theorising about cultural identity, in particular arguments that identities are unstable and in flux. These ideas in turn have been used by protestors and artists alike in their variously cultural and political critiques of globalisation.

Conclusion

In 1992, Homi Bhabha, one of the leading cultural theorists of post-colonialism and globalisation, reminded his readers that 'The globe shrinks for those who own it; for the displaced or the dispossessed, the migrant or the refugee, no distance is more awesome than the few feet across borders or frontiers.'[55] Any study of globalisation needs to acknowledge the conflict between these two standpoints, and to reflect upon the seemingly irreconcilable differences in the ways in which the same phenomena are experienced and interpreted by individuals in different social, political and economic circumstances. The freedom of the artist, both as an agent of criticism and as a participant in and beneficiary of the international art market, stands in stark contrast to the lack of freedom that is still experienced by the majority of the world's population. The spheres of art and life remain as enmeshed today as they were in the time of the classic avant-gardes of the early twentieth century, even as the politics of resistance changed immeasurably in the period after the Second World War. In the early twenty-first century, the practice of art continues to take place in a situation characterised by tension, between the hope of making a difference and the risk of colluding with forces beyond its control.

Notes

I would like to thank my colleagues Steve Edwards, Jason Gaiger, Mark Pittaway and Paul Wood for their substantial contributions to this chapter.

1 David, Introduction to Paul Sztulman, *Documenta 10 Short Guide*, p.7.

2 Catalogue entry in *Documenta 11_Platform 5*, p.180.

3 Catalogue Appendix (separate insert) in *ibid.*, p.4.

4 Atlas Group, *Hostage: The Bachar Tapes (English Version)* (2001), in a catalogue entry in *Documenta 11_Platform 5*, p.181.

5 Giddens, 'Runaway World', p.7; based on the author's 1999 BBC Reith Lectures.

6 Enwezor, 'The Black Box' (2002), in Ander and Rottner, *Documenta 11_Platform 5*, p.44; extract reprinted in Gaiger and Wood, *Art of the Twentieth Century*, pp.320–6; quote pp.320–1.

7 Gaiger and Wood, *Art of the Twentieth Century*, p.324.

8 *Ibid.*, p.320.

9 *Ibid.*, p.321.

10 Enwezor, Introduction to 'Travel Notes: Living, Working and Travelling in a Restless World' (1997), in *Trade Routes: History and Geography*, pp.7–12; quote p.7.

11 Nadja Rottneri, 'Multiplicity', in Documenta and the Museum Fridericianum Verandtaltungs-Gmb, *Documenta 11_Platform 5: Exhibition, Short Guide*, p.164.

12 'Platform 1, Democracy Unrealized' was held in Vienna (15 March–20 April 2001) and Berlin (9–30 October 2001); 'Platform 2, Experiments with Truth: Transitional Justice and the Process of Truth and Reconciliation' in New Delhi (7–21 May 2001); 'Platform 3, Créolité and Creolization' in St Lucia, West Indies (12–16 January 2002); 'Platform 4, Under Siege: Four African Cities – Freetown, Johannesburg, Kinshasa, Lagos' in Lagos (16–20 March 2002). For descriptions of the four 'platforms', see Ander and Rottner, *Documenta 11_Platform 5*, pp.49–53.

13 Theories of creole language originally took as their object of attention specific Caribbean creole languages, before applying the model of *créolité* as a general way of understanding post-colonial cultural structures.

14 Bauer, 'The Space of *Documenta 11: Documenta 11* as a Zone of Activity' (2002), in Ander and Rottner, *Documenta 11_Platform 5*, p.104. It can be argued, however, that the Kassel exhibition 'Platform 5' continued to function as a summary for, and centre of, the project as a whole.

15 Mackay, 'The Globalisation of Culture?', p.48.

16 Toby Nangle, 'Global Markets' (2002), in *Free Trade: Neil Cummings and Marysia Lewandowska*, p.45.

17 Enwezor, 'Preface', in Ander and Rottner, *Documenta 11_Platform 5*, p.40.

18 Bonami, 'I Have a Dream', in Bonami *et al.*, *Biennale di Venezia*, unpaginated preface.

19 Stallabrass, 'Free Trade/Free Art' (2002), in *Free Trade: Neil Cummings and Marysia Lewandowska*, p.38.

20 Said, Introduction to *Orientalism* (1978), extract reprinted in Harrison and Wood, *Art in Theory 1900–2000*, VIID15, pp.1005–9; quote p.1007.

21 *Ibid.*, p.1008.

22 *Ibid.*, p.1009.

23 *Ibid.*

24 Gilroy, *The Black Atlantic*, p.2.

25 *Ibid.*

26 Enwezor, 'The Black Box' (2002), in Ander and Rottner, *Documenta 11_Platform 5*, p.44; extract reprinted in Gaiger and Wood, *Art of the Twentieth Century*, p.321.

27 Hardt and Negri, *Empire*, p.151.

28 *Ibid.*, p.146.

29 The argument is that the workings of an international system based on highly unequal nation states reinforce the power of multinational capital to dictate terms to the majority of the world's population. The concentration of power both in the world economy and the state system (currently expressed through the global power of the USA) creates 'empire': a system of domination that exists despite the end of imperialism in its nineteenth-century sense. For Hardt and Negri, it is the existence of this neo-imperialism that undermines a 'post-colonialist' perspective.

30 Hardt and Negri, *Empire*, p.61.

31 See, for example, Rogoff, *Terra Infirma*, pp.73–111.

32 Fahlström, 'Description of five paintings' (1975), cited in *Öyvind Fahlström: Another Space for Painting*, p.258.

33 Hardt and Negri, *Empire*, p.190.

34 *Ibid.*, p.208.

35 See *Varieties of Modernism*, Chapter 12.

36 See Klein, *No Logo*, pp.279–309.

37 Jantjes, 'The Long March from "Ethnic Arts" to "New Internationalism"', p.270.

38 Santamarina, 'Recodifying a Non-existent Field', p.22.

39 Kapur, 'A New Inter Nationalism: The Missing Hyphen', p.42.

40 Oguibe 'A Brief Note on Internationalism', p.54.

41 Tomlinson, *Globalization and Culture*, p.84.

42 E-mail correspondence with author, 20 January 2003.

43 Maharaj, 'Perfidious Fidelity: The Untranslatability of the Other', p.28; reprinted in Gaiger and Wood, *Art of the Twentieth Century*, pp.297–304.

44 A moulid is a religious festival to celebrate a birth.

45 Stallabrass, Introduction to 'Globalization' section in Araeen, Cubitt and Sardar, *The Third Text Reader on Art, Culture and Theory*, p.279.

46 Žižek, 'Against the Double Blackmail'.

47 *Ibid.*, p.313.

48 *Ibid.*, p.311. As Žižek goes on to say: 'When the West fights Miloševic, it is *not* fighting its enemy, one of the last points of resistance against the liberal-democratic New World Order; it is rather fighting its own creature, a monster that grew as the result of the compromises and inconsistencies of the western politics itself.' The same point holds in respect of Iraq: its strong position was also a result of the American strategy of containing Iran.

49 Žižek, 'Against the Double Blackmail', in Araeen, Cubitt and Sardar, *The Third Text Reader on Art, Culture and Theory*, p.316.

50 Hertz, *The Silent Takeover*, p.1.

51 See Fisher, 'Towards a Metaphysics of Shit' (2002), in Ander and Rottner, *Documenta 11_Platform 5*, p.63.

52 Gómez-Peña, 'Marcos', p.101. EZLN stands for Ejército Zapatista de Liberación Nacional or Zapitista Army of National Liberation.

53 Medina, 'Masked Allegories', unpaginated.

54 *Ibid.*

55 Bhabha, 'Double Visions', p.88.

References

Ander, H. and Rottner, N. (eds), *Documenta 11_Platform 5*, exhibition catalogue, Hatje Cantz, Ostfildern-Ruit, 2002.

Araeen, R., Cubitt, S. and Sardar, Z. (eds), *The Third Text Reader on Art, Culture and Theory*, London: Continuum, 2002.

Bhabha, H.K., 'Double Visions', *Artforum*, January 1992.

Bonami, F. *et al.*, *Biennale di Venezia: Dreams and Conflicts: The Dictatorship of the Viewer*, exhibition catalogue, Skira, Milan, 2003.

Documenta and the Museum Fridericianum Verandtaltungs-Gmb, *Documenta 11_Platform 5: Exhibition, Short Guide*, Ostfildern: Hatje Cantz Verlag, 2002.

Fahlström, Ö., *Öyvind Fahlström: Another Space for Painting*, exhibition catalogue, Museu d'Art Contemporani, Barcelona, 2001.

Fisher, J. (ed.), *Global Visions: Towards a New Internationalism in the Visual Arts*, London: Kala Press in association with The Institute of International Visual Arts, 1994.

FreeTrade: Neil Cummings and Marysia Lewandowska, exhibition catalogue, Manchester City Art Gallery, 2003.

Gaiger, J. and Wood, P. (eds), *Art of the Twentieth Century: A Reader*, New Haven and London: Yale University Press, 2004.

Giddens, A., 'Runaway World: How Globalisation is Reshaping Our Lives', London: Profile, 1999.

Gilroy, P., *The Black Atlantic: Modernity and Double Consciousness*, London: Verso, 1993.

Gómez-Peña, G., 'Marcos: the "Subcommandante" of Performance', *Third Text*, nos28/29, autumn/winter 1994.

Hardt, M. and Negri, A., *Empire*, Cambridge, MA: Harvard University Press, 2000.

Harrison, C. and Wood, P. (eds), *Art in Theory 1900–2000: An Anthology of Changing Ideas*, Malden MA and Oxford: Blackwell, 2003.

Hertz, N., *The Silent Takeover: Global Capitalism and the Death of Democracy*, London: Arrow Books, 2002.

Jantjes, G., 'The Long March from "Ethnic Arts" to "New Internationalism"', in K. Owusu (ed.), *Black British Culture and Society: A Text Reader*, London and New York: Routledge, 2000, pp.265–70.

Kapur, G., 'A New Inter Nationalism: The Missing Hyphen', in Fisher, *Global Visions*, pp.39–49.

Klein, N., *No Logo*, London: Flamingo, 2001.

Mackay, H., 'The Globilisation of Culture?', in D. Held (ed.), *A Globalizing World? Culture, Economic, Politics*, London and New York: Routledge, 2000.

Maharaj, S., 'Perfidious Fidelity: The Untranslatability of the Other', in Fisher, *Global Visions*, pp.28–36.

Medina, C., 'Masked Allegories', in C. Amorales, *Los Amorales*, Amsterdam: Artimo Foundation, 2001, unpaginated.

Oguibe, O., 'A Brief Note on Internationalism', in Fisher, *Global Visions*, pp.50–9.

Rogoff, I., *Terra Infirma: Geography's Visual Culture*, London and New York: Routledge, 2000.

Said, E., *Orientalism*, London: Routledge & Kegan Paul, 1978.

Santamarina, G., 'Recodifying a Non-existent Field', in Fisher, *Global Visions*, pp.20–7.

Sztulman, P., *Documenta 10 Short Guide*, Stuttgart: Edition Cantz, 1997.

Tomlinson, J., *Globalization and Culture*, London: Polity, 1999.

Trade Routes: History and Geography, exhibition catalogue, 2nd Johannesburg Biennale, Johannesburg Metropolitan County, 1997.

Wood, P. (ed.), *Varieties of Modernism*, New Haven and London: Yale University Press in association with The Open University, 2004.

Žižek, S., 'Against the Double Blackmail', in Araeen, Cubitt and Sandar, *The Third Text Reader on Art, Culture and Theory*, pp.309–15.

Further reading

Chapter 1

Anderson, P., *The Origins of Postmodernity*, London: Verso, 1998.

Clark, T.J., *Farewell to an Idea*, New Haven and London: Yale University Press, 2000.

Hopkins, D., *After Modern Art 1945–2000*, Oxford: Oxford University Press, 2000.

Potts, A., *The Sculptural Imagination: Figurative, Modernist, Minimalist*, New Haven and London: Yale University Press, 2000.

Stiles, K. and Selz, P. (eds), *Theories and Documents of Contemporary Art*, Berkeley, CA: University of California Press, 1996.

Wood, P., *Conceptual Art*, London: Tate Publications, 2002.

Chapter 2

Alberro, A. and Stimson, B. (eds), *Conceptual Art: A Critical Anthology*, Cambridge, MA and London: MIT Press, 1999.

Danto, A.C., *After the End of Art: Contemporary Art and the Pale of History*, Princeton, NJ: Princeton University Press, 1997.

Harrison, C., *Conceptual Art and Painting: Further Essays on Art & Language*, Cambridge, MA and London: MIT Press, 2001.

Harrison, C., *Essays on Art & Language*, Cambridge, MA and London: MIT Press, 2001.

Chapter 3

Colpitt, F. (ed.), *Abstract Art in the Late Twentieth Century*, Cambridge: Cambridge University Press, 2002.

Richter, G., *The Daily Practice of Painting: Writings 1962–1993*, ed. H.-U. Obrist, trans. D. Britt, London: Thames & Hudson, 1995.

Storr, R., *Gerhard Richter: Forty Years of Painting*, exhibition catalogue, Museum of Modern Art, New York, 2002.

Storr, R., *Gerhard Richter: October 18, 1977*, New York: Museum of Modern Art, 2000.

Chapter 4

Buchloh, B.H.D., *Neo-Avantgarde and Culture Industry: Essays on European and American Art from 1955 to 1975*, Cambridge, MA and London: MIT Press, 2000.

Campany, D., *Art and Photography*, London: Phaidon, 2003.

Osborne, P., *Conceptual Art*, London: Phaidon, 2002.

Roberts, J. (ed.), *The Impossible Document: Photography and Conceptual Art in Britain 1966–1976*, London: Camerawords, 1997.

Chapter 5

Kwon, M., *One Place After Another: Site-Specific Art and Locational Identity*, Cambridge, MA and London: MIT Press, 2002.

Rush, M., *New Media in Late Twentieth Century Art*, London: Thames & Hudson, 1999.

Schimmel, P., *Out of Actions: Between Performance and the Object 1949–1979*, exhibition catalogue, Museum of Contemporary Art, Los Angeles and Thames & Hudson, London, 1998.

Sunderburg, E., *Space, Site, Intervention: Situation Installation Art*, Minneapolis: University of Minnesota Press, 2000.

Warr, T. (ed.), *The Artist's Body*, London: Phaidon, 2000.

Chapter 6

Colomina, B. (ed.), *Sexuality and Space*, Princeton, NJ: Princeton University Press, 1992.

Lingwood, J. (ed.), *Rachel Whiteread: House*, London: Phaidon in association with Artangel, 1995.

Oxford Art Journal, special issue on installation, vol.24, no.2, 2001.

Oxford Art Journal, special issue on Louise Bourgeois, vol.22, no.2, 1999.

Perry, G., (ed.), *Difference and Excess in Contemporary Art: The Visibility of Women's Practice*, Oxford: Blackwell, 2004.

Chapter 7

Bhabha, H.K., *The Location of Culture*, London and New York: Routledge, 1994.

Clifford, J., *The Predicament of Culture*, Cambridge, MA and London: Harvard University Press, 1988.

Friedman, J., *Cultural Identity and Global Process*, London: Sage, 1994.

Schirato, T. and Webb, J., *Understanding Globalisation*, London: Sage, 2003.

Wollen, P., *Raiding the Icebox*, London: Verso, 1993.

Young, R.J.C., *Postcolonialism: A Very Short Introduction*, Oxford: Oxford University Press, 2003.

Index

Page numbers in **bold** refer to plates. Exhibitions, galleries and museums are listed alphabetically under 'exhibitions' or 'galleries and museums' rather than as independent entries.